D1374674

THE ECONOMIC IMPORTANCE OF THE ARTS IN BRITAIN

Much of the research on which this overview report is based is derived from regional studies carried out in three locations. Separate reports, in paperback, are being published to coincide with the overview:

The Economic Importance of the Arts in GLASGOW, MERSEYSIDE & IPSWICH

All three reports are available separately.

In addition PSI and the Gulbenkian Foundation will be issuing a separate *summary paperback* of the main findings and conclusions from the research.

These reports are available from good bookshops or in case of difficulty from:

PSI PUBLICATIONS DEPARTMENT
100 PARK VILLAGE EAST
LONDON NW1 3SR (01-387 2171)

THE ECONOMIC IMPORTANCE OF THE ARTS
IN BRITAIN

JOHN MYERSCOUGH
with
Alec Bruce, Michael Carley, Andrew Feist, Kate Manton, Ruth Towse
and Roger Vaughan

Policy Studies Institute

PSI Publications are obtainable from all good bookshops, or by visiting the Institute at: 100 Park Village East, London NW1 3SR (01-387 2171).

Sales Representation: Pinter Publishers Ltd.

Mail and Bookshop orders to: Marston Book Services Ltd, P.O. Box 87, Oxford, OX4 1LB.

A CIP catalogue record of this book is available from the British Library.

PSI Research Report 672

ISBN 0 85374 354 1

Published by Policy Studies Institute
100 Park Village East
London NW1 3SR

Printed by Blackmore Press, Longmead, Shaftesbury, Dorset

CONTENTS

LIST OF TABLES

ACKNOWLEDGEMENTS

The preparation of this series of reports would not have been possible without assistance from many people. I owe a particular debt of gratitude to my associates who were responsible for various aspects of the work: Michael Carley of PSI who made a major contribution to the preparation of the Merseyside study, managing much of the survey work, interviewing senior executives and drafting several sections of the report; Kate Manton for contributions to each of the studies, especially those on Glasgow and Ipswich, where she executed surveys and drafted sections of the reports; Ruth Towse for her work interviewing senior executives in Glasgow and Ipswich and other help, including commenting on drafts; to Alec Bruce who carried out the special study on arts and crafts businesses in Ipswich, bringing to bear his unrivalled experience and particular insight into the lives of creative artists; and to Roger Vaughan of DRV Research who was unfailingly generous with his time and advice in undertaking the impact analyses for the three regional studies. A special word of thanks must go to my colleague at PSI, Andrew Feist, who assisted me in many aspects of the work and made a particular contribution in assembling information on the overseas earnings of the arts and in implementing the survey of the art trade. Of many helpful colleagues at PSI, Karen MacKinnon deserves particular mention for undertaking the computing with good humour, as does Clare Pattinson for her great efforts with the wordprocessing of text and tables. British Market Research Bureau, which carried out the customer and general population surveys was helpful at every stage of a protracted project and I would like to thank John Samuels and his staff for all their work. Wise counsel came at an early stage in the preparation of the project from J. Pinder, W.J. Baumol, M. Nissel and J. Ermisch. Each of the three regional studies had an Advisory Group. Their memberships were as follows:

Merseyside

J. Last	Merseyside Arts
M. Nolan	Tourism Committee, Merseyside County Council
J. Riley	Arts and Culture Committee, Merseyside County Council
D. Highet	Granada (Liverpool)
B. Adcock	Merseyside Development Corporation
D. Fishel	Liverpool Playhouse (nominee of Merseyside Arts)
R. Jarman	Merseyside Arts
P. Booth	Merseyside Arts
P. Wilsher	Tourism Development, Merseyside County Council
M. Chechett	Development and Planning, Merseyside County Council
G. Clark	Project Manager

Glasgow

W.J. English	Glasgow District Council
D. MacDonald	Glasgow Action
H. McCann	Scottish Arts Council
L. Miller	Scottish Arts Council
E. Friel	Greater Glasgow Tourist Board
I. Williams	Scottish Development Agency
V. Goodstadt	Strathclyde Regional Council
B. Hay	Scottish Tourist Board
T. Ambrose	Scottish Museums Council

Ipswich

J. Newton	Eastern Arts
P. Labdon	Suffolk County Council
C. Crowther	Suffolk County Council

A. Gillespie	Suffolk County Council
R. Stephenson	Ipswich Borough Council
J. Parry	Babergh District Council
D. Long	Mid Suffolk Coastal District Council
W. Croft	Suffolk Coastal District Council
A. Osmanski	Suffolk Coastal District Council

A National Advisory Group supervised the overall progress of the programme of research and paid close attention to the overview report. Its members were:

R. Guthrie	Joseph Rowntree Memorial Trust
K. Taylor	Gulbenkian Foundation
I. Reid	Gulbenkian Foundation
R. Stone	Office of Arts and Libraries
D. Lodge	Office of Arts and Libraries
J. Warren	Museums and Galleries Commission
P. Oppenheimer	Christ Church Oxford
D. Derx	Policy Studies Institute
W. W. Daniel	Policy Studies Institute

I am deeply grateful to the members of each of these Advisory Groups for informed advice and for support at every stage of the project. It remains to thank the many individuals who responded to our requests for help by completing questionnaires supplying information and granting interviews. Without their co-operation the completion of these reports would have been impossible. I would hope that they feel this generous grant of time has been justified by the result.

John Myerscough

SYMBOLS, CONVENTIONS AND ABBREVIATIONS

Symbols used

The following symbols are used in the tables:

—	Nil
Ø	Less than half the final digit shown
..	Not available
n.a.	Not applicable

Rounded figures

In tables where the figures have been rounded to the nearest final digit, totals may not correspond exactly to the sum of the constituent items.

Non-calendar years

The symbol / represents the financial year (for example, 1 April 1985 to 31 March 1986), unless otherwise stated.

Box office and other receipts

The figures for box office and other receipts are given exclusive of VAT, unless otherwise stated.

Abbreviations

ABSA	Association of Business Sponsorship of the Arts
ACGB	Arts Council of Great Britain
BBC	British Broadcasting Corporation
BHTS	British Home Tourism Survey
BPI	British Phonographic Industry
BSIS	Business Sponsorship Incentive Scheme
BTA	British Tourist Authority
CC	Crafts Council
CP	Community Programme
CSO	Central Statistical Office
DTI	Department of Trade and Industry
ETB	English Tourist Board
FES	Family Expenditure Survey
GDC	Glasgow District Council
IBA	Independent Broadcasting Authority
IFPI	International Federation of Phonographic Industries
ILR	Independent Local Radio
IPS	International Passenger Survey
ITCA	Independent Television Companies Association
ITV	Independent Television
MCPS	Mechanical Copyright Protection Society
MGC	Museums and Galleries Commission
MPA	Music Publishers Association
MSC	Manpower Services Commission
NMGs	National Museums and Galleries
OAL	Office of Arts and Libraries
PRS	Performing Right Society
RAA	Regional Arts Association
RLPO	Royal Liverpool Philharmonic Orchestra
SDA	Scottish Development Agency
SEM	Special Employment Measure
SIC	Standard Industrial Classification
SWET	Society of West End Theatre
YTS	Youth Training Scheme

INTRODUCTION

PSI was originally approached by the UK Branch of the Calouste Gulbenkian Foundation to discuss the feasibility of a research programme on the economic importance of the arts in Britain, and to draw up a possible research brief. Such a brief was eventually developed and agreed, and the research programme was formally commissioned by the Foundation and the Office of Arts and Libraries. Further financial support was provided from national sources by the Museums and Galleries Commission, the Arts Council of Great Britain and the Crafts Council. Whilst the most important decisions in launching the programme of research were taken at the national level, and the central government funding was generally confined to the national aspects of the study, it was clear from the outset that the regional dimension would be vital. Much of the necessary detailed economic information could only be collected in practice by confining the study to selected localities or regions, and if the research were to lead to any concrete results, the locus for detailed action and implementation was most likely to be the region or the city.

A search for appropriate regions willing to provide the necessary finance led to the establishment of three regional case studies. The first of these, in which most of the methodology was piloted, was carried out in Merseyside. It related to the area covered by Merseyside Arts, the regional arts association for this region, and included seven districts or metropolitan boroughs, with Liverpool at the centre. The resident population of this study region was roughly 1.5 million. The research was undertaken between July 1985 and March 1986 under pressure of the abolition of the Merseyside County Council.

The second study was of greater Glasgow, an area with a population of 1.6 million. The defined study region represented the Glasgow travel-to-work area and did not coincide with any particular administrative structure. It actually included ten district councils with the massive Glasgow District Council at the centre. Strathclyde Regional Council, within which the study region lay, covered a broader territory including large tracts of the West of Scotland. The interest of a wider public in the Glasgow example centres on the fact that the city, in the face of major problems of urban decay (losing 22 per cent of its population between 1971 and 1981), has made vigorous efforts to reverse the decline by investing , as one journalist shrewdly observed, in 'looks, learning and cultural infrastructure'. This has included concentrating physical redevelopment and refurbishment on a focussed area of central Glasgow, which is undertaking one of the largest urban renewal schemes in the world (the Glasgow Eastern Area Renewal project), adopting clear-sighted and practical programmes of business initiatives and carrying out a brilliant PR campaign. Glasgow has also experienced a major creative revival with a new artistic excitement and mood arising in the West of Scotland.

The third study concerned a smaller region, with a population of under 400,000 — the area in Suffolk around Ipswich, covering four district councils. The region centred on Ipswich, a medium-sized county town (120,000), with industrial, commercial and administrative functions. The rest of the study region was rural in character, including small towns, villages and some coastal development. It was considered important to undertake a study of a rural area because conditions there might be different from the rest of the country. The area around Ipswich was selected as a region which was reasonably remote from the influence of a great metropolis, yet which already had in place a network of arts provision. It was also significant that the region had experienced a population surge and a wave of prosperity, so that it might be possible to assess the actual and potential role of the arts in relation to a dynamic situation. The study represents one rural case, though it is realised that the situation may be different in other rural areas of Britain.

The three regional case studies address local questions and stand on their own as separate published reports. One purpose of the overview report has been to pull together the threads of the regional studies. But anyone interested in the particular regions or in practical examples of

regional strategies to realise the economic potential of the arts should turn to the case studies, especially those dealing with Glasgow and Ipswich, where proposed programmes of initiatives are described in detail. The use of virtually identical methodologies in the three regions means that comparisons can be made between contrasted regions and this is one important aspect of the overview report. The national report incorporates the results of further research on the national dimension of the arts, including the value of overseas earnings. Thus, a second intention of the overview is to provide a full picture of the arts sector in Britain as a whole and give a basis for drawing conclusions of national significance.

The rising tide of European policy interest in the economic dimension of the arts is a recent development. Previously, concerns had centred more on cultural democracy and on the conditions and terms of work for those employed in the arts. It became apparent only as recently as 1983 at the Munich Research Workshop on 'Financing of Cultural Policy' (see Myerscough) that the economic importance of the arts was attracting an interest across Europe. This was a time when central government spending on the arts was levelling off. Arguments based on their intrinsic merits and educational value were losing their potency and freshness, and the economic dimension seemed to provide fresh justification for public spending on the arts.

In retrospect, the early 1980s' stress on the economic value of the arts reads like special pleading by those defending the arts against threatened reductions in public spending. It was set in no particular policy frame and might have applied equally to any area of public spending, to defence as much as to drama companies. In the space of a few years, the argument has moved on to higher ground, by relating the role of the arts to the fact that we live in an era of industrial restructuring characterised by the growing importance of the service industries (especially in the areas of finance, knowledge, travel and entertainment), and of industries based on new technologies exploiting information and the media. The success of cities in the post-industrial era will depend on their ability to build on the provision of services for regional, national and international markets. By the same token, regional policy must concentrate on attracting service industries as a more urgent aim than winning manufacturing plant.

The arts fit naturally into this frame, especially when any likely increase in the availability of free time, and the intensification of its use, will place new and increasing demands on them. The issue is now not so much whether the arts have an economic dimension. Rather, what is the specific and distinctive economic contribution the arts can make? How can this be most appropriately encouraged and exploited? And what is the relevant policy frame in which to relate the interests of the arts to wider economic aims?

The changing policy perspective in which the arts are being considered means that not only those carrying prime responsibility for arts policy are intrigued by their economic prospects, but also new partners of the arts are emerging from other quarters of government and the private sector. Evidence for this can be seen in the diverse funding of the regional case studies in this project. It is not without significance that two of the studies attracted support from the business community, in Glasgow from Glasgow Action (a group of leading business people and politicians which seeks to implement a plan for Glasgow to develop a strong business and consumer-service industrial base), and in Merseyside from the Granada Foundation.

The Merseyside study formed part of a larger commission by Merseyside County Council, Merseyside Arts (with the help of the Granada Foundation), Merseyside Development Corporation and the Commission of the European Communities to provide a detailed study of the economic impact of tourist and associated arts developments, as suggested in a previous report, an integrated development operations feasibility study for Merseyside. In Ipswich, on the initiative of Eastern Arts (the regional arts association for the area) finance was provided by Suffolk County Council, Babergh, Mid Suffolk and Suffolk Coastal District Councils and by Ipswich Borough Council. The strong public-sector support, in this case, as in others, came from the planning departments of

local authorities as much as from sections concerned narrowly with the arts. The motive was a desire to explore every avenue for promoting the economic vitality of their region. In addition to Glasgow Action, the Glasgow study was commissioned by the Glasgow District Council and the Scottish Arts Council, which provided important national backing for the project. The tourist interest was reflected by a contribution from the Greater Glasgow Tourist Board. In these complicated funding packages, new partners for the arts emerged from unexpected quarters and the combination of public and private, central, regional and local finance was important for this research.

The main aim of the study has been to provide an assessment of the economic contribution of the arts to the British economy. It has involved examining the arts as a form of productive activity, in terms of levels of employment, income generation and patterns of economic organisation. But it has also addressed the role of the arts in relation to the future prospects of the British economy, and includes consideration of the ways in which the economic potential of the arts might be realised through national and regional initiatives.

The study has not been restricted to the tangible economic impact of the arts, for example, as a source of direct employment and stimulus to allied industries through the spending of arts organisations and their customers. Less easily quantifiable aspects of the influence of the arts have also been included. There is a growing belief that the arts can bring a competitive edge to a city, a region and a country as a source of creativity, a magnet for footloose executives and their businesses, and as a means of asserting civic, regional or national identity through the quality of cultural life. The influence of the arts on the business community forms part of this study, including their place in decisions about where businesses might choose to invest and where executives might live and work. Apart from the potential role of cultural amenities in sustaining the economic attraction of a region, the study also assesses the part played by the arts in developing the image and appreciation of particular regions by their resident populations, including senior business executives.

Whilst a broad assessment of the economic contribution of the arts was the overriding aim of the research, the study has focussed on a number of specific objectives, which are worth summarising here. They were to establish:

— the benefit, in terms of employment and other economic returns of public spending on the arts, and how these compared with other public services;

— the importance of cultural tourism and its contribution to the national economy, including the areas of possible development;

— the significance of overseas earnings attributable to the arts, both in terms of direct earnings from fees and royalties and indirect earnings through the role of overseas tourism;

— the value to the business community of a healthy arts sector;

— the importance of the arts as an agent of urban renewal;

— the prospects of the arts sector, and the opportunities provided for realising the economic potential of the arts.

The empirical approach adopted in the programme of research necessitated many surveys, some 23 in total. They included:

— censuses of arts organisations and enterprises (large and small) in the three study regions to

establish business information (turnover, activity, sales, employment) and to discover the geographic and sectoral patterns of their spending;

— surveys of particular cultural industries (film and video companies in Glasgow and arts and crafts enterprises in the Ipswich region);

— surveys of arts customers to establish the market profile of people attending arts events and attractions (residents, day visitors and tourists), together with their associated levels and patterns of spending; three were carried out in the study regions and additional surveys were undertaken of overseas tourists in London and of other London arts customers (very small sample);

— surveys of ancillary businesses (e.g. hotels) which attract the spending of arts customers;

— surveys of the resident population of the three study regions to establish the use made of arts events and attractions, together with amateur participation in the arts, and the importance attached to arts provision in the region;

— interviews with senior business executives about the importance and influence of the arts on business and social life, including decisions by businesses about where to invest and decisions by executives where to live and work, and the part played by the arts in boosting the image and confidence of the region;

— surveys of middle managers on factors affecting decisions where to live and work.

In addition, many supplementary enquiries were made with individuals in the arts, business (including tourism), public agencies and local authorities to collect information on other matters, including public policy towards the arts, funding and the role of the arts in the planning process. Preparing estimates of the value of the overseas earnings of the arts involved numerous enquiries within the arts sector, including several small postal surveys and a major survey of the art trade.

As for the methods of analysis employed in the study, these are described as appropriate at the relevant places in the text of the report, including the technical appendices. A few general observations on the main approaches adopted may be useful here. The basic aim of the study was to assemble relevant facts about the economic effects of the arts sector. This empirical approach has resulted in an extensive description of the arts sector covering its organisational structure, its turnover and value-added, the employment it generates, its market and its overseas earnings (see Phillips for a pioneering study in the allied area of intellectual copyright). An assessment of the economic prospects of the sector has formed part of this, together with some observations on the scope of public and private initiatives to realise its economic potential. The interaction between the different sub-sectors of the arts has been stressed by placing independent provision alongside subsidised activities. The findings on some of the points (for example, overseas earnings) are so important that updates of the information should be undertaken. At the regional level, the pictures provided of the operational and financial details of the sector, including the size and importance of the market for the arts, will have wide future applications in determining relevant public or private strategies and in the assessment of progress in the sector.

Despite much recent criticism of economic impact (see Radich), the technique has been used in the regional case studies. The claims made here on behalf of the technique are rather more restricted than in some previous studies. The application of the analysis was limited to descriptions of the indirect effect of the arts sector on income and jobs in the regional economy and to assessing the differential impact of the various parts of the arts sector (museums v. theatres; residents v. tourists), with some applications to predicting likely effects of various policy options.

Economic impact studies of the arts have been criticised for, among other things, grossly exaggerating positive economic benefits, ignoring negative effects, using 'second-hand' multipliers, failing to consider alternative uses of public money and measuring displacement effects rather than real gains (see Radich and Graves). Efforts have been made in this study to avoid these pitfalls. The analysis of the customer effect of the arts (the spending on food, drink, travel, and accommodation which underpins arts attendance) is based on an attempt to differentiate arts-specific spending from 'deadweight expenditures', which would have occurred irrespective of visits to museums and galleries, theatres and concerts. By the same token, the analysis of the public expenditure cost of generating extra jobs through the arts made allowance for the substitution effect (some new jobs are taken by people who were not previously part of the unemployed count), potential inflationary effects and the displacement effect (the danger of developing one sector of the arts at the expense of others without generating real gains). The analysis is also set in the comparative context of the benefits arising from public monies spent on alternative projects, including special employment measures. This approach is analogous to cost benefit analysis but it falls short of the full adoption of the method as advocated for application to the arts by some economists (see Blaug and Hendon), especially as an economical means of appraising specific policy decisions.

The above approaches to the arts involved treating the sector much like any other industry. In this the arts cannot escape value for money considerations, and the study stresses the need to utilise spare capacity, among other things, so that the more effective use of public money, with box office earnings as the major driving force, may continue to be a feature of this sector (see *Facts 2*). The argument based on economic benefits does not translate simply into extra claims on public or private money, though governments should respond to the need for investment in research and experimentation in an economic sector where the risk of failure is high and some of the positive returns relate to a long-term perspective.

There is more than one way to examine the economic benefits of the arts and the approach in the rest of the study has been to explore the 'economics of the quality of life', the kind of effects which generate so-called 'external benefits'. These include the impact of the arts on the location of economic activity, the influence of cultural infrastructure on decisions about where to live and work, the impact of museums and galleries, theatres and concerts on the image and self-confidence of the city or region and the pervasive contribution of the arts to the spirit of creativity and innovation. This aspect of the work has been close in its methods and concerns to important studies undertaken in Australia and Canada (see Throsby and Withers, and West).

In the definition of the arts sector, the study has adopted a broad view which is not restricted to the public sector. It includes independent provision alongside grant-aided activities and it covers the museums and galleries, theatres and concerts, creative artists, community arts, the crafts, the screen industries, broadcasting, the art trade, publishing and the music industries. Among the important exclusions from the study were the amateur organisations and education in the arts.

It is still sometimes thought that cultural life is split between high art, which should have no contact with commercial values, requiring public subsidy to keep its creative process pure, and the market sector which gives rise to suspicion because it is charged with supplying the world with debased products of mass culture. A more realistic interpretation of the role of the profit motive in the transmission of artistic ideas and experiences to the public should take account of the following points:

— there is a degree of overlap in the type of entertainment offered by commercial and subsidised organisations (including transfers to the West End from the subsidised stage and vice versa);

— subsidised organisations increasingly observe business disciplines; they are 'non-profit distributing' rather than 'non–profit making' in format;

— most creative and performing artists make their living from both the commercial and subsidised sectors (for example, musicians in recording and actors in film and broadcasting);

— the commercial sector can be a vehicle for minority interests (such as specialist publishing, and the 'alternative charts' in rock music) and for high quality one-off products (most work by artists and craft people);

— some cultural industries seek to counteract standardisation by projecting, say in film and television, a distinct image of Britain as a basis for competition in world markets.

The relationship perhaps needs deeper study, but it is clear that the interaction and overlap between independent and subsidised provision is marked.

It should be stressed that there are few parts of public life where the arts in one sense or another, especially in the form of design, do not penetrate. A recent study of British design consultancies estimated that the sector's turnover was £1.7 billion in 1985 with exports valued at £175 million (see McAlhone). It is recognised that many sectors of the economy derive direct inputs from artistic ideas and personnel trained in the arts. Advertising is a prominent example of this. Wherever words or personal presentation or skills are necessary an arts background can be an advantage. Consideration of these wider ramifications is not part of the remit of the study.

The present report is arranged in five parts: they deal with the profile of the arts sector (including its weight), its power as a magnet for people, its economic impact and value, its influence and its economic potential. It is worth briefly summarising the contents and conclusions of each part in its various sections.

Part I: Economic profile of the arts sector

Section 2. Market for the arts. This provides a profile of the market for arts events and attractions. Attendance totalled some 251 million in 1984/85 of which 73 million were museum and gallery visits and 49 million admissions to theatres and concerts. The market is analysed separately for residents, day visitors and tourists. In the three study regions residents are in the majority but in London they form the minority of the market for the arts. The arts reach about two thirds of the adult population; the reach is higher for ABC1s than for C2DEs but it is by no means negligible for the latter. Museums and galleries have a wider social range than theatres and concerts and they draw more day visitors and tourists from further afield. The section considers the rise of 'cultural' preoccupations in the home (especially an increase in television viewing) and the growing acquisition of cultural equipment (videos, musical instruments) for use in the home, but it concludes that cultural activities outside the home (attending arts events and attractions) are not declining.

Section 3. Economic structure of the arts sector. This section summarises the basic economic facts about the arts sector which has a turnover of £10 billion, amounting to 2.5 per cent of all spending on goods and services by UK residents and foreign buyers, and giving direct employment to almost half a million people. It examines the overseas earnings attributable to the arts and concludes that the arts are placed fourth among the top invisible export earners. Public funding of the arts is set in the perspective of the arts sector as a whole. It represents 18 per cent of income for the sectors; the balance is shifting from central government to local authorities and from public funding to private finance. The large element of small businesses in the sector makes it a seedbed for future growth and a place for research and development.

Part II: The arts as a magnet for people

Section 4. The customer effect relates to the spending which underpins attendance at arts events and attractions. The section provides estimates for spending by arts customers on food

and drink, travel, shopping and accommodation. Not all purchases are attributable specifically to the arts because some of the attendance is essentially casual and not the main reason for being in a region or vicinity. A means of measuring the degree to which people are influenced by the pull of the arts is described. The conclusion is that most of the spending would be lost to particular regions if the arts events and attractions were not operating. The customer effect is one of several ways in which the arts act as a catalyst for urban renewal, including city-centre rehabilitation, and the section concludes with a discussion ot these issues.

Section 5. Art and tourism. This section assesses the nature of the complementary relationship between the arts and tourism. It sets out the degree to which tourists provide audiences for the arts and assesses the importance of the arts as a draw for tourists. It shows that some 27 per cent of overseas earnings are specifically attributable to the arts. After discussing the prospects for arts tourism and the nature of that market, it concludes that there is a major opportunity for developing the mutual relationship between the arts and tourism. The elements of an arts tourism strategy are spelt out, including the necessary guidelines and some of the broader implications.

Part III: Economic impact and value of the arts

Section 6. Assessing the economic impact of the arts. The aim of this section is to provide estimates of the total economic impact of the arts in the three study regions. This is carried out by means of a proportional multiplier analysis, and it concludes that the arts are a potent means of sustaining employment in the regional economy. The concept of the 'arts multiplier' is developed: for every direct job in an organisation further jobs are linked to it through the spending of arts organisations and their customers in the wider economy. The section also compares the impact of different types of arts organisations and of various types of customers. This permits some assessment of the 'best buys', measured in terms of extra jobs generated, for different strategies of market development.

Section 7. Subsidising the arts. The main conclusion of this section is that the arts are a cost-effective means of cutting the unemployment count. It shows that the arts have a cost advantage over other public forms of revenue spending. Some of the problems to be faced in trying to generate jobs through the arts, including inflationary effects and displacement (shifting audiences from one event to another without achieving real gains), are also discussed. A critical re-assessment of the rationale for public spending on the arts includes the relevance of the concepts of 'external' and 'public' benefits. It points to the growing emphasis on the benefit of private funding. The special role for public finance as a means of encouraging experimentation and innovation is highlighted. As for special employment measures, the sector concludes that it might be better if these resources were devoted to assisting with training and helping bodies in a growth sector to expand their output and employment.

Part IV: Economic influence of the arts

Section 8. Arts provision and the general public. The next two sections examine some of the less tangible economic influences of arts provision on business and social life. Section 8 seeks to throw light on how the arts are in fact regarded by the public at large which is called upon to pay for them through the compulsory exactions of taxation. It also examines the part played by cultural institutions in defining the image of particular regions. It shows that practical interest in the arts is not confined to a small minority of people and that a vast majority (over 90 per cent) perceive positive community benefits in the arts, including an improved image of the city or region and a feeling of pride in its amenities. This was confirmed in their willingness to pay for this through taxation, but the evidence in favour of increased public expenditure was rather mixed.

Section 9. Arts provision and the business community. The value of the arts to the business community is the subject of this section. It shows that senior executives place an increasing value on cultural amenities as a means of improving the image of, and of boosting confidence in, a region. It considers how far this is an operational matter, as well as a question of image, by looking at the role of culture infrastructure in the thinking of 'mover firms' and as a factor in attracting and retaining senior personnel. The willingness of the business community to contribute financially through sponsorship to the maintenance and development of the arts is discussed. Finally, there are some reflections on the factors affecting the location of business and enterprise and the growing competition in the use of amenity factors as an encouragement to the regional and national economy.

Part V: Economic potential of the arts

Section 10. Economic potential of the arts. The final section of the report begins by summarising the findings of the study on the economic weight, power, impact and influence of the arts in Britain. The main task of this section is to suggest the areas for possible action by which the economic potential of the arts sector in the British economy might be realised. A particular challenge arises from the fact that the sector is already expanding in terms of attendance, jobs and output. Eight specific areas of opportunity are defined, which might form the basis of strategies for growth: arts and tourism; rectifying regional imbalances; initiatives in rural areas; urban renewal and redevelopment; provision of extra jobs; increasing overseas earnings; the use of amenity factors to improve the competitiveness and appeal of a region; adding to arts programmes under strict criteria which reinforce policies in parallel areas. The respective roles of public and private finance in the economic expansion of the arts are discussed together with the returns to central government from seeking to realise their economic potential.

The study comes to a number of conclusions about the economic importance of the arts in the British economy; about the size and significance of the sector itself, the value of the arts as a people magnet and the exploitation of the customer effect in regional economic development; the perceived value of cultural amenities as a business asset, a font of creativity and a valued amenity for the resident population; the role of the arts as a leading edge for tourism growth; and the cost-effective contribution of the arts as a means of cutting the unemployed count.

The study has been concerned with the economic value of the arts but there are many other reasons why the arts are important to the British people. The fact that the arts have a far-reaching importance for the economic modernisation of Britain should not be interpreted to mean that artistic considerations can be regarded as secondary. On the contrary, this gives an even greater primacy to the needs of artists, cultural organisations and their public, and it provides a means whereby artistic ambitions might be more readily realised. Encouraging experimentation and innovation in the arts is the most difficult and the most vital task. Any artificiality introduced into artistic life — say, plastic schemes specially mounted for tourists — would depreciate the region's cultural assets, alienate the most important aspects of the market and end in eventual failure. The purpose of the arts must never solely become related to alien objectives, be it job generation or social rehabilitation.

Finally, a word should be said about the dates to which the report refers. The financial and operational data in the report relate mainly to the year 1985/86 (1984/85 in the case of Merseyside) and so the description of the arts in Britain has been written in the past tense. The various surveys of opinion (customers, middle managers, residents) were carried out in 1985 and 1986. The report, especially those parts suggesting ways of realising the economic potential of the arts, was finalised in November 1987. The arts in Britain are a fast changing world and significant changes in the pattern of provision have already begun to appear before the report is

published. It is to be hoped that further developments will take place in response to the findings of the report.

The report is addressed to those who paid for it — central government, a private foundation, the business community, a development corporation, local authorities (planners as well as those responsible for arts policy), various public agencies in the fields of tourism and the arts, and the Commission of the European Communities — together with the wider public. Much good and little harm would come from these bodies, collectively and separately, addressing the findings of this report with urgency.

PART I: ECONOMIC PROFILE OF THE ARTS SECTOR

2. MARKET FOR THE ARTS

This section begins with some general observations on the size of the overall arts and culture market, as roughly indicated by official figures on the consumer spending it attracted. But its largest task is to survey the market for the arts, in terms of attendance at the core arts organisations, museums and galleries, theatres and concerts. New estimates are given of the value of consumer spending on events and attractions, which are compared with the rival appeal of entertainment in the home. The section concludes by considering the structure of the market for the arts and some of its social characteristics.

Cultural goods and services attract 5 per cent of consumer spending

One guide to the size of the cultural leisure market is the consumer spending it attracted as reported by the Central Statistical Office (CSO). This amounted to £10.5 million, or 5.4 per cent of total consumer expenditure, in 1984 (see Table 2.1). The figure includes goods as well as services. In round terms, less than one fifth of the total went on recreational and entertainment services; rather more than a third on books, records and other cultural items for private enjoyment; and the remainder (almost half) represented the purchase of musical instruments, video hire, TV licence fees, and, above all, domestic electronic equipment, such as televisions, radios and video players. The figures are a useful general guide but they relate to categories which are far too broad to provide anything other than a general context in which the size of the market for the arts can be considered. Another limitation is that figures on 'recreational and entertainment services' include some non-cultural spending (e.g. admissions to spectator sports).

The same statistical source provides a more useful indication of the overall trend in spending in the cultural leisure field. Table 2.1 shows that the cultural sector grew strongly from 1974 to 1984. It stayed more or less in line with overall consumer spending, remaining at between 5.3 and 5.5 per cent of the total throughout the period. At current prices, spending on this broadly-defined basket of cultural goods and services more than doubled from £4 billion to £10.5 billion between 1974 and 1984. The growing volume of spending, expressed at constant (1980) prices, can be seen in the index which rose from 100 in 1974 to 144 in 1984. Detailed figures are not available for 1985, but according to *The CSO Blue Book*, 1986 Edition, consumer expenditure on recreation, entertainment and education grew in 1985 by 8.8 per cent at current prices and by 5.3 per cent at 1980 prices, compared with an 8.9 per cent increase in total consumer expenditure at current prices.

Table 2.1 Consumer spending on culture and leisure at current prices

£ billion and percentages

	1976	1979	1980	1981	1982	1983	1984
Consumer spending (£ billion) on:							
Recreational and entertainment services (a)	0.7	1.2	1.4	1.6	1.6	1.8	1.9
Book, records, newspapers, photo (b)	1.4	2.2	2.7	3.0	3.3	3.5	3.7
Radio, TV, instruments, durable (c)	2.0	2.9	3.2	3.5	4.1	4.6	4.9
Total	4.0	6.3	7.2	8.1	9.1	9.8	10.5
Total as percentage of consumer spending	5.3	5.4	5.3	5.3	5.5	5.4	5.4

Source: *Facts 2*.
(a) Includes admissions to theatres, cinemas, other arts events, galleries and museums, and country houses and social subscriptions and spectator sports; the club fees include sports and swimming clubs.
(b) Photographic equipment included under durables.
(c) Includes radio, TV, musical instruments, TV and video hire charges, licence fees and repairs.

The arts can be enjoyed inside and outside the home

The market for the arts falls broadly into two parts; one relates to events and attractions outside the home (museums and galleries, theatres and concerts); the other provides entertainment (video, TV, records and books) within the home. Whilst this report is primarily concerned with the former market, it will be obvious from the final consumer's point of view that, in terms of their content, the two markets substantially overlap. They offer choice in the forms of access to what can be seen as essentially similar entertainment and artistic experiences. The same piece of music may be enjoyed in a number of different ways. It can be read in a musical score or listened to at a concert; the concert may be attended or it might be heard live in a broadcast; the broadcast might be privately recorded and listened to subsequently; finally, the performance might be commercially recorded and sold as a compact disc. Each mode of access to the music, from reading the score to playing a recording, demands attention from the listener and is in competition with the alternative forms of access for expenditure both of money and of time.

Whilst the various ways of approaching the arts, inside and outside the home, compete, they also reinforce each other. Viewing a video might be regarded as a substitute for visiting an exhibition, but it can equally well serve as a preparation for seeing the show and as a memento of the visit. For creative and performing artists the various ways of distributing artistic experience, live or packaged, are complementary rather than alternatives. Contact with a live audience is professionally as important for actors and musicians as are the financial rewards from studio work. Paintings are sold equally to hang on private walls or in public galleries. Thus, there are a variety of channels by which artistic ideas may reach a public and this is reflected in the structural complexity of the market for the arts. The section considers first events and attractions outside the home and then turns to spending on domestic entertainment.

Attendance at arts events and attractions totals 251 million

(a) *Total picture*
Attendance at cultural events and attractions totalled an estimated 251 million in 1984/85 (or the nearest available year). The figures include attendances at museums and galleries, heritage properties (built attractions only, excluding parks, steam meetings, etc.), theatres and concerts and the cinema. Despite the contraction of commercial cinema admissions to less than half of what they were 10 years ago, cinema continued to be the most popular attraction for evening entertainment with 70 million attendances. Theatre and concert going amounted to 49 million admissions. Evening entertainment as a whole (theatres, concerts and cinema) at 119 million admissions roughly balanced the 132 million visits to museums, galleries and heritage attraction properties. Not surprisingly, museums and galleries (with 73 million visits) exceeded the heritage (59 million) as an attraction. Visits to zoos, safari parks, gardens, steam railways and other attractions, many of them with cultural aspects, have been left out of consideration.

Table 2.2 Arts attendance in Britain, 1984/85

Millions

	Attendance
Museums and galleries	73
Built heritage (a)	59
Theatres and concerts	49
Cinema	70
Total	251

Source: As for Tables 2.3 and 2.4; English Tourist Board; British Film Institute.
(a) Including an estimated 5 million in Scotland.

THE ECONOMIC IMPORTANCE OF THE ARTS IN BRITAIN

The rest of the section concentrates on the main areas of interest of the report, the core arts organisations, that is museums, galleries, theatres and concerts. Some uncertainty surrounds all the figures quoted, especially those concerning attendance at museums and galleries.

(b) *Museums and galleries*

Within a total attendance at museums and galleries estimated at 73 million, the 19 national museums and galleries (NMGs) with over 50 facilities between them had the largest share of the market at 25.1 million admissions in 1985. Included in this figure are the national military museums (e.g. RAF Museum Hendon), accounting for 1.1 million attendances in 1983/84, and the 1.1 million attendances at the Merseyside museums, which were given national status in 1986. The British Museum (4.1 million) and the National Gallery (3.2 million) were among the top tourist attractions in any field, second only to the Blackpool Pleasure Beach. The NMGs in London attracted the bulk of the attendance. Among the many outstations of the NMGs, the National Railway Museum York (administered by the Science Museum) was the most popular, drawing 0.9 million visits. Attendances at the NMGs of Scotland, based mainly in Edinburgh, totalled 1.2 million.

The latter figure compared unfavourably with the 3.2 million visits to museums and galleries in the Glasgow region, of which 2.8 million were to local authority museums. Overall, the 906 local authority museum facilities in England, Wales and Scotland accounted for 22.6 million attendances (31 per cent of the total). Among the major attractions were the Burrell Collection (1.1 million) and Kelvingrove Glasgow (806,000), Castle Museum York (670,000) and Birmingham City Art Gallery and Museum (501,000). Important metropolitan facilities were matched by the small museums operated by most district councils. Local authorities also managed heritage properties, of which the Roman Bath Bath (931,000 visits) and the Royal Pavilion Brighton (285,000 visits) were very popular. Attendance at the independent museums was estimated at 20 million. This much ex-panded sector included a wide range of organisations from major commercial operations to a host of small museums run by local enthusiasts, making heavy use of voluntary labour. A commercial operation, the Jorvik Viking Centre York (691,000 visits), and the Beaulieu Motor Museum (488,000 visits) were the top attractions among the independent museums. The 21 university museums, such as the Fitzwilliam Museum Cambridge, formed a long-established and important part of the independent sector.

Table 2.3 Attendance at museums and galleries, 1984/85

Millions, percentages and numbers

	Attendance		Number of
	Millions	Percentages	facilities
National museums and galleries (a)	25.1	34	54
Local authority museums and galleries	22.6	31	750
Other museums (b)	19.7	27	906 (b)
Galleries and temporary loan exhibitions (c)	5.4	7	255
Total	72.8	100	1,965 (b)

Source: *Facts 2; Museums UK; Arts Centres UK.*

(a) Figures relate to 1985: include Merseyside Museum.

(b) Probably an underestimate owing to the low response rate to the Museums Data Base survey; some put the figure as high as 1,200 which would bring the total museum facilities to 2,004 and the total for all museums and galleries, including those specialising in temporary ex-hibitions, to 2,259.

(c) Mainly galleries and arts centres; in 1983/84 some 193 galleries showed exhibitions arranged by the Arts Council of Great Britain and the Scottish and Welsh Arts Councils; these were based mainly in arts centres and local authority museums and galleries.

(c) *Theatres and concerts*

Attendance at live arts events totalled an estimated 49 million in 1984/85. The figure relates to professional events and does not take account of audiences for amateur dramatics (estimated at 14–16 million) and attendance at amateur concerts given by schools, colleges and local societies (2-3 million). Audiences for festival events have not been separately identified; they are included under the relevant art-form headings.

The market for the theatre at 38 million attendances was almost four times larger than that for concerts at 10 million. London's West End drew a massive attendance of 10 million. This included 2 million at performances by the national drama, opera and dance companies, with the remainder drawn to presentations by independent theatre managements. Among the various types of productions, musicals attracted the largest share of audiences. The national audience for opera and dance amounted to 2.4 million, of which 2.1 million was for 'main-scale' performances with an estimated 0.3 million attending small-scale productions. Some 1.2 million of these attendances were at the opera houses outside London, such as the Grand Theatre Leeds, the home of Opera North, and the Theatre Royal Glasgow, owned and operated by Scottish Opera, and at the principal receiving theatres (e.g. Empire Theatre Liverpool and Theatre Royal Newcastle). In addition to the opera and dance attendance, the major receiving theatres attracted audiences estimated at 4.5 million for touring drama (some of the tours funded by the Arts Council), musicals, pantomime and other attractions.

Table 2.4 Attendance at theatres and concerts, 1984/85

Millions and numbers

	Attendance (millions)	Facilities (numbers)	Performances (numbers)
Theatres			
London's West End (a)	10.0	51 (b)	16,193
Opera houses and number-one receiving theatres outside London (c)	5.7	23	5,290
Producing theatres (d)	4.4	52	15,250
Other theatres outside London (e)	14.1	166	34,540
Small venues and arts centres (f)	3.1	311	19,710
Sub-total	37.3	603	90,983
Film theatres	0.9	51 (g)	..
Concerts			
Symphony concerts	2.5	152 (h)	1,720
Chamber orchestras, ensembles, recitals	2.2	..	7,300
Pop, rock, jazz and folk	5.7	..	3,900
Sub-total	10.4	..	12,920
Total	48.6	..	103,903

Source: *Facts 2; British Theatre Directory;* Arts Council of Great Britain; Theatrical Management Association.

(a) Includes national companies (drama, opera and dance) operating 7 auditoria with 1.99 million attendance in London; also includes one subsidised producing theatre, the Royal Court.

(b) The National Theatre and Royal Shakespeare Company operate 5 theatres in London making a total of 51 auditoria in London's West End.

(c) Includes an estimated 2 million attendances at Arts-Council-funded opera, dance and drama tours *(Notes to tables continued overleaf).*

15

(d) Arts-Council-funded producing theatres outside Central London; includes Royal Shakespeare Theatre and The Other Place, Stratford; studio theatres attached to producing theatres included under 'small venues'.

(e) Includes 10 large receiving theatres; 6 large independent seaside theatres; 35 independent and seaside theatres; 115 local authority theatres.

(f) Based on company data, including average figures for number of performances and attendances; facilities include 21 studios attached to producing theatres, 240 arts centres and an-estimated 50 other small venues mainly in London.

(g) Number of screens.

(h) The main concert halls numbered 35.

Some 50 Arts Council funded producing theatres provided the main drama seasons across the country (including outer London) with an audience of 4.4 million. The figure of 14 million attendances at a further 166 provincial theatres covers several types of operation. A small number of the theatres were seasonal seaside operations, including 13 in private ownership. More than 100 were local authority theatres presenting mixed entertainment programmes of drama, musicals, light music, variety artists, concerts, pantomimes and sometimes major amateur shows. A few independent theatres concentrated on the market for touring drama. There were also half a dozen other, large, multi-use touring venues. The estimated attendance at this varied array of theatres is based on performance data in those houses which were members of the Theatrical Management Association, combined with attendance data taken from the three local case studies. No figures are available on the different types of presentations and their audiences.

Small venues and arts centres, which numbered over 300, drew a total audience of between 3 and 4 million. The relatively low figure reflects the small size of the venues and the periodic nature of programming at non-theatre venues. The average attendance for Arts-Council-funded small-scale drama touring companies was 132 per performance, many of which played at established arts centres. Arts centres drew the greater share (2 million) of the audiences for small venues, but drama, dance and opera were only one aspect of their mixed programming.

The market for live music was split equally between classical and popular concerts. The estimate for attendance at popular concerts is very rough; it is based on the statistic that 12 per cent of the adult population attended a popular concert at least once during the previous 12 months. The number of performances is derived from a sample survey of the entertainment press. Symphony concert audiences were concentrated in 35 main halls, which drew 2.1 million of the 2.5 million attendance. The main halls were also the location for many concerts by chamber orchestras, ensembles and recitalists. A few specialist recital halls (e.g. Wigmore Hall London) drew a particular audience. Otherwise, chamber concerts were widespread over a vast array on non-specialist venues.

The market for the arts is expanding

For most arts events and attractions the market would appear to have been expanding in recent years. This confirms the conclusion above that consumer spending showed an upward trend. It is less clear that the increase has been enjoyed equally by all sections of the arts and in all parts of the country. Comprehensive data on arts attendances are not available and so interpretation of trends must be approached with caution.

(a) *Museums and galleries*

Estimates prepared by the English Tourist Board suggest that museum and gallery visits increased by 6 per cent overall from 1976 to 1985. The only consistent trend data on museum and gallery attendance concern the national museums and galleries (NMGs). They show an uneven picture. After a massive increase during the 1970s NMG attendance declined from more than 23 million in

1980 to just under 21 million in 1982. Attendances subsequently rose to 22.9 million in 1985 but still remained below the 1977 peak. On the other hand, the 1985 attendance at the NMGs was 48 per cent above the level of 1971. Some of the growth can be accounted for by the creation of new national museums, such as the National Museum of Film and Photography in Bradford (opened 1983). No comprehensive attendance data for the local authority museums exist. Analysis of attendances in Glasgow, Ipswich, and Merseyside would suggest that the underlying trend is upward, but this may not be true in all parts of the country. A major boost to museum and gallery attendance has come from the expansion in the number of independent museums. But there is evidence of sharply increasing competition in the sector. As many as 39 per cent of the estimated 1,200 museums in the independent sector were founded between 1971 and 1984 (see *Museums UK*), and most probably the growth in facilities stimulated attendance. This remains a matter of surmise in the absence of reliable, comprehensive, attendance data.

Visitor trends for galleries and temporary loan exhibitions are unclear. The latter are affected by the popularity of particular shows. In London, the addition of a major new gallery facility at the Barbican Centre in 1982 caused an overall expansion of the market, so that record attendance was delivered by the Royal Academy of arts, Hayward, Serpentine, Tate and Barbican Galleries in 1983 (1.67 million) and the 1984 figure of 1.5 million remained higher than for any previous year since 1979.

(b) *Theatres and concerts*
Attendance at London's West End grew by 28 per cent from 8.5 million in 1981 (when statistics were first collected) to 10.8 million in 1985. The City University Box Office Research undertaken for the Society of West End Theatre (SWET) shows that between 1982 and 1985 the largest rise was in ticket sales to overseas tourists (an increase of 68 per cent). Sales to London residents grew by 15 per cent but visitors to London from the rest of Britain bought 4 per cent fewer tickets. The increase in attendance was achieved by broadening the 'reach' of the West End. The number of individuals attending rose and fewer tickets went to frequent attenders. Increased attendances were served by an even faster rising number of performances, and so the average attendance per performance fell between 1981 and 1985 from 654 to 637.

Outside London's West End the Arts-Council-funded producing theatres in the rest of the country saw attendances rise by 12 per cent between 1981/82 and 1985/86. Previously, attendances had been falling. The national drama companies reached the bottom of the trough in 1981/82 and the producing theatres elsewhere in 1982/83. With subsequent increases, attendance in the Arts-Council-funded producing theatres reached a new high in 1983/84 with further rises of 0.4 per cent in 1984/85 and 4.3 per cent in 1985/86. The growth was achieved partly by increasing the number of performances, but average attendances also rose from a low of 353 in 1981/82 to a new high of 382 in 1985/86. Thus, the mid 1980s saw London's West End and the subsidised producing theatres attracting record audiences. No trend data exist for the rest of the theatrical world. MINTEL carried out an annual survey of theatre-going by the general population which confirms the rising trend. MINTEL's estimated 1981 theatre audience of 37 million rose to 39 million in 1984.

Symphony concerts were also on a rising trend. British orchestras gave 28 per cent more concerts in Britain in 1983/84 (1,460) than in 1974/75 (1,142). The number of concerts in London alone rose by 38 per cent from 418 in 1974/75 to 587 in 1983-84. The rise in the rest of Britain between the same dates was 22 per cent. Attendance in London also rose to a new high in 1983/84 of 1,110,000 admissions, compared with 995,000 in 1974/75. The low point was in 1980/81 at 853,000 admissions. The opening of the Barbican Hall appeared to widen the market, but the average attendance per concert in London fell in 1974/75 from 2,380 to a lowest point of 1,815 in 1982/83.

The market trends were less clear cut in opera and dance. Opera attendances were overall slightly

larger in the 1980s than in the 1970s, mainly as a result of more annual average performances in the 1980s, 727 a year compared with 713 in the 1970s. Average attendance per performance remained static at around 1,410. The figure for average attendance in 1985/86 of 1,503 was the highest for several years. In dance the number of performances by the major companies based in England fell from a high of 1,028 in 1978/79 to a low point of 788 in 1983/84. The figure had risen again to 891 by 1985/86. Average attendances responded with an increase and so the total attendance declined only marginally by 2 per cent in the 1980s. The fluctuations from year to year were very small but the total attendance of 993,000 in 1985/86 was the second lowest during the previous 10 years.

In aspects of the arts not covered by general statistics, there are signs that the market was also expanding. Both in Ipswich and Glasgow, the small mixed-programme venues were expanding their activities and the early 1980s saw a wave of openings of the most recent batch of art centres (see *Arts Centres UK*, p.8).

(c) *Other sectors*
The English Tourist Board (ETB) estimate that visits to historic buildings increased 10 per cent between 1975 and 1985. This trend is based on a constant sample of attractions. If newly-opened historic buildings are taken into account, the increase of visits between 1975 and 1985 was at least 16 per cent. The economic depression affected attendances adversely between 1978 and 1982, when the number of visits fell by 18 per cent. They recovered by 17 per cent from 1982 to 1985 (see *Heritage Monitor*, various years).

As in most other industrial countries, cinema attendances fell rapidly from the mid 1950s. The rate of decline slowed in the 1970s and by 1982 the market had levelled out at around 60 million admissions. In 1985 signs of recovery had appeared and with further growth of 3.5 per cent in 1986 cinema has entered a new phase of development.

(d) *Most of the arts are trading at higher levels than 10 years previously*
Thus, in recent years the market for the arts has increased in almost all fields. Most of the arts were trading at higher levels in the mid 1980s than prevailed some 10 years previously. The exceptions were cinema and dance, and the national museums and galleries had not quite topped their 1977 peak in attendance. After being adversely affected by the depression in the early 1980s, the arts have shown significant recovery across the board, including the cinema. The expansion has been achieved both by extra provision (new museums, halls, extra performances) and by better exploitation of existing events and attractions (higher average attendance per performance). In London, average concert and West End attendances per performance have fallen so that the growth has been through extra performances. The producing theatres have increased both the numbers of performances and average attendances. There have been major additions to the array of museums and galleries, especially by the independent sector. The NMGs increased their average attendance from 1982 to 1985.

Consumer spending on arts events and attractions is worth £433 million.

(a) *Overall*
The value of consumer spending on admissions to arts events and attractions was an estimated £433 million in 1985/86. Well over half (55 per cent) was generated by theatres and concerts at £256 million, some 29 per cent (£125 million) by cinema admissions and the remainder (12 per cent) by paid admissions to historic buildings (£34 million) and to museums and galleries (£18 million).

(b) *Theatres*
These new estimates were prepared by aggregating data from various sources. For some of the live arts, box office receipts and numbers of paid admissions were available (eg London's West End and

Table 2.5 Consumer spending on admissions to arts events and attraction, 1985/86

	£ million
Museums and galleries	18
Built heritage	34
Theatres and concerts	256
Cinemas	125
Total	433

Source: PSI.

the Arts-Council-funded producing theatres). Where such information was not available, figures on attendances (as described above) were combined with sample information on ticket yields (average prices paid for admission, including VAT), taken from appropriate sources, including the three regional case studies. Thus the average ticket yield for small venues in the Ipswich area, surprisingly close to the equivalent figure for arts centres (see *Arts Centres UK*), was combined with attendance data on 'small venues and arts centres'. The figure for total box office receipts, including VAT, by the theatres was £207 million. The ticket yields used in the calculation of the figure are set out in Table 2.6.

Table 2.6 Ticket yields in theatres, 1985/86

	£
London's West End (a)	8.41
Opera houses and number-one receiving theatres outside London (b)	5.94
Producing theatres (c)	3.63
Other theatres outside London (d)	4.36
Small venues and arts centres(e)	2.52

Source: See notes.
(a) From Society of West End Theatre: includes national opera, drama and dance companies.
(b) Glasgow and Merseyside.
(c) Arts Council of Great Britain.
(d) Ipswich and Glasgow.
(e) Ipswich; *Arts Centres UK*; the Arts Council of Great Britain supplied a ticket yield for studio theatres of £2.85

(c) *Concerts*
A similar method was used for estimating spending on concert tickets at £49 million, of which £19.5 million was on classical concerts and £30 million on jazz, folk, rock and pop concerts. Symphony concerts drew £13 million and chamber concerts and recitals some £6 million. Estimates of spending on popular concerts were approached in two ways; the ticket yield for popular concerts in St David's Hall Cardiff was combined with an estimated national attendance of 5 million to produce a figure of £30.7 million; additionally, estimates of the constituent parts of the popular music market were made (special venues and concert halls £10 million, stadium concerts £9 million, performances at small venues £9 million; arts centres £2 million) which gave a similar total of £30 million.

(d) *Museums and galleries*
Admission charges at museums and galleries yielded an estimated £14.6 million. *Museums UK* provided data on average charges for adults and children, together with figures on the proportion

of facilities which made entry charges. These were combined with estimates of attendance to show that admission charges roughly yielded £1–2 million for NMGs, £2–4 million for local authority museums and £11 million for the other (mainly independent) museums. Spending on admission to temporary loan exhibitions, primarily in London, was estimated at £4 million.

(e) Other sectors
The figure of £124 million for cinema admissions was taken from *Facts about the Arts 2*, as provided by the Central Statistical Office. The ETB estimated an average admission charge of £1.04 at built heritage properties; attendance totalled 54 million in England and Wales and 60 per cent of properties were said to charge for admission. No figures were available for Scotland.

(f) New estimate is higher than official figures
There are no direct official estimates of spending on admission to art events or attractions, apart from the figures on cinema admissions. The nearest that official figures come to an estimate is in the *Family Expenditure Survey* (FES) which gave 23p as the average weekly household expenditure on 'theatres, concerts etc. admission' in 1985. When grossed-up, this figure implies total spending for the year of £233 million. This is lower than the new estimate above of £256 million. One reason is that the FES figure excludes spending by overseas tourists; on the other hand it refers to the UK rather than Britain (this difference could be worth 3 per cent) and includes admission to amateur performances, which are excluded from the new estimate.

Spending on cultural products for use in the home

(a) Attendances and ticket yields are rising together
It was explained above that in round terms total consumer expenditure on cultural products and services has been rising strongly, more or less in line with total consumer spending. But the data set out in Table 2.1 are not good enough to make clear the meaning of the trend. We still lack a good indicator of the *trend* of consumer spending on arts events and attractions. The role of relative prices and their influence on substitution between goods and services, say CD players and concert tickets, is little understood. Whilst attendance at theatres and concerts has been increasing, what people paid for admission tickets has also been rising. Table 2.2 shows that for almost all forms of live entertainment the ticket yield (average value of tickets sold) grew faster than both retail prices and average earnings between 1975/76 and 1983/84. Whilst average earnings increased by 170 per cent, ticket yields rose in the West End by 184 per cent, in the English producing theatres by 253 per cent and for the opera performances by 240 per cent. Only at the

Table 2.7 Ticket yields and prices for arts events and cultural items, 1983/84

Index: 1975/76 = 100

English producing theatres	353
London's West End	284
Opera companies	340
Henry Wood Promenade Concerts	323
Royal Festival Hall	258
Cinema	311
Records	216
Colour TV	126
Retail prices	249
Average earnings	271

Source: *Facts 2.*

Royal Festival Hall did the rise (158 per cent) sink below average earnings, but it remained above the 149 per cent increase in retail prices. Thus, the real cost of live entertainment has increased in relation both to average earnings and to goods and services generally.

When the prices of those goods which might be regarded as direct substitutes for live entertainment are taken into account, the difference becomes even more marked. For example, the price of records grew by 116 per cent and of colour TVs by a mere 26 per cent. Thus the relative price, say, of a concert ticket (which rose by 158 per cent) compared with that of a record (rising by 116 per cent) increased dramatically. Nonetheless, after a period of some price resistance in the early 1980s, attendance at live events, as shown above, has been growing. One explanation of this phenomenon is that the market for the arts has been maturing with growing demand for greater quality and for more personal choice of products.

(b) *Cultural services gain at the expense of goods*
The effect of rising attendances combined with rising real prices has meant that spending on admissions has grown as a proportion of total cultural spending at current prices from 16.2 per cent in 1976 to 18 per cent in 1984. This can be seen in Table 2.8. Though the proportion of cultural spending on goods fell, it still accounted for over four-fifths of the total. Radio, TV and instruments (down from 48.4 per cent to 46.4 per cent) and newspapers, books and magazines (up slightly from 25.5 per cent to 26 per cent) were the major items. Records and tapes accounted for a roughly constant share at 6.3–6.4 per cent and photo processing and printing, a growing share, rose from 2.9 per cent to 3.2 per cent, of total cultural spending.

Table 2.8 Consumer spending on cultural goods and services: by main categories

		Percentages	
		1976	1984
Percentage of spending at current prices			
Recreational and cultural services (admissions and subscriptions)		16.2	18.0
Newspapers, books, magazines		25.5	26.0
Records and tapes		6.3	6.4
Photo processing and printing		2.9	3.2
Radios, TVs, instruments and other durables		48.6	46.4
Total		100.0	100.0

Source: *Facts 2.*

(c) *Volume of TVs and videos purchased expands but books and newspapers shrink*
These figures show the changing patterns of spending at current prices within the cultural sector, but consumer spending overall was rising (see Table 2.9) and the relative prices of goods and services were also changing. Thus, the actual volumes of goods purchased should also be considered and these are set out in Table 2.10. It shows that TV was the main beneficiary, with the volume of purchases of radios, TVs and musical instruments rising from an index of 100 in 1976 to 264 in 1984, with a particularly rapid growth since 1980 reflecting the rise of home video as a new mass domestic market. In comparison with TV, records and tapes and books, newspapers and magazines did less well. Strong growth in the sales of records in the 1970s was followed by a crisis in the market in the early 1980s. Consumer expenditure in real terms remained virtually static from 1979 to 1983. Unit sales of discs and cassettes fell from 170.7 million in 1980 to 164.3 million in 1983.

Table 2.9 Consumer spending on cultural goods and services at current prices

£ million

	1976	1980	1984
Recreational and entertainment services			
Cinema admissions	81	147	124
Other admissions (a)	517	1,148	1,611
Social subscriptions (b)	55	101	158
Sub-total	653	1,396	1,893
Newspapers, books magazines etc.			
Books	222	451	650
Newspapers and magazines	820	1,405	2,074
Records and tapes	255	548	672
Photo processing and printing (c)	118	266	332
Sub-total	1,415	2,670	3,728
Radio, TV, instruments, etc.			
Radio, TV, musical instruments and other durables	1,006	1,587	2,689
TV and video hire charges, licence fees and repairs	953	1,578	2,186
Sub-total	1,959	3,165	4,875
Total	4,027	7,231	10,496

Source: *Facts 2.*
(a) Includes admissions to theatres, and other performed arts events, galleries and museums, and country houses. Also includes admissions to spectator sports, which account for about 10 per cent of the total.
(b) Includes spending on participatory sports, club membership fees and fees to sports clubs and swimming pools.
(c) Photographic equipment included under 'other durables'.

Table 2.10 Consumer spending on culture and leisure at 1980 prices

Index: 1974 = 100

	1976	1980	1984
Cinema admissions	76	69	43
Other admissions (a)	118	139	125
Social subscriptions (b)	106	104	100
Books	95	105	84
Newspapers and magazines	91	90	84
Records and tapes	92	120	130
Photo processing and printing (c)	104	168	191
Radio, TV, musical instruments and other durables	112	147	264
TV and video hire charges, licence fees, repairs	119	136	168
Total	104	121	144

Source: *Facts 2.*
(a) Includes admissions to arts events and attractions. Also includes spectator sports.
(b) Includes spending on participatory sports.
(c) Photographic equipment included under 'other durables'.

Private copying and piracy were blamed for the decline, and some felt a profound change had taken place in the market for recorded music, which had lost its hold on the interests of young people. But with a sharp rise in pre-recorded cassette sales and the eventual consumer acceptance of compact discs the market began to grow again in 1984 (see Table 2.11).

Table 2.11 Sale of records

Millions of units

	1980	1981	1982	1983	1984
Albums	67.4	64.0	57.8	54.3	54.1
Singles	71.8	77.3	78.6	74.0	77.0
Pre-recorded cassettes	21.2	28.7	31.5	35.8	45.4
Compact discs	—	—	—	0.2	0.8

Source: J. Qualen, *The Music Industry*, 1986.

Compared with other cultural products, the situation for book selling was grave. From a high in 1980 of 105 (index 1974 = 100) consumer spending in constant prices fell to 84 in 1984. Another indication of the falling interest in reading was a gentle but unmistakable decline in books issued per head of population from public libraries. The figures were 12 per head in 1980/81 down to 11 per head in 1983/84; 61 per cent of issues were adult fiction, 22 per cent non fiction and 16 per cent children's books (see *Facts 2*). These figures relate to a period before new enterprise and growing competition in high-street book retailing could take effect.

In terms of the media, therefore, the most important changes were related to television, where the expansion of possibilities (video, cable, breakfast television, Channel 4) resulted in a relatively large extension in the numbers of hours spent in front of the screen. Between 1977 and 1985 the minutes per day spent viewing rose from 125 to 185 (the 1985 level was second only to Spain in Europe). Mainly women and elderly people accounted for the extra hours viewing. Whilst ABs also increased their watching, the distance between the social classes increased considerably. Whereas DEs watched 8 hours more per week than ABs in 1983, the difference increased to 14 hours in 1985 (see Table 2.12).

Table 2.12 Average amount of TV viewing in UK

	1983	1985
Hours per week, all TV, viewed by following social grades:		
AB	18.2	20.4
C1	20.2	23.4
C2	22.1	26.4
DE	26.1	35.5

Source: P. van Montfort, 'The arts and their public', Unpublished paper to Conference on European Arts Statistics, Lisbon, 1986.

Spending on the arts is expanding inside and outside the home

Despite the counter examples of books and cinema, the market for the arts appears to have been performing relatively well. More research is needed to establish what adjustments have been made in domestic activities to accommodate the rise of TV viewing but it is important to understand that cultural activities outside the home (attending arts events and attractions) appear not to have

declined, despite the rise in domestic cultural preoccupations (such as television viewing) and the growing acquisition of cultural equipment (videos, musical instruments) for use in the home.

Structure of the market for arts events and attractions

(a) London is dominant

Not surprisingly, London dominated the market for the arts. It attracted rather over a third of total national attendance at arts events and attractions. The London proportion was generally much the same for museums and galleries as for theatres and concerts. The concentration of the audience in London was particularly marked for symphony concerts (45 per cent) and opera (57 per cent), more the consequence of bigger theatres and greater appeal of productions than a larger number of performances; the latter represented 34 per cent of the national total for symphony concerts and 40 per cent for opera. With regard to drama, publicly-funded performances were spread more evenly across the country (if not the central government funding of these performances), but the weight of the commercial West End established the heavy concentration of the market in London (see *Facts 2*).

By contrast, it was the publicly-funded national museums and galleries predominantly located in London which drew 37 per cent of total museum and gallery attendance to the capital. Such national organisations as the Royal Academy of Arts and other organisations promoting temporary loan exhibitions, together with the heavy concentration of the art trade in London, made the city the main centre for gallery going. The point is self evident though the data are not refined enough to confirm this in detail.

Table 2.13 Share of arts attendance in selected regions, 1984/85 (a)

Percentages

	Glasgow	Merseyside	Ipswich	London
Share of national attendance for:				
Museums and galleries	4.9	2.9	0.8	37.0
Theatres and concerts	3.5	2.2	1.1	36.0
Percentage of total population	2.9	2.5	0.7	12.0

Source: PSI; *Facts 2*.
(a) Some of the basic data relate to 1983/84

(b) Glasgow is a point of concentration

The London market for the arts, which amounted roughly to one third of the national total, was three times larger than might be expected from the London proportion of the national population (12 per cent). Regional, national and international interest combined to give London this dominant position as the great British cultural resort. Though generally outside London arts attendance was dispersed more evenly, particular centres of market concentration can be identified. These clusters are explained partly by the quality of regionally-available attractions and also by the level of active interest displayed by local residents and those attending from a wider regional catchment area. By comparing the share of national markets with the proportion of the population in each of the three study areas, it can be seen that Glasgow was a point of particular concentration. Whilst Glasgow's share of the national population was 2.9 per cent, it accounted for 4.9 per cent of the national museum and gallery market and 3.5 per cent of the theatre and concert market. The national proportion of museum and gallery attendance in Merseyside was rather larger than its share of total population, but the theatre and the concert proposition was somewhat lower. The Ipswich theatre and concert market (based on Aldeburgh and the Wolsey Theatre) was surprisingly well developed

at 1.1 per cent of the national market, compared with 0.8 per cent of the national population in the region; museum and gallery attendance was about average.

(c) *Residents, day visitors and tourists*
Markets for the arts in a particular region are made up of attendance by residents of the region, day (and evening) visitors and tourists (staying overnight). These three elements in the arts market of the study regions and of Greater London are set out in Table 2.14 which shows their relative importance. Museums and galleries showed significant differences from theatres and concerts. In each case London had its own pattern. In the three study areas, residents formed a much larger share of the market (over 80 per cent) for theatres and concerts than they did for museums and galleries (65 per cent and less). Tourists were relatively unimportant in the theatre and concert audience, apart from Ipswich where Aldeburgh registered its influence. Glasgow attracted rather more day visitors to its theatres and concerts (13 per cent of attendance) than did the other regions, reflecting the unique strength of its live arts institutions in Scotland. Museums and galleries relied to a greater extent on day visitors and tourists, who formed 44 per cent of the market in Glasgow, 35 per cent in Merseyside and 64 per cent in Ipswich (drawn to the mainly seasonal museums and heritage attractions in this rural region). Tourists alone accounted for 25 per cent of visits to the Glasgow museums and galleries.

Table 2.14 Residents, day visitors and tourists in the arts markets for selected regions

Percentages

	Glasgow	Merseyside	Ipswich	London
Museums and galleries: percentage of attendance by:				
Residents	56	65	36	29
Day visitors	19	20	34	27
Tourists	25	15	30	44
Theatres and concerts: percentage of attendance by				
Residents	85	87	83	39
Day visitors	13	9	9	21
Tourists	2	4	8	40

Source: PSI; *Facts 2.*

The role of particular institutions stood out in the regional pattern. Thus, the Burrell Collection drew 62 per cent of its visitors from outside the Glasgow region (compared with 44 per cent for museums and galleries in Glasgow overall), and the Maritime Museum in Merseyside attracted 49 per cent of attendance from non-residents. On the other hand, the small theatre venues in Glasgow played almost exclusively to a Glasgow audience at 94 per cent of the total. Some 54 per cent of the audience for concerts in the Ipswich region were non-residents, proving that tourists and day visitors could be attracted in significant numbers to live arts events when the presentation and quality was right.

(d) *London residents form a minority of its market*
In London the picture was completely different. The majority of the arts market was made up of day visitors and tourists both in museums and galleries (66 per cent) and at theatres and concerts (61 per cent). Tourists alone accounted for 40 per cent of the theatre and concert audience, with 35 per cent drawn from overseas. London residents were just in the majority at symphony concerts (53 per cent) and at the Royal Opera House (62 per cent). Tourists constituted 44 per cent of the

THE ECONOMIC IMPORTANCE OF THE ARTS IN BRITAIN

market for museums and galleries, with 31 per cent drawn from overseas. Not surprisingly, day visitors formed a rather larger proportion of museum and gallery goers at 22 per cent compared with 21 per cent of theatre and concert goers.

Social characteristics of arts market

(a) *Market for museum and galleries is socially wider than for theatres and concerts*
The market for museums and galleries was socially much wider than for theatres and concerts (see Table 2.15). C2DEs represented between 30 per cent (Glasgow) and 47 per cent (Merseyside) of museum and gallery attendance, compared with 20 per cent of theatre and concert audiences in Glasgow, 26 per cent in Merseyside and 33 per cent in Ipswich. The social catchment of the theatre audience was widest for two types of attraction: first, the receiving theatres in Glasgow, where 33 per cent of the audience was composed of C2DEs, a reflection of popular programming at the theatres in question and the wide appeal of musicals and pantomimes; and second, the mixed programme venues in the Ipswich region (mainly based in small country towns) which drew a remarkable 46 per cent of their audiences from C2DEs.

Table 2.15 Social class of attendance in three study regions

Percentages

	Glasgow	Merseyside	Ipswich
Percentage attending:			
Museums and galleries			
ABC1	70	53	67
C2DE	30	47	33
Theatres and concerts			
ABC1	80	73	67
C2DE	20	26	33

Source: PSI.

(b) *Females predominate in theatre audiences*
The sex composition of the market for museums and galleries was relatively evenly balanced, with a slightly higher proportion of males (56 per cent in Glasgow, and 52 per cent in Ipswich). This impression of overall balance masked sharp contrasts between different types of museums; whereas many more males went to science and transport museums, females predominated in art galleries. In London, the Science Museum drew 64 per cent males, compared with 43 per cent at the Victoria and Albert Museum (see *Facts 2*). Females predominated in the theatre and concert audiences and were in the majority for all forms of live entertainment in the three study areas. They constituted 70 per cent of the audience in Glasgow and 63 per cent in Ipswich. The Glasgow case was extreme and as many as 75 per cent of the audience for opera and ballet were female. In London, the audience was again predominantly female (56 per cent), but males formed the majority for opera at the Royal Opera House (56 per cent) and for symphony concerts, for example, 58 per cent at the South Bank Halls (see *Facts 2*).

(c) *Museums and galleries draw more young people*
Age was the most variable characteristic of the arts market. Overall museums and galleries attracted a younger audience than theatres and concerts, mainly because of the appeal of museums

26

and galleries to 16-24 year olds. In Glasgow the 16-45 age group formed 65 per cent of the museum and gallery attendance compared with 53 per cent of theatre and concert audiences. The 16-24 group represented 17 per cent and 10 per cent respectively. In London the 11-40 year olds visiting the Victoria and Albert Museum (V&A) and the Science Museum formed 80 per cent of the total 11-plus market; the figure for the V&A alone was 71 per cent. In London the theatre and concert market was significantly younger than in the three study areas, with 74 per cent as the under-45 proportion. Some 34 per cent of the West End audience was aged 16-24 years, a reflection of the massive student element in the total audience. The under-45 proportion was 77 per cent, compared with 53 per cent of the theatre and concert audience in Glasgow. The London concert audience was also younger with 19 per cent aged 16-24 years and 59 per cent as the under 45 proportion at the Barbican Hall. The Ipswich market was distinctly older than in London and elsewhere. For theatres and concerts 58 per cent were aged 45 and over; in museums and galleries the equivalent figure was 51 per cent. The over-65s in this rural areas formed 15 per cent of the audience for theatres and concerts. It is no surprise to discover that the figures for big cities were much lower at 8 per cent in Glasgow and 4 per cent in London's West End.

Table 2.16 Age of arts attendance in three study regions

Percentages

	Glasgow	Ipswich	London
Percentage of visits:			
Museums and galleries			
Aged 16-44	65	49	80 (a)
45+	35	51	20 (a)
Theatres and concerts			
Aged 16-44	53	42	74 (b)
45+	47	58	26 (b)

Source: PSI.
(a) Age ranges 11-40 and 41+.
(b) Weighted average of West End and concert audiences.

(d) *Theatre and concert going is more gregarious than visiting museums*
There was remarkable consistency in the three study areas over the size of party in which people attended arts attractions. Theatre and concert going was a more gregarious activity than visiting museums and galleries. Overall some 10 per cent of adults went to theatres and concerts on their own. Upwards of 30 per cent of residents made unaccompanied visits to museums and galleries, whilst visitors and tourists in museums were less likely to be on their own, 14 per cent in Ipswich and 23 per cent in Merseyside. Parties of two were the most common social arrangement both in theatres and concerts (54-56 per cent of the total) and in museums and galleries (40-45 per cent of residents and 49-57 per cent of non–residents). Surprisingly, large adult groups of three and over were more common at the theatre and at concerts (35 per cent of the audience) than in museums and galleries (between 16 and 29 per cent). The picture was similar in London, with 9 per cent attending the West End alone and 53 per cent accompanied by one other (see Gardiner).

Reach of the arts and frequency of attendance

The size of the market for the arts was measured above in terms of the total attendance at arts events and attractions. Some of those who attend do so frequently and so the total attendance is not a guide to the number of separate individuals attending in a given period. The latter can be

expressed as the 'reach' of the arts and it might be measured, for example, as the percentage of the adult population attending at least once during the previous 12 months.

(a) *Reach of the arts similar in the three regions*
The overall reach of the arts market is summarised in Table 2.17. Some 65 per cent of Ipswich residents had attended one or more of the listed attractions (museum, art exhibition, historic house, play or musical, classical concert, ballet, opera, pop concert, cinema) during the previous 12 months. The Glasgow figure was slightly lower at 62 per cent. The reach was virtually identical in the three regions for the different social classes (82-81 per cent for ABC1s and 54 per cent for C2DEs). The wider reach for Ipswich as a whole is explained by the larger share of ABC1s in the resident population, 39 per cent compared with 29 per cent in Glasgow and 31 per cent in Merseyside respectively. More marked regional differences begin to emerge when the arts reach is measured in terms of attending two or more attractions in the previous 12 months. On this more stringent test Glasgow achieved the highest scores: all adults, 41 per cent; ABC1s, 67 per cent; and C2DEs, 31 per cent. The arts reach was lower in Merseyside than in the other regions.

The reach of the arts for various arts attractions in each of the three study regions and in the South East of England is set out in Table 2.18. It shows a similar picture across the country. Some 31-39 per cent of the population visited museums and a similar proportion went to the cinema. Theatre going was enjoyed by about a quarter of the population. Concerts, ballet and opera reached 10 per cent or less of the population and a similar proportion had been to a pop concert. The data on the South East are taken from a study by MORI which suggests that the reach was somewhat greater in the South East than in the rest of the country for most arts attractions. Museum going reached a particularly wide public in Glasgow (39 per cent), as did plays and musicals (28 per cent) in the Ipswich region.

Table 2.17 Reach of the arts: by social class in three study regions

Percentages

	Glasgow	Merseyside	Ipswich
Percentage of adult population visiting selected arts attractions: (a)			
Total population			
Once or more	62	..	65
Twice or more	41	32	37
ABC1			
Once or more	82	..	81
Twice or more	67	..	53
C2DE			
Once or more	54	..	54
Twice or more	31	..	27

Source: PSI.
(a) During 12 months previous to interview

(b) *Arts reach of same social groups in different regions very marked*
The somewhat wider social reach of the arts in the South East may be explained by a higher proportion of ABC1s (upper middle and lower middle class) in the population. Tables 2.19 and 2.20 set out the figures separately for ABC1s and C2DEs in the three study regions. The results

show a striking similarity in the three different regions for the reach of the arts in the two social groups. The similarity between the social groups is statistically closer than that between the three regions remarked on above. Not surprisingly, the arts reached roughly twice as many ABC1s as C2DEs. Details deserving comment are the exceptional interest taken by Glaswegian ABC1s in museums (60 per cent) and in the ballet (11 per cent). Ipswich ABC1s attended plays and musicals (49 per cent) and concerts (17 per cent) to a greater than average extent. It should be noted that the level of interest among C2DEs was by no means insignificant, especially in relation to museums, plays and musicals, historic houses and the cinema. The comparison shows that the C2DEs in Glasgow had the lowest interest in plays (12 per cent) and historic houses (11 per cent). C2DEs in the other regions registered 20 per cent for each of these attractions.

Table 2.18 Reach of the arts by region, 1985/86

Percentages

	Glasgow	Merseyside	Ipswich	South East (a)
Percentage of population attending: (b)				
Museum or gallery	39	34	31	34
Art exhibition	11	18	16	28
Historic house	19	24	22	..
Play or musical	17	24	28	32
Classical concert	5	5	9	14
Ballet	5	4	3	5
Opera	1	2	2	5
Pop concert	10	..	12	18
Cinema	33	32	33	50
One or more of the above	62	..	65	..
Twice or more	41	32	37	..

Source: PSI; *Facts 2.*
(a) Figures from MORI Survey carried out in 1981.
(b) During 12 months previous to interview.

Table 2.19 Reach of the arts amongst ABC1s by region, 1985/86

Percentages

	Glasgow	Merseyside	Ipswich
Percentage of ABC1s attending: (a)			
Museum or gallery	60	42	43
Art exhibition	22	26	24
Historic house	35	35	36
Play or musical	33	33	40
Classical concert	10	11	17
Ballet	11	8	5
Opera	2	4	4
Pop concert	14	..	14
Cinema	49	44	44
One or more of above	82	..	81
Twice or more	67	..	53

Source: PSI
(a) During 12 months previous to interview.

Table 2.20 Reach of the arts among C2DEs by region, 1985/86

Percentages

	Glasgow	Merseyside	Ipswich
Percentage of C2DEs attending: (a)			
Museum or gallery	30	31	24
Art exhibition	7	15	11
Historic house	12	20	21
Play or musical	11	20	20
Classical concert	4	2	4
Ballet	2	2	3
Opera	1	1	—
Pop concert	9	..	11
Cinema	26	27	26
One or more of above	54	..	54
Twice or more	31	..	27

Source: PSI.
(a) During 12 months previous to interview.

(c) *Frequency of attendance*

The frequency of attendance converts the reach of the arts (the number of individual attenders) into the total attendance. Audiences can be enlarged both by extending the reach and by increasing the frequency of attendance. Table 2.21 sets out the frequencies of attendances by residents in each of the regions. The frequencies relate to local attendance in the study region by residents of the study region and they omit attendances by residents elsewhere. Museums in Merseyside and theatres in Ipswich drew an average of between 2 and 3 attendances a year from their local adherents. Otherwise, the poor range of choice in the Ipswich region kept the frequencies rather low. Glasgow attenders were relatively active in most fields, with a high average frequency for opera at 4.4 visits. It is well recognised that very active minorities of enthusiasts clock up large proportions of total attendances for some arts attractions, especially concerts, dance and opera. It has

Table 2.21 Frequencies of attendance by residents at arts events and attractions

Numbers

	Glasgow	Merseyside	Ipswich
Number of visits to attractions in region by those attending: (a)			
Museums and galleries	3.9	2.4	1.2
Plays and musicals (b)	2.9	1.4	2.7
Opera	4.4
Dance	1.0
Classical concerts	2.4	2.0	1.2

Source: PSI.
(a) During 12 months previous to interview.
(b) Excluding pantomime.

30

been estimated on the basis of reported average frequencies of attendance at the Royal Festival Hall in London that 99,000 individuals accounted for a total sale of 893,000 tickets in 1982/83 (see *Facts 2*). By the same token, it would appear that the 249,000 tickets sold for the Royal Opera in 1982/83 were purchased by some 47,000 individuals. A well developed subscription system, such as operated in the Theatre Royal Glasgow for Scottish Opera, tends to produce the same phenomenon of concentration on regular attenders. On the other hand, the bulk of theatre goers in London were infrequent attenders, with less than 10 per cent of the audience attending more than 12 times a year. The average appeared to be 2 or 3 times a year (see Gardiner).

Not a unified demand

The broad economic implications of these differently composed markets for the arts is discussed in Section 4 below, which also considers the role of overseas tourists. Quite apart from the differences between residents, day visitors and tourists, it would be a mistake to assume that arts attendance formed a single unified demand. It is true that people who attended one type of arts attraction or event were more likely than the general population to attend others. But museum and gallery goers and theatre and concert attenders would appear to represent separate market segments. The levels of cross-visiting within each segment were higher than the cross-visiting between the segments. Tables 2.22 and 2.23 show that in Glasgow, for example, the most enthusiastic cross-visitors were classical concert goers, followed by art exhibition attenders and opera and dance goers. Museum and gallery goers, who conformed most closely in other respects to the general population, were least interested in other arts activities, though they had a relatively high propensity to visit historic houses. By the same token, play goers scored low in museum and gallery going. There appeared to be two way linkages between concert going and attending art exhibitions, and also between concert going and opera and dance attending. People going to pop concerts had a high propensity to attend art exhibitions, but the relationship was weak vice versa. In Ipswich, opera, ballet and concert goers were the most enthusiastic cross-visitors; pop concert and cinema goers were the least interested in other arts activities.

Table 2.22 Visitors to arts venues and events in Glasgow: by attendance at more than one type of venue or event

	Museum/ gallery	Art exhibition	Historic house	Play or musical	Classical concert	Opera/ dance	Pop concert	Cinema
Percentage of those visiting venues and events below who also attend and other venues and events: (a)								
Museum and gallery	100	26	40	22	10	9	13	50
Art exhibition	87	100	59	37	24	19	20	48
Historic house	83	36	100	26	16	11	18	47
Play or musical	51	25	28	100	14	15	20	57
Classical concert	73	50	54	42	100	32	23	62
Opera/dance	56	38	35	45	30	100	21	54
Pop concert	50	23	33	33	13	12	100	75
Cinema	59	17	27	30	10	10	23	100

Source: PSI.
(a) Figures relate to people who attended at least once during the 12 months previous to the interview. The table is read across: taking the top row, of those visiting a museum or gallery 26 per cent also visited an art exhibition, 40 per cent an historic house, 22 per cent a play or musical etc.

Table 2.23 Visitors to arts venues and events in Glasgow: standardised probability of attending other venues and events relative to arts visiting by the Glasgow public at large

	Museum/ gallery	Art exhibition	Historic house	Play or musical	Classical concert	Opera/ dance	Pop concert	Cinema
Probability of those visiting following venues or events also attending other venues and events: (a)								
Museum and gallery	n.a.	2.4	2.1	1.3	2.0	1.8	1.3	1.5
Art exhibition	2.2	n.a.	3.1	2.2	4.8	3.8	2.0	1.5
Historic house	2.1	1.9	n.a.	1.5	3.2	2.2	0.9	1.4
Play/musical	1.3	2.3	1.5	n.a.	2.8	3.0	2.0	1.7
Classical concert	1.9	4.5	2.8	2.5	n.a.	6.4	2.3	1.9
Opera/dance	1.4	3.5	1.8	2.6	6.0	n.a.	2.1	1.6
Pop concert	1.3	3.0	1.7	1.9	2.6	2.4	n.a.	2.3
Cinema	1.5	1.5	1.4	1.8	2.0	2.0	2.3	n.a.

Source: PSI.

(a) Probability of 1.0 means the level of visits was the same as for the Glasgow population at large; probability of 2.0 means twice as likely to visit.

High levels of satisfaction

The levels of consumer satisfaction with arts events and attractions were generally very high. Museums and galleries and theatres and concerts gave broadly similar levels of satisfaction. More than four-fifths of attenders found their visit either extremely or very interesting and enjoyable. The levels of satisfaction were slightly higher amongst day visitors to a region than amongst residents. Tourists were even more contented with 90 per cent levels of satisfaction and over. This makes an excellent foundation on which to build market developments, either by extending the reach or increasing the frequency of attendance by residents, day visitors or tourists alike.

Table 2.24 Levels of consumer satisfaction with arts events and attractions (a)

	Residents		Day Visitors		Tourists	
	Museums/ galleries	Theatres/ concerts	Museums/ galleries	Theatres/ concerts (b)	Museums/ galleries	Theatres/ concerts (c)
Percentage finding visit						
Extremely/very enjoyable	78	79	87	78	91	88
Fairly/not enjoyable	22	21	13	22	9	12

Source: PSI.
(a) Average of three study regions.
(b) Glasgow only.
(c) Ipswich only.

CONCLUSION

This section began with the observation that cultural leisure spending overall, as measured by official statistics, including spending on items for use in the home, such as videos and musical instruments, represented over 5 per cent of consumer expenditure. This was growing in line with consumer spending overall.

There were a variety of channels by which artistic ideas reached the public. Despite the rise of 'cultural' preoccupations in the home (especially an increase in television viewing) and the growing acquisition of cultural equipment (videos, musical instruments etc.) for use in the home, cultural activities outside the home (attending arts events and attractions) were expanding.

Arts attendances totalled 251 million in 1984/85, of which 73 million were museum and gallery visits and 49 million were admissions to theatres and concerts. Most fields of the arts, after a lull in the 1980s, were trading at higher levels in the mid 1980s, than prevailed some 10 years previously. Consumer spending on admissions to arts events and attractions was estimated at £433 million in 1986/86 of which £256 million was paid for entrance for theatres and concerts and £18 million to museums and galleries. The figures exclude amateur events and activities.

The section concluded with some observation on the structure of the market for the arts. Not surprisingly this was dominated by London as a great cultural resort, but Glasgow among the three study regions was also a point on which the market particularly concentrated.

The market was analysed into residents, day visitors and tourists. In the three study regions, residents formed a much larger share of the market for theatre and concerts than they did for museums and galleries. Tourists were relatively unimportant in theatres and concert audiences. Museums and galleries relied to a greater extent on day visitors and tourists.

In London the picture was completely different. The majority of the arts market for both museums and galleries (66 per cent) and at theatres and concerts (61 per cent) consisted of day visitors and tourists. In a discussion of the reach of the arts (the proportion of the population attending at least one event in the previous 12 months) it was shown that the arts reached almost two thirds of the adult population. The reach was higher for ABC1s than C2DEs but it was by no means negligible for the latter. It was shown that the reach of the arts was virtually identical for the different social classes in the three regions and so differences between regions were mainly attributable to contrasts in social composition.

Museums and galleries overall reached more of the population (between 31 and 39 per cent), with a significant minority attending plays or musicals (17-32 per cent).

The demand for the arts was not unified. People who attended one type of arts event were more likely than the general population to attend others. But the evidence suggests that museum and gallery goers represented to a considerable degree a separate market segment from theatre and concert goers.

The levels of satisfaction with arts events and attractions were high which gave an excellent foundation on which to build market developments, either by extending the reach of the arts or by increasing the frequency of attendance.

3. ECONOMIC STRUCTURE OF THE ARTS SECTOR

The arts sector can be defined as that part of the economy which has the function of devising and supplying artistic ideas and experiences to the public. Section 2 contained a preliminary discussion of the strengths and limitations of the relatively narrow definition adopted in this report and provided estimates of consumer spending on arts events and attractions, put at £433 million, and on cultural goods (such as books and television). But these do not reflect the full economic weight of the sector, which receives income from a variety of other sources, including related trading activities, direct overseas earnings, public subsidies, private contributions and, most significantly in the case of broadcasting, the sale of advertising. These sources of finance are described later in the section. The first job is to describe the sector and its constituent parts in terms of turnover, value-added, organisational structure and the number of people it employs.

Arts sector and its constituent parts.

The arts do not lend themselves to easy measurement. Official statistics rarely identify the arts as a distinct activity. The dimensions of the arts and their place in the economy examined in this report are based on a number of assumptions about their scope. There are two aspects to their economic contribution: the first concerns the arts sector itself, which supplies artistic ideas and experiences to the public; and the second concerns economic activities which underpin attendance at arts events and attractions. For our purposes, it is helpful to view the arts sector in three parts:

— presentation of arts events and attractions (museums and galleries, theatres and concerts);

— production and distribution of performances by mechanical means (through broadcasting and the cinema);

— creation of cultural items for sale (books, pictures, discs and videos, craft items).

Whilst each of these three sub-sectors seeks to convey artistic experiences, they use different technical means to reach the public; live performances and public displays; broadcasting and cinema presentation; and factory production and sale of items. But the three parts are not always easy to differentiate. Performing and creative artists work in all three. Areas overlap and boundaries change. Videos are now sold as individual consumer items and recordings are used extensively in broadcasting. Despite some artificiality, the categories can be useful in the factual analysis which follows. The report concentrates mainly on the first of these sectors, the presentation of arts events and attractions, often regarded as the most prominent and basic aspect of the arts.

The second economic contribution of the arts concerns the productive activities which underpin attendance at arts events and attractions. What people spend on food, transport, accommodation and other purchases in the course of visiting cultural facilities represents economic activity which is attributable in whole or part to the influence of the arts. Not all such spending can be said to be induced by the arts, because the trips of some attenders are not undertaken solely or specifically with cultural objectives in mind. A method is outlined in Section 4 below for judging the influence of the arts on decisions by tourists, day visitors and residents to make the trip, which enables estimates to be prepared of the amount of spending attributable to the specific influence of the arts. The resulting figures on ancillary spending associated with art attendance are discussed in detail in Section 4. They are relevant here as part of the description of the overall place of the arts in the economy.

Turnover of £10 billion

It is estimated that the arts sector had a turnover of £10 billion in 1985. This represents the combined value of the three aspects of the arts sector defined above and of ancillary spending

34

specifically induced by the arts. The details are summarised in Table 3.1. Some 36 per cent of turnover was generated by the production of cultural consumer items (books, records, arts and crafts). Mechanical performance (broadcasting and the screen industries) accounted for 29 per cent and the share of events and attractions was only 8 per cent. The remainder took the form of arts-specific spending on refreshments, hotels etc, incurred in connection with attending events and attractions. The main exclusion from these figures is the turnover of heritage attractions.

Table 3.1 Arts sector: turnover and value-added, 1985

£ million

	Turnover	Value-added
Events and attractions (a)	846	464
Mechanical performance (b)	2,824	1,370
Cultural products (c)	3,674	1,687
Ancillary spending (d)	2,621	471
Total	9,976	3,992

Source: PSI.
(a) Museums and galleries £230 million; theatre £422 million; and concerts £194 million.
(b) Broadcasting, film and video production and cinemas.
(c) Books, art trade, record industry and crafts.
(d) Arts specific spending, excluding spending in venues.

(a) *A restricted definition*
The estimate may differ from those put forward by others (see Battelle) because of the relatively narrow definition of the arts sector employed. It excludes libraries (turnover of £450 million), the built heritage and the arts in education, including professional training in the arts. It further excludes many industries which have a significant input from art and design, such as architecture, fashion, advertising, graphic design and photography. The line is difficult to draw. Such industries gain ideas and inspiration from the arts but their products are not in themselves fine art, though they may have strong cultural connotations. Newspaper and periodical publication, usually regarded as a cultural industry in continental Europe is excluded here. The decision was also taken to exclude the manufacture of 'tools of the trade', such as musical instruments, video players, televisions, radios and artists' colours and brushes, which could arguably be included as cultural equipment, essential for creating and enjoying many kinds of cultural experiences. Some reference is made to these sectors in the discussion of overseas earnings attributable to the arts. These sectors provide the wider context in which the arts operate but they are not exclusively an arts preserve. The temptation to include them was resisted, because it would take the study away from the central concern of the arts and might give rise to misleading claims.

(b) *Place in the economy: 2.5 per cent of total final expenditure*
The £10 billion turnover of the arts sector amounted to 2.5 per cent of all spending on goods and services by UK residents and foreign buyers, defined as total final expenditure in the national accounts. It was comparable to the market for cars, motorcycles and other vehicles, or to total sales of fuel and power. If the various items listed above (libraries, advertising, architecture, fashion, musical instruments, radio and television manufacture) were included, the figure for turnover would be 5—6 per cent of total final expenditure. In terms of its value-added (£4 billion), the arts sector contributed 1.28 per cent of gross domestic product, roughly equivalent to motor vehicles and parts (£3.8 billion), rather larger than rubber and plastics (£2.6 billion) and somewhat smaller than agriculture, forestry and fishing £6.5 billion).

THE ECONOMIC IMPORTANCE OF THE ARTS IN BRITAIN

Generally, the turnover of the arts sector as defined above was related to delivering a product to a final consumer, say as a performance or an item for sale. As such, the turnover can be regarded as a measure of the value of the final output of the sector. In a small number of cases, the arts sector delivered intermediate products to other industries, such as the commercials made for the advertising industry. In some other cases, it supplied intermediate products within the sector. The input of independent orchestras into broadcasting and the screen industries was an example of this. These are not large enough seriously to distort the use of turnover as a measure of final output.

Museums and galleries

The turnover of museums and galleries was estimated at £230 million in 1985/86. Details of the sector, covering the national museums and galleries (NMGs), local authority museums and other museums and galleries, are set out in Table 3.2. The NMGs, which drew the largest share of attendance (34 per cent), also generated the largest turnover at £113 million, or 50 per cent of the total. Over 50 facilities varied greatly in type and scale from individually-housed historic collections, such as the Wallace Collection, and small out-stations, such as the Bethnal Green Museum, to the large integrated national collections like the British Museum. Not surprisingly, despite the wide variation in the size of individual facilities, the average turnover per facility at £2.1 million was much the highest amongst the three categories of museums. The total turnover of the local authority museums and galleries was estimated at £81 million, but with 750 facilities the average was £108,000. They ranged from the major metropolitan museums such as Kelvingrove, part of the Glasgow Museums and Art Galleries, with an annual expenditure of £2.3 million, bigger than many NMGs, to the small museums operated by most district councils. The other museums formed the most numerous category, with at least 900 facilities (though the figure may be as high as 1,200) but they had the smallest turnover at £30 million, or 14 per cent of the total. Their 27 per cent share of attendance was proportionately much larger. The average turnover of £33,113 reflects the fact that the sector, which included some major commercial operations and very important university museums, was characterised mainly by a host of small museums, run by local enthusiasts, making heavy use of volunteer labour.

Table 3.2 Museums and galleries: turnover and value-added

£ million

	Turnover	Value-added
National museums and galleries (a)	113	74
Local authority museums (b)	81	43
Other museums and galleries (c)	30	20
Sub-total	224	137
Galleries and temporary loan exhibitions	7 (d)	4
Total	230	141

Source: *Facts 2*: Appropriation Accounts: Chartered Institute for Public Finance and Accountancy: *Museums UK*.
(a) Combines data from 1983/84, 1984/85 and 1985/86.
(b) 1984/85: in previous November's pay and prices.
(c) Combines information from several years.
(d) Estimated box office income and sponsorship of temporary loan exhibitions in London plus Arts Council spending on exhibitions.

As for finance, the NMGs were supported mainly from central government funds, whilst the local authorities assumed full responsibility for their own museums. Some small central government grants to the museum system as a whole were administered by the Museums and Galleries Commission. The publicly owned and operated museums were supported for all but 7-10 per cent of their income from public sources. Some facilities achieved significant earnings from refreshment, bookshop and other sales; for example, the Burrell Collection which earned 18 per cent of its income in this way. Admission generally remained free of charge. It has been estimated that charges for admission were made at 35 per cent of NMG facilities, 27 per cent of local authority museums, and 63 per cent of other museums (see *Museums UK*). Income from sales and charges for admission were more important to the independent museums. Somewhat surprising was the degree to which independent museums relied on public funding, either via universities, or from the Manpower Services Commission for special labour schemes, or from local authorities. The reliance on local authorities varied greatly. In Glasgow they gave grants amounting to 4 per cent of the income of the independents; in this case, the University of Glasgow was the major benefactor of the independents. At the other extreme, the Museum of East Anglia Life in Suffolk received 54 per cent of its income from local authorities. No comprehensive data are available on the incomes of museums and galleries. Table 3.3 summarises a variety of information, including material from the three regional case studies.

Table 3.3 Museums and galleries: income sources

Percentages

	Admissions/ sales (a)	Public funds	Private sources	Total
National museums and galleries (b)	7	93	..	100
Local authority museums (c)	5	91	5 (d)	100
Other museums and galleries (e)	37	53	9	100

Source: *Facts 2*: PSI; *Museums UK*.
(a) Admission charges raised an estimated £112 million at NMGs, 2.4 million at local authority museums and £11 million at other museums.
(b) Office-of-Arts-and-Libraries-funded museums only: relates to 1983/84.
(c) England and Wales only, 1983/84.
(d) Includes 'other' income.
(e) Average of Glasgow, Merseyside and Ipswich, 1985/86.

Theatre

(a) *Turnover £422 million*
The turnover of the theatre sector, including opera and dance, was estimated at £422 million in 1985. Some 663 theatrical venues presented roughly 90,000 performances. The sector fell into three parts (see Table 3.4): 103 theatres with resident companies, including the main network of producing theatres outside London and, operating on a rather different basis, London's West End; 500 theatres and other venues without resident companies, including arts centres and small venues; and an estimated 350 touring companies and independent producers who provided shows for the venues. It will be realised that the detailed picture was more complex than this three-fold division implies: some building-based theatre companies went on tour and they also received touring shows in their own theatres — but for our purpose a simple description will suffice. The scale of operation varied greatly from the Royal Opera House, with three companies, its own theatre, and a turnover of £21 million in 1983/84, to the 125 companies in membership of the Independent Theatre Council with an average annual turnover of £63,000 (see *Facts 2*).

Table 3.4 Theatres, theatre companies and arts centres: facilities, turnover and value-added

Numbers and £ million

	Number of facilities	Turnover (£ million)	Value-added (£ million)
Building-based companies			
National companies (drama, opera, dance) (a)	9	58	40
Producing theatres (b)	51	33	18
London's commercial West End	43	68 (c)	39
Sub-total	103	159	97
Venues			
Number-one receiving theatres (d)	23	45	11
Local authority theatres	115	43	9
Independent theatres	51	25	8
Arts centres and small venues (e)	311	53	21
Sub-total	500	166	49
Theatre companies, producers, artists			
Main-scale opera, dance (f)	11	29	17
Small-scale opera, dance	20	2	1
Subsidised drama touring companies and projects	160	11	7
Other small drama companies	40	3	2
Commercial producers	120	25	21
Other (g)	..	28	23
Sub-total	351	97 (g)	71
Total	925	422 (i)	217

Source: *Facts 2; Arts Centres UK; British Theatre Directory;* First Leisure Corporation; Society of West End Theatre; Independent Theatre Council; Theatrical Management Association; Arts Council of Great Britain; Chartered Institute of Public Finance and Accountancy.

(a) Royal Shakespeare Company and National Theatre £28 million 1984/85; Royal Opera House and English National Opera £31 million 1983/84; the four companies operated nine auditoria.

(b) Turnover includes 21 studio theatres attached to producing theatres.

(c) Box office only.

(d) Including Glynebourne Opera House.

(e) Includes 240 arts centres, several of which housed small producing companies.

(f) Scottish Opera, Welsh Opera, Opera North, Kent Opera, Glyndebourne Festival and Touring Opera, Opera 80, London Contemporary Dance, London Festival Ballet, Scottish Ballet, Northern Ballet, Ballet Rambert.

(g) Variety acts, circuses, dancers, overseas earnings from stage appearances by individuals.

(h) Less fee income received from venues, the figure was £21 million.

(i) The estimated fee income of £76 million paid by venues to companies is included twice in this total once under venues and also under companies.

The building-based companies accounted for the largest part of the sector at £159 million, or 38 per cent of the total. Included in the category were the national drama companies (the National Theatre and the Royal Shakesphere Company) with a turnover of £28 million and the national opera and dance companies (the Royal Opera, Royal Ballet, Sadler's Wells Royal Ballet and the

English National Opera), which turned over between them £31 million. The 51 Arts-Council-funded producing theatres (with 21 studio theatres) had a throughput of £33 million in relation to 15,000 performances. Finally, the commercial producers of London's West End, including the subsidised Sadler's Wells Theatre (part receiving and part producing house), operated in upwards of 40 theatres giving 14,000 performances with an estimated turnover of £68 million (box office receipts only). These were not strictly speaking building-based companies, but the structure of the West End has been changing and more producing managements have acquired ownership of theatres in recent years.

The network of theatrical venues, without resident companies, operated under a variety of arrangements. Some theatres were available for hire by independent promoters and others received and promoted touring shows themselves. There were no standard commercial terms under which promoters operated. The core of the network consisted of the 22 designated number-one receiving theatres, which presented main-scale touring opera, dance and drama, subsidised by the Arts Council, together with commercial tours of musicals, pantomimes, drama and other entertainment. These included such theatres as the Theatre Royal Glasgow (owned and operated by Scottish Opera) and the Grand Theatre Leeds (the home of Opera North). Performances of the six main-scale touring opera companies were concentrated in 13 theatres throughout Britain, a reduced grid based on the number-one receiving theatres (see *Facts 2*). These companies, together with the Royal Opera, the English National Opera and Glydebourne, gave performances numbering over 800 in 1983/84. Seven large and middle-scale dance companies, including the Royal Ballet and the Sadler's Wells Royal Ballet, supported by the Arts Council, presented over 800 performances. Those outside London were mainly in the number-one receiving theatres. The turnover of these theatres, which presented roughly 5,000 performances, amounted to £45 million.

Finally, art centres and small venues accounted for upwards of 300 performance spaces. As a rule, the seating capacity of arts centres was small and 62 per cent had a seating capacity of 200 or less. The other venues were various theatre clubs, studios, lunch-time theatres, whose standing and number were difficult to track. Their place, together with that of the arts centres, in the economic picture of the theatre can be judged from the fact that they formed more than half of the venues, presented one fifth of the events and drew 8 per cent of audiences. Their artistic value was greater than this implies. The arts-centre circuit was important for small-scale drama, dance and music, especially for development work and as a breeding ground for new talent. Arts centres were also important as promoters of the visual arts and music (see *Arts Centres UK* for the most recent assessment of the role of arts centres). The economic contribution of small venues and arts centres (including all aspects of their mixed programme activities) amounted to £53 million in terms of turnover.

The most difficult area to measure concerned the independent producing companies and individual artists. They ranged from the major opera companies, such as the Welsh and Scottish Operas, to the commercial musicals and variety shows and the numerous small companies which sprang into life when funds became available, often but not always from public sources. The turnover of the sector was estimated at £65 million, on the basis of the fee income available from the venues combined with grants, sponsorship and other forms of income. The number of independent producers and companies was estimated at 350. The 11 main-scale opera and dance companies had a combined turnover of £25 million in 1983/84. The Arts Council and regional arts associations in addition supported some 20 small-scale dance, mime and opera companies. As for drama, Arts-Council support was offered to some 160 touring companies and drama projects in 1985/86. The remaining 160 organisations consisted of commercial producers (132 in membership of the Theatrical Management Association) and small companies operating without public subsidies. This is probably an under-estimate of total activity in this area. The figures relate to the venues described above and exclude appearances in mixed-use halls (many of which were operated by local authorities), occasional venues, clubs, hotels, holiday camps and dance halls.

(b) *Private interest amounts to 48 per cent of turnover*

Wide sections of the theatre still operated without the benefit of public subsidy (especially London's West End), but the balance between subsidised and independent provision has altered in favour of the former over the years. The network of commercial theatres was substantially reduced in the 1960s and 1970s and outside London, where the local authorities have become the main providers of theatres, they are in minority. Most of the producing theatres are owned by trusts or non-profit distributing companies (33), with three owned by universities and 15 by local authorities. Seven of the 22 number-one touring theatres are commercially owned and operated, with ten held by trusts or non–profit companies and five by local authorities. As explained previously, the local authorities owned and operated 115 other theatres and a further 51 theatres remained in private hands, of which the majority were commercially operated. The latter included six large seaside theatres, ten multi-use metropolitan venues and 35 smaller theatres. Two-thirds of arts centres were owned and operated by local authorities and a significant number (23) were based at universities, schools and colleges.

The private interest in the theatre sector, in terms of commercially operated theatres in London and elsewhere and the activities of commercial producers, is estimated at £170 million, or 48 per cent of the total theatre sector. There is some evidence that the trends in the theatre towards more subsidised and public provision may have been reversed. Major theatre closures have given way to an active market in theatre freeholds, especially in London. Despite some improvement, anxieties remain about the state of the physical fabric of London's private theatres. Private money has also been put into theatre buildings outside London, usually in partnership with public funds (see *Fact 2*). Commercial managements are still very active in London's West End and in certain kinds of touring productions. There is also evidence that the subsidised companies have become marginally less dependent on public subsidy, as grants have been made to go further supplemented by other sources of finance, especially box office receipts and other earned income (see *Facts 2*).

(c) *Public resources shift from hardware to software*

An important recent development has been the growing co-operation in artistic and financial matters between the commercial and the subsidised stages. First, this took the form of transferring productions from the subsidised theatres to London's West End. There were 41 transfers in the years 1982/83-84/85. More recently, financial co-operation has extended to co–production deals. This is a good instance of the way in which public money can play a 'research and development' role in the risky task of creating new productions for eventual exploitation in the commercial theatre. Whilst more private money is going into theatre buildings, or the hardware of the theatre, there appears to be a growing need for public money in theatre productions, or the software of the sector. A deeper change is the acceptance of more commercial influences on the management of subsidised organisations, if not on their artistic policies. The difference between commercial and subsidised operations becomes more difficult to draw both in theory and in practice (see West).

Despite these changes, the place of subsidy in the theatre remained important. Unlike museums and galleries, subsidised theatre companies were expected to cover from the box office and other sources between 30 and 50 per cent of their income, more for the producing theatres and less in the case of opera and dance companies and the small experimental drama companies (see Table 3.5). Central government grants, allocated via the Arts Council, were generally given to producing companies. Local authority funding went more towards the subsidy of venues (£67 million in 1983/84), though they increasingly grant-aided independent producing theatres and companies (£15 million).

Music

The music sector consisted both of the performing organisations (orchestras, etc), solo artists and ensembles and the principal venues where concerts took place. The combined total turnover was an estimated £194 million in 1985/86. There were 22 principal orchestras in Britain in 1986 of which five were part of opera and dance companies; their turnover was included under theatre. The

remaining 17 (the four London orchestras, five contract orchestras, six radio orchestras and two contract chamber orchestras) had an estimated turnover of £40 million. The figures on venues relate to the 35 specialist concert halls (see *Facts 2*). It will be apparent that concert life extended well beyond the main organisations (performing groups and venues). Symphony concerts were given in over a hundred non-specialist venues, such as general halls, churches, art centres and even the open air (see *Facts 2*). It was impossible to measure the economic value of the contribution of every such venue. Table 3.6 includes estimates of the turnover of non–contract orchestras (mainly chamber orchestras) and of ensembles and solo performers (excluding appearances with the orchestras, opera companies, etc). The figures on jazz, pop, folk and rock relate to concerts only and derive from the estimates of consumer spending. This has been allocated notionally between the performing groups and the venues. The total turnover for live performance was £116 million and for venues £73 million. Not surprisingly, the value-added by performers was much higher at £88 million, compared with £14 million for the venues. As explained above, these figures relate to concerts and so do not include performers in holiday camps, hotels, pubs, clubs, dance halls and theatres.

Table 3.5 Financing the subsidised theatre

Percentage

	Box office and sales	Local authorities	Central government	Private sources
Percentage of income of following arising from different sources:				
National drama companies	46	4	49	1
English producing theatres	48	21	29	2
Small companies (a)	28	18	52	2
Dance companies	34	18	45	3
Opera companies	33	4	56	7
Local authority theatres and halls (b)	53	47	—	—
Arts centres	37	43	17	3

Source: *Facts 2; Arts Centres UK.*

(a) Independent Theatre Council members
(b) England and Wales

The main earnings for popular musicians derived from mechanical performance which has not been considered so far. This includes broadcasting engagements, royalties from the sale and public performance of recordings. These figures are included under the recording industry below. This aspect of music is so important economically that it can make sense to put it at the centre of the analysis. This is one of the reasons why reference is often made to the 'music industry', drawing together performance in all its aspects, including the recording industry, music publishing and music-related manufacturing of such items as sound equipment, specialist recording equipment and musical instruments. The turnover of the music industry in this sense can be estimated at £1.3 billion. The details are set out in Table 3.7 which shows the central role of recording with a turnover of £896 million, including royalty receipts.

Mechanical performance

In this description of the economic structure of the arts sector, some brief attention must finally be given to two important areas: mechanical performance; and the production of cultural items, such as records, books, the arts and crafts. These sectors do not form the centre of the report. As

explained above, it is important to understand that they provided a parallel means of transmitting artistic ideas to the public and an important source of earnings to performing and creative artists.

Table 3.6 Music performers and venues: turnover and value-added

£ million

	Turnover	Value-added
Performers (a)		
Principal orchestras (b)	40	29
Non-contract orchestras (c)	6	4
Classical solo artists and ensembles	15	12
Jazz, pop, folk, rock (d)	19	17
Military bands	36	26
Sub total	116	88
Venues		
Main concert halls	59	11
Chamber concert halls	1	1
Other venues	13	2
Sub total	73 (e)	14
Other	5	4
Total	194	106

Sources: PSI; *Facts 2*.
(a) Excludes overseas earnings from concert appearances.
(b) Excluding 5 orchestras attached to opera, dance companies; including radio orchestras.
(c) Mainly chamber orchestras.
(d) Excluding employment in holiday camps, hotels, dance bands, pubs, clubs and theatres; estimated as percentage of spending on admissions.
(e) Arts centres included under theatres.

Table 3.7 'Music industry'; turnover

£ million

Concerts	
Performers	116
Venues	73
Theatre music, live background music and other (a)	25
Recording industry	896
Music publishing	88
Sound equipment (b)	66
Musical instruments	57
Total	1,321 (c)

Source: As for table 3.6; BPI; Music Publishers' Association; Business Monitor.
(a) Includes opera and dance company orchestras; pub, club, dance bands and music in theatres.
(b) Specialist recording equipment only.
(c) Excludes music teaching estimated at £14 million for independent music teachers and principal conservatoires.

Within mechanical performance is included broadcasting, independent film and video production and the cinema (see Table 3.8). These have in common the fact that the entertainment is conveyed by mechanical means to the spectator who witnesses from afar what is (or once was) a live spectacle. Of course, in the age of video cassettes, a film can be a consumer item to be carried away like a book or a record. The broadcasting of records is also a kind of mechanical performance, but the main earnings of the recording industry derive from individual sales to separate customers and so recording is grouped here with other manufactured items for sale to individuals.

Table 3.8 Mechanical performance: turnover and value-added

£ million

	Turnover	Value-added
Broadcasting (a)	2,264	1,024
Independent film and video production		
Feature films (b)	155	90
Commercial video	234	
Corporate video	45	175
Pop videos	12	8
Sub-total	446	273
Exhibition	108	70
Other (c)	24	9
Total	2,842	1,376

Source: *Peacock Report*; *Screen International*; Advertisers' Association; Association of Independent Programme Producers; Channel 4; *Facts 2*.
(a) BBC £807 million; ITV £1,388 million; ILR £69 million.
(b) Channel 4 estimated the value of independent films and programmes in which they were financially involved at £40 million; some but not all of this is included under feature films; no estimate was available of the value of independent production of 'non-feature films'.
(c) Direct overseas earnings through specialist film TV and theatrical services, such as equipment hire.

(a) *Broadcasting*
The turnover of the broadcasting sector was £2,264 million in 1986, with a gross value added of £1,024 million. The BBC (radio and television), the 15 regional ITV programme contractors, together with TV-AM, Channel 4, Independent Television News and 48 independent local radio stations, are included in the figure. Cable operators and satellite broadcasters are not included. The BBC was financed primarily from licence fees (£723 million in 1984/85), with a grant for the overseas service from the Foreign and Commonwealth Office (£81 million) and income from other sources such as the sale of programmes (£13 million). The main source of revenue for ITV was provided by the sale of advertising time on ITV and Channel 4 (£983 million in 1985), with additional resources from the sale of programmes, especially overseas (£47 million in 1984).

Of course, much of the output of the broadcasting organisations was not related directly to the arts. In 1984/85, the BBC estimated that £185 million or 23 per cent of expenditure went on music and arts features, drama and popular music (including TV variety shows). The ITV companies estimated their total costs on arts programmes (relays of classical plays, opera, ballet, documentaries on arts subjects, opera and ballet artistes' appearances in variety programmes) at £21 million with a further £178 million spent on programmes which to a significant extent employed the talents of actors and actresses, musicians and writers. Channel 4 estimated that its arts expenditure was £27 million in 1984. ILR stations undertook to spend 3 per cent of advertising receipts on live and

43

specially recorded music. The actual expenditure on music was £9 million (£2 million on live music and £7 million on royalties). The Welsh Fourth Channel, according to a liberal definition of the arts, spent £4.8 million. Thus, the total independent broadcasters' spending on the arts could be estimated at £219 million in 1984/85, compared with £185 million spent by the BBC (see Facts 2).

(b) *Film and video production*
Independent film and video production had an estimated turnover of £446 million in 1986. Commercial videos represented the largest part at £234 million. Feature films (numbering 37 in 1986, including productions from overseas), were valued at £155 million; the 1985 figures were higher at 55 films with a value of £260 million. Independent films and programmes commissioned by Channel 4 were valued at £40 million but this may partly overlap with the estimated figure for feature films. Corporate videos were a growing sector at £45 million, as were pop videos at £12 million. No estimates are available on the numbers of companies involved in independent production, though the Department of Trade and Industry included 316 film companies in its survey of annual earnings and this gives an indication of the size of the sector.

The exhibition of films accounted for a turnover of £108 million in 1985 (box office takings net of VAT). Cinemas numbered 660 in 1984, with 1,226 separate screens; some 58 per cent of the cinemas were owned by four leading proprietors.

No figures are available on the numerous companies supplying specialist services to the film and broadcasting industries in areas such as lighting and equipment hire, processing and editing, and other post-production facilities, as well a general theatrical supplies. Their output is counted within the overall turnover of the sector and an allowance for their direct overseas sales has also been included in the figures in Table 3.8. It was not possible for the figures on value-added to take into account their specific contribution.

Cultural products

(a) *Records*
The turnover of the record industry was an estimated £896 million in 1986 (see Table 3.9). This included the wholesale value of UK sales by British manufacturers of records, pre-recorded tapes and compact discs (£425 million) and their overseas sales (£76 million). In addition, invisible earnings from royalties and other sources by British record companies and by British recording artists were estimated at £396 million. Record retailing is not included in these figures.

(b) *Publishing and printing of books*
The publishing and printing of books had a turnover of £2,285 million in 1985. This related to 4,134 enterprises, with 4,325 establishments, but it excluded companies with 25 or fewer employees. Publishing of newspapers (£2,887 million) and periodicals (£2,074 million) were important sectors not included in the totals.

(c) *Art trade*
The art and antique trade has a long tail which shades off into general dealing in second-hand goods. The 1982 retail enquiry estimated that the dealers' margin on 'antiques, works of art, prints, etc' was £645 million. PSI carried out a sample survey of the organised fine art trade in 1986, which covered the four main trade organisations (the Society of London Art Dealers, the British Antique Dealers Association, the Antiquarian Booksellers Association and the London and Provincial Antique Dealers Association). The combined membership of 1,297 represented 16 per cent of traders registered with the Customs and Excise for the VAT category 'antique dealers and secondhand furniture shops, etc'. The results of the survey showed that the turnover of the organised fine art trade was valued at £859 million, of which £299 million represented the dealers' margin and £180 million value-added.

Table 3.9 Cultural products: turnover and value-added

£ million

	Turnover	Value-added
Recording industry (a)		
Record companies UK trade deliveries	425	225
Record companies export of records	76	
Royalties and other payments from overseas		
British artists	228	316
British companies (b)	167	
Sub-total	896	531
Publishing and printing of books	2,285	849
Art trade (c)		
Organised trade (d)	299	180
Auction houses	61	26
Other	11	7
Sub-total	371 (c)	213
Crafts (e)	122	77
Total	3,674	1,680

Source: PSI; BPI; IFPI; Customs and Excise; Business Statistics Office.
(a) Pressing and tape manufacturers (including video) have been estimated at 217 (with 234 establishments); the membership of British Phonographic Industries was 131; number of pressing plants has been estimated at 30, and of recording studios at upwards of 150; 4,850 retail outlets, are not included.
(b) Includes royalties to composers and publishers.
(c) Figures relate to dealers' margin.
(d) Membership of Society of London Art Dealers, British Antique Dealers Association, London and Provincial Art Dealers Association and the Antiquarian Booksellers Association.
(e) Estimates from Crafts Section of Small Business Section of Scottish Development Agency and from Crafts Council 1981 Survey revised in the light of the Ipswich regional case study.

The weight of the trade was heavily concentrated in London, which accounted for 33 per cent of the membership but 67 per cent of the market. Some £21 million of earnings arose from professional services (valuation, etc). The major auction houses were also included in the survey, which showed 'sales' (at the hammer price) of £367 million, with a margin of £61 million and a value–added of £26 million. It was further estimated that the dealers' margin for some 200 contemporary art dealers and galleries, not in membership of the four main trade organisations, was £11 million. The *Arts Review Yearbook 1986* listed over 400 galleries in England, Scotland and Wales. Thus, the estimate of the total dealers margin for the relevant parts of the fine and contemporary art trade totalled £371 million.

(d) *Crafts*
The Crafts Section of the Small Business Division of the Scottish Development Agency has chosen to define the crafts rather more widely than the Crafts Council in England and Wales to cover factory-based batch production of craft items, as well as workshop production of one-off designs. An estimated turnover of £39 million in Scotland for 1984 was related to some 3,000 firms and

crafts people. The full-time craft workers in England and Wales numbered 7,000 according to the 1981 Crafts Council study *Working in Crafts* (see Bruce). This figure can be combined with the figures provided in the Ipswich case study on full-time craft enterprises to a turnover of £83 million for England and Wales the total turnover including Scotland was £122 million. A marked difference can be seen between the sectors in Scotland and in England. Table 3.10 sets out details of the average firm in Glasgow and of a full-time craft enterprise in the Ipswich region. The comparison shows that Glasgow had the bigger enterprises, with a higher turnover and more staff, but the higher level of part-time staff (48 per cent of the total) meant that both the turnover per employee and the gross value-added per job were lower than in Ipswich. Both the Glasgow and Ipswich case studies concluded that the large element of small business in the craft and design sector made it an important seedbed for future growth.

Table 3.10 Crafts enterprises in Glasgow and Ipswich

	Glasgow	Ipswich (a)
Total		
Number of firms	166	35
Turnover (£ thousand)	3,500	413
Jobs (number)	985	73
Value-added (£ thousand)	1,800	207
Per firm		
Turnover (£)	21,084	11,800
Jobs (number)	5.9	2.1
Value-added (£)	10,843	5,914
Value-added per job (£)	1,838	2,816

Source: PSI.
(a) Full-livelihood firms only.

Overseas earnings of the arts

The arts are a major export earner for Britain. Overseas earnings from the arts amounted to an estimated £4 billion in 1984. Sales to overseas customers contributed some 34 per cent to the turnover of the British arts sector. This can be compared with 27 per cent of British manufacturing sales which are exported.

(a) *Fourth among top of invisible earners*
The overseas earnings of the arts are summarised in Table 3.11. A note on the methods used for establishing those figures can be found in Appendix 4. The table shows that £3.2 billion (79 per cent) of the £4 billion were invisible earnings (royalties, fees from performances overseas, and spending by overseas tourists), with 0.9 billion arising from exporting cultural goods. The latter covered the export of a relatively confined range of items, books, printed music, musical instruments, records and tapes and craft items. These fell within the definition of the arts sector explained above (apart from musical instruments and some minor items). Here, as elsewhere, much else might have been included, such as fashion products, architectural services, graphic design, not to mention recording studio equipment and hi-fi equipment, but the temptation to exaggerate the scope of the sector, succumbed to in a number of recent overseas studies (see Battelle), has been resisted.

Table 3.11 Overseas earnings of the arts

£ million

	Goods	Invisible earnings	Total
Theatrical performance, films and TV material	33	426	459
Musical performance, composition, publishing, recorded and broadcast material	126	428	554
Publishing and the book trade	642	57	699
Art trade, visual arts and crafts	43	743	786
Miscellaneous transactions (a)	12	28	40
Cultural tourism (b)	—	1,476	1,476
Total	856	3,158	4,014

Source: See Appendix 4.
(a) Direct ticket sales, overseas students, examinations and cultural spending by overseas governments.
(b) Arts-specific spending by overseas tourists; see Section 5 for the basis of this estimate.

The £4 billion overseas earnings from the arts sector represented 3 per cent of all export earnings. The invisible earnings from the arts at £3.2 billion were relatively more important as a share of invisible earnings at 4 per cent of the total. This meant that the arts were placed fourth amongst the top invisible earners, below banks (£40.6 billion), travel (£4.6 billion), and shipping £3.5 billion), but above civil aviation (£2.9 billion) in 1984.

(b) *Cultural tourism largest earner*
The largest item under invisible earnings was cultural tourism. This represented the proportion of earnings from overseas tourists (excluding fare payments to carriers) which was specifically induced by arts events and attractions in Britain. The method for judging the influence of the arts on the decision to make a trip is described in Section 4 below.

(c) *Art trade; £798 million*
The art trade enjoyed significant levels of business with overseas customers (see Table 3.12). Of course, many of the transactions were carried out over the counter in Britain, but in so far as they involved remittances from abroad they should be regarded as foreign earnings. Although physical goods change hands in the art trade, it is classified here as an invisible earner because the productive contribution of the trade lies not in the manufacture and sale of mass produced items but in market–making (in galleries and auction houses) for unique and scarce works of art. There is an element of re-export from auction houses in the art trade total. The sale of new art abroad was impossible to estimate. The value of overseas sales of craft items was estimated by the Crafts Council. Further earnings came to the art trade from valuations, restoration and shipping. There were also remittances from overseas branches. A small miscellaneous item includes income from temporary loan exhibitions, artists' commissions and consultancies.

(d) *Theatre and music: £1 billion*
Theatre (see Table 3.13) earns well over £400 million abroad for Britain and music even more at over £500 million. The most valuable part of the trade consisted of royalties from the sale and broadcast of recordings (£381 million) and the sale of film and television material (£370 million). Appearances overseas by theatre companies, orchestras, ensembles and solo artists earned £27 million. Some £10 million came from the tours of orchestras and individual musicians compared with £6 million from theatre tours and £9 million from other stage appearances. Fees for individual

Table 3.12 Overseas earnings of the art trade

	£ million
Sale of art, antiquities and craft items	
Organised art trade (a) (b)	484
Other trade (b)	220
Craft items	43
Auction houses, valuations, shipping	
Auction houses (c)	19
Valuations, restoration and other dealer services	8
Fine art shippers and forwarders	4
Remittances to trade from overseas branches	7
Other receipts (d)	1
Artists' colours and paint brushes	12
Total	798

Source: PSI.
(a) Society of London Art Dealers, British Antique Dealers Association, London and Provincial Antique Dealers Association and Antiquarian Booksellers Association.
(b) Includes some re-exports from auction houses.
(c) Margin from overseas buyers and sellers.
(d) Exhibition, direct sales by artists, consultancies.

stage appearances in North America were very small at less than £250,000, but appearances elsewhere in the world by actors, variety and circus artists, chorus members and especially dancers brought the total to £9.4 million. Indirect earnings from royalties for live performances were much more important as a source of income than overseas appearances. Musical works yielded £25 million for composers, writers and publishers. As for theatre, an estimated £20 million was earned as royalty payments to writers and producers for performances of British works overseas of which £12.8 was from North American productions. Ancillary theatre and film services were also significant sources of overseas earnings, estimated at £24 million including the hire of equipment, theatre consultancies, theatre design, technical advice and earnings of technical staff.

(e) *Publishing and miscellaneous transactions: £739 million*
The estimates for earnings from publishing comprised £57 million from rights and £642 million from the sales of books, a new estimate which allows for dispatch by means of the parcel post.

The miscellaneous category of £28 million included earnings from direct ticket sales (£7 million), overseas students on higher education courses in the performed and visual arts (£7 million from fees and £11 million from other spending), examining fees (mainly £2 million from music diplomas) and the cultural spending by overseas governments in Britain (£1 million).

The overseas earnings of the arts represented a substantial addition to what could be earned from the domestic market. It is unlikely that the arts sector depends to any significant extent on imports to provide what is earned from overseas customers. The art trade is the main exception. Otherwise, the cost of overseas guest artists to companies and ensembles is small in relation to the overall picture. Spending on imported materials, goods and services required by the arts sector is

Table 3.13(a) Overseas earnings from theatrical performance, film and television material

£ million

Performances overseas

Theatre companies (a)	6
Appearance fees	9
Royalties from performances of British work	20

Film and television material

Film companies	260
Television companies (c)	110
Exposed cinematographic film (d)	15
Fees and royalties paid direct to writers, actors	15

Ancillary goods and services (e)	24
Total	459

Source: PSI; Actors' Equity.
(a) Includes £1.1 million exploitation of rights and other earnings.
(b) North America accounted for £12.8 million.
(c) Includes £9 million residuals paid to British artists for overseas use of television material, £2 million by the BBC and £7 million by the ITV companies.
(d) Not included elsewhere.
(e) Includes hire of equipment, theatre consultancies and theatre design.

Table 3.13(b) Overseas earnings from musical performances, composition, writing, publishing recorded and broadcast material.

£ million

Performances overseas

Appearances by orchestras, ensembles, soloists	10
Performing rights to composers,writers, publishers	22

Recorded material

Royalties to individuals and recording companies	396
Sales of records, tapes	76

Musical composition and publications

Fees and royalties not included above	Ø
Printed music	17

Musical instruments	32
Total	554

Source: PSI; PRS; MPA; BPI.

most probably a significantly lower proportion than in most manufacturing activities. This gives more significance to the contribution of the arts to the balance of payments. It will assume greater significance as the revenues from North Sea oil diminish. It was not part of the remit of this report to estimate imports of arts items and performances to this country.

Multiplier effects of art spending and spin-off

(a) *Multiplier effects: preliminary observations*
The turnover of the arts sector is one indication of the contribution of the arts to the British economy. But the effects of arts-sector spending are felt throughout the economy. Revenues are earned by those companies and industries which supply the arts sector; they include general suppliers such as those who provide food and drink to theatres and halls for their catering requirements and goods for resale in museum shops. Others are specialist suppliers, for example, lighting companies and providers of post-production facilities in the film business, advertisers, effects suppliers, costume makers and maintainers in the theatre; shippers and conservators in museums and galleries. The 1986 *British Theatre Directory* listed several hundred specialist commercial suppliers of goods and services to the theatre alone in 53 different categories.

In addition to the specific support for specialist suppliers, the effect of spending by the arts sector has general economic repercussions as it percolates throughout the economy. Payments to suppliers and employees and other outgoings are spent and respent as money changes hands with each successive round of expenditure in the economy. The process of generating additional income and employment from an initial injection of purchasing power into the economy is known as the multiplier effect. From a national point of view, the size of the multiplier depends on the links between the arts sector and rest of the economy, the scale of spending at the various stages within the economy and the need for imports. This is discussed in more detail in Section 6 where it is examined from a regional perspective in the light of the results of the regional case studies. As a matter of interest, these results give some confirmation to the conclusions of S. Medlik in relation to tourism. The arts sector might be thought to have some characteristics in common with tourism. According to Medlik, 'estimates for the United Kingdom suggest multiplier values of direct tourist expenditure in the region of 1.7 indicating that each £1,000 spent by tourists ultimately generates £1,700 of spending in the economy as a whole' (see Medlik). The arts are probably no more dependent on imports than tourism, put by Medlik at '10 per cent, a significantly lower proportion than goes into producing most manufacturing output'. With an income multiplier of 1.7, total incomes due to the arts in Britain would have approximated to £17 billion in 1985. The question of the multiplier effect on jobs is examined later in this section.

(b) *Spin-off and inputs into other industries.*
It was explained above that the borderline between the fine arts and design-based industries is difficult to draw. The arts are a source of ideas, stimulus, expertise and trained personnel for many of the applied arts, such as fashion design, graphic design, printing and photography. The arts have an input into retailing (window dressing), catering (hotel pianists) and marketing (theatrical sales presentations), not to mention religion (church music) and defence (military music). New design applications have arisen through advanced technology in computer software and animation. There is also a deeper synergy between creative activity in the arts and other forms of creative thinking in industry and high technology. This is a difficult area to illuminate and quantify. Some indications of the wider economic role of the arts can be gained from looking at the industries in which people with 'artistic and literally occupations' are employed. Table 3.14 shows that of the 189,960 people enumerated by the 1981 census in 'literary and artistic occupations' only 34 per cent (63,920) were employed in arts industries. The majority of employment in most of these occupations was outside the arts, in retailing, catering, manufacturing, and newspaper and magazine publishing. Only 'actors, musicians, entertainers and stage managers' found the majority of their jobs (77 per cent) within the arts, though a large minority (23 per cent) was still employed in other industries.

Table 3.14 Industrial employment of people with literary and artistic occupations, 1981 (a)

Numbers

	Arts sector (b)	Other industries	Total
Actors musicians, entertainers and stage managers	35,000	10,460	45,460
Artists, commercial artists, designers, window dressers	13,390	45,420	58,860
Photographers, cameramen, sound and vision equipment operators	6,610	26,210	32,820
Authors, writers, journalists	8,920	43,900	52,820
Total	63,920	126,040	189,960

Source: *Facts 2*, based on special tabulation of 10 per cent economic activity sample of 1981 Census of Population.
(a) Excludes unemployed; includes self-employed.
(b) These were, according to the Standard Industrial Classification, 'libraries, museums and art galleries', 'authors, music composers and other own account artists', 'radio and television services, theatres etc' and 'film production, exhibition and distribution'.

Earnings of performing and creative artists

(a) *Performers*

Great complexities surround the earnings of individual creative and performing artists. But it is worth giving some rough indication of their standing in the arts sector. A 1978 study showed that only 54 per cent of actors' work was in the theatre, with 19 per cent in the mechanical media and the remainder in clubs and other activities (see *Facts 1*). Some 12 per cent of musicians' work was in the mechanical media, 14 per cent in concerts, 17 per cent in the theatre, with 52 per cent in clubs, hotels and dance halls. Very rough estimates of total payments to performers for live appearances (in concerts and on stage etc) and from the mechanical media are set out in Table 3.15). Whereas for stage artists the bulk of the work was in the live theatre, most of the money came from the mechanical media. Recording royalties were the main source of income for popular musicians and their backup teams. For other musicians, the principlal earnings came from live performance, with broadcasting engagements and recordings providing a useful supplement.

Table 3.15 Earnings of performing artists by category of work

£ million

	Actors/dancers	Musicians
Live appearances (a)	44 (b)	51 (c)
Broadcasting engagements	58 (d)	7 (e)
Film, video	51 (f)	..
Recording	—	281 (g)
	153	339

Source: ITCA; Association of Independent Radio Contractors; Musicians' Union; Actors' Equity; British Phonographic Performance Ltd; *Facts 2*.
(a) Including earnings from overseas.

See further notes overleaf.

(b) Estimated as 22 per cent of turnover of producing theatres plus 60 per cent of turnover of theatre companies.

(c) Orchestral players, classical solo artists, ensembles and jazz, pop and rock musicians; excluding military bandsmen.

(d) BBC £22.4 million related mainly to TV appearances (£14.1 million for first engagements); ITV £35.3 million.

(e) Excludes BBC houses orchestras which are included under live appearances; BBC £1.2 million; ITV £3.8 million; ILR £1.9 million.

(f) All artists fees; estimated from industry turnover by applying fee-proportion established in survey of Glasgow independent film and video companies; includes fees paid to overseas artists.

(g) Mainly royalties paid to popular performers: public performance £2 million; sales in British market £51 million (estimated as standard 13 per cent royalty on sales of top 100 singles with UK artists — 19 per cent of total — in British charts); and overseas sales £228 million (see Appendix 4).

(b) Composers and writers.

Similarly, creative artists relied on diverse sources of income. Composers in particular received earnings from a very varied exploitation of their output. Estimates of the earnings of composers, song writers and creators of musico-dramatic works, totalling £123 million, are set out in Table 3.16. Live performance was a significant source of earnings at £23 million, but earnings from recordings formed 73 per cent of the total. The remainder came from the sale of printed material and a small amount from direct commissions.

Table 3.16 Earnings of composers, song writers and creators of musico-dramatic works

	£ million
Performance	
Performing Right Society	23
Musico-dramatic works	10
Mechanical rights	
Recordings sold in UK	26
Recordings sold overseas	71
Publishing, commissions	
Printed materials	3
Commissions	\emptyset
Total	134

Source: PRS; MCPS; BPI; Music Publishers' Association; *Facts 2.*

Writers lack the collecting societies which serve composers and so information about their earnings is much less adequate (see Table 3.17). Royalties from the sale of books by UK publishers were estimated at £31 million in 1984 and a similar figure (£30 million) represented payments to writers from the broadcasting companies. Overseas earnings, grants and prizes and payments under the Public Lending Right made up the remainder. Dramatic works were included under composers.

(c) Artists and crafts people

Average earnings of full-time crafts people were estimated at £2,854 in the 1981 Crafts Council survey of England and Wales (see Bruce). This can be compared with the equivalent figure of £5,900 in the Ipswich case study for 1986. The part-time figures were £643 and £1,240 respectively. This implies a total of £51 million for the net earnings of the craft enterprises in England

and Wales. In Scotland, with a broader definition of crafts, the turnover of the sector was estimated at £39 million in 1986, of which an estimated £20 million was retained as earnings by the craft workers.

The value of purchases of new art was estimated at £15 million in 1980 (source BBC). The average turnover of galleries dealing in new art in Glasgow was put at £110,000. An estimated 200 galleries in Britain would imply a total turnover of £22 million, with earnings to artists of £13 million. According to the Ipswich survey, artists received 59 per cent of earnings through galleries, 30 per cent from commissions and 11 per cent from direct sales. The overall income for artists from UK sales might be estimated at £22 million in relation to a total art market of upwards of £30 million. The net earnings of full-time artists in the Ipswich region were estimated at £6,000 in 1986, with part-livelihood artists receiving £581. Grants and prizes would add no more than an extra £1 million to artists' earnings overall.

Table 3.17 Earnings of writers

	£ million
Royalties	
UK publishers	31 (a)
Overseas publishers	11 (b)
Public Lending Right	2
Grants and prizes	1 (c)
Broadcasting	30 (d)
Film rights	..
Total (e)	75

Source: ITCA; BBC; *Facts 2.*
(a) Royalties from books of all kinds; the Writers' Guild put earnings at £7.2 million in 1982/83; fiction represented 26 per cent of new titles.
(b) Estimated as one fifth of total receipts from foreign rights by publishers.
(c) Prizes amounted to £200,000.
(d) BBC £10.7 million; ITCA £19.5 million.
(e) Dramatic works are included under composers; see Table 3.15.

Employment in the arts

(a) *Estimates are crude and affected by choice of definitions*
Official employment statistics about the arts relate to a range of activities defined as arts industries in the Standard Industrial Classification (SIC). These are identified as:

— libraries, museums and galleries;
— authors, music composers and other own-account artists;
— radio and television services, theatres, etc;
— film production, exhibition and distribution.

The categories more or less coincide with the areas described in this report as 'arts events and attractions' and 'mechanical performance'. The inclusion of libraries alongside museums and galleries is the main deviation from the definitions used here. One problem with the categories is that they are somewhat general and do not adequately reflect the detailed structure of the industry. By combining sectors such as television and the theatre they make the necessary detailed analysis impossible.

THE ECONOMIC IMPORTANCE OF THE ARTS IN BRITAIN

Employment in the arts covers professional artists — those who are performers in the arts or are otherwise directly involved in artistic creation — and it also refers to the large number of administrators, technical and support workers associated with the arts and whose employment is an integral part of the arts sector. As explained previously, many with 'literary and artistic occupations' were engaged in industries other than the arts, such as catering and retailing.

A full discussion of the strengths and weaknesses of employment statistics in the arts can be bound in *Facts About the Arts 2*. A brief summary of some of the main difficulties is appropriate here. The only comprehensive measure of employment on both an occupational and an industry basis is the decennial Census of Population, but these figures tend to go quickly out of date. Since the Census also defines a person's occupation as the most recent held at the time of the Census, it does not provide reliable statistics in areas of work such as the arts which are characterised by double-job holding and short-time, casual and seasonal employment. The resulting figures almost certainly underestimate the numbers in 'literary and artistic occupations'. The chief source of official statistics on employment is the triennial Census of Employment. This is based on returns from employers and so does not record the numbers of self-employed people. This is a particular problem when a high level of self–employment is characteristic of literary and artistic occupations. The Census of Population does record the self–employed and the 1981 Census showed that 29 per cent of those with 'literary and artistic occupations' were self-employed, including 56 per cent of musicians and 38 per cent of 'actors, entertainers, singers and stage managers' (see *Facts 2*). Some salaried regular positions are available in the arts, for example, in the contract orchestras and opera houses, but short–contract and part-time engagements are the main characteristics of work in the performing professions. There is also heavy reliance on income supplementation, mainly from teaching, especially in the visual arts. As explained above, this irregular pattern of work is matched by a varying array of income sources. In view of the limitations of the available data and techniques of measurement, all estimates of arts employment must be regarded as relatively crude indications.

(b) *In 1981 450,000 direct jobs in arts sector*

In 1981, the year of the most recent Census of Population, the level of direct employment due to the arts was some 450,000 jobs. The details are set out in Table 3.18. Some 192,000 were employed in providing performances (live and mechanical) and manning arts attractions. Of these 51,000 worked as, or for, authors, music composers, artists and other own-account artists.

The manufacture of cultural products (books, records, etc.) occupied an estimated 99,000 people. Thus, that part of the economy which had the function of devising and supplying artistic ideas and experiences to the public, the arts sector as defined in this report, directly employed 291,000 people.

It is also relevant to consider two other related categories of employment. First, the arts-specific proportion of spending on refreshments, travel, accommodation etc. by those attending arts events and attractions generated an estimated further 96,000 direct jobs. The basis for this estimation is given in Section 4 below. Second, a number of individuals held 'literary and artistic occupations' in industries other than the areas considered in this report. The overall total for people employed in artistic and literary occupations was 189,960 (see *Facts 2*). Some 64,000 were engaged in the SIC arts industries. Perhaps, half the remainder worked on the manufacture of cultural products, leaving some 63,000 employed outside the arts sector. Those with non-literary and artistic occupations working in the arts industries or in ancillary areas numbered 260,000. None of these figures include teachers of music, dance, drama and art.

(c) *Some sectoral details.*

For the reasons explained above, official employment statistics give little detail on the numbers of individuals engaged in different sectors of the arts. The difficulties of measuring irregular and part-

time work and self employment, which characterises many sectors of the arts, are virtually insurmountable. The picture of employment can be filled out with a few details either obtained during the course of this study or taken from published sources (see *Facts 2*). As for the museums and galleries, it is estimated that they employed some 19,000 individuals, 5,000 in the national museums and galleries (see *Facts 2*), 7,000 in the local authority facilities and 6–7,000 in other museums. The producing theatres employed an estimated annual average of 8,000 people; theatrical venues some 8-10,000; arts centres alone employed some 4,000 (see *Arts Centres UK*); and the companies were roughly estimated at 7-10,000 with opera and dance companies alone employing 4,500. The overall figure for theatre was thus 25-30,000.

Table 3.18 Employment in the arts, 1981

	Thousands
Arts events and attractions	
Libraries, museums and galleries	56.3
Authors, music composers and other own-account artists	51.1
Radio and television services, theatre etc	65.7
Film production, exhibition and distribution	19.1
Sub-total	192.2
Cultural products (a)	
Recording industry	8.9
Publishing and printing books	46.6
Art trade	10.8
Crafts	32.8
Sub-total	99.1
Ancillary spending (b)	96.0
Those with literary and artistic occupations in other industries	63.0
All in employment	450.3

Source: Census of Population: PSI; BPI; *Business Monitor.*
(a) Figures relate variously to 1984, 1985 and 1985/86.
(b) Figures relate to 1986.

No figure exists for the number of actors and dancers. The membership of Actors' Equity was 32,000 in 1984; perhaps half were full-time performers. There were some 2,000 individuals employed in running the specialist concert halls. The 22 principal orchestras had 1,714 playing members. The Musicians' Union estimated the session musicians at 750 (650 in London and 100 elsewhere); engagements in theatres, hotels, dance bands, holiday camps gave work to an estimated 1,250 individuals; thus, the number of full-time players may have been about 4,000. This does not take account of 3,222 military bandsmen and thousands of jazz, pop, rock musicians with varying levels of success and interest in regular work. The membership of the Musicians Union totalled 39,000 in 1984.

Broadcasting was the biggest sub-sector, with direct employees numbering 48,995; 26,557 were in the BBC with a further 4,981 responsible for external services; the figure for ITV of 17,497 covered the contracting companies, Channel 4, TV AM, Independent Television News, Independent

Local Radio, the IBA itself and the provision of other central services (see Peacock Report). The *Business Monitor* published a figure for jobs in cinemas of 9,706 for 1984. If this is subtracted from the Census of Employment's estimate of employees in 'film production, exhibition and distribution', the jobs in production would appear to have been upwards of 18,000.

Creative artists are the most difficult of all to enumerate. First, the Mechanical Copyright Protection Society had 6,000 registered composers and song writers in 1984; the Performing Rights Society collects on behalf of 13,000 UK resident composers and authors; the membership of the Composers' Guild was 500 in 1984. Over 11,000 authors were registered with the Public Lending Right in 1985; some 13 per cent of them were authors of fiction and children's books. The current membership of the Society of Authors is towards 4,400 and of the Writers' Guild 1,700. The best guess for the number of visual artists implies a figure of 23,000 for practising artists, of whom some 6-8,000 might be full-timers. Crafts people in England and Wales numbered 20,000 in 1980 according to the Crafts Council report, including 7,000 full-timers, 8,000 part-timers and 5,000 others. Crafts people and enterprises in Scotland totalled 3,000 in 1984, employing some 15,000.

(d) *Between 1981 and 1986 23 per cent extra jobs*
A previous study suggested that job growth in the arts was already strong in the 1970s (see *Facts 2*). The decade 1971-81 saw a 45 per cent increase in the number of actors, musicians, entertainers and stage managers, and an 8 per cent increase in authors, writers and journalists. The latest data from the Department of Employment show that the growth has continued and even accelerated to the present day. As explained above, the Department of Employment figures (consisting of a quarterly sample survey revised every three years on the basis of the full Census of Employment) exclude self-employment, but the upward trend is unmistakable. The details are given in Table 3.19. They show that the numbers employed in the SIC arts industries increased by 23 per cent from 1981 to 1986. Some 36,000 extra jobs were created during that period. Almost half of the jobs (17,000) were in museums, art galleries and libraries, which experienced a 20 per cent increase in employment. The fastest growing sector was the heterogeneous category, 'film production, authors, composers and artists', which expanded by 49 per cent during the same period. This probably reflected the rapid development of independent film and video production. Some 10,700 extra jobs were created in 'theatre, radio and television etc', an increase of 16 per cent. It hardly needs saying that these substantial increases represent an exceptional achievement for the arts sector in relation to overall trends in the national economy. The quality of extra jobs in the arts was also distinctive, in that few were part-time and men shared in the growth equally with women. Elsewhere in the economy, the major increase has been in part-time and female employment. Of the new jobs in the arts, 18,700 were for men with 17,100 for women, of which only 1,100 were part-time posts. These were concentrated in museums, art galleries and libraries.

Table 3.19 Employment in the arts

Thousands and percentages

	1981 (thousands)	1986 (thousands)	Gain 1981-86 (thousands)	Percentage gain
All employees				
Libraries, museums and art galleries	57.1	68.5	17.4	20
Film production, exhibition, authors, composers, artists	27.7	41.2	13.5	49
Radio, television, theatres etc	68.5	79.2	10.7	16
Total	153.3	188.9	35.6	23
Males	73.4	92.1	18.7	25
Females	79.7	96.8	17.1	21
Part-time females	34.1	35.2	1.1	3

Source: Department of Employment.

(e) *Jobs expected to reach 550,000 by 1990*

It would seem very unlikely that self-employment in literary and artistic occupations has declined since 1981 when it lay at 60,720 (see *Facts 2*). Assuming that it has remained at the same level, the total employed labour force in the arts might have already reached an estimated 486,000 in 1987; a small increase in self-employment since 1981 would ensure that the figure had already topped 500,000. If the present trend continues, a total of 550,000 jobs in the arts sector as a whole by the end of decade is a realistic proposition.

(f) *Jobs in the arts amount to 2.1 per cent of employed population.*

The employed labour force (employees and self-employed, excluding the unemployed) was roughly 24 million people in 1984. The total direct employment arising from the arts in Britain of 486,000 in the mid-1980s accounted for 2.1 per cent of the total employed population. The 291,000 jobs in arts events and attractions (live and mechanical) and making cultural products accounted for 1.2 per cent of total employment. If the employment is compared with the total turnover of the sector, it can be seen that each direct job in the arts sector was supported by some £22,000 of spending. Each job in the manufacture of cultural products was supported by some £36,000; for events and attractions and mechanical performance the figure fell to £19,000. The figure for cultural products is probably artificially high because it excludes employment in the retailing of books and records and the employment of artists in the recording industry and art trade. For events and attractions alone the figure is very roughly estimated at £16,000 per job. Medlik has pointed recently to the fact that each job in tourism is supported by £14,000 of tourist expenditure, somewhat below the national average of £16,000 spending for each job in the economy (see Medlik). He commented that 'the knowledge that each direct job in tourism in 1983 called for £14,000 of expenditure is of significance because additional spending supports additional jobs. Once spare capacity is used up, the question of how much additional spending is required to support a new job becomes of major importance in assessing the prospects of the tourist industry as a generator of employment'. A similar lesson applies to the arts. The related question of the marginal cost to the public purse of increasing jobs in the arts sector is examined in Section 7 below.

(g) *Multiplier effect on jobs*

As with income, direct jobs are only part of the total contribution to employment from the arts sector. Indirect employment arises amongst suppliers of the arts sector in the rest of the economy. The scale of the multiplier effect depends on the relationship of the arts sector to the rest of the economy. The incremental multipliers calculated in the three regional case studies showed that for each job in an arts organisation the spending of that organisation sustained between one third and one half of a job elsewhere in the regional economy. The effect is larger for the economy as a whole. Ancillary spending by arts customers had a lower multiplier effect and for every direct job generated by the spending of cultural visitors a further one-tenth to one-quarter of a job arose elsewhere. No co-efficients are available for the multiplier effect of the cultural industries. It is not relevant to consider the multiplier effect of artists employed in other industries. Thus, over and above direct jobs, indirect employment arising from the arts sector in broad terms can be estimated at 175,000 jobs. This brings the total employment in, and arising from, the arts sector to 671,000 jobs or 2.8 per cent of the employed population. These estimates do not include jobs generated as part of capital spending on new buildings and facilities.

Financing the arts

(a) *Public funds account for 18 per cent of the sector's overall income*

The arts sector, which is sometimes thought of as a predominantly subsidised area, draws on more than one source of support for its finance. These fall broadly into three categories: income from the sale of goods and services (box office revenue, fees, receipts from other trading, the sale of items and the provision of advertising); public finance in the form of grant-aid from central

government and local authorities (in which might be included the revenue for broadcasting from the payment of statutory licence fees); and private subsidy from individuals and organisations, foundations and business corporations. In terms of the arts sector overall, 81 per cent of income arose from sales, 18 per cent from public expenditure and as little as 1 per cent from private subsidy in 1984/85 (see Table 3.20). This sets public subsidy in a wider context.

Table 3.20 Financing the arts, 1984/85 (a)

	Sales	Public contributions (b)	Private contributions	Total (c)
Income (£ million)				
Museums and galleries	23	189	18	230
Theatres and concerts	329	262	25	616
Mechanical performance	2,000	824 (d)	—	2,824
Cultural products	3,641	24 (e)	9	3,674
Total	5,993	1,299	52	7,344
Percentages				
Museums and galleries	10	81	9	100
Theatres and concerts	55	40	4	100
Mechanical performance	71	29	—	100
Cultural products	99	1	Ø	100
Total	81	18	1	100

Source: PSI
(a) Or nearest equivalent year for which figures were available.
(b) Excluding contribution to libraries, training, education and heritage.
(c) Revenue income only.
(d) Of which £723 million was from licence fees.
(e) Including £9 million spent on arts-related small businesses through Enterprise Allowances.

The pattern of finance was different for each sub-sector of the arts. Cultural products were most dependent on sales. A small amount of grant aid (amounting to less than 1 per cent of total finance of the sector) was given to the crafts, the visual arts and to literature. Public finance played a more important part in mechanical performance. This took the form of licence fee revenue which was the main source for the BBC, together with a grant from the Foreign and Commonwealth Office for operating the overseas service. In addition, central government gave some support to film production and the development of film culture, mainly by means of a grant to the British Film Institute. The sum at around £10 million seemed slight in relation to a film, video and cinema industry with a turnover of £554 million. Sales in broadcasting mainly took the form of advertising-time on commercial television and radio.

For events and attractions, public funding was the most important source of income at 51 per cent of the total. Sales were also significant at 43 per cent. Private funding, sponsorship and donations,

made up the difference. The financial picture for museums and galleries was rather different from that of theatres and concerts. Museums and galleries relied to a greater extent on public sources which supplied some four-fifths of the necessary income. Central government alone gave some 54 per cent, with local authorities contributing 27 per cent. Rather more was earned from sales (about 10 per cent) than from private sponsorship and donations. Sales were much more important to theatres and concerts where they represented some 54 per cent of income. The share of government support (central and local) was 40 per cent with the rest in the form of private sponsorship and donations. As indicated above, these proportions differed greatly for various aspects of the arts and for the individual organisations involved. Arts events and attractions as defined here also included commercial and independent elements, especially popular music and theatrical entertainment, but also a number of commercial museums. Some of the inter-connection and cross-financing between the commercial and non-commercial sectors is described below in Section 7.

(b) *Public funding*

Public revenue expenditure on the arts amounted to roughly £450 million in 1984/85. The figure differs from some previous estimates because, among other things, it includes contributions from central government departments which do not carry the main responsibility for the arts, such as the Ministry of Defence spending on military music, Department of Employment special employment measures including arts-related community and voluntary programmes (£21 million) and Department of Education and Science spending on museums. The data on capital spending are poor; it would appear that central government spent £12 million on museums and gallery buildings in 1983/84; local authorities contributed £45 million, including revenue contributions to capital (mainly debt charges at £27 million) and £18 million on museum and gallery projects; figures are not separately identified for local authority capital spending on theatres and concert halls (see *Facts 2*). Rather more of the revenue spending was contributed by central government at £255 million, compared with £185 million by local authorities, or £157 million excluding debt charges. These detailed figures relate to 1983/84; equivalent figures for subsequent years are not available.

Public expenditure on the arts has increased substantially over the last 20 years, but the contribution of the local authorities has recently been growing faster than that of central government. There is a long tradition behind direct local authority support for museums and galleries. Some £67 million (excluding debt charges) were spent on museums and galleries in 1983/84 (see *Facts 2*). Spending on the live arts is a more recent development and its share has been increasing. Since neither this nor support for museums is a statutory responsibility, the commitments are uneven across the country. Much of the spending went on providing and operating theatres, halls and arts centres (£75 million), but a growing number of local authorities were making grants and contributions to independent arts organisations (£35 million).

With regard to museums and galleries, the national collections were supported from central government funds, whilst the local authorities assumed full responsibility for their own museums. Some central government grants were administered by the Museums and Galleries Commission. Such specialised allocation of responsibility between central government and the local authorities does not apply for theatres and concerts where public funding was obtained from all possible sources, central government (via the Arts Councils and regional arts associations) and from local authorities. Public subsidies as a rule did not go to commercial organisations. They were generally directed at subsidising artists and arts organisations, the producers of artistic ideas and experiences. No subsidies were given directly to consumers, though from time to time voucher schemes have been discussed (see West for a critical discussion of these issues in the public funding of the arts).

Central government finance is mainly made available to the arts through the Office of Arts and Libraries (OAL) which was given independent status as a 'mini-ministry' in 1983. Funds for the national museums and galleries are administered directly by the OAL; the grants for the arts are

filtered through such organisation as the Arts Council of Great Britain (ACGB), the British Film Institute (BFI) and the Crafts Council (CC), set up as buffers between government and individual arts organisations. The funds going to theatres and concerts and the live arts (£112 million) were somewhat greater than the £92 million given to museums and galleries in 1984/85, but the museums and galleries share has been growing. A number of other governmental departments give support to the arts, including the Scottish Education Department, responsible for funding the national museums of Scotland, with a similar role for the Welsh office in Wales, not to mention funds for the arts made available through the Department of the Environment and the Ministry of Defence. The regional arts associations are independent organisations receiving the bulk of their funding from the national bodies, mainly ACGB, with smaller grants from BFI and CC. They have a growing role in devising regional policies and in co-ordinating arts funding between the central agencies and the local authorities.

(c) *Private funding in a changed climate*
The arts have not escaped the change in political climate with the reaction against bureaucracy and a more stringent attitude toward public expenditure. This has meant growing emphasis on plural funding, the need to use a variety of sources for supporting the arts, in which public expenditure can complement more private, particularly commercial contributions (see Myerscough). There are no comprehensive figures on private giving to the arts, though all are agreed that it has been expanding, especially sponsorship. The Association for Business Sponsorship of the Arts (ABSA) estimated sponsorship at £25 million in 1986; no figure is available for private donations, though the rise of successful organisations of 'friends' has generated significant sources of income. An important distinction must be drawn between business sponsorship and patronage (by private individuals or corporations). Business sponsorship is designed to benefit the giver as well as the recipient. Patronage implies the equivalent of a private gift, with no expectation of a direct or indirect private return. In sponsorship the recipient organisation provides some benefit, usually in the form of a promotional or marketing facility. In practice, the distinction is not always clearly observed, and many companies give to the arts for a combination of motives. For this reason the ABSA figures on sponsorship most probably include an element of donations.

(d) *Regional studies show that donations remain important*
Exact figures were collected on donations and sponsorship in the three study regions. The totals are set out in Table 3.21. It shows that sponsorship was a modest source of income to museums and galleries; overall, donations remained more important than sponsorship. Most probably sponsorship had greater relative importance in London than elsewhere, but it would be difficult to conclude that donations were currently running at a lower level than sponsorship. A total of £40-50 million for both streams of private support would therefore appear to be reasonable.

Table 3.21 Sponsorship and donations in the three study regions (a)

£ thousand

	Donations	Sponsorship	Total
Museums and galleries	275	91	366
Theatres and concerts	841	704	1,545
Total	1,116	795	1,911

Source: PSI.
(a) Glasgow, Merseyside and Ipswich.

Detailed figures on the aspects of the arts which attract sponsorship are only available in Scotland. They show that sponsorship went overwhelmingly to the opera and dance companies, the Scottish

National Orchestra and festivals in 1983/84 (see *Facts 2*). But the evidence of the Business Sponsorship Incentive Scheme (BSIS) shows that business sponsorship is now reaching many less conventional areas of the arts. Section 9 examines the rise of business sponsorship and the motives of businesses for involvement in the arts. The vigorous campaigns by ABSA (with all party-support) and the government incentive scheme (BSIS) have played an important part. The development of private funding has been significant in widening the choice of support for the arts and ensuring, as one person has put it, that 'the scope is not unduly limited by the commercial considerations of the box office and private sponsors on the one hand and the political objectives of public funding on the other' (see Nissel).

(e) *Sales the main motor*
Sponsorship is part of a process in which the arts have, to a small but significant degree, become less dependent on government for their survival. Making use of private resources was part of this but, equally, expanding sales, developing box office earnings and revenue from other sources had an important part to play. The most recent analysis of trends in the different sources of income for the arts showed that between 1980/81 and 1984/85 central government spending grew by 40 per cent at current prices, compared with sponsorship expanding, admittedly from a low level, by 127 per cent, local authority support increasing by 100 per cent (1979/80–1983/4), and box office income rising for a range of organisations by between 55 and 86 per cent (see *Facts 2*). The same study examined trends in the income of the English and Scottish producing theatres and the contract orchestras between 1981/82 and 1983/84. The analysis showed that, whereas income overall grew by 29 per cent, the contributions from central government rose by 21 per cent and private contributions by 15 per cent. Local-authority finance expanded by 33 per cent, but the growth of activity in these organisations was mainly attributable to the fact that the largest single source of their income (the box office and other trading) was also the fastest growing source, expanding by 34 per cent in the three-year period. This meant that the role of public finance in relation to this particular sector of the arts was reduced. There is every reason to believe that these trends have continued since 1983/84 and they mean that the balance of funding was shifting strongly from central government towards the local authorities, but also from public funding towards private finance, especially in the form of sales. In this particular example, sponsorship and donations were not the most rapidly expanding source of finance.

CONCLUSIONS

This section examined the economic weight of the arts, together with their organisational structure and methods of finance. The main conclusion is that the arts formed a significant economic sector in their own right, with a turnover of £10 billion. This amounted to 2.5 per cent of all spending in goods and services by UK residents and foreign buyers, and was comparable to the market for cars, motorcycles and other vehicles.

Within the sector, arts events and attractions (museums and galleries, theatres and concerts) at 8 per cent of total turnover were overshadowed by the contribution of broadcasting and film (29 per cent) and the manufacture of cultural products such as books and records (36 per cent). Theatre was worth £422 million, concerts £194 million and museums and galleries £230 million.

A second conclusion is that the arts are a major export earner for Britain. The sector was very much oriented to overseas sales, which contributed 34 per cent to the turnover of the sector, compared with the 27 per cent of British manufacturing sales which are exported. The overseas earnings of the arts totalled £4 billion, representing 3 per cent of total export earnings. Some £3.2 billion were invisible earnings, royalties, fees from overseas appearances and spending by overseas tourists drawn to visit Britain because of the attractions of the arts. This meant that the arts were placed fourth among the top invisible export earners, below banking, shipping and travel, but above civil aviation and insurance. Theatre contributed well over £400 million and music over £500

million to the balance of payments, but most of the trade consisted of the sale of film or television material and royalties from the sale and broadcast of records. Cultural tourism brought in about one-third of the overseas earnings of the arts.

The overall conclusion on jobs was that the arts sector gave direct employment to some 486,000 of whom 228,000 were engaged in devising and supplying artistic ideas and experiences to the public, 99,000 were involved in making cultural products, a further 96,000 helped supply the essential catering, travel, retailing and accommodation which underpin visits to arts events and attractions, and some 63,000 people with literary and artistic occupation worked in productive areas other than the arts. The latter were part of the spin-off from the arts into allied industries, especially those which made use of a strong element of art and design, such as fashion and graphic design. The input of artistic ideas and people with artistic skills was also important in other areas, such as retailing (window dressing), accommodation (hotel pianists) and religion (church musicians).

The arts are a dynamic sector of the economy. They created some 23 per cent extra jobs between 1981 and 1986. Elsewhere in the economy the major increases had been in part-time and female employment. The extra arts-jobs were shared equally between men and women and less than one tenth of the extra jobs for women were part-time.

Seen in the perspective of the arts sector as a whole, public funding (including revenue for television from licence fees) accounted for some 18 per cent of income. Apart from the TV revenue, this concentrated heavily on museums and galleries and theatres and concerts, where much of the innovation and experimentation of the sector was carried out. The balance of funding was shifting from central government to the local authorities and from public funding towards private finance, with the growth of income from sales (box office etc) as the most important factor. The results of the three case studies suggested that donations may still be an equally important aspect of private funding as sponsorship, despite the latter's remarkable growth.

The large element of small businesses in the arts made it a seedbed for future growth. The small companies concentrated mainly in the areas of events and attractions. The scale of organisation in the theatre varied greatly from the Royal Opera House, with a turnover of £21 million in 1983/84, to the 125 companies in membership of the Independent Theatre Council with an average annual turnover of £63,000. The turnover of theatres in the main network of producing theatre averaged between £0.5 and £1 million.

A similar range in the scale of operations marked the museums and galleries. The individual facilities in the national museums and galleries averaged as much as £2.1 million in turnover, despite the existence of several small outstations. Some of the major metropolitan museums were larger than this, though the average of local authority museums was much lower at £108,000. The other museums, mainly small independent organisations, run by local enthusiasts, making heavy use of volunteer labour, were on average even smaller at £33,000. Arts and crafts enterprises were characteristically small, but had great potential for moving towards higher value-added operation in batch production or manufacturing.

It was in the small performing groups and companies where much experimentation and research was undertaken. Research and development was one reason why the work of the small companies depended more heavily on public subsidy than other areas in the arts.

PART II: THE ARTS AS A PRIME MAGNET TO PEOPLE

the Sponsers

4. THE CUSTOMER EFFECT

Part I of this report presented an economic profile of the arts sector. It was concerned to describe the market for the arts and to establish the size of the arts sector as a prime source of income and employment in the British economy. But the arts have extra economic effects, which arise from their role as a magnet for people and through the stimulus they give to parallel industries, especially from the impact of spending by those attending arts events and attractions. What arts customers spend on food and drink, shopping, accommodation and other purchases represents an injection of purchasing power into the regional and national economy. This secondary economic contribution of the arts might be called the customer effect, and the main task of this section is to examine its importance. Another aspect of the customer effect is its contribution to the vitality and attraction of places where arts venues can be found, especially city centres. This has implications for the quality of inner–city life and for regional development which are examined briefly towards the end of the section.

What do arts customers spend?

It is estimated that people attending museums and galleries, theatres and concerts spent a total of £4,033 million in 1985/86. Spending in businesses such as restaurants, shops and hotels, excluding the arts venues visited, gave rise to an estimated 190,000 direct and indirect jobs. The figures cover all visits and trips which involved attending an arts event or attraction. Of course, not all such spending was eligible to be counted as induced by the arts, because the trips of some attenders were not wholly or specifically undertaken for cultural reasons. A method is outlined below for judging the influence of the arts on such trips. The conclusion is that purchases worth £2,735 million were induced specifically by the arts, 68 per cent of the total, and this gave rise to some 130,000 jobs in the national economy. The rest represented spending which would have occurred irrespective of the existence of arts events and attractions.

(a) *Survey methods for estimating the customer effect*
Good information on consumer spending is not easy to obtain. The method chosen was personal interviews of the attenders, which were undertaken by the British Market Research Bureau, at a representative sample of arts events and attractions in the various study areas. Interviews at museums and galleries were conducted with people as they left. For theatre and concert goers the interviews were done by telephone within three days following an initial contact made in the theatre or concert hall. Sampling and weighting procedures and other aspects of the methods employed are described in the appendices of the three regional reports. Some 3,145 interviews were carried out in the Glasgow, Merseyside and Ipswich regions. Similar information was collected in an additional survey (807 interviews) of overseas tourists in London. This was a particular focus of the study and information on London was also an essential ingredient in the national picture. Resources were not available for a full study of London, but a further small survey of London residents, day visitors and British tourists attending arts events and attractions was undertaken to obtain a very rough indication of the level of spending in the capital. But the sample (255 interviews) was very small (see Appendix I for a description of the methods employed).

Two drawbacks which attach to all surveys of spending should be noted: the problem of exaggerated claims and the difficulties of making accurate recall. One of the main reasons for using personal interviews as a method was to counteract the first problem. The interviewers were highly experienced at handling questions on spending. As for the problem of recall, interviews at museums and galleries were carried out before a visit was completed. Outlays made on the visit so far could be recollected with a reasonable degree of accuracy, but the anticipated spending during the rest of the visit (for example, on refreshments after leaving the museum) required an element of prediction on the part of the respondents which could have led to some inaccuracies. The telephone interviews used for theatre and concert visits had the advantage that they could record

actual expenditures after completion of the visit. The problem here was the accurate recall of financial outlays made up to three days previously.

The intention was to measure outlays by individual respondents on purchases made in the context of a particular completed visit. Where the expenditure related to a party, say a taxi shared by a party of two, the interviewer divided the expenditure by the number of adults in the party to give a figure per head. Children were excluded from the survey and no people under the age of 16 were interviewed. Some allowance for expenditure by and on behalf of children was made in the grossing up procedure of the three regional case studies and this is described below. It was not feasible to make any allowance for children in the work on overseas tourists.

(b) *Coverage of the data*
The required information on spending was collected under a number of different headings: spending in the venue on admissions, programmes, refreshments, guidebooks, cards and souvenirs; food and drink bought nearby the venue before going in and after coming out; also, shopping purchases nearby before and after visiting the venues; travel within the region, mainly bus, rail and taxi fares, and parking; other spending (including visits to other attractions), food, drink, and shopping elsewhere in the region during the rest of the visit; and, for tourists only, spending on accommodation. Among the exclusions were the cost of travelling into the study regions and all spending on petrol. Certain categories of shopping and other spending were also excluded from the survey. The questions on shopping outlays were not asked of those respondents giving shopping as their main reason for being in the vicinity of the venue. By the same token, those residents living in the sub-region where they visited the arts venue were not questioned about what would have been essentially local shopping and other expenditures. The aim was to include only expenditures drawn into a particular sub–region by the presence of arts events and attractions.

(c) *Types of customers and the measures of spending*
In order to provide the means of evaluating the customer effect and to give a guide to likely future effects (see Section 6 below), it was necessary to divide arts customers into different types and to adopt a measure of spending which indicated the rate of spending and likely rate of future impact. The following approaches where adopted:

(i) Arts attenders (or customers) were first divided into residents and non-residents of the region where the study was being carried out. The non-residents were then divided into day visitors and tourists staying overnight. As is evident throughout the study, there were marked differences in the levels and patterns of spending related to the three categories of customers. A further sub-division with a bearing on spending was the distinction between museum and gallery going (mainly a daytime activity) and theatre and concert going (mainly an evening activity). This was a particularly relevant distinction for residents and day visitors. The spending implications of a visit to the theatre by a non-resident, typically coming in for the evening from the wider region, were likely to be different from the day visit to a museum.

(ii) Spending was measured as the average outlay per visit or trip day. In the case of residents and day visitors a visit was defined as the full period elapsing between leaving home or work and the return. The relevant period for tourists was 24 hours or the trip-day.

Average spending in three study areas

(a) *Residents*
The average amounts spent by the different types of arts customer in the three study areas are set out in Table 4.1. As a rule, visitors to a region spent more than residents (not taking into account outlays on travel into the region); and theatre and concert goers generally spent more than museum and gallery attenders. The average outlay by residents on museum and gallery visits was £8.85 compared with £9.59 for theatre and concert trips. But the amounts spent outside the

venues (excluding tickets, refreshments, souvenirs and other purchases made inside) were greater on museum and gallery visits at £7.36 than on theatre and concert trips at £4.39. Apart from differences in the level of spending, the patterns of outlay revealed some notable contrasts between day (museum and gallery) and evening (theatre and concerts) visits. Not surprisingly, those attending theatres and concerts spent virtually nothing (£0.08) on shopping nearby either before or after the event. But their spending on food and drink at £1.52 was higher than the £1.34 spent in the course of a museum and gallery visit.

Table 4.1 Spending by arts customers in three study regions: average per visit or trip day
(a)

£

	In venue (tickets, refreshments etc)	Shopping nearby	Food, drink nearby	Travel in region	Other spending	Accommodation	Total
Residents							
Museums & galleries	1.49	2.40	1.34	1.02	2.88	—	8.85
Theatres & concerts	5.20	0.08	1.52	1.05	1.74	—	9.59
Day visitors							
Museums & galleries	2.53	3.56	2.56	1.84	2.75	—	13.24
Theatres & concert	8.11	0.07	1.97	1.74	1.61	—	13.50
Tourists							
All	2.48	4.53	4.47	1.46	4.24	10.30	27.47
Glasgow overseas (b)	1.91	4.83	2.90	1.67	6.41	18.20	35.92

Sources: PSI.
(a) Average of Glasgow, Merseyside and Ipswich regions
(b) Excluding those tourists visiting friends and relatives.

(b) *Day visits*
Spending by day visitors was in one sense all gain to a region. Day visitors to museums and galleries were bigger spenders than residents. More was spent by them inside museums and galleries (an average of £2.53 compared with £1.49 by residents) and more was spent in shops, restaurants and on transport within the region (£10.71 compared with £7.45). In contrast, day visitors to theatres and concerts spent less outside the venue (£5.39) than museum and gallery goers (£10.71) and they spent little more than residents attending theatres and concerts (£4.39). It is worth noting that, according to the Glasgow case study, those visiting for a concert or a play (mainly driving from the Strathclyde region) spent much more on tickets, refreshments and other purchases within the venues (£8.11) than did residents (£5.20).

(c) *Tourists*
The high spending by tourists per trip day at £27.47 was to be expected. It is more surprising that the outlays were higher on shopping (£4.53) and food and drink (£4.47) and that they were lower on spending within the venues on tickets, refreshments etc. (£2.48) than the equivalent outlays by residents and day visitors. The average outlay on accommodation was £10.30. The large numbers of tourists staying free of charge with friends and relatives (VFRs) brought down the averages, especially in Glasgow. If VFRs are excluded from the calculations, average spending rose to £33.53. Spending by overseas tourists in Glasgow (excluding VFRs) was £35.92 per trip day. The average

outlay by Ipswich tourists, excluding those staying free of charge, was the highest in the three regions of the survey at £39.77.

Spending in London

(a) Spending generally higher in London
The equivalent figures for spending by arts customers in London are set out in Table 4.2. The estimated outlays by residents, day visitors and British tourists are based on a very small sample and are consequently subject to a wide margin of error. Spending by residents and day visitors was significantly higher in London than elsewhere, especially in the context of theatre and concert going. For example, London residents going to theatres and concerts spent an average of £17.69 compared with £9.59 in the three study areas elsewhere in Britain. The difference was less marked for museum and gallery visits and the outlays in London by day visitors to museums and galleries were actually lower at £11.70 than in the three study regions at £13.24.

Table 4.2 Spending by arts customers in London: average per visit or trip day (a)

£

	In venue (tickets, refreshments etc)	Shopping nearby	Food, drink nearby	Travel in region	Other spending	Accommodation	Total
Residents							
Museums & galleries	1.68	4.55	1.17	1.05	4.55	—	13.00
Theatres & concerts	9.75	1.05	3.64	1.25	2.00	—	17.69
Day visitors							
Museums & galleries	1.97	1.57	1.21	2.30	4.65	—	11.70
Theatres & concerts	12.08	0.96	1.88	3.42	1.41	—	19.72
Tourists							
British (museums only)	1.79	5.89	1.52	3.44	9.13	11.52	33.29
Overseas	7.84	2.92	3.46(b)	3.08	1.71	11.03	30.05

Source: PSI.
(a) Based on very small sample of the figures here a wide margin of error.
(b) Some 62 per cent bought food and drink with an average spent of £5.58

(b) Patterns of outlay similar in London and elsewhere
Though the level of spending on theatre and concert going in London was much higher than elsewhere, the patterns of outlay were remarkably similar. Table 4.3 shows that 55 per cent of the spending by residents in London took place in the venue, compared with 54 per cent elsewhere. The shares of day visitor outlays on the venues were 61 per cent in London and 60 per cent elsewhere. The main difference was related to spending on food and drink nearby the venues; London residents put 21 per cent of their total outlay into this, compared with 15 per cent spent by residents elsewhere. The reason was that a higher proportion of London residents (53 per cent) spent something on food than, say, the Glasgow residents (38 per cent); the average outlays on food were £6.89 by London and £5.71 by Glasgow residents respectively. Similarly, a higher proportion of London day visitors (37 per cent) spent something on food in comparison, say, with Glasgow day visitors (25 per cent). On the other hand, the average outlay by London day visitors was significantly lower at £4.74 than by day visitors elsewhere, for example, in Glasgow, where the

figure was £6.14. It seems to represent the difference between a snack in London and a meal elsewhere.

Table 4.3 Spending by theatre and concert goers: by region and type of spending

Percentages

	In venue	Food etc nearby	Other	Total
Residents				
London	55	21	24	100
Elsewhere (a)	54	15	31	100
Day visitors				
London	61	9	30	100
Elsewhere (a)	54	15	25	100

Source: PSI.
(a) Average of Glasgow, Merseyside and Ipswich.

(c) *European short-stay tourists biggest average daily spenders*
As for average tourist outlays, the London figures at £33.29 for British tourists (museum visitors only) and £30.05 for overseas visitors were higher than the figures for tourists elsewhere in Britain (£27.47). It was somewhat surprising that the difference between London and elsewhere was no greater. The spending by London's overseas tourists was brought down by the large number of long-stay European tourists (32 per cent of the total) for whom the average outlay was £21.36 in the summer and £20.42 in the winter. Generally they were young — some 75 per cent were aged 16-34 years — and many were staying with relatives. Table 4.4 shows the range of outlays by overseas tourists visiting arts attractions and events. The largest daily outlay was by European short-stay visitors in the autumn at £59.31, but summer visitors from North America spent as much as £55.55 per trip day. There may be a guide to policy in these two figures. The European autumn short-stays are a very small part of the market but they are ripe for expanding.

Table 4.4 Daily outlays of overseas arts tourists in London: by country of origin and time of year

£

	Accommodation	Other	Total
North America			
Summer	18.72	36.78	55.55
Autumn	11.21	15.45	26.66
Europe (long-stay)			
Summer	8.14	13.22	21.36
Autumn	8.06	12.41	20.47
Europe (short-stay) (a)			
Summer	20.80	23.60	44.40
Autumn	18.97	40.34	59.31
Rest of world			
Summer	10.00	26.68	36.68
Autumn	6.21	12.19	18.40

Source: PSI.
(a) Three nights or less.

What was the total customer effect?

As stated above, spending by people attending museums and galleries, theatres and concerts totalled an estimated £4,003 million in 1985/86. The estimate was prepared by combining summary information on average trip outlays for different categories of arts customer with national data on total attendances at arts events and attractions. The estimates for the three study regions and for the national picture should be considered separately.

(a) *Three study regions*

In the three study regions, total outlays by arts customers could be estimated with some degree of accuracy. To carry out the appropriate calculations, it was necessary to convert figures on attendance into numbers of completed trips. For residents it was assumed that multiple-visits (attending more than one similar type of venue) and cross-visits (museums and gallery goers attending the theatre and concerts and vice versa) were negligible within a single trip and so the number of trips was taken to be identical to the attendance. The surveys provided data on cross- and multiple-visits which formed the basis of the adjustment made to day visitor and tourist attendances within the same day. For tourists, further allowances were made for multiple- and cross–visits for the rest of their trip. The details of the method can be found in the case studies.

Some allowance was made for the place of children (under the age of 16 years) among arts attenders. The customer surveys showed that children were most numerous in museums and galleries. The results for Glasgow and Ipswich are summarised in Table 4.5. Almost a quarter of visits to museums and galleries by Glasgow residents would appear to have been made by children, and over a half in Ipswich. In calculating the financial outlay by arts customers it was assumed (somewhat arbitrarily in the absence of any direct survey information) that spending by and on behalf of children was 20 per cent below the equivalent adult outlays.

Table 4.5 Children as arts attenders in Glasgow and Ipswich

Percentages, numbers and percentages

	Percentage of parties with children		Children per party		Children as percentage of all attenders	
	Glasgow	Ipswich	Glasgow	Ipswich	Glasgow	Ipswich
Residents						
Museums & galleries	26	42	2.6	3.0	24	55
Theatres & concerts	9	13	2.2	3.6	7	17
Day visitors						
Museums & galleries	14	23	1.2	2.8	7	27
Theatres & concerts	11	7	2.7	2.0	10	3
Tourists						
Museums & galleries	31	18	1.5	3.1	17	24
Theatres & concerts	—	8	—	1.6	—	5

Source: PSI.

The results of the calculations for the three study regions are set out in Table 4.6. The figures show the over-riding importance of spending by tourists at between 60 and 70 per cent of the total. Spending by residents attending theatres and concerts and visiting museums and galleries represented 7 to 11 per cent. The remainder was accounted for by day visitors. The total customer effect

for the three regions amounted to £165 million, representing an injection of spending into the relevant regional economies greater than the turnover of the respective *core arts organisations* i.e. museums and galleries, concerts and theatres.

Table 4.6 Spending by arts customers: aggregate outlays by residents, day visitors and tourists in three study regions

£ million

	Glasgow	Merseyside	Ipswich	Total
Residents	23.65	15.80	3.28	42.73
Day visitors	8.55	5.51	1.87	15.93
Tourists	48.72	45.77	12.05	106.54
Total	80.90	67.08	17.20	165.20

Source: PSI.

(b) *National picture*

Similar procedures were followed for estimating the national outlay by people on trips which included visits to arts events and attractions. The figures for attendance were converted into numbers of completed trips and combined with estimates of average trip outlays. The spending data for London resulted from surveys which, with the exception of the information on overseas tourists, were based on very small samples. This is one of several reasons why the figures should be treated as very rough approximations. Another weakness relates to the use of data from the three study areas as the basis for estimating spending for the whole of Britain outside London. Average outlays and the split of arts customers into various types (residents, day visitors and tourists) were based on the results in Glasgow, Merseyside and the Ipswich regions, and they cannot be taken as anything other than a rough guide to the national picture outside London. The figure relating to overseas tourists outside London is the weakest part of the picture, being derived from general tourist numbers adjusted by reference to the survey results for overseas tourists in London. Furthermore, it was not possible to make any allowance for differential spending by and on behalf of children in the national calculations.

With these qualifications and cautions in mind, it is possible to approach the results set out in Table 4.7. The figure of £4,003 million includes spending in the venues on tickets, refreshments, programmes an souvenirs. It excludes spending on travel, except on local transport within the region, and it excludes petrol and other motoring charges, apart from parking and tolls. Residents attending events and attractions within their regions spent £628 million. Day visitors to a region accounted for £288 million: their average individual outlays were greater than those by residents but day visitors were less numerous as a group and so their total outlay was somewhat smaller than that of residents. Over three quarters of total spending was accounted for by tourists at £3,121 million, of which overseas tourists to London alone represented £1,802 million.

Finally, it should be remembered that these figures do not include customer spending related to cinema going or attending heritage attractions. Nor was it possible to make separate calculations for specialist tourism such as overseas visitors to London for the art trade and auction houses.

Deadweight expenditures

(a) *The problem and a proposed solution*

The numbers of jobs to which the spending by arts customers gave rise will be examined below. But it is necessary first to ask how much of the above £4 billion spending is eligible to be counted

as arts-induced. Some trips which included arts events and attractions were not made solely or mainly for cultural reasons. Spending on a business trip which incidentally included an opera visit could not be said to have been induced by the arts; the trip would have occurred anyway. How much spending generally was attributable to the arts and how much would have happened anyway as part of other shopping, pleasure or business trips is a question which applies equally to tourists, day visitors and to residents.

Table 4.7 Spending by arts customers in Britain: by residents, day visitors and tourists.

	£ million
Residents	
Museums & galleries	288
Theatres & concerts	340
Sub-total	628
Day visitors	
Museums & galleries	218
Theatres & concerts	70
Sub-total	288
Tourists	
British	950
Overseas	2,171 (a)
Sub-total	3,121
Total	4,037

Source: PSI.
(a) Of which £1,802 million was spending by overseas tourists visiting London.

The point was explored by means of the arts-customer surveys. Visitors to each region were asked how important museums, theatres and other cultural things were in their decision to visit the region. The same question was put to overseas tourists in relation to the decision to visit Britain. The replies were used as a basis for attributing spending specifically to the arts or not. The method was as follows. Spending by those who answered 'not a reason at all', even though they had visited an arts event or attraction, was excluded from further consideration. Spending by those replying that arts and cultural facilities were the 'sole reason' for their visit was wholly attributed to the arts. Finally, the outlays by those responding with answers between the extremes were attributed to the arts in graduated proportions; 30 per cent for those responding 'small importance'; 70 per cent for 'fairly important', and 90 per cent for those who replied 'very important'.

As an example of the method, responses to the questions by 'cultural tourists' in Glasgow are set out in Table 4.8, together with the calculation of the 'arts-specific proportion'. On the basis of the calculation, it can be argued that 78 per cent of visitor spending by 'cultural tourists' was specifically induced by the arts attractions in Glasgow. Some 22 per cent of spending represented the dead weight element, which would have occurred whether or not the arts events and attractions were available in the region.

A slightly different procedure was followed for residents. They were asked the hypothetical question what would they have done when planning their visit had they known that the particular arts venue they were visiting would have been closed. As an example of the results, the answers given to the question by Glasgow residents are set out in Table 4.9. The expenditures by those responding that

they would have 'done something completely different', that is 36 per cent of those visiting museums and 11 per cent of those attending theatres and concerts, are clearly not specifically attributable to the arts. The other responses, such as 'stayed in' or 'gone to another cultural venue', indicated that the spending was specifically triggered by the desire to visit a museum or go to the theatre. This suggests that on average some 64 per cent of spending by Glaswegians going to museums and galleries was specifically induced by the arts attractions, and the arts specific proportion of spending by theatres or concert goers was 89 per cent.

Table 4.8 Cultural tourists (a): importance of the arts in decision to visit Glasgow and calculation of arts-specific proportion of spending

	Percentage answering	Percentage of expenditure attributed to the arts	Total arts-specific proportion
Importance of the arts in decision to visit region			
Sole reason	23	100	23
Very important	42	90	38
Fairly important	21	70	15
Small importance	6	30	2
No importance	8	—	—
	100		78

Source: PSI.

(a) A sub-group of all arts tourists, defined as those who visited the region in order to attend a specific arts event or attraction, or for general sightseeing.

Table 4.9 Glasgow residents' responses if their chosen cultural attraction had not been available on the day of interview.

	Museums and galleries	Theatres and concerts
Percentage who would have		
Gone to another cultural venue or entertainment	38	18
Stayed in and waited until venue was open or could obtain a ticket	16	53
Stayed in and not visited at all	9	15
Done something completely different	36	11

Source: PSI.

(b) *Arts-specific proportions high for theatre and concert goers*

The overall proportion of arts-specific and deadweight expenditures for day visitors and residents in London and elsewhere (the three study regions) are set out in Table 4.10. The arts-specific element in the spending of theatre and concert goers was generally higher than in the outlays by museum and gallery attenders, who seemed more willing to accept alternative attractions as a focus for their entertainment. Museum and gallery going had a more casual aspect to it, as can be seen in the relatively low arts-specific proportion for residents visiting museums and galleries, especially outside

London. Theatre and concert goers were much less willing to accept a substitute focus for their evening entertainment and the degree of commitment to a chosen visit was much stronger. As a rule, the arts-specific proportion for spending by theatre and concert goers was above 90 per cent.

Table 4.10 Deadweight and arts specific proportion of arts customer spending: residents and visitors.

Percentages

	Deadweight	Arts-specific
Museum and galleries		
London		
Residents	24	76
Day visitors	22	78
Elsewhere		
Residents	33	67
Day visitors	20	80
Theatres and concerts		
London		
Residents	5	95
Day visitors	22	78
Elsewhere		
Residents	10	90
Day visitors	9	91

Source: PSI.

Only the spending by day visitors attending London theatres and concerts appeared to contain a much lower arts-specific proportion at 78 per cent, compared with 91 per cent by day visitors elsewhere. However, when day visitors to London were asked the hypothetical question about their reaction had the specific venue not been available when the visit was being planned, only 5 per cent indicated they would have done something completely different. The rest would have postponed or cancelled the visit to that part of London. This indicates an arts-specific level in line with the rest of the results for the theatre and concert going among residents and day visitors. The relevant data are set out in Table 4.11, together with the equivalent figures for London day visitors to museums and galleries. The latter also produced a somewhat lower deadweight calculation than was reached by the prior method, though as usual the museum and gallery visitors' deadweight spending was higher than that by theatre and concert goers.

Table 4.11 London day visitors' responses if their chosen cultural attraction had not been available on day of interview

	Museums and galleries	Theatres and concerts
Percentage who would have		
Gone to another cultural venue or entertainment	41	25
Stayed in and waited until venue was open or could obtain a ticket	27	44
Stayed in and not visited at all	18	22
Done something completely different	14	5

Source: PSI.

73

(c) *Arts-specific proportion higher for overseas tourists*
The results of calculating the deadweight and arts-specific elements in the spending of tourists are set out in Table 4.12. The deadweight was generally higher than for residents and day visitors, reflecting the more complex mix of motives which go into tourist trips. Some 43 per cent of overseas visitors who included arts events and attractions in their trip considered 'arts and cultural things a very important reason for choosing to come to Britain'. Some 7 per cent made it the sole reason. These results were reflected in the calculation of the arts-specific proportion of spending. It was much higher for overseas visitors at 68 per cent than for British tourists at 56-57 per cent.

Table 4.12 Arts-specific proportion and deadweight elements in spending by tourists

Percentages

	Deadweight	Arts-specific
British tourists		
London	44	56
Elsewhere	43	57
Overseas tourists		
London	32	68

Source: PSI.

There was little variation in the results amongst overseas tourists from different regions of the world. Arts and cultural things scored highest for short-stay visitors from the rest of Europe; some 17 per cent said they were the sole reason for the visit. This was further confirmation of the great potential for cultural tourism among short-stay European visitors. The figures are set out in Table 4.13.

Table 4.13 Overseas arts tourists: importance of arts in decision to visit Britain

Percentages

	North America	Europe Long-stay	Europe Short-stay	Rest of world	All
Percentage answering					
Sole reason	7	6	17	3	7
Very important	44	42	47	43	43
Fairly important	24	30	19	23	25
Small reason	12	15	14	24	18
No reason/don't know	8	7	3	7	6

Source: PSI.

A further check was made on the role of the arts as an inducement to tourists. The responses of tourists to the hypothetical possibility that arts events and attractions would not have been available when planning their trip are recorded in Table 4.14. This shows that between 31 and 39 per cent would have reacted by delaying or cancelling the trip or going elsewhere. Overseas visitors at 39 per cent were most likely to have changed plans and not come to Britain, confirming the high ranking given by them to cultural things in responses to previous questions.

Table 4.14 Arts tourists: response if cultural attractions had not been available when deciding trip.

Percentages

| | British tourists | | Overseas |
	London	Elsewhere (a)	tourists (b)
Percentage responding			
Come on trip anyway	64	69	61
Gone somewhere else	9	24	10
Delayed visit	24	3	21
Cancelled trip	3	1	5
Don't know	—	3	3

Source: PSI.
(a) Museum and gallery visitors' reactions in Ipswich only.
(b) London only.

(d) *Arts specific customer spending 74 per cent of total*
The subsequent calculation of the arts-specific proportion of the customer effect was simply a matter of subtracting the deadweight element from total resident, day visitor and tourist spending. The results can be seen in Table 4.15. As might be expected, the relative importance of tourist spending is lower than previously, but it remains much the largest aspect of the customer effect, accounting for £2,015 million or 74 per cent of the total. Residents spent some £513 million (18 per cent of the total) specifically on account of the attraction of the arts, and day visitors a further £230 million or 8 per cent of the total.

Table 4.15 Arts-customer spending: total and arts-specific proportion

£ million

	Total spending	Arts-specific proportion
Residents		
Museums & galleries	288	202
Theatres & concerts	340	311
Day visitors		
Museums & galleries	218	173
Theatres & concerts	70	57
Tourists		
British	950	539
Overseas	2,171	1,476
Total	4,037	2,758

Source: PSI.

(e) *Customer effect sustains 128,000 jobs*
Spending by arts customers represents a contribution to the turnover of the national economy. The effect is felt throughout the economy, including the employment to which it gives rise. It is estimated that the spending of arts customers supported 128,000 jobs, of which 97,000 arose from

75

tourist spending, 9,000 were the result of spending by day visitors and 22,000 by residents (see Table 4.16).

Table 4.16 Arts-customer spending: impact on jobs

	Number of jobs
Residents	21,901
Day visitors	8,944
Tourists	
British	30,195
Overseas	67,100
Total	128,140

Source: PSI.

The estimates are based on the analysis of employment developed for the three regional case studies (described in Section 6 below). They cover the jobs generated in the businesses where arts customers spent their money (restaurants, shops, hotels). These can be called 'direct' jobs. The estimates also include the multiplier effects on jobs in the regional economy where the spending takes place. These can be divided into:

(i) jobs attributable to the purchasing of goods and services in the regional economy by the business in which arts customers had spent their money ('indirect' jobs);

(ii) jobs resulting from the re-spending within the regional economy of 'direct' income earned as a result of the initial spending by arts customers ('induced' jobs).

Like the national estimates of customer spending, the figures should be regarded as no more than a rough indication of orders of magnitude. They are based on regional economic analysis so that national 'estimates' are no more than the sum of the effects *within* regions across the country. They exclude jobs created through multiplier effects *outside* the framework of the regional economy and so underestimate the full multiplier effects on jobs in the national economy, perhaps by up to 50 per cent. To build a national picture on the basis of three regions is also a very rash exercise, especially when in this case no specific information on the relation between spending and jobs was available for London.

Some 70 to 75 per cent of the jobs were attributable to the 'direct' effect of purchases by arts customers in the catering, retailing and accommodation industries. The remaining 25 to 30 per cent represented the 'indirect' and 'induced' multiplier effects.

Implications for urban and regional development

The implications of the above figures for future arts developments are discussed in Section 6 below. In general terms, it will be clear that the arts act as prime magnets drawing people to particular regions and localities. The estimates of consumer spending calculated above give some indication of the size and strength of the drawing power of the arts. Arts customers constitute a specialised market segment; they are highly dedicated to pursuing specific cultural objectives and command substantial purchasing power towards that end. By adding drawing power and economic vitality of their immediate localities, arts attractions and events contribute to the quality of inner-city life and to the appreciation of property values. In this they are a potent force for environmental improvement, as well as a tool for regional and urban development. By bringing life to city centres, they assist public safety and provide a foundation for social reconstruction.

(a) *Property rehabilitation schemes*
The relationship between arts facilities and property rehabilitation can be very immediate. Artists were in at the beginning of the rise of Glasgow's Merchant City with a number of group-studios established in derelict buildings. The area spawned more studios, workshops and designer shops. Rising rents may now jeopardise further developments along these lines. The studios and designer enterprises in the area make a distinct contribution to its attractiveness; their continuing presence is needed not least for the life they bring to the area. Rising rents and appreciating property values are often seen as a threat to artists and arts organisations. They can also be turned to advantage through the mechanism of planning gain and by means of integrated developments incorporating provision for the arts and artists. The image of high risk and business failure which surrounds some arts enterprises makes them an unattractive proposition in conventional financial terms. Good access to business advice is already provided for individual artists and craftspeople. A study is needed to examine the opportunity for arts organisations provided by property development in relation to the specific housing requirements of arts organisations (studios and rehearsal and performing space) and to show how appropriate finance and advice might be made available.

(b) *Major arts facilities*
The revival of Glasgow's Merchant City benefitted from settlement by individual artists and the establishment of studios. Arts-led urban renewal in the case of Liverpool's Albert Dock involved the creation of two major arts facilities, a new Maritime Museum and the Tate Gallery Merseyside (the latter opened in 1988/89). The project is a public and private partnership between the Merseyside Development Corporation and the Arrowcroft Group, from which commercial offices, flats, retail and tourist developments will emerge. As the largest collection of Grade 1 listed buildings in Britain, the scheme puts the exploitation of Merseyside's cultural heritage at the centre of a redevelopment strategy. An analogous project is proposed for the Ipswich study region to house a European Visual Arts Centre in a new building at the Ipswich Wet Dock. The building will be an attraction in itself and act as a focus and a catalyst for ancillary developments in the area, a working dock with under-utilised, historic, commercial buildings.

(c) *Criteria for assessing success*
The link between such projects and regional economic development can be identified in the form of five streams of influence. These linkages also provide the criteria for evaluating the success of such projects. This can be judged by the degree to which the arts project:
— builds confidence in the immediate vicinity as a business environment amongst politicians, the public and financial decision makers;
— enhances the prestige of the region and makes a mark in business and cultural circles outside the region;
— creates extra jobs (some capable of local targetting);
— services the needs of the working population in the vicinity;
— draws significant numbers of people and their purchasing to the vicinity at appropriate seasons and times of day.

Some of these above linkages have begun to operate in the case of the Albert Dock including its role in building confidence as a symbol of a possible new future for Merseyside.

(d) *Need for ambient circumstances to be favourable*
The strength of the customer effect is a vital part in evaluating the success of such arts-led urban renewal. Of course, there is no guarantee that its impact should or could be confined to the immediate locality. The ambient circumstances need to be favourable, for example, with adjacent shops and restaurants to achieve a local effect and spill-over to a wider area. But there is no doubt that arts facilities are prime magnets, with strong pulling power towards particularly localities. They are particular influential with the prosperous sections of the community. On the other hand, some arts facilities, especially museums and galleries in prime sites, are themselves recipients of a passing trade.

THE ECONOMIC IMPORTANCE OF THE ARTS IN BRITAIN

(e) *Arts are a strong social magnet*

The three case studies provided some evidence on the strength of the 'arts magnet', and of the relative power of the two main sectors. Theatre and concert goers were most likely to be drawn to a particular vicinity specifically by the performance itself. Well over 90 per cent of residents in the three study regions gave attending the performances as their main reason for being in the area. Casual visiting was higher among museum and gallery goers. On average 41 per cent had travelled to the localities where they were interviewed specifically to visit the venue, and a further 12 per cent were interested generally in seeing arts and cultural things. Some 16 per cent cited general sightseeing as their main reason. Among non-residents a contrast was evident between day visitors and tourists. The majority of day visitors (54 per cent) had gone to the region to visit a particular museum or gallery. For tourists the drawing power of particular facilities was less strong (10 per cent), with considerations such as visiting friends and relatives (53 per cent) and general sightseeing (23 per cent) being more important.

Amongst non-residents attending theatres and concerts, over 90 per cent of day visitors gave the performance itself as the main reason for travelling to the region. Tourists attending concerts and theatres were less numerous and too few interviews were conducted to provide conclusive evidence. In the Ipswich region, however, where Aldeburgh was a strong influence, some 67 per cent of tourists interviewed at concerts or the theatre, said that the arts attraction was the main reason for their being in the region.

(f) *General animation*

The provision of street attractions (entertainers, musicians, theatre groups and other forms of animation) is often cited as a means of using the arts to increase the drawing power of a particular vicinity. Such exercises can be effective with certain sections of the public and in specific locations, and they have indirect uses including a role in the promotion of public safety. The experience of the Albert Dock in Merseyside was that regular general animation did little to increase visitor flows, whereas developing major arts facilities and concentrating resources on special festivals and major attractions was a more effective means of stimulating the flow of incomers. This is consistent with the research which showed that visitors and tourists came because they wanted to see specific things, and this is a point on which to build policy.

(g) *Role as a social need*

The customer effect was thus a potent tool for populating an environment and giving economic stimulus to a zone or a region. Artists' studios in a rehabilitated quarter could be as much a prime magnet for visitors as major arts facilities, existing ones or new projects. A different role for cultural facilities in re–animating city life can be seen in a further Glasgow example. The Citizens' Theatre remained the sole public building in a large quarter of the Gorbals, which had been subject to clearance. Theatrical life was maintained as the sole vestige of city life in an urban wilderness, and the theatre audience continued to attend. The Citizens' Theatre became both the symbol for continuity with the Gorbals' past and the social node around which its future prospects could cohere. The quarter is now being successfully resettled and its spirit has endured in the theatre and its audience.

CONCLUSION

This section has dealt with the customer effect of the arts, that is the impact of spending incurred by people in the course of attending an arts event or attraction. The effect of customer spending was felt by businesses from which purchases were made in industries such as retailing, catering and accommodation. The benefit was shared throughout the economy by those industries which supplied the shops, restaurants and hotels patronised by arts customers. Many jobs were sustained by this spending in the national economy.

Not all the purchases underpinning arts attendance were specifically attributable to the arts, because some arts attendance was essentially casual and not the main reason for visiting a region or vicinity. The point was explored by measuring the degree to which people were encouraged by the pull of the arts to spend in the regional economy. Estimates were prepared of the deadweight and (its reciprocal) the arts-specific proportion of customer spending. Deadweight spending, that which would have occurred irrespective of the existence of arts attractions, was higher for museum and gallery visits than for theatre and concert going. The deadweight element in spending by tourists was greater than for day visitors. It was lowest in the spending by residents and it was estimated, for example that between 67 and 95 per cent of the total arts-customer spending by Glasgow residents was induced specifically by the existence of arts attractions and events.

The implication of the arts-specific portion was that it was not budgeted, at least in the short run, for spending on alternative goods and services within the regional economy. Without the arts attractions of the region, the arts-specific part of spending by residents would have been saved or spent on cultural visits elsewhere in Britain, or further afield, presumably lost in various ways to the local economy. By the same token, the arts-specific proportion of day visits and tourist spending would not have entered the regional economy. After allowing for deadweight spending, it is estimated that the jobs attributable to arts–related spending totalled 130,000.

The arts are prime magnets which draw people to particular regions and specific vicinities. Arts customers are dedicated to pursuing specific cultural objectives. Theatre and concert goers are very unwilling to accept a substitute focus for their entertainment; less so museum and gallery attenders. More detailed consideration is given to the arts and tourism in the following section. Suffice it to conclude here that the arts are a magnet to residents and visitors alike.

The customer effect is one of several ways in which the arts can act as a catalyst and a focus for urban regeneration, including city-centre rehabilitation. Local ambient circumstances need to be favourable, for example, with adjacent shops and restaurants, if local success is to result and wider spill-over effects achieved. In this the arts can be a potent tool for environmental improvement and for regional and urban development, including their role as a social node around which new social life can cohere.

5. ARTS AND TOURISM

It is self-evident that the arts and tourism enjoy a complementary relationship. The arts create attractions for tourism and tourism supplies extra audiences for the arts. In Section 4 the level of spending by arts tourists in shops, restaurants and hotels was established. Tourists with an arts ingredient in their trips spent some £3.1 billion in 1985/86, of which £950 million was due to domestic tourists and £2.2 billion to overseas tourists. These figures covered all trips which involved the use of arts facilities. Not all such spending was eligible to be counted as induced by the arts, because the trips of some arts attenders were not undertaken wholly or specifically with cultural objectives in mind. On the basis of answers to questions aimed at judging the strength of influence of the arts on the decision to make the trip, it was estimated that £2 billion of tourist spending was attributable to the specific influence of the arts.

This section explores in more detail the role of the arts in relation to tourism and considers how the benefits derived from tourism and the arts might be maintained and improved. Several research elements feed into the section. It incorporates the results of a survey of overseas tourists in London. The Glasgow and Ipswich case studies covered in detail the question of the arts and tourism, including the prospects for developments, and the findings of these studies are summarised in this section. As for Merseyside, it was not necessary to include tourism in the arts research because a parallel study on the economic impact of tourism in Merseyside was carried out by DRV Research. The results of the arts and tourism studies were combined in an overview report 'An Economic Impact Study of Tourist and Associated Arts Developments in Merseyside', which brought forward proposals for developing tourism, including the 'new ' markets built on the search for culture and the heritage. The Merseyside overview report and its proposals are taken into account in what follows.

How important is tourism for the arts?

seems to be promoting an access for all but its aim is to attract tourists - income

Tourists form part of the attendance at arts events and attractions. In this they provide an extra avenue for audience development, they broaden the market for the arts and extend the basis of support for arts organisations. The section begins with a discussion of the relative importance of tourists in the overall picture of arts attendance.

Museums and galleries depended most heavily on support from tourists, especially in London where they formed some 44 per cent of attendance accounting for an estimated 11.7 million visits in 1984/85. Overseas tourists alone accounted for 8.3 million visits (31 per cent of total attendance). Museums and galleries elsewhere attracted a significant volume of tourists with an estimated 12.6 million visits overall, more than the total visits by tourists to museums and galleries in London. This represented 21 per cent of attendance at museums and galleries outside London. Visits by overseas tourists were much less important than in London, numbering some 5.3 million, or 11 per cent of total attendance. The figures on museums and galleries and theatres and concerts are set out in Table. 5.1.

It is worth noting that, according to the results of the regional studies, tourists accounted for 25 per cent of visits to the museums and galleries of Glasgow, 30 per cent in the Ipswich region and 20 per cent in Merseyside. The overseas proportion was highest in Glasgow at 7 per cent.

Theatres and concerts were less attractive to tourists overall, particularly outside London, where the tourist share in attendance lay between 5 and 10 per cent of the total. The figure is based on the pattern of attending in the three study areas where 5 per cent of attendance was attributable to tourists. An upward adjustment was made to this figure, since it could not be fully representative of the picture outside London where account should be taken of types of attractions not covered in the study areas, for example, the major seaside theatres operating in the summer which must have

Table 5.1 Tourist and other attendance at arts events and attractions: percentages in London and elsewhere

Percentages

	Museums and galleries		Theatres and concerts	
	London	Elsewhere	London	Elsewhere
Tourists				
British	13	15	5	8
Overseas	31	11	35	Ø
Sub-total	44	26	40	8
Day visitors	27	22	21	10
Residents	29	46	39	82
Total	100	100	100	100

Source: PSI.

Table 5.2 Tourist and other attendance at arts events and attractions: in London and elsewhere

Millions of visits

	Museums and galleries		Theatres and concerts	
	London	Elsewhere	London	Elsewhere
Tourists				
British	3.5	7.3	0.9	2.4
Overseas	8.3	5.3	4.2	Ø
Sub-total	11.7	12.6	5.1	2.4
Day visitors	7.2	10.1	3.0	3.0
Residents	7.7	21.1	4.9	24.1
Total	26.7	45.9	12.8	29.5

Source: PSI.

increased the tourist proportion overall. Special attractions drew exceptionally large proportions of tourists. Some 77 per cent of visitors to the Aldeburgh Festival in 1986 (5 per cent from overseas) had come specially for the Festival (*1986 Aldeburgh Festival Audience Survey*, MAS, 1986): 53 per cent of attenders at the Bath Festival were staying overnight, including 7 per cent from overseas; and the Royal Shakespeare Theatre at Stratford drew about 60 per cent of its audience from more than 50 miles from Stratford, with 16 per cent from outside the UK. Such detailed figures were important in the local context. No data are available on the overall level of tourist attendances at festivals and special events in Britain. The national total probably lies in the range between a half and one million attendances.

The picture was very different in London where tourists formed 40 per cent of theatre and concert audiences. Some 37 per cent of audiences in London's West End were from overseas in 1986, 10 percentage points higher than in 1982 (according to Gardiner). The drawing power of London concerts was lower; tourists from overseas averaged 8 per cent of audiences. Music is more international than drama and so London's particular musical appeal was less distinctive than that of its theatres.

81

THE ECONOMIC IMPORTANCE OF THE ARTS IN BRITAIN

Thus, it can be seen that tourists were of exceptional importance for the arts in London, especially for its museums and galleries and theatres; they formed the largest segment (43 per cent) of the arts market overall. Elsewhere, museums and galleries relied to a significant extent on tourists; theatres and concerts much less so. For festivals and other special attractions outside London, the local importance of the tourist audience could be considerable.

It should be noted that these figures relate only to arts attendance in the narrow sense of museums and galleries and theatres and concerts. This study is restricted to the area of responsibility of the Minister of the Arts. Excluded are figures on cinema attendance, general sightseeing (often with a cultural aspect to it) and visits to built- and natural-heritage sites, all of which would have increased the numbers under consideration and given a greater place to tourism in a wider cultural context.

Are the arts important to tourism?

Tourism is a wide concept which incorporates holiday making and business travel, the conference trade and travel for health and education. The common factor is staying away from home over-night. Less than two-thirds of tourist traffic consists of holiday trips or visits to friends and relatives. The decision to make a particular trip may involve more than one consideration. A business trip might be an occasion for some recreation; equally, taking a holiday may involve visiting friends and relatives.

(a) £3.1 billion of the tourism market contains an arts ingredient
The arts are an attraction for tourists in two senses. They form part of the entertainment and sightseeing itinerary of many tourists and as such may be a secondary influence in the decision to make the trip. For a smaller group of tourists they are the prime reason for making a trip.

It was estimated in Section 4 that spending by tourists who included arts attendance in their trip totalled £3.1 billion in 1985/86; some £950 million was spent by domestic tourists in Britain and £2.2 billion by overseas visitors. For overseas visitors the estimate relates to spending in this country and it excludes fare payments to British and other carriers. For domestic tourists in Britain the figure relates only to spending within the region of the visit and it excludes fare payments and other transport costs for travel to the region. Spending on arts-related day visits at an estimated £288 million is not included in these calculations.

Table 5.3 Tourist spending in Britain, 1986

£ billion and percentages

	All UK tourism (£ billion)	Arts-related tourism (a) (£ billion)	Arts-related as percentage of all tourism
Overseas tourists	5.4	2.2	41
Domestic tourists	7.1	0.9 (b)	13
Total	12.5	3.1	25

Source: IPS and BHTS; PSI.
(a) Refers to Britain only.
(b) Excluding spending on day trips of £288 million.

Overseas visitors to Britain spent £5.4 billion in 1986 and a record £7.1 billion was spent by domestic tourists in the same year (International Passenger Survey and British Home Tourism Survey). Spending by overseas and domestic tourists with an arts ingredient in their trip at 3.1 billion amounted to 25 per cent of the total. The arts ingredient was much more important to

overseas tourism. The proportion of overseas visitor spending by arts tourists was 41 per cent; the equivalent figure for domestic tourism was 13 per cent. It is difficult to disentangle the different tourist strands. Some of the arts-related tourist spending was by people on business trips or visiting friends and relatives. But it should be noted that the arts ingredient in overseas tourism was equivalent to a major proportion of holiday tourist spending by overseas visitors.

(b) *Arts tourism already established in Glasgow and Ipswich*
The case studies of Glasgow and of Ipswich showed that tourism with an arts ingredient already had a significant place in the tourist markets of the two regions. In Glasgow, it accounted for 34 per cent of trips, 31 per cent of bed nights and 31 per cent of spending. Cultural tourists (those whose sole motive for making a trip was to enjoy the cultural facilities of that region) were separately identified in Glasgow. Their contribution was 8 per cent of trips, representing about half the holiday market. In Ipswich, where business tourism and visiting friends and relatives was much less developed than in Glasgow, arts-related tourism accounted for 14 per cent of bed nights and 23 per cent of expenditure.

(c) *Some 27 per cent of overseas tourist spending was specifically induced by the arts*
A method for assessing the strength of influence of the arts on the decision to make a trip was described in Section 4. Responses to a series of questions were used to allocate total trip spending so as to reflect the importance of the arts in the decision to make the trip. The results showed that for overseas visitors with an arts ingredient in their trip some 68 per cent of spending was specifically induced by the arts. The arts were less important in the thinking of domestic tourists; the arts specific proportion of their spending was 56 per cent in London and 57 per cent elsewhere. The total arts specific spending by tourists amounted to £2.0 billion, or 16 per cent of total tourist spending. Overseas tourists spent £1.48 billion specifically induced by the arts or 27 per cent of total overseas tourist spending. The arts specific spending by domestic tourists was much lower at £522 million or 7 per cent of the total.

(d) *The arts are important especially to overseas tourism.*
Thus the arts were important for tourism in that some 25 per cent of total tourist spending was by tourists with an arts ingredient in their trip. Some 16 per cent of spending was specifically induced by the arts. The arts were particularly important as an influence on overseas tourism, where the arts-related proportion was 41 per cent with an arts-specific share of 27 per cent.

Overseas tourists in London

Overseas arts-related tourism in London was the subject of a survey designed mainly to establish its scope and economic contribution (see Appendix 1 for a description of the survey techniques). The survey also provided a picture of the market for overseas tourism which is of relevance here. The figures refer mainly to a sample of museum and gallery attenders but they also relate to theatre and concert going.

(a) *Areas of residence*
North America was the largest market, accounting for 46 per cent of total trips among museum and gallery goers (see Table 5.4). Some 35 per cent came from West Europe and 19 per cent from the rest of the world. The USA alone contributed 40 per cent of trips, with West Germany the next largest single source at 11 per cent. A smaller proportion of tourists originated from North America in the winter (44 per cent) than in the summer (47 per cent). The reverse was the case with Australia and New Zealand contributing 6 per cent in the summer and 12 per cent in the winter. Theatre goers included rather more North Americans (53 per cent), with Europeans amounting to 30 per cent.

Table 5.4 Overseas arts tourists in London: by country of origin

Percentages

	Museums and galleries			Theatres		
	Summer	Winter	Total	Summer	Winter	Total
Country of origin						
North America	47	44	46	57	48	53
Europe	35	35	35	27	33	30
Rest of world	18	21	19	15	19	17

Source: PSI.

(b) *Reasons for making trip*

Some 31 per cent of overseas arts tourists in London gave 'sightseeing', which can cover many things, as their main reason for coming to Britain. 'Visiting friends and relatives' at 17 per cent was the second most cited reason, slightly more important than 'arts and cultural things' at 15 per cent. Sightseeing was cited by 29 per cent as the second most important reason, with arts and cultural things rated next at 24 per cent. Europeans put the arts and cultural things higher (17 per cent) than the tourists from the rest of the world (8 per cent), with the North Americans rating them at 16 per cent. The main difference between the summer and the autumn concerned the number of people giving 'business' as a reason for coming to Britain; in the summer it was the main reason for 6 per cent of the sample, compared with 18 per cent in the autumn.

Table 5.5 Overseas arts tourists in London (a): reason for coming to London

Percentages

	Main reason	Second reason	Summer	Autumn
Percentage giving as reason				
Visiting arts and cultural things	15	24	19	11
Sightseeing in London	31	29	32	29
Travelling to different parts of Britain	15	14	21	9
Visiting friends and relations	17	8	13	22
Business	11	1	6	18
Other	11	24	9	11

Source: PSI.
(a) All including an arts event or attraction in trip.

(c) *Age of tourists*

The European market was much the youngest, with 75 per cent aged 16-34 years. Tourists from the rest of the world were also young; the equivalent proportion was 67 per cent. North Americans were older with only 41 per cent under the age of 35 years, whilst 39 per cent were aged 45 years and over. (See Table. 5.6.)

(d) *Length of stay and spending*

The average stay in Britain was 20 days, with 14 spent in London and the remainder elsewhere. Winter tourists from the rest of the world stayed longest at 34 days, but their average daily outlay

was low at £18.40. The highest trip outlays were made by summer tourists from the rest of the world at £873. North American tourists in the summer spent only marginally less at £810, though their stay was shorter at 18 days, with only eight of them spent in London. The highest average daily outlay was £59.31 by European short-stay visitors in the winter. This category also registered the highest interest in arts and cultural things as a reason for making the visit. It was the sole reason for 17 per cent of them and a very important reason for a further 47 per cent. At present this section of the market was relatively small, accounting for only 5 per cent of total trips, but the development possibilities were considerable.

Table 5.6 Overseas arts tourists in London: by age and country of origin.

Percentages

	North America	Europe	Rest of world
Percentage aged			
16-34 years	41	75	67
35-44 years	20	13	15
45 and over	39	12	18

Source: PSI.

Table 5.7 Overseas arts tourists in London: length of stay and spending

Numbers and £

	Days in Britain (numbers)	Days in London (numbers)	Spending Per day (£)	Per trip (£)
North America				
Summer	14.6	8.1	55.55	810
Autumn	25.7	20.7	26.66	685
Europe (long-stay)				
Summer	17.5	18.8	21.36	378
Autumn	21.6	15.3	20.47	442
Europe (short-stay)				
Summer	2.5	2.4	44.40	111
Autumn	2.9	2.9	59.31	172
Rest of world				
Summer	23.8	13.8	36.68	873
Autumn	34.3	21.7	18.40	631
All	20.4	13.7	30.05	613

Source: PSI.

(e) *Arts tourists compared with overall tourist market*
The comparison between arts tourists and overseas tourists in general reveals several significant differences. The daily outlay of arts tourists from overseas at £30.05 was similar to that of overseas tourists as a whole (£32.20). But arts tourists stayed much longer (20.4 days compared with 11.6

for all overseas tourists). As a result, their average expenditure per trip was greater at £613 compared with £373 for all tourists. There was also a major difference in the areas of residence. North Americans were more important to arts tourism than tourism overall. Whereas 46 per cent of arts tourists came from North America, only 26 per cent of all tourists were Americans. The proportion from the rest of the world was 19 per cent in both cases. Europeans accounted for 35 per cent of arts tourism and 55 per cent of all tourism.

Table 5.8 London's overseas arts tourists compared with all overseas tourists

Numbers, £ and percentages

	Arts-related tourists	All tourists
Length of stay (number of nights)	20.4	11.6
Average spend per trip-day (£)	30.05	32.20
Average spend per trip (£)	613.03	73.0
Percentage of trips by residents from		
North America	46	26
Europe	35	55
Rest of world	19	19

Source: PSI, IPS.

(f) *Attendance at arts events and attractions*
Museum and gallery goers amongst tourists were less likely to attend theatres and concerts than theatre and concert goers were to attend museums and galleries. Some 57 per cent of museum and gallery goers also went to the theatre during their trip. But among a small booster sample of concert, opera and dance goers, many more went to museums (74 per cent) and to galleries (67 per cent).

Table 5.9 Overseas arts tourists: percentages attending more than one type of attraction

Percentages

	Museums	Galleries	Theatres	Concerts	Opera/dance
Percentage of the following also attending:					
Museum and gallery goers	n.a.	n.a.	57	15	11
Concert, dance, opera goers	91	78	89	n.a.	n.a.
Theatre goers in Stratford	74	67	n.a.	48	16

Source: PSI.

The levels of visiting by those who attended were also instructive (see Table 5.10). Museum attenders went on average 2.7 times during their trip; theatre goers attended an average of 2.5 performances. Unsurprisingly, theatre enthusiasts went yet more often. Theatre goers interviewed at Stratford-on-Avon indicated that they averaged five visits to the theatre during their stay in Britain. There were some significant differences according to the area of residence. Tourists from the rest of the world on average stayed longer and not surprisingly went to rather more things. North Americans showed particular interest in the theatre: some 68 per cent of museum and gallery goers from North America went to the theatre on average of 3.1 times.

(g) *Numbers of overseas tourists*

On the basis of the attendance frequencies established above and the known number of visits by overseas tourists to museums and galleries and theatres and concerts, it was possible to estimate the number of individual overseas tourists in London who included an arts ingredient in their itinerary. They totalled an estimated 2.94 million: some 1.45 million attended both museums and galleries and theatres and concerts; 1.09 million visited museums and galleries only; and the remaining 0.40 million concentrated on theatres and concerts. In 1985 overseas tourist trips to London were estimated at 9.1 million of whom 32 per cent included one or more arts event or attraction in their trip. Some 28 per cent of London's overseas tourists visited one or more museums and galleries and that some 20 per cent went at least once to the theatre or a concert. These figures, which take account of multiple visits to events and attractions and relate to actual arts attendance, are lower than those obtained in the BTA surveys of overseas visitors to London, though the latter relate to the summer period only.

Table 5.10 Overseas arts tourists in London: frequency of attendance at arts events and attractions

Number of visits per attender

	Museums	Galleries	Theatres	Concerts	Opera/dance	Cinema
Average number of visits in London by those who went						
Museum and gallery goers						
North Americans	2.7	2.4	3.1	2.3	1.4	2.1
Europeans	2.6	1.9	1.6	1.2	1.3	1.9
From rest of world	3.1	2.4	2.6	2.3	1.4	2.9
All	2.7	2.2	2.5	1.9	1.3	2.2
Concert, opera, dance goers (a)	1.5	1.5	2.7	2.1	0.9	0.8

Source: PSI.
(a) Very small sample.

Who were the arts tourists in Glasgow, Merseyside and Ipswich?

The Merseyside case study concluded: 'The arts in Merseyside are taking part in an important development in relation to the region's heritage and its future earnings prospects for tourism and the leisure industries. The flow of cultural tourists and day visitors into Merseyside was well over half a million people, and 95 per cent responded that they would recommend someone they knew to visit the museums and theatres in Merseyside. . . . Seen in this light, a role for Merseyside as a centre for cultural and heritage tourism looked credible'.

The DRV Research study of tourism in Merseyside drew a similar conclusion. It argued that tourism 'is not a single demand but a group of often strongly contrasted demands, each with its own market, associated facilities and economic, social and environmental costs and benefits. For Merseyside, tourism demand can be divided into the 'traditional' visitor, who is either drawn to the resort areas of Southport and Wirral for a 'seaside' holiday or is visiting friends and relatives, and the 'new' visitor who is attracted by the cultural associations and facilities of Merseyside.' The study showed that the 'new' visitors were more likely to be ABC1s and to be staying in hotels than the 'traditional' visitors.

(a) *New tourism in Glasgow and Ipswich*

The Glasgow and Ipswich case studies explored the nature of cultural tourism in more detail. They both concluded that the trip and product characteristics of arts tourists were different from the rest

of tourist demand. The main distinguishing characteristics of arts tourists can be briefly summarised as follows:

— they came from higher social classes than tourists as a whole (85 per cent were ABC1s in Glasgow and 82 per cent in Ipswich compared with 53 and 58 per cent for tourists overall in Glasgow and Ipswich respectively);
— they were older (46 and 55 per cent aged 45 and over, as against 37 and 41 per cent);
— they spent more (£24.62 and £22.15 per day compared with £23.85 and £10.66);
— they stayed longer (3.9 and 5.5 nights compared with 3.2 and 4.7 nights).

As for the place of residence, the new tourists were drawn from further afield, for example, 31 per cent in Glasgow from London and the South East compared with 11 per cent for all tourists. Arts tourists demanded different types of accommodation. In Ipswich they made more use of serviced accommodation (23 per cent compared with 13 per cent) and of large hotels within this category (15 per cent). They also demanded accommodation in inland towns and villages away from the traditional coastal areas. Glasgow's arts tourists made more use of large hotels (26 per cent) and their demand was strong for accommodation in budget hotels (24 per cent).

(b) *New market*
There was good evidence that Glasgow and Ipswich had both tapped new markets through the influence of the arts. In Glasgow 71 per cent of cultural tourists were first-time visitors. The first–timers in Ipswich were 55 per cent of cultural tourists overall and 45 per cent of tourists attending theatres and concerts. The rise of a new market was all the more impressive because there had been little marketing of the two areas from a cultural angle. Some promotion of a new cultural image for Glasgow had been carried out in overseas markets, and as many as 20 per cent of overseas tourists in Glasgow had seen an advertisement for the area. But this did not include British tourists, and less than 10 per cent of cultural tourists overall had seen an advertisement. In Ipswich the figure was 6 per cent.

(c) *Season*
Cultural tourism conformed to the holiday season in Suffolk, and spring and autumn short breaks with a cultural theme had not yet been developed. There was some evidence in Glasgow and Merseyside that cultural tourists continued to visit outside the high summer season. In Glasgow the length of stay was shorter in the autumn than in the summer, 2.7 days compared with 4.9, but the trip numbers were higher.

(d) *Response to Glasgow and its cultural facilities*
 (i) *Impression of Glasgow*
The response of visitors (tourists and day visitors) to Glasgow's cultural facilities was especially strong. They were asked to assess Glasgow as follows: 'Taking all in all, how interesting and enjoyable a place do you think Glasgow would be to visit for someone who was just beginning to be interested in the arts and cultural things?' A total of 79 per cent of all visitors considered that Glasgow was either a very (55 per cent) or extremely (24 per cent) interesting and enjoyable place. As few as 5 per cent said they found it unenjoyable. The implication is that a considerable visitor market may exist based on further encouraging and awakening public interest in the arts.

Another very strong result concerned the great improvement in impressions of the City of Glasgow which followed from a visit. Visitors were presented with a series of statements about the city. Table 5.11 gives results for all visitors and Table 5.12 for those who had not visited the city during the previous five years. Half the sample was asked for impressions of the city before coming to Glasgow, and the other half for impressions at the time of the interview. Four positive statements were given, and one negative comment. When the impressions before the visit were compared with impressions at the time of the interview, all the positive statements recorded increases and the negative statement a loss. Gains in percentage points were higher for 'first-time' visitors, who in general had a poorer impression of Glasgow before their visit than those who knew the place. The

highest gain in percentage points was for approval of museums and galleries, and the lowest for the theatre and music on offer. Generally, the live arts made an indistinct impression on the visitor. At the time of interview, a third of all visitors and a quarter of first-time visitors felt there was so much to do that they would have liked to stay longer.

Table 5.11 All arts visitors to Glasgow region: impression of Glasgow before their visit and at time of interview

Percentages

	Before visit	At time of interview	Gain or loss
Percentage of visitors agreeing with following statements:			
Glasgow in an attractive city full of fine old buildings	52	54	+ 2
There is a wide variety of interesting museums and art galleries to visit	54	67	+13
The city offers a great variety of theatrical and musical events of high quality	36	37	+ 1
There are so many cultural things to do I wish I could stay longer	23	33	+10
Glasgow is a rough and depressing place	22	19	− 3
Don't know/no impression	9	6	− 3

Source: PSI.

Table 5.12 First-time arts visitors to Glasgow region (a): impression of Glasgow before their visit and at time of interview

Percentages

	Before visit	At time of interview	Gain or loss
Percentage of visitors agreeing with following statements:			
Glasgow in an attractive city full of fine old buildings	24	38	+14
There is a wide variety of interesting museums and art galleries to visit	39	64	+25
The city offers a great variety of theatrical and musical events of high quality	16	20	+ 4
There are so many cultural things to do I wish I could stay longer	13	25	+12
Glasgow is a rough and depressing place	28	21	− 7
Don't know/no impression	12	8	− 4

Source: PSI.
(a) Not visited Glasgow during previous five years.

(ii) *Likelihood of repeat visits*
These favourable impressions were reinforced by the positive response from interviewees on the subject of likely repeat visits. Respondents were asked how likely it was that they would take a holiday or a short break in the Glasgow region during the next three years. Of course, tourists were more likely to return to stay than day visitors, many of whom lived close to Glasgow but some 45 per cent of cultural day visitors responded that they 'might', 'probably' or 'definitely would' return for a holiday or short break. For those day visitors staying as tourists elsewhere in Scotland, the equivalent figure rose to 52 per cent. Over two thirds of cultural tourists (69 per cent), who

excluded VFRs, business, tourists and casual arts visitors among leisure tourists, said they 'might', 'probably' or 'definitely would' return for a holiday or short break.

(e) *Response to Ipswich region and its cultural facilities*
Arts visitors to the Ipswich region showed a slightly less strong appreciation of its facilities than Glasgow visitors. Some 74 per cent considered it interesting and enjoyable from the cultural point of view. Nevertheless, 80 per cent of first-time tourists said they 'might', 'probably' or 'definitely would' return during the following three years for a holiday or short break.

(f) *Several markets*
Though arts tourists had distinct trip and product characteristics, it should not be thought that arts tourism represented a unified demand in which all responded equally to different attractions. The 'hardcore' cultural tourists (those who undertake the trip mainly to pursue the cultural attractions of the region) should be distinguished from tourists who fitted in the arts as an incidental extra. Glasgow's 'cultural tourists' numbered 152,000 out of a total 473,000 arts-related tourists in 1986. They were overwhelmingly museum and gallery goers. Rather more of the cultural tourists in the Ipswich region were theatre and concert goers, drawn by the influence of the Aldeburgh Festival. The Glasgow and Ipswich studies concluded that it took special events to attract cultural tourists to the theatres and concerts outside London. Despite the fact that Glasgow had the widest array of regularly available dance, drama, opera and music, few visitors from beyond the West of Scotland were attracted by its theatres and concerts. Regular performed arts seasons are difficult to sell to tourists unless, as in the case of London's West End, they offer the guarantee of an exceptionally wide choice of consistently available attractions.

Museums and galleries were a powerful primary attraction to cultural tourists and an important supplementary influence on general tourists. It was clear from the description of London's overseas tourists that museum and gallery goers did much less theatre and concert going. Some three-fifths of museum and gallery goers among overseas tourists in London attended the theatre. Elsewhere the pattern was more extreme. In Glasgow, less than 5 per cent of tourists appeared to attend both the theatre or a concert and a museum or a gallery during their stay. In Suffolk among non-resident museum and gallery goers, only 5 per cent of day visitors and 4 per cent of tourists mentioned theatre, music and live entertainment as an attraction (see Table 5.13).

Table 5.13 **Non-resident museum and gallery attenders in Ipswich region: factors attract-ing visits to region**

		Percentages
	Day visitors	Tourists
Percentages mentioning:		
Historic houses	55	56
Museums and galleries	56	27
Distinctive and interesting countryside	46	71
Beaches and the seaside	11	27
Nature reserves and nature study	19	17
Local crafts	16	20
Theatres, music and live entertainment	5	4
Military history	4	3
Others	10	14

Source: PSI.

Thus, the market characteristics of the arts as a tourist attraction can be summarised as follows:

— a substantial number of tourists were drawn to a region primarily by its arts facilities; many other tourists recognised the arts as a supplementary attraction;
— museums and galleries in London and elsewhere were a powerful primary and supplementary attraction;
— special events such as festivals were prime attractions for theatre and concert goers;
— London's West End acted as a primary and a supplementary tourist attraction;
— regular theatre and concert seasons elsewhere (even Glasgow's outstanding array) functioned little as primary or supplementary tourist attractions;
— outside London museum and gallery goers were generally little interested as tourists in theatres and concerts.

The new market and prospects for the arts and tourism

The conclusions of the section so far are that:
— the arts are already important to tourism (affecting 41 per cent of overseas tourist spending);
— arts tourism constitutes a new market segment with distinct demand and trip characteristics;
— major opportunities exist for developing the relationship to the mutual benefit of the arts and tourism.

There are already considerable achievements for arts tourism, especially in London. Five of the six fastest growing tourist attractions in 1986 were museums and the sixth was an historic battlefield. Four of the six most popular tourist attractions were museums and galleries (the British Museum, National Gallery, Science Museum and Natural History Museum). Though the field is internationally very competitive, other regions, including the three areas of the case studies, have considerable potential in the market.

The characteristics of existing arts tourism provide an encouraging basis on which to build. The reasons are as follows:
— the trade is a new and expanding market (71 per cent were first-timers in the case of Glasgow);
— it has an upmarket profile;
— levels of satisfaction are high (in Glasgow impressions improved as a result of a visit);
— willingness to repeat the holiday or take a short break was high (69 per cent in Glasgow).

Some further factors point in the same direction:
— the trend in European tourism towards short breaks, activity holidays and more sophisticated tourist tastes strengthens the case for some stress on the cultural segment as an important aspect of tourism development;
— the potential of new tourism is particularly relevant to areas such as East Suffolk and parts of Merseyside where traditional seaside tourism faces problems;
— other developing aspects of the tourist trade are reinforced by cultural tourism (particularly the conference trade);
— the danger of damaging the heritage through tourism and leisure developments can be minimised by encouraging cultural tourism which tends to harness new resources for the cause of preservation and the sensitive exploitation of heritage assets:
— Britain has more comparative advantages in cultural tourism than in sun-based leisure, including existing artistic associations in a number of areas (such as Stratford and Shakespeare and the perception of Suffolk as the county of Constable, Gainsborough and Britten);
— Britain is strong in support attractions for cultural tourism, such as arts and crafts, museums of local life, natural heritage, landscape and bold historic themes (their exposition and interpretation) from the industrial as well as previous eras.

Arts and tourism strategies

Major opportunities exist for developing the relationship of the arts and tourism to their mutual benefit. The arts gain from new avenues for audience development and the strengthened recognition of their contribution to the economy. The interest of the resident population in

developing and utilising cultural facilities overlaps with that of tourists. As summarised by DRV Research in relation to Merseyside: 'The benefits to tourism are the expansion of special interest groups, a new potential clientele, and finally an expanded season as the arts are not dependent on the weather. Thus, the challenge to both "arts and tourism" is great and intriguing because of the large potential benefits in both economic and quality of life terms'.

(a) *Need for a national reassessment*

The purpose of this report has been to assess the economic contribution of the arts, including their contribution to tourism, and this is not the place to comment on national tourism policy. In the light of the new findings above, however, about the great importance of the arts to tourism earnings, it would now seem timely to suggest that some detailed reassessment of the place of the arts in tourism policy might take place. This should include identifying good practice and new developments in relating tourism to the arts.

This report can do no more than refer to the good work of the Society of West End Theatre which has ensured that after six years' effort the role of London's West End is better understood and appreciated by the tourism industry. 'The Tourism Strategy for London' being developed by the London Tourist Board and Convention Bureau is likely to pay due regard to the contribution of the arts. It should also be mentioned that the travel trade has begun to evolve theatre-based packages, including most recently weekend breaks with theatre as the special ingredient for the continental market.

(b) *Originating regional strategies*

Detailed consideration of the particular factors to be examined in originating and extending arts and tourism strategies for Glasgow and Ipswich can be found in the relevant case studies. DRV Research made proposals for a programme to exploit the 'new' market for culture and heritage in Merseyside in the overview report. It may be helpful to summarise here the major challenges facing Glasgow and Ipswich. These were for Glasgow:

— to widen the basis of Glasgow's tourist appeal from one facility (the Burrell Collection) to include other major facilities; the aim was to achieve the status of an acknowledged 'cultural destination';
— to exploit its strength in the live arts (drama, opera, dance and music) as a tourist asset;
— to find the means within specific programmes (especially in the museums and galleries) to encourage repeat visits;
— to establish effective collaboration with other component parts of the Scottish tourist trade (for example, two-city packages with Edinburgh).

The major challenges facing Suffolk can be summarised as follows:

— to widen the market and draw in more first-time visitors;
— to create two new flagship facilities in the museums and the performed arts to provide a focus for tourism development;
— to establish the capacity to promote and market tourism within the county at an operationally appropriate level (between the region and the district councils).

The two cases studies showed how the pay-off from specified tourism initiatives would be an extra 3,500 jobs in Glasgow and 890 jobs in the Ipswich region.

Any initiative to expand arts-related tourism will need to define the project under a number of headings, including:

— the nature of the product to be marked;
— guidelines for linking tourism initiatives to arts policies and other relevant considerations;

— the role of general tourism objectives in relation to arts tourism;
— means of implementing relevant initiatives.

(i) Consideration should be given to the *nature of the product* which it is proposed to market. This should include the following points.

— To what extent and by what means can the locality be promoted as a 'cultural destination'? Which elements among existing arts events and attractions combined to justify the designation?
— Which cultural facilities (singular or in groups) require marketing? What are the relevant national and international markets?
— What cultural packages can be developed? Do they contain education or participatory elements? What are the relevant national and international markets? And how specific can they be made?
— Are there additional facilities or events which should be added to the cultural programme of the locality?

(ii) Arts tourism initiatives must grow out of the locality or the region and not be artificially implanted without reference to local needs and organisations. The following *guidelines* should be borne in mind:
— the travel trade, local authorities and arts organisations will need bringing together in any initiative; close consultation and co-operation with existing arts organisations is essential if the initiatives are to be successful;
— the relevant public policies and agencies will need to be co-ordinated in pursuit of arts tourism initiatives; the local authorities will have a major role in this, and in the development of the new attractions; effective co-ordination between different departments within local authorities should not be forgotten;
— preference should be given to adding new events and to upgrading existing activities, rather than creating new facilities, though these may also be necessary;
— new initiatives should be rooted in the needs and expectations of the local arts community and its public;
— cultural tourism should remain in keeping with, and seek to reinforce, related policy aims, for example, for developing the potential of city centres, raising the prestige of a locality as a business address, improving the image of the region.

(iii) *Broader tourism objectives* will have a role in relation to arts tourism initiatives. These are likely to be relevant in the following areas:

— transport and communications: improved direct air links from provincial cities to the continental market place may be vital for development of cultural tourism;
— accommodation: there may be a need to address investment opportunities in relation, say, to budget price hotels, where much demand from cultural tourists concentrates;
— servicing of the tourist: this will include providing specialist promotional and explanatory literature, good roadside information, developing relevant sign-posting, designating cultural precincts and improving the utility and legibility of public transport services.

(iv) The *means of implementing* an initiative must be developed. This will require an entity to design and implement promotional and marketing measures for the development of tourism, in partnership with the travel trade, at an appropriate operational level. The Greater Glasgow Tourist Board, funded jointly by a consortium of local authorities and the travel trade, fits the bill well. Suffolk at present has nothing between the regional tourist board, covering four countries, and the district councils. Detailed operational considerations would include the following:

— better advanced scheduling of arts events; travel professionals work up to 12 months ahead;
— a descriptive brochure for the travel trade, introducing the cultural possibilities of the region;
— workshops and seminars to inform the arts community about the travel trade and how it works;
— education programmes aimed at different sectors of the market;
— developing special promotional devices, such as 'cultural cards'.

THE ECONOMIC IMPORTANCE OF THE ARTS IN BRITAIN

CONCLUSION

The section has shown that tourism is important to the arts and that the arts are important to tourism. Some 42 per cent of arts attendance in London was by tourists. Museums and galleries were a major attraction within London and elsewhere; theatres (and to a lesser extent concerts) were also an important draw in London but, apart from festivals and special cases like Stratford upon Avon, they were not a prime attraction elsewhere.

Tourism with an arts ingredient (basic or incidental) was worth £3.1 billion or 25 per cent of total tourist earnings. Tourist spending specifically induced by arts events or attractions was estimated at £2 million or 16 per cent of the total. The arts were especially important in overseas tourism as they attracted 41 per cent of earnings or £2.2 billion. The arts-specific element was £1.5 billion or 27 per cent. As for domestic tourism the arts element was much smaller than for overseas tourism.

The figures related only to museum and gallery and theatre and concert attendance. A wider interpretation of culture to include the natural and built heritage and historic sites (not to mention gardens, landscapes, preserved railways and other working industrial monuments) would have resulted in even larger estimates of their importance to tourism.

Arts tourism constitutes a new market segment with distinct demand and trip characteristics. The potential for development seems considerable, since the demand is relatively new, upmarket, expanding and fed by high levels of satisfaction and willingness to repeat the experience. Tourism saturation may be a real fear, though the structural changes in tourism (towards short breaks, more sophisticated tastes, activity holidays) will reinforce the expansion of arts tourism.

It will be necessary to develop arts tourism strategies making use, among other things, of the body of experience which is accumulating, for example, in London towards this. Some reconsideration of tourism policy is needed to re-assess the place of the arts in that policy and to identify good practice and new developments in relating tourism to the arts.

There is a particular challenge in defining and exploiting the possibilities in the great cities and rural locations outside London. The potential rewards are considerable in terms of job creation and the wider dispersal of visitors over the country. It will be particularly relevant, for example, to find the means of easing pressure on the popular museums and galleries in London and expanding tourism to related facilities (major and minor) elsewhere in the country.

Tourism has a big demand for unqualified manual labour but plenty of workers are now needed with skills, and an expansion of the arts as a primary attraction will call forth further requirements for skilled labour.

It is important that arts initiatives in a tourism context should be related to the work of existing arts organisations and grow out of the needs and ambitions of the arts community and its public. Effective co-ordination between the relevant bodies (local authorities, the travel trade, its administrative organs, and the arts bodies) will be essential, as will the creation of effective means of implementing appropriate marketing and promotional initiatives.

PART III: ECONOMIC IMPACT AND VALUE OF THE ARTS

6. ASSESSING THE ECONOMIC IMPACT OF THE ARTS

Assessing the economic value of the arts to Britain, which is the main purpose of this study, takes the form of three specific research aims. They are to:

— establish what importance the arts may have to the national company in terms of their contribution to employment and income;

— assess the stimulus given by the arts to allied industries, especially through the spending induced by people attending arts attractions;

— examine the comparative impact of different sectors of the arts and provide the means of assessing the benefits of possible future arts developments.

Previous sections have produced findings on the first two points, the primary impact of the arts in terms of income and jobs, and the importance of the 'customer effect'. This section looks at the third aim and seeks to provide information which can be used in assessing the effects of different policies. This is best done in a regional perspective and so the section provides a summary of the main findings on the economic impact of the arts in the three regional case studies.

Methods of analysing economic impact

The analysis of economic impact can be useful in two respects. First, it can measure the total income due to an economic activity arising from the flow of money through the economy, so that its full worth (or productive contribution) may be demonstrated. Second, it can provide data for use in evaluating comparable projects and developments. It is in the second context that impact analysis is most useful as a planning tool.

The economic impact analysis in the three regional studies was provided by DRV Research and the three reports contain detailed accounts of the methods employed. There are a number of ways in which economic impact can be assessed. Proportional multiplier analysis was the method chosen for the research, because it combines many of the advantages of input-output analysis without the high cost and lengthy time required for collecting the large quantity of detailed data necessary to complete a full input–output matrix. Like all multiplier analysis the proportion method is based on the concept of the circulation of money within an economy. The multiplier co-efficient simply measures the ripple (additional) effect of an initial injection of expenditure into the economy.

The aim of the analysis is to measure the economic repercussions of spending as it percolates through the regional economy. The ripple effects on output, income, employment and taxation arise in three stages: direct, indirect and induced. In relation to arts organisations, the stages can be broadly described thus:

(a) direct income: the income (wages, salaries and profits) paid to employees and proprietors of theatres, galleries etc.;

(b) indirect income: the income (wages etc.) paid by the suppliers to the theatres, galleries etc. of goods and services (and the suppliers of the suppliers);

(c) induced income: the income paid as a result of the re–spending of income earned directly and indirectly under (a) and (b) above.

The ripples continue as business and individuals re-spend part of their revenue and money changes hands with successive rounds of expenditure. 'The flow diminishes as income leaves the region to

pay for imports, as some is saved and not spent, and as national taxes are levied at each successive stage, until the effect has worked its way through the regional economy' (see Medlik, for a clear description of the multiplier concept).

The multiplier effect can be expressed in different ways, either on an incremental or a proportional basis. The value of the incremental multiplier is represented by

$$\frac{\text{Direct} + \text{indirect} + \text{induced}}{\text{Direct}}$$

The value of the proportional multiplier by

$$\frac{\text{Direct} + \text{indirect} + \text{induced}}{\text{Initial spending}}$$

Whereas the incremental multiplier expresses the size of the ripple effect in proportion to the direct effect, the proportional multiplier expresses the total impact in relation to the size; of the initial injection of expenditure. In this case the initial spending consists of spending in arts organisations (trading receipts and grants) and arts customer spending. The same data can be used to calculate the two different measures of the multiplier. Both types of multiplier were referred to in the regional studies.

The above approach works equally well for examining income flows (or value-added) and for assessing the impact on jobs. Both of these aspects were considered in the three regions.

The necessary data were obtained in each region from the following sources, mainly special surveys:

— surveys of arts organisations: to provide data on income and employment and on the spending patterns of arts organisations;

— surveys of arts- and tourist-related businesses: to provide the means of converting the data on customer spending into estimates of income and jobs in shops, catering and accommodation establishments;

— surveys of suppliers of goods and services to the tourism and entertainment industries; for use in the input-output matrix (carried out by DRV Research);

— arts customer surveys: to establish spending by arts attenders in the three regions;

— Family Expenditure Survey: information on consumer spending patterns by residents in the various regions.

The three studies considered spending by both the arts organisations and arts customers, so that the relative effect of the two key components of the total arts impact could be examined. Care was taken to avoid double counting by subtracting outlays in arts venues from total arts customer spending. Spending in the venues on tickets, refreshments etc. was treated as revenue for the arts organisations, alongside other trading income and finance from public and private contributions. One limitation of the studies was that the available data and resources were not sufficient to extend the impact analysis to the cultural industries (broadcasting, film and video production etc.), though some very rough estimates were attempted and these are referred to as appropriate below.

THE ECONOMIC IMPORTANCE OF THE ARTS IN BRITAIN

What was the total impact of the arts in the three regions?

Table 6.1 summarises the impact of the arts in terms of income and of jobs in the three regions. The values include the indirect and induced multiplier effects. No information exists on the size of the multiplier effects of other economic sectors in the regional economies under consideration and so comparisons with the arts are difficult. The only practical comparison is in terms of jobs. The total contributions of the arts sectors towards employment, including the customer effect, were as follows: 14,735 jobs in the Glasgow region, equivalent to 2.25 per cent of total employment; 6,647 jobs or 1.23 per cent of those in work in Merseyside; and 2,025 jobs or 1.19 per cent of employment in the Ipswich region. It is clear that the arts represented a significant part of the economy in Merseyside and Ipswich, and a major part in Glasgow.

Table 6.1 Economic impact of arts organisations, their customers and the cultural industries in Glasgow, Merseyside and Ipswich

£ million and numbers

	Spending (£ million)	Income (£ million)	Jobs (numbers)
Glasgow			
Arts organisations	25.5	11.4	2,620
Customer spending (a)	66.6	13.9	4,185
Cultural industries (b)	193.2	..	7,930
	285.3	..	14,735
Merseyside			
Arts organisations	14.0	6.4	1,698
Customer spending (a)	60.3	7.9	3,405
Cultural industries (b)	15.8	..	1,544
	90.1	..	6,647
Ipswich			
Arts organisations	4.4	1.7	610
Customer spending (a)	13.9	2.7	781
Cultural industries (b)	6.4	..	654
	24.7	..	2,025

Source: PSI.
(a) Excluding spending in arts organisations.
(b) Including own-account artists not counted in arts organisations and cultural industries.

The impact of the museums and galleries, theatres and concerts was reinforced by the effect of purchases by their customers, which accounted for 63 per cent of the impact on jobs in the three regions. The cultural industries were also a significant source of employment, especially in Glasgow, where, together with own-account artists they represented over half the jobs sustained by the arts sector. The ratio of jobs to turnover in the cultural industries was generally lower than in the arts organisations.

What was the impact of museums and galleries, theatres and concerts?

Local income generated by the core arts organisations in the three study areas ranged from £30 to £64 per £100 of turnover. This was after allowing for the leakages of income from the local economy in successive rounds of spending and re-spending. The figures in Table 6.2 set out the successive stages of the impact effect in terms of direct, indirect and induced income. They show

that the rate of impact was generally higher for museums and galleries than for theatres and concerts. This was mainly a reflection of the fact that wages and salaries and building overheads formed a higher proportion of operational spending in the museums and galleries than in the performed arts. Less of the spending on wages and buildings leaked from the local economy than purchases of goods and services and spending on fees. The difference can be seen in the relatively higher impact at the 'direct' level for museums and galleries (£44—£56 per £100 of turnover), compared with performed arts organisations (£26—£37 per £100).

Table 6.2 Impact of arts organisations in three regions: total net value-added per £100 turnover

£

	Direct (£)	Indirect (£)	Induced (£)	Total (£)
Museums and galleries				
Glasgow	46	3	6	56
Merseyside	44	2	3	49
Ipswich	56	3	5	64
Theatres and concerts				
Glasgow	34	2	4	40
Merseyside	37	2	3	41
Ipswich	26	2	2	30

Source: PSI.

The proportion of operational spending going to the regional economy is set out for the three study regions in Table 6.3. In each region the figure for museums and galleries was higher than for theatres and concerts. The figures for individual performed arts organisations varied greatly. Some were pulled down by special factors. The national performed arts companies in Glasgow, for example, undertook touring responsibilities (as did the Royal Liverpool Philharmonic Orchestra in Merseyside) which entailed spending outside the region. They also engaged more visiting artists. By the same token, the producing theatres drew actors from the national pool, with a corresponding fall in the regional percentage of purchases, despite the return to the region from subsistence spending by visiting actors. The venues and receiving theatres in the Ipswich region inevitably incurred relatively high expenses outside the region through payments to visiting artists and ensembles.

Table 6.3 Operational spending within the region by arts organisations in Glasgow, Merseyside and Ipswich

Percentages

	Museums and galleries	Theatres and concerts
Percentage of total operational spending within the region		
Glasgow	84	53
Merseyside	72	62
Ipswich	74	49

Source: PSI.

The ratio of indirect and induced income to direct income (the incremental multiplier) was higher in Glasgow for both sectors of the arts than in the other regions (see Table 6.4). Glasgow would appear to have been a more self-sufficient economic region than Merseyside and the Ipswich area. The incremental multiplier for the museums and galleries in Glasgow was 1.20, compared with 1.11 in Merseyside and 1.14 in Ipswich. Similarly, Glasgow gained more from its theatres and concerts with an incremental multiplier of 1.18, than did Merseyside (1.14) and Ipswich (1.15).

Table 6.4 Impact of spending by arts organisations in three region: incremental multiplier for income

	Multiplier (a)
Museums and galleries	
Glasgow	1.20
Merseyside	1.11
Ipswich	1.14
Theatres and concerts	
Glasgow	1.18
Merseyside	1.14
Ipswich	1.15

Source: PSI.

(a) The incremental multiplier expresses the size of the ripple effects (*indirect* and *induced*) in proportion to the *direct* effect on income of spending.

The economic impact on jobs is expressed in terms of numbers of jobs resulting from £100,000 spending by the arts organisations. Again, the indirect and induced effects are set down alongside the direct effects (jobs in the arts organisations themselves). Table 6.5 shows that the rate of impact ranged from 11 to 19 jobs per £100,000 spending. As with income, the impact of museums and galleries was higher than that of theatres and concerts. It should be pointed out that the figures on jobs relate to the numbers of jobs, not to full time equivalents, and so the high figure of 19 jobs per £100,000 spending by the Ipswich region museums and galleries reflects the many part-time and seasonal jobs in museums which were closed for the winter.

Table 6.5 Impact of arts organisations in three regions: jobs generated per £100,000 turnover

Numbers

	Direct	Indirect	Induced	Total
Museums and galleries				
Glasgow	8.69	1.18	2.92	12.79
Merseyside	10.19	0.77	2.04	13.00
Ipswich	15.09	0.69	3.31	19.09
Theatres and concerts				
Glasgow	6.47	0.62	2.09	9.18
Merseyside	8.64	0.66	1.82	11.12
Ipswich	9.26	0.58	1.59	11.43

Source: PSI.

As was the case with income, Glasgow's incremental multipliers were higher than those in the other regions. The incremental multipliers for jobs were higher than those for income, in the range 1.23—1.47 for jobs, compared with 1.11—1.29 for income. This implies that the suppliers to the arts organisations may have been concentrated in economic sectors with part-time, casual or low paid employment.

Table 6.6 Impact of arts organisations in three regions: incremental multiplier for jobs

	Multiplier (a)
Museums and galleries	
Glasgow	1.42
Merseyside	1.28
Ipswich	1.26
Theatres and concerts	
Glasgow	1.42
Merseyside	1.29
Ipswich	1.23

Source: PSI.

(a) The incremental multiplier expresses the size of the ripple effects (*indirect* and *induced*) in proportion to the *direct* effect on jobs of spending.

What was the impact of arts customers?

The rate of impact of spending by arts customers was much lower than for spending by arts organisations. Jobs generated per £100,000 spent by arts customers ranged from 4.6 to 6.7, compared with the range of 9 to 19 jobs arising from spending by arts organisations. The lower rate of impact is explained by the fact that a much smaller proportion of spending by businesses such as shops and restaurants was paid to local employees as wages and salaries, and more supplies were purchases by these businesses outside the region. Nonetheless, as stated above, the overall impact of arts customer spending was greater than that of the arts organisations. The reason for this was the higher total spending by arts customers.

As for the impact of the different types of arts customers, the results (see Tables 6.7 and 6.8) show that spending by tourists had the highest rate of impact at 5.6 to 6.7 jobs per £100,000 spent, compared with 4.6 to 5.7 jobs per £100,000 spent by residents and day visitors. This reflects the fact that tourists spent proportionally more on labour-intensive services, such as restaurants and hotels, and less on shopping, than other types of customer. The leakages from the region of this spending were lower and so it gave rise to proportionally more income and jobs.

When the *rate* of impact is combined with the *actual amounts* spent per trip or trip day the difference in total impact increases and the importance of tourists' spending becomes even more significant. The higher level of tourist spending is compounded by its higher rate of impact. Accordingly, a smaller number of tourists will be required to produce the same impact in the regional economy as a given number of day visitors or residents. The effect is illustrated in Table 6.9 which shows the number of trips required by different categories of customers to produce 100 jobs in the Glasgow and Ipswich regions.

Whereas some 287,000 trips by residents to theatres or concerts would be needed to give rise to 100 jobs in the Glasgow region, a mere 57,000 tourist trip days would give the same result.

Table 6.7 Impact of arts customer spending in three regions: total net value-added per £100 spent

	Direct	Indirect	Induced	Total £
Residents				
Museums and galleries				
Glasgow	12	2	2	17
Merseyside	9	Ø	1	10
Ipswich	13	1	1	16
Theatres and concerts				
Glasgow	13	2	2	15
Merseyside	11	Ø	1	12
Ipswich	11	2	1	16
Day visitors				
Museum and galleries				
Glasgow	13	2	2	17
Merseyside (a)	10	Ø	1	12
Ipswich	13	2	1	16
Theatres and concerts				
Glasgow	11	2	2	15
Merseyside (a)	10	Ø	1	12
Ipswich	15	2	2	19
Tourists				
Glasgow	18	2	3	23
Merseyside	13	1	1	14
Ipswich	16	3	2	20

Source: PSI.

(a) Average of museum and gallery, and theatre and concert goers.

Implications for future development

The same data can be used to show the potential economic benefit arising from developments in arts audiences. The implications of future audience developments are illustrated in Table 6.10. Known levels of spending by different types of customer are combined with the rates of impact to show the number of extra jobs which would result from the spending induced by specific numbers of additional trips and trip days. That considerable gains can be made from expanding arts-related tourism is evident from the analysis. An extra 50,000 tourist trips would provide 338 more jobs in Glasgow and 318 in Ipswich.

It should be noted that impact analysis is not designed to handle problems of marginality, and so the above analysis assumes a constant relationship between jobs and spending. Of course, the marginal cost of extra jobs will only equal the average cost under certain conditions, for example when there is excess labour supply, constant capacity utilisation and an unchanging level of productivity.

102

Table 6.8 Impact of arts customer spending in three regions: jobs arising per £100,000 spent

Numbers

	Direct	Indirect	Induced	Total
Residents				
Museums and galleries				
Glasgow	3.9	0.8	0.7	5.4
Merseyside	3.9	0.1	0.4	4.4
Ipswich	3.5	0.3	0.8	4.6
Theatres and concerts				
Glasgow	3.9	0.6	0.6	5.1
Merseyside	4.6	0.2	0.5	5.3
Ipswich	3.9	0.4	0.8	5.1
Day visitors				
Museum and galleries				
Glasgow	3.9	0.8	0.7	5.8
Merseyside	4.4	0.1	0.5	5.0
Ipswich	3.8	0.4	0.8	5.0
Theatres and concerts				
Glasgow	3.8	0.6	0.6	4.9
Merseyside	4.4	0.1	0.5	5.0
Ipswich	4.2	0.6	1.0	5.7
Tourists				
Glasgow	4.7	0.9	1.1	6.7
Merseyside	5.2	0.2	0.6	6.0
Ipswich	4.0	0.6	1.0	5.6

Source: PSI.
(a) Average of museum and gallery, and theatre and concert goers.

Table 6.9 Impact of arts customer spending: number of trips or trip days needed to produce 100 jobs in Glasgow and Ipswich regions

Number of trips

	Glasgow	Ipswich
Residents		
Museums and galleries	432,900	312,500
Theatres and concerts	287,400	961,500
Day visitors		
Museums and galleries	185,200	221,200
Theatres and concerts	320,500	390,600
Tourists (trip days)	57,600	89,100

Source: PSI.

THE ECONOMIC IMPORTANCE OF THE ARTS IN BRITAIN

Table 6.10 Extra jobs arising from additional arts trips in Glasgow and Ipswich

Numbers

	Additional trips	Extra jobs Glasgow	Ipswich
Residents			
Museums and galleries	100,000	23	32
Theatres and concerts	100,000	35	10
Day visitors			
Museums and galleries	100,000	54	44
Theatres and concerts	100,000	31	24
Tourists	50,000	338 (a)	318 (b)

Source: PSI.
(a) Refers to additional trips by cultural tourists averaging 3.9 nights.
(b) Refers to additional trips by museum and gallery tourists averaging 5.5 nights.

How large is the 'arts multiplier'?

Another way of looking at the impact of the arts is to relate the numbers of jobs in arts organisations to all the other jobs attributable to the arts in the regional economy. Jobs produced by customer spending, together with the indirect and induced jobs caused by the spending of arts organisations, can be expressed as a quotient of jobs in the arts organisations themselves. The resulting coefficient can be called the 'arts multiplier'. Each job in the arts organisations of Merseyside, for example, gave rise to a further 2.8 jobs in the region because of the spending by arts customers and the arts organisations in the local economy. The arts multiplier in Ipswich was 1.8 and in Glasgow 2.7. Even if the deadweight effects are taken into account in calculating the 'arts multiplier', the ratios were 1.6 in Merseyside and Glasgow and 1.1 in Ipswich. Thus, the arts emerge as a potent means of sustaining employment in the regional economy.

A specific example: temporary loan exhibitions

Finally, the discussion of the impact of the arts through the customer effect has so far been concerned with the appeal of museums and galleries and of concerts and theatres as a whole. It is also relevant to examine the impact of particular events or attractions. The case chosen for study was the temporary loan exhibitions promoted in four major London galleries, the Royal Academy of Arts, the Barbican Gallery, the Hayward Gallery and the Tate Gallery. The survey was carried out during autumn 1986 when the galleries were showing exhibitions mainly on twentieth-century topics: Gwen John, Kurt Schwitters, the Art of Barcelona and German Twentieth-Century Art. The results may therefore not be typical of the usual range of major exhibitions in London.

Loan exhibitions attracted people to London in considerable numbers, with 35 per cent of visits by people from the rest of Britain (10 per cent tourists and 25 per cent day visitors) and 10 per cent by overseas tourists. More of their market was from those who live or work in London than for museums and galleries in general. Some 55 per cent of visits were by Londoners compared with 29 per cent of visits to museums and galleries overall.

The power of temporary loan exhibitions to draw people into a region can be further judged from Table 6.11 which shows responses to questions on the importance of the exhibition in making the decision to visit London.

Table 6.11 Visitors to temporary loan exhibitions: importance of exhibition in decision to visit London, by British visitors and overseas tourists

Percentages

	British visitors	Overseas visitors
Percentage giving exhibition as reason to visit London		
Sole reason	32	2
Very important	30	12
Fairly important	23	31
Small/no importance	15	55

Source: PSI.

It can be seen that as many as 62 per cent of British visitors registered that the exhibition was the sole or a very important reason; not surprisingly overseas tourists attributed less importance to such a single attraction but 14 per cent still gave the exhibition in question as the sole or very important reason for making the trip. Following the procedure described above (pp. 70–76), the arts specific proportion of total expenditure committed by various categories of exhibition goers amounted to 78 per cent for British visitors and 43 per cent for overseas visitors. This meant that over three quarters of the spending by British visitors to an exhibition in London was specifically attributable to the exhibition, as was about half the spending by overseas visitors.

The actual sums concerned are set out in Table 6.12. They amounted to an average of £34.67 a day by overseas tourists (including £7.82 on food and drink nearby and £5.14 on shopping), £37.48 by British tourists and £21.48 by British day visitors.

Table 6.12 Spending by temporary loan exhibition visitors in London: average per visit or trip day

£

	In exhibition (a)	Shopping nearby	Food, drink nearby	Travel in region	Other spend	Accommodation	Total
British tourists	3.26	3.71	2.48	3.84	4.13	11.52 (b)	37.48
British day visitors					4.65 (b)	n.a.	21.48
Overseas tourists	4.26	5.14	7.82	1.17	1.17	11.03	34.67

Source: PSI.
(a) Excluding cost of admission and catalogue purchases.
(b) Figures refer to museum and galley goers as a whole.

On the basis of these figures, it was estimated that for every 100,000 visits to a temporary loan exhibition in London, some £6.03 million was injected into the London economy. This figure takes into account the different levels of spending by the various categories of visitor (residents, British day visitors, British and overseas tourists) and the length of stay in London by tourists (3.8 days by British tourists and 26.8 days by overseas tourists). The figure represents the arts-specific spending by exhibition goers and is net of deadweight expenditures which would have occurred irrespective

of the mounting of the exhibition. The extra spending by each group of 100,000 visits on shopping, food and drink nearby amounted to over £2 million and on accommodation was upwards of £1.6 million.

It might be calculated that a 'blockbuster' exhibition attracting 500,000 visits would specifically bring to London some £30 million spending over and above what might otherwise have been spent, of which £10 million would go to shops and restaurants and £8 million to hotels, etc. It is not possible to estimate the full impact (taking account of induced and indirect spending flows) of this spending on income and jobs in London. As a guide, an equivalent volume of spending in, say, Glasgow would sustain some 1,650 jobs, not taking into account jobs within the galleries themselves and the further jobs generated by gallery spending within the region.

CONCLUSION

This section has examined the full economic impact of the arts in the three regions studied. It considered the spending of arts organisations themselves and of their customers, and the arts were shown to be a major source of economic activity. In Glasgow direct and indirect jobs in the arts sector amounted to 2.25 per cent of the employed population. The arts emerge as a potent means of sustaining employment in the regional economy. Each job in the arts organisations of Merseyside gave rise to a further 2.8 jobs in the region because of arts spending in the local economy. The equivalent figures were 1.8 jobs in Ipswich and 2.7 in Glasgow.

The influence of arts customer spending in the regional economy was greater than the impact of the arts organisations themselves. This was due to the larger volume of customer spending. But the rate of impact of the arts organisations (proportional to their spending) was higher than that of customer spending. This was because of the relatively large share of operational spending by museums, theatres etc. which went on suppliers and especially employees based within the region.

Museums and galleries had a higher rate of impact (between 13 and 19 jobs created per £100,000 of museum turnover) than theatres and concerts (9 to 11 jobs per £100,000 turnover). Furthermore, the spending by museum and gallery goers generally had a higher impact than that by theatre and concert goers. This apparent superiority of the museums and galleries on two counts should be set alongside the conclusion of a previous section that museum and gallery goers were less determined at pursuing arts attractions than theatre and concert goers and seemed more willing to accept a substitute focus for their entertainment. Theatres and concerts had a lower impact but their audiences were more dedicated. These are nuances; overall, the prospects for extra jobs arising from an expanding arts sector are considerable, especially when the extra benefits from exploiting the 'customer effect' are borne in mind.

Taking the core arts organisations alone (the museum and galleries, theatres and concerts), the spending by their customers in restaurants, shops and hotels etc. was responsible on average for 63 per cent of arts-related jobs in the local economy. The role of tourists was particularly important. Since a larger share of tourist spending was on local labour-intensive services (such as hotels), and less on shopping, its rate of impact in the regional economy was higher than the spending of other types of customer (residents and day visitors), in respect of both extra jobs and income. Tourists were also bigger spenders than the other arts customers — they stayed longer and spent more — and so in terms of their overall impact on the regional economy they constituted much the best buy amongst an attractive range of options for future arts audience development.

7. SUBSIDISING THE ARTS

Pay-off from public spending

The economic pay-off from public spending on the arts can be examined from a number of aspects. Several were looked at in previous sections where the arts were considered as:

— an economic sector in their own right and a source of significant levels of income and employment;
— a source of export earnings (fees and royalties from performances overseas);
— a stimulus to ancillary industries (through the 'customer effect' on retailing, catering, accommodation and transport), especially as a loss leader for tourism.

Some further potential areas of benefit are considered in this section. They are the extent to which the arts:

— generate extra jobs;
— provide lines of artistic and financial support to commercially-based cultural industries;
— supply public benefits (as distinct from private benefits) which are not translated into effective demand by the market place.

Generating extra jobs: public expenditure cost of jobs in the arts

(a) *Public expenditure cost of jobs in the arts*
At a time when job creation is an important economic policy goal, it is relevant to ask whether the arts are a more suitable or cost-effective instrument for generating jobs than some others which are currently being tried. Public expenditure (by central government and local authorities) on the core arts organisations (museums and galleries, theatres and concerts) was examined for its job content in each of the three study regions. The direct and indirect jobs generated by the 'customer effect' were taken into account in the calculation. The *gross* public revenue expenditure cost of jobs (all forms of public spending) in the museums and galleries and the performed arts sectors was calculated by dividing the relevant public expenditure by the number of jobs. The results are as follows:

Table 7.1 Gross cost of arts jobs in terms of public revenue expenditure

£

	Glasgow	Merseyside	Ipswich (a)
Museums and galleries	1,256	2,448	1,637
Performed arts	4,614	3,407	2,268
All arts jobs	2,278	2,754	1,984

(a) Excluding heritage attractions.

These figures can be compared with the best available estimates (see Davies and Metcalf) of the public sector borrowing requirement cost of creating jobs, which, taking into account direct and indirect effects, was put at £16,700 in terms of current public expenditure, while the cost of a job through public infrastructure investment was put at about £28,600. These were, however, gross figures. Some allowance should be made for a tax and expenditure flowback to government from the existence of the jobs. According to Davies and Metcalf, such an adjustment produced a net cost per job of £11,200 for revenue expenditure and £19,100 for capital expenditure. A further consideration is that, of course, not all new jobs go to people previously included in the unemploy-

107

ment count. Following Department of Employment estimates, Davies and Metcalf assumed that 27 per cent of new jobs go to people previously excluded from the unemployed count. The final figure therefore for the cost per person removed from the unemployment count was £15,300 for current public expenditure and £26,200 for public infrastructure investment.

The same procedure was adopted for arts jobs, taking into account tax and expenditure flowback, in order to arrive at a *net* cost figure for arts jobs (see Helm for an attempt to measure the net cost of public spending on the Arts Council). Tax flowback, including national income taxation, corporation tax and rates but excluding VAT, was established for the arts organisations (museums and galleries, theatres and concerts) from the survey of core arts organisations and for customer spending in each region from the use of the economic impact model. The tax flowback was estimated only at the direct income stage, not for the subsequent impact in the various regions. The figures were thus underestimates. Estimates of benefit 'saving' (arising from the person finding work) were taken from the First Report of the House of Commons Select Committee on Employment, *Special Employment Measures and the Long-term Unemployed* (HC 199, 1985-86 Session). Following Davies and Metcalf, it was assumed that 27 per cent of new jobs went to people previously excluded from the unemployed count.

The resulting figures for the net public sector borrowing requirement cost per person removed from the unemployment count through current public expenditure on the arts in each of the regions are set out in Table 7.2, and they range from £1,066 in Merseyside to £1,361 in Glasgow.

Table 7.2 Net public sector borrowing requirement cost per person removed from the unemployment count through public expenditure on the arts

£

	With 'customer effect'	Without 'customer effect'
Glasgow	1,361	4,999
Merseyside	1,066	2,945
Ipswich	1,241	2,737

Source: PSI.

Several factors may explain the variations in the figures for the different regions. These include the higher levels of income leakage from Merseyside in comparison with the more self-sufficient Glasgow economy: and the large numbers of short-contract and part-time employees in the arts organisations of the Ipswich region. Despite the differences, the arts figures in each of the regions compare favourably with the average figure for all current public expenditure of £15,300. The cost of extra jobs in the arts was also lower than for jobs arising from education and local government revenue expenditure (£10,400 net cost per person removed from unemployment) and health expenditure (£10,700 per person removed).

If the 'customer effect' (jobs arising in the regional economy from spending on catering, shops etc. by people attending arts attractions) is left out of account, the equivalent figure for the public sector borrowing requirement cost per person removed from the unemployed count was £4,999 in Glasgow and £2,737 in the Ipswich region. Even discounting the 'customer effect', the cost of extra jobs in the arts compares very favourably with other areas of public expenditure.

The arts are clearly a cost-effective way of cutting the unemployment count. There are three reasons why the arts have an advantage in this over most other public services. First, they generate income in addition to their grant-aid because of their trading activities, through charging for

admission etc, and they also attract significant contributions from private sources. Second, the multiplier effects of arts organisations in the regional economy are high, partly on account of the large salary component in their expenditure going on local labour. Third, these advantages are compounded by the direct stimulus given by the arts to ancillary industries through the so-called 'customer effect' in the local economy. The figures cited above have been calculated on the basis of each of three regional economies and so some of the benefits (ripple effects) which leaked outside the regions in question were not taken into account. Were it possible to calculate equivalent figures at the national level, they would certainly show an even greater cost advantage for the arts.

Special employment measures

Davies and Metcalf also discussed the public expenditure cost of employment creation through special employment measures (SEMs), for example, the Community Programme (CP). The gross cost of each place filled on the CP was put at £4,920 and the net cost at £2,200. In comparison, the net public expenditure cost of jobs generated by public spending on the arts was lower in each of the regions studied at £1,241 in Ipswich, £1,361 in Glasgow and £1,066 in Merseyside.

A certain amount of expenditure on SEMs was itself directed towards projects with an arts or arts-related content. The largest slice of money for this came from Manpower Services Commission (MSC) programmes, usually in the framework of the CP, less often through the Urban Programme. The surveys of core arts organisations revealed that museums, especially the independent sector, took most advantage of the opportunities available (172 posts in Glasgow and 70 in Merseyside) whilst the performed arts (with 24 funded slots in Glasgow and 58 in Merseyside) derived little benefit from the schemes (see Table 7.3). Community arts activities were heavy users with 114 posts in Glasgow and 333 in Merseyside. These 760 posts overall commanded funds amounting to roughly £2.6 million.

Table 7.3 Manpower Service Commission funded posts in the arts: Glasgow and Merseyside

Numbers

	Museums and galleries	Theatres and concerts	Community arts	Total
Glasgow (a)	172	24	113	309
Merseyside	70	58	333	461
Total	242	82	446	760

Source: PSI.
(a) Glasgow City Area only.

The Community Programme (CP) provides temporary work or training opportunities for up to one year for long-term unemployed adults (aged 18 or over). The projects must be useful for the community, carry out work which would not otherwise have been undertaken and they must be geared to the needs of participants. Table 7.4 lists the CP projects in the Glasgow City Area, together with a brief description of their aims and content. Whilst it is evident that few of these projects gave jobs specifically to professionals in the arts, much of the work was carried out in the context of artistic activity, be it therapeutic use of the arts or crafts or archival work in a museum.

An important exception was the arts section of the Glasgow Council for Voluntary Services (GCVS) Sports and Arts project in which a high proportion (90 per cent) of the CP recruits were recently-qualified art-school graduates and others with college training in the arts. The continuity of this

major CP project was provided by three core staff employed under the Urban Programme. Generally operating through established community groups, the project gave practical support in the arts and crafts at 110 centres. The main interest was in the visual arts and crafts (basket work, leather work, drawing and painting), but drama and music were also available. The centres ranged from elderly and unemployed groups to youth and handicapped organisations. The unemployed youth showed most interest in photography, pottery, mural painting, decorating and drama. At its best, the project succeeded in stimulating a more creative use of free time and in re-establishing self-esteem and confidence. In the rapid growth from 20 arts workers in 1984/85 to 36 in 1986/87 the project had discovered a 'major need'.

As yet, there was no structure of professional expectations for this type of work, nor was there much recognition of its value by the social services. GCVS believed that the demand for arts based rehabilitatory work is so great that it would be possible to create 'hundreds of jobs for artists' in this way. On the other hand, the project had little contact with the rest of the arts world. It might be helpful if more bridges could be built especially with the performed arts organisations, which could provide a practical input into the programmes offered by the project (workshops etc.).

In Merseyside, work with similar aims of social service through the arts was carried out under the CP in a range of smaller organisations, involving rather more music and drama. One difference was that some of the schemes gave slots to trained musicians and dancers. In Merseyside the Youth Training Scheme (YTS) made more use of the arts and crafts than in Glasgow, especially as part of the off-the-job training through the Merseyside Youth Arts Training Programme. Further training experiments were carried out in Merseyside with short courses, such as Act Now for 60 young (18-25) unemployed actors to improve skills and Mersey Theatre Skills providing short courses in artistic, technical and administrative areas. The latter were not funded under the auspices of the MSC.

'It is often said that special measures are only cosmetic, or at best a palliative because they do not result in "proper jobs"' (see Davies and Metcalf). CP jobs last only for 12 months but there is some evidence that they help previously long-term unemployed people into jobs. One third of CP participants were in jobs seven months after leaving the scheme, according to one study. The results of the Glasgow arts-related CP projects were significantly better than that, at least for the Hunterian and GCVS projects, where over two-thirds of participants moved into jobs, albeit almost never in the arts. Experiments were being conducted in floating off projects into businesses and already there had been some success in Merseyside. A handful of participants had made use of the Enterprise Allowance Scheme. The prospects for business creation were most realistic for projects involving the crafts, or silk screen printing, or photography.

In many ways the arts are exceptionally well suited to providing the varied forms of experience which effectively serve the social aims of the CP in relation to the long-term unemployed. The value of these projects to the arts themselves is less clear-cut. Museum-based and archival projects have proved their worth to the institutions concerned and in helping previously long-term unemployed people into jobs. Other programmes have found a valuable niche for the arts applied to social welfare. From the standpoint of the arts, it would be better if SEMs, especially an expanded YTS, could be co-ordinated with programmes of work which relate to the financial and personnel needs of the established arts organisations, so that they might assist with training and help bodies in a growth sector to expand output and employment.

Table 7.4 MSC Community Programme projects with an arts content in Glasgow City
 area, 1986/87

Project location	Number of places	Description of project
Strathclyde University Addiction Art	11	Project assists (former) drug addicts through arts and crafts therapy. Exhibition of clients' work shown.
Hunterian Museum	28	Archiving of museum exhibits using micro and mainframe computer facilities. Includes biological, zoological, etc. exhibits.
Scottish Film Council	5	Archiving Scottish documentary film footage which represents Scotland's recent heritage. Material is documented, catalogued and given out on loan to interested parties.
Maryhill Corridor Festival Group	9	The scheme runs workshops in: pottery, ceramics, drama, screen printing etc, which are available to all members of the community. The scheme is also promoting 'Enterprise in the Community', with one of the CP staff — currently involved in this initiative — hoping to start his own business in screen printing.
The Garret Mask & Puppet Centre	9	The project provides a resource centre for the props needed to perform puppet and mask shows — it also has a workshop where these props are made. The scheme is used by various community groups, schools, voluntary organisations etc. who aim to promote the educational value of puppetry.
Glasgow Council for Voluntary Service (GCVS) Sports and Arts Project	79 (44 Arts)	To encourage, tutor and organise activities in the arts field with a wide range of groups in the Glasgow area. They go into community centres, tenants groups, church halls, etc. and give tuition to small groups in making trays, handicrafts etc.
Royal Highland Fusiliers (GCVS)	5	The project will operate in the Royal Highland Fusiliers museum. It will initiate and establish a register cataloguing all medals, books, journals, silver, pictures and uniform badges belonging to this regiment.
Maryhill Community Central Halls Woodside & North Kelvin Local History Project (GCVS)	9	To research and record the history of the area through a variety of different methods and secondly to stimulate discussion amongst school children and community groups. This will be done through photographic and video film, tape recorded interviews and talking books for the blind.

continued from page 111

Project location	Number of places	Description of project
Strathclyde Regional Council (SRC) Scotland Street Museum of Education	12	Catalogue collections sent from schools, colleges and general public to design and produce exhibits/displays/posters to conduct guided tours of the Museum.
Anne Shaw Archival Survey (SRC)	9	To survey, quantify, catalogue and identify the collection of photographic equipment, cinefilm, slides, stereo chronocyclegram donated to Stow College.
Cardonald Community Video (SRC)	13	To produce high quality videos for Community Groups and Projects.
Costume Reproduction (SRC)	5	Research and Design of Historic Costumes for schools Museum Service, Advisory Service for Teachers. Period costumes made for school children to enact a specific historic event.
Community Video Productions (SRC)	7	To complete videos involving community organisations depicting training videos and current projects in the area e.g. anti-drug campaigning.

Remaining issues

Although generating jobs through the arts may be desirable, a number of issues remain. These include:

— how to measure output in the arts;
— doubts about SEMs and whether they support 'real jobs';
— how to ensure that 'marketed output' in the arts increases;
— the source of extra audiences?;
— the inflationary effects of any expansion in public expenditure.

(i) The measurement of *output in the arts* is beset with problems, including the intangible nature of the arts product, the fact of variable quality in the arts and the problem of waste when there are empty seats at performance or unvisited galleries and exhibitions. Whilst value-added can be used as a means of expressing the productive contribution of the arts, it gives no indication of the volume of output in the arts. Two ways of measuring this have been suggested by Alan Peacock *et al* in *Inflation and the Performed Arts*. One is to estimate 'intermediate' or 'performed output', expressed, for example, as the number of concerts or the number of open days at a museum. The other concept is 'marketed output', which incorporates the customers' response and can be measured by attendance at a museum or by the number (or value) of the seats sold at a concert. Marketed output is the relevant measure here because much of the wider economic impact of the arts is intimately related to the 'customer effect', the ancillary spending of visitors to arts attractions.

(ii) A second problem concerns *the value of output generated by special employment measures (SEMs)*. Extra jobs in the arts can be said to create extra output (or value-added) at the value of the average wage of the new job. But, if the purpose of the new job is simply to create work, there must be a presumption that the 'value' of the output is less than the net wage. Of course, as Davies and Metcalf point out, if wider considerations are introduced, like the effect of training, special employment measures may 'have a favourable effect on output in the long term'. This consideration means that arguments for increasing expenditure on the arts through SEMs will be most effective if they show that training will result, whether it takes effect in the short or long run.

(iii) The arts can be an effective means of job creation provided due account is taken of the *need to expand 'marketed output'*. Jobs in the arts are good value for public money because the arts produce their own marketed output and they stimulate the related 'customer effect'. To retain the advantage, on this argument, extra jobs in arts organisations will need to produce extra marketed output (larger attendances, increased sales). Equally, where there is a waste, for example, in the shape of empty seats, the marketed output might be increased through extra attendance without much need for extra jobs within arts organisations. Better marketing should have the effect of increasing the marketed output and probably pay for itself into the bargain. On the other hand, using extra jobs to expand the 'performed output' (more or better performances, or better customer care) should also have the effect of increasing 'marketed output' by raising the value and/or the number of admissions.

(iv) A second strand of the stress on extra marketed output is the need to *win extra attendances* and not simply switch audiences from one part of the country to another or displace them from one sector of the arts and entertainment to another. Whilst the displacement of audiences may be to the advantage of a particular region, it does not increase effective demand overall and add to the national sum of economic activities. Some displacement will inevitably accompany any phase of arts development, and it is difficult to form an overall impression of the size of any likely displacement effect. One study (carried out by the Department of Employment) examined displacement in three new tourist attractions and the result ranged from 100 per cent to zero. The general indications in the arts seem to be that additional facilities attract substantial, new audiences. This was the case with all the extra facilities and additional programmes examined in the three study areas. The extra attendance at Glasgow's Burrell Collection stimulated admissions to other museums and galleries in the Glasgow region. Doubling the number of performances by Scottish Opera in 1983/84 increased the total opera attendances despite a 15 per cent fall in average opera attendances per performance, but there was no discernible displacement from other attractions; on the contrary they actually succeeded in expanding their attendances in the same year. In the Ipswich region, more performances at Aldeburgh outside the Festival were accompanied by rising audiences elsewhere in the region. The picture was slightly different in London. Some 19 per cent of the audiences for the new Barbican Concert Hall were displaced from other London concerts in the first year of operation. The figure fell to 11 per cent in the second year. Thus, the level of displacement caused by extra arts attractions would appear to be no more than 20 per cent of new attendances. In many cases new facilities stimulate extra attendances at established attractions. In this context, it is worth recalling that the existing reach of the arts and average frequencies of attendance are so relatively low (see Section 2) that the scope for 'additionality' is considerable.

Detailed appraisals of the likely future employment effects of two planned projects were carried out in the course of the regional case studies. The first related to the combined development of the Maritime Museum and Tate Gallery in Merseyside, due to be fully open to the public in 1988/89. The study concluded that the new facilities were likely to generate an extra 825 jobs in the Merseyside region, at a net public sector borrowing requirement cost of £386 per job. The second case was the new concert hall due for completion in Glasgow in 1990. The equivalent figures for the cost of each person removed from the unemployed count by the extra revenue expenditure was £1,518. These figures show the exceptional cost advantage of job generation through the arts, where the average cost of the extra jobs in the two projects was lower than the average cost of each

slot on the Community Programme. The capital cost of creating the extra jobs did not form a part of these calculations.

(v) Whilst underlying *inflationary pressure* is likely to be intensified by any expansion of the public sector borrowing requirement (PSBR), an increase of the PSBR to finance extra jobs in the arts would be less inflationary than other public spending. Anyway, the argument here does not require an expansion of the PSBR, but a switch of resources from other public spending, including SEMs, to the arts. For a given level of public spending, the arts are less inflationary because the spending can be targeted towards regions with many long-term unemployed. Excess labour supply in the arts (especially among performing artists) is chronic, and need not be a source of inflationary wage settlements.

Lines of support from the subsidised to the commercial sector of the arts

Public expenditure on the core arts organisations provides indirect lines of support to the wider commercially-based arts sector. The lines are particularly evident between broadcasting and the live arts. And the transfers of personnel and of artistic products can run in both directions. The subject has not been tackled in detail in this study. Nevertheless, it can easily be appreciated that the film and television industry benefits from the skills and experience of actors who master (and refresh) their craft in the subsidised repertory companies and national theatres. Equally, without the supplementary fee income received from engagements in the commercial sector, it is difficult to see how actors would find the fees prevailing in grant-aided companies acceptable. The transfer of productions from grant-aided producing theatres to commercial managements in London's West End and the touring circuits is well documented. Some 41 subsidised productions moved into the West End in the period from 1982/83 to 1984/85. Co-production arrangements are now more common, in which the subsidised drama company and commercial managements share both the risk and the benefit.

Other examples of indirect subsidy can be taken from the symphony orchestras and local authority theatres. The public core-funding of the London orchestras, for example, means that they are available for commercial work, such as film and recording sessions. The entertainment sector benefits greatly from the existence of a network of local authority-funded venues around the country. Hire charges rarely represent the 'full cost' of staffing and servicing the venue and so the system provides a subsidised grid on which commercial entertainment can thrive.

Thus, in one sense, public expenditure on the arts sustains not only the core arts organisations but also a much wider sector of the economy, which it irrigates with trained personnel, tested products and new ideas.

Public and private benefits

One basic response to the question, what are the public and private benefits arising from public spending on the arts, must refer to the available national array of arts events and attractions sustained in whole or part by the programme of public spending: some 2,000 museums and gallery facilities with changing displays (not to mention rolling programmes of research and interpretation of the collections, including educational activities); and some 1,000 performed arts organisations providing perhaps over 100,000 concerts, plays, dance and opera performances and other dramatic events during the year.

This was referred to above as the 'intermediate' or 'performed' output of the arts, expressed, for example, as the number of concerts or the number of open days at a museum. A second response would bring into play the other concept from the same study, 'marketed output', which incor-

porates the customer's response to what is available and can be measured b,
museum or by the number (or value) of the seats sold. In the case of the core,
'market output' amounted to 122 million attendances (73 million at the museums ;
49 million at theatres and concerts) and £350 million worth of tickets and other goc
purchased by arts customers. To these measures of what in effect is the 'private bene.
to the arts (the part that individuals were prepared to pay for) should be added,
completeness, £25 million business sponsorship contributed by corporations in return ..us
private business benefits supplied through arts organisations.

Some £470 million was the non-marketed component of the output of the core arts organisations,
which was funded in the main by public sources, but, interestingly enough, also by private
donations, albeit to a lesser degree of around £25 million. This might be regarded as the 'public
benefit' of the arts.

There is a long economic debate about the reasons for 'market failure' in the arts and the rationale
for public financing. One argument is that 'individuals may derive a general satisfaction from the
provision of (cultural) services to the community at large, which is quite distinct, though admittedly
difficult to distinguish, from their own immediate (private) enjoyment of them (see Peacock Report
para. 129). Examples often cited include:

— *prestige value of the arts:*
 people enjoy a feeling of local or national pride and identity promoted by arts organisations
 even though they do not attend events and performances themselves;
— *option value:*
 individuals believe that arts organisations should be kept in being, because they, their family
 and friends, may wish to make use of them one day;
— *legacy value:*
 artistic traditions, organisation and products should be maintained for the sake of future
 generations who are not in a position to express a preference in today's market place;
— *intrinsic value:*
 individuals who do not enjoy the arts themselves, but appreciate their artistic or creative worth,
 derive satisfaction indirectly from the enjoyment that family, friends or others derive from them.

This leaves to one side related arguments about social, distributional and educational reasons for
subsidising the arts. The above considerations might apply to organisations as much as to individ-
uals, say a business which may value the prestige given to a locality by the quality of its arts
organisations. Since these general benefits do not translate into demand for the immediate enjoy-
ment of the arts at any particular moment, the market cannot deliver cultural services in the
amount desired, though individuals are free to (and do) make voluntary donations in support of the
arts. 'Free-riding' is another problem. 'The willingness of people to pay for (the general benefits of
the arts) depends on whether or not others are also prepared to support them. Individuals may
have an incentive in such circumstances to disguise their true preference if there is a prospect of
benefitting without paying' (see Peacock). Establishing the 'true' preferences of people may be
feasible but also expensive. When the 'transaction costs' of supplying services 'which everyone
values other than for their immediate enjoyment are high', public financing can be the most
reasonable alternative.

It is nonetheless appropriate to encourage those organisations and individuals who gain direct
private benefit from the arts to contribute more to their support. With the recent growth of
business sponsorship and an evident increase in the share of box office receipts and other trading
returns in the income of performed arts organisations, this seems to have been the national trend
anyway (see *Facts 2* pp.66-68). Private individuals and organisations are taking a greater share of
the burden of subsidy for the arts. This is often called 'internalising the benefit'. On the other
hand, if public funding is to enjoy a continuing role, it is important to know whether the putative

general benefits ('public goods' or 'external benefits') are perceived to be such by the general population, both individuals and organisations, which in effect is called upon to pay for them through the compulsory exaction of taxation. This is the subject of the following two sections.

CONCLUSION

The main conclusion of the section is that the arts are a cost-effective way of cutting the unemployment count. The public sector borrowing requirement (PSBR) cost per person removed from the unemployed count by public revenue spending on the arts in the three study regions ranged from £1,066 to £1,361. This can be compared with the cost of £2,200 for each place filled on the Community Programme. The cost of jobs arising from revenue expenditure on education and local government was £10,400 and on the health services £10,700. There are a number of reasons why the arts are a 'good buy'.

The arts have a built-in public and private partnership element because they generate income from admission charges and other trading in addition to their grant aid, and they attract significant contributions from private sources. This advantage is compounded by the direct stimulus given by the arts to ancillary industries through the so-called 'customer effect'. The regional multiplier effects of the arts organisations were high because of their considerable use of local labour.

Edwin West in his recent study *Subsidising the Performing Arts* states that 'the advocates of the economic impact argument (in favour of spending public money on the arts) typically neglect the opportunity cost of public money spent on the arts: economic recovery could be accomplished by public money spent on alternative projects such as, for example, physical recreation facilities or infrastructure'. This section has provided empirical evidence that the arts have a cost advantage over other forms of public sector revenue spending.

Generating jobs through the arts may be desirable and economical, but a number of issues remained with which the section sought to deal. These included the problem of measuring output in the arts, whether special employment measures (SEMs) supported 'real jobs', the inflationary effects of expansion in public expenditure and, in particular, where the extra audiences needed to increase the 'marketed output' of the arts would come from. The conclusion on inflation was that there is an argument for a switch of resources within public spending towards the arts, not for an expansion of PSBR. Excess labour supply in the arts is chronic and need not be a source of inflationary wage settlements. Extra spending can be targeted towards regions with many long-term unemployed, in line with the needs for dispersal referred to in the discussion of tourism policy in Section 5 and the need to rectify regional imbalances in arts provision. As for extra audiences, the evidence was that the level of displacement in the arts (switching audiences from one sector to another) was low. New facilities created new audiences and stimulated attendances in established attractions.

Some consideration was given to the special advantages of the arts in providing the varied forms of experience relevant to the social aims of SEMs, especially the Community Programme (CP). The value to the arts of CP projects was less clear-cut. Museum and archival programmes had been successful in helping long-term unemployed people into jobs. Other programmes had found a valuable niche for applying the arts to social and medical welfare. From the narrow standpoint of the arts, it would be better if SEM resources were devoted to assisting with training and helping bodies in a growth sector to expand output and employment.

As for the other benefits, it was argued that public expenditure on the arts, sustains, in addition to the arts organisations directly in receipt of subsidy, a wider commercial sector of the arts. The subsidised sector provided trained personnel, tested products and new ideas for the commercial

sector. Not all such benefits could be 'charged' to the commercial sector, though some would say that low wages in the subsidised theatre were themselves a 'charge' for experience. The new co-production arrangements between subsidised producing theatres and commercial managements, replacing the previous transfer system, were an example of the new partnership forming between the public and the private sector, which has the effect of making public expenditure go further.

The section concluded with a short discussion of the rationale for public spending on the arts, especially the question of external benefits, which cannot be translated into direct demand in the market place. It was pointed out that the trend was for 'external effects' to be 'internalised'; private payments for public benefits were also an increasing factor. It was important to know whether external benefits, such as the contribution of the arts to local prestige, were recognised by the public and by the business required to pay for them through the compulsory exactions of taxation. This is the subject of the following two sections.

PART IV: ECONOMIC INFLUENCE OF THE ARTS

8. ARTS AND THE GENERAL PUBLIC

Previous sections have looked at the arts regarded as an economic sector in their own right. The following two sections examine some of the less tangible economic influences of arts provision on business and social life. They seek to establish whether the cultural infrastructure (the existing array of museums, theatres, orchestras etc.) affects in any way decisions of businesses to invest in a region and decisions about where to live and work. Section 7 raised some theoretical issues about the problems of defining and measuring external benefits arising from the arts. This section seeks to throw some light on how the arts are in fact perceived by the population at large, which is called upon to pay for them through taxation (see Throsby and Withers, *What Price Culture?* for a valuable summary of their pioneering work on the subject). It also examines the part played by cultural institutions in determining the image of the three study areas, Glasgow, Merseyside and the Ipswich region. Whereas Section 9 will concentrate on the business community, this section is concerned with the resident public in the three regions.

Survey

The information in this section is based on a survey of a representative sample of the resident adult population undertaken in each of the study regions. Interviews were conducted by BMRB interviewers at residents' homes throughout the region, with a sample designed to be representative of the adult population in terms of occupation and area of residence. Some 1,172 interviews were completed overall, 473 in 25 sample areas in Glasgow, 235 in Merseyside and 464 in the Ipswich area. The survey pursued the following lines of enquiry:

— attendance at arts events;
— active participation in the arts;
— perception of the general benefits arising from the arts experienced by the community at large;
— perception of public financial support for the arts and a willingness to pay out of taxation for arts subsidies.

Attendance at arts events and attractions

(a) *Majority of adult population attended arts events and attractions in previous 12 months*
Some might have expected the arts to be of practical interest only to a small minority of the population. The results of the survey show that the majority of the population (62 to 65 per cent) in the three study regions had attended at least one arts event or attraction in the previous 12 months. The figures were set out in Tables 2.18-2.20 in Section 2 above. Those attending twice or more in the same period represented 32 per cent of Merseyside residents, 37 per cent of adults in the Ipswich area and 41 per cent of Glaswegians. Museums and galleries were the most popular attractions 'reaching' between 31 per cent (Ipswich) and 39 per cent (Glasgow) of the adult population. Roughly one third had visited a cinema. Plays and musicals attracted a significant minority to the theatre, 17 per cent in Glasgow, 24 per cent in Merseyside and 28 per cent in Ipswich.

(b) *Majority of C2DEs attended arts events and attractions*
Among the factors examined in the survey, social class had the most bearing on the 'reach' of the arts (see Table 8.1). People in social classes ABC1 (upper and lower middle class) were more likely to have attended at least once in the previous 12 months (82 and 81 per cent in the Glasgow and Ipswich regions respectively) than the C2DEs (skilled, semi- and unskilled working class) (54 per cent in both regions). Despite the evident bias in attendance, it should not be thought that the level of interest among C2DEs was insignificant, even in the fine arts; between 24 per cent (Ipswich) and 31 per cent (Merseyside) had visited a museum; and some 11 per cent (Glasgow) and 20 per cent (Merseyside and Ipswich) had attended one or more plays or musicals (see Table 2.20).

120

Table 8.1 further shows that amateur involvement in the arts, which to some extent cut across social class, was also a significant determinant of attendance at events and attractions. In Ipswich as few as 42 per cent of those not engaged in amateur activity had attended one or more events. The difference between active participant and passive spectator was smaller in Glasgow.

Table 8.1 Attendance at arts events and attractions: by social class and engagement in amateur activities

Percentages

| | Social class | | Amateur activities | |
	ABC1	C2DE	Engaged	Not engaged
Percentage of adult population attending in: (a)				
Glasgow	82	54	77	57
Ipswich	81	54	81	42

Source: PSI.
(a) Figures relate to people who attended at least once during the 12 months previous to he interview.

(c) *Interest in the arts can be strong in a less well provided region*
As shown above, regional contrasts in the reach of the arts were rather less than might have been expected. The relative popularity of the various arts attractions was broadly similar in the three regions. But some significant differences did emerge. Glasgow had much the highest reach for museum and gallery going, 39 per cent compared with 34 per cent in Merseyside and 31 per cent in Ipswich, which probably reflected the relative quality of the locally available facilities. On the other hand, theatre going was more developed in Ipswich (28 per cent) than in Glasgow (17 per cent), despite the more restricted range of local choice in the smaller, rural area. Thus, the level of active interest in the arts was not necessarily set by what was available locally. For one thing, residents in the rural area were prepared to travel to their arts entertainment: as many as 22 per cent of Ipswich area residents had travelled to events in the rest of the Eastern region and 19 per cent had attended something in London. Glaswegians travelled to visit 'historic houses', reflecting both the location of the attraction and the practice of visiting as part of a 'day out'. They were drawn to Edinburgh for arts exhibitions and pop concerts. But generally Glasgow was self-sufficient in meeting the needs of its residents. The point is confirmed in Table 8.2 which compares Glasgow and Ipswich in terms of the proportion of the adult population attending arts events exclusively outside their respective regions. The Glasgow figures were much lower.

In Ipswich as many as 9 per cent attended museums and galleries exclusively outside the region and 7 per cent had been to a play elsewhere, but not in the Ipswich area. The conclusion is that active interest in attending arts events and attractions can be encouraged by strong local provision (as with the museums and galleries of Glasgow) but strong active interest can pertain in a rural area, such as the Ipswich region, despite some limitations in what is immediately available locally.

(c) *Residents in peripheral areas showed less interest in theatres than those in the centre*
Residents living at the centre of a region were more likely to attend arts events and attractions than those living on the periphery. The reach of the arts overall was 6 percentage points higher in the City of Glasgow and 9 points higher in the Borough of Ipswich than in the outlying areas. The difference was most marked for museum and gallery attendance, 45 and 40 per cent in Glasgow and Ipswich, compared with 34 and 29 per cent in the periphery of the respective regions. One explanation for the difference was that casual access to museums and galleries was easier for central residents than for those living on the periphery. For plays and musicals the difference was

less marked and those living in the rural hinterland of Ipswich were more likely to attend once or more a year (29 per cent) than Ipswich Borough residents (23 per cent). Going to the theatre involved making special arrangements (booking tickets etc.) in which the resident at the centre of the region had no particular advantage.

Table 8.2 Percentage of Glasgow and Ipswich population visiting arts events and attractions but not within their region of residence

Percentages

	Glasgow residents	Ipswich residents
Percentage visiting following: (a)		
Museum or gallery	4	9
Art exhibition	2	5
Historic house	11	12
Play or musical	3	7
Classical concert	1	3
Ballet/modern dance	1	1
Opera	—	2
Pop concert	2	3
Cinema	6	3

(a) Figures relate to people who attended outside region of residence and not within region at least once during the 12 months previous to the interview.

Table 8.3 Attendance at arts events and attractions: by residents at centre or on periphery of Glasgow and Ipswich region

Percentages

	Resident at centre	Resident on periphery
Percentage of adult population attending: (a)		
One or more event		
Glasgow region	65	59
Ipswich region	72	63
Play or musical		
Glasgow region	18	16
Ipswich region	23	29
Museum or gallery		
Glasgow region	45	34
Ipswich region	40	29

Source: PSI.

(a) Figures relate to people who attended at least once during the 12 months previous to the interview.

A similar pattern was exhibited in Merseyside. Residents of Liverpool who formed 28 per cent of the Merseyside population accounted for 39 per cent of museum attendance by residents and 37

per cent of theatre and concert attendance. It should also be pointed out that, in all three regions, marked differences were apparent in the interest shown in the arts among various segments of the peripheral areas, reflecting social, and in the case of Ipswich, some geographic factors.

Participation in amateur arts and crafts

(a) Significant minority engaged in amateur arts and crafts

It was no surprise to find smaller percentages for those engaged actively in artistic pursuits. Participants in the arts and crafts nevertheless formed a solid core at 39 per cent of the adult population in Glasgow and 53 per cent in Ipswich. Those engaged in one or more of the fine arts (singing, playing a musical instrument, drama, painting, drawing, sculpting or creative writing) formed a smaller group at between 21 per cent of the adult population (Merseyside) and 29 per cent (Ipswich).

Table 8.4 Resident adult population engaged in amateur activities

Percentages

	All arts and crafts	Fine arts (a)	Crafts only (b)
Percentage of adult population engaged in amateur activities: (c)			
Glasgow	39	23	16
Merseyside	..	21	..
Ipswich	53	29	24

Source: PSI.

(a) Singing in choirs, playing musical instrument, drama, painting, drawing, sculpting, creative writing.
(b) Craft work, knitting, dressmaking, photography.
(c) Figures relate to people who had participated at least once during 12 months previous to the interview.

(b) Participation in amateur activity attracted a more balanced social cross-section

Participation in specific fine arts was confined to a small minority of respondents (see Table 8.5). Some 7 per cent played a musical instrument in Glasgow and 5 per cent in Ipswich. Two per cent took part in amateur dramatics in both regions. Dancing was rather more popular at 10 and 15 per cent participation in Glasgow and Ipswich respectively. Though a smaller section of the population was engaged in amateur activities, the social cross-section was more balanced than for attendance at arts events and attractions. Some 55-57 per cent of ABC1s participated in one or more activities compared with 32-50 per cent of C2DEs. The social differences were most narrow in craft work, knitting and photography.

In the fine arts the differences were less marked than for attendance at equivalent events and attractions. Table 8.6 shows, for example, that ABC1s were 3.4 times more likely to have attended a concert than C2DEs, but were only 1.9 and 2.5 times more likely respectively to have sung in a choir or played a musical instrument. Whereas ballet and dance performances reached proportionally four times more ABC1s than C2DEs, dancing and dance classes attracted only a 20 per cent higher response from the ABC1s. In drama and painting the ratios of ABC1s to C2DEs participation and attendance were much closer.

123

Table 8.5 Amateur participation in the arts: by social class, Glasgow and Ipswich regions

	Total		ABC1s		C2DEs	
	Glasgow	Ipswich	Glasgow	Ipswich	Glasgow	Ipswich
Percentage of adult population engaged in: (a)						
Choir/singing	5	4	9	5	3	4
Drama	2	2	4	2	1	2
Playing musical instrument	7	5	12	8	5	3
Dancing/dance classes	10	15	10	18	10	13
Painting/drawing/sculpture	5	7	9	10	3	5
Craft work	4	11	7	15	2	9
Knitting/dressmaking	16	19	26	15	13	21
Photography	13	17	22	22	9	14
Creative writing	3	4	7	6	1	3
One of more of the above	39	53	55	57	32	50

Source: PSI.

(a) Figures relate to people who participated at least once during the 12 months previous to the interview.

Table 8.6 Participation and attendance at arts events: by social class

Percentages and ratios

	ABC1	C2DE	Ratio of ABC1s to C2DEs
Percentage of adult population: (a)			
Attending the following: (b)			
Concert	13.5	4.0	3.4
Play or musical	20.0	15.5	1.3
Ballet/dance	8.0	2.0	4.0
Art exhibition	21.0	9.0	2.3
Engaged in following: (c)			
Choir/singing/playing musical instrument (d)	16.5	7.5	2.2
Drama	3.0	1.5	2.0
Dance/dance classes	14.0	11.5	1.2
Painting/drawing	9.5	4.0	2.4

Source: PSI.

(a) Figures relate to people who had participated at least once during the 12 months previous to the interview.
(b) Average for Glasgow, Merseyside, and Ipswich.
(c) Average for Glasgow and Ipswich.
(d) Participation rates for singing and playing instrument have been combined.

(c) *Ipswich residents were more active in amateur arts, especially in crafts*
The regional contrast between Ipswich and Glasgow was more marked for active participants than for passive spectators. Overall participation was much higher in Ipswich (53 per cent at least once in previous 12 months) than in Glasgow (39 per cent). The difference is attributable entirely to the higher level of activity by the Ipswich region C2DEs, at 50 per cent compared with 32 per cent in Glasgow. ABC1s in the two regions had a broadly similar overall level of participation, though the Glaswegians were more active in choirs, playing musical instruments and amateur dramatics than their Suffolk counterparts. The latter were in turn more engaged in craft work, 15 per cent compared with 7 per cent of Glaswegian ABC1s. As for C2DEs, the Glaswegians were less active than C2DEs from Suffolk in everything except playing a musical instrument. This may reflect the greater self reliance of a rural area, or the greater prosperity and higher levels of home ownership in Suffolk.

(d) *Scope for multiple amateur activities greater in the city*
Another contrast between the Ipswich and Glasgow regions may reflect the difference between a rural and a metropolitan area. Glaswegians active in one cultural organisation were more likely than their Ipswich counterparts to take part in several activities. Some 56 per cent of those engaged in Glasgow amateur dramatics also sang in a choir, compared with 38 per cent of Ipswich amateur actors. City life gave more scope for getting involved than a rural existence.

Table 8.7 Participation in the arts: by more than one activity

Percentages

	Choirs	Drama	Musical instrument
Percentage of those engaged in following also taking part in:			
Choirs			
Glasgow	n.a.	22	43
Ipswich	n.a.	15	10
Drama			
Glasgow	56	n.a.	22
Ipswich	38	n.a.	13

Source: PSI.

(e) *Parental inspiration vital for children's involvement in arts*
As for children, the rates of participation in amateur arts activities outside school were lower than for adults. Residents of Ipswich and Glasgow with children aged between 5 and 15 years were asked which of the activities their children took part in outside school. The intention was to determine children's interests in the arts as reinforced by the family rather than in the context of the school curriculum. The question applied to 289 respondents. In Glasgow 37 per cent answered positively to at least one activity compared with 39 per cent of adults; in Ipswich the figures for children were 45 per cent and for adults 53 per cent. The usual social differences were apparent, but the most influential factor in determining a child's involvement in the arts outside school was parental interest. Children whose parents were not actively engaged in amateur activity were very unlikely to be involved in the arts at home. In the survey not a single case occurred of a child playing an instrument or singing in a choir outside school when the parents were not also engaged. The results suggest that firm limits were set to the influence of schooling in this area. Some children were active in crafts work, knitting and dressmaking and photography without the inspiration of parental involvement.

Table 8.8 Participation in the arts outside school by children aged 5-15 years

Percentages

	All families		Amateur activities	
	Glasgow	Ipswich	Engaged	Not engaged

**Percentage of families with children
aged 5-15 years in which children engage in the following outside school:**

Choir/singing	3	5	13	—
Drama	1	1	2	—
Play musical instrument	5	4	16	—
Dance/dancing classes	5	13	32	—
Painting/drawing/sculpture	3	11	14	4
Knitting/dressmaking	20	14	23	16
Photography	6	15	12	9
Creative writing	4	3	12	—
One or more of the above	37	45

Source: PSI.

Perceptions of the benefits from the arts

The study now turns to the opinion of the resident population in the various regions on the value and importance of arts provision. The background to this part of the investigation is the suggestion that the arts may give rise to general benefits for the community at large which are not reflected in the market place, in addition to the private benefits which people can purchase for their own immediate enjoyment. The presumption is that general benefits might require collective support because people could not be individually charged directly for these satisfactions.

(a) *Arts rated above rival recreations and below 'green' amenities*
Residents were first asked to relate the arts to other factors which made living and working in the region enjoyable. They were shown a list of amenities and invited to indicate which were important to them in terms of their life in the region. Table 8.9 sets out the percentages replying positively to each amenity. It shows that 42 per cent in Glasgow considered the arts important, compared with 50 per cent in Merseyside and 24 per cent in Ipswich. The low score in Ipswich probably reflected the limitations of the locally available events and attractions. The 'green' amenities — 'parks and gardens' and 'access to countryside' — were foremost in all three regions. In Ipswich and Merseyside, the built environment ('fine old buildings') was rated higher than the arts, but not in Glasgow. Rival entertainments — 'pubs, clubs, night life', 'spectator sports' and opportunities for participation in 'sport and outdoor recreation' — scored lower than the arts. Social class made little difference to the order of priorities, except that C2DEs in Merseyside and Glasgow set pubs, clubs and night life higher than theatres. In Ipswich, both ABC1s and C2DEs agreed that the pubs of the region were more important than the theatres as contributors to the enjoyment of living and working there.

(b) *Over 90 per cent believed the arts were important for their region in general*
Residents were next asked how important it was for the *residents of their region in general* that cultural facilities were available. In all three regions, more than 90 per cent thought that the arts were either 'very' or 'quite' important. There was scarcely any difference in opinion between social classes. The lowest score was recorded by C2DEs of Ipswich but still 89 per cent regarded the availability of the arts as important for residents in the region.

Table 8.9 Importance attached to amenity factors by adult resident population of Glasgow, Merseyside and Ipswich regions

	Total population			ABC1s			C2DEs		
	Glas.	Mers	Ips.	Glas.	Mers.	Ips.	Glas.	Mers.	Ips.

Percentage of adult population considering the following amenities important for enjoying living and working in region:

	Glas.	Mers	Ips.	Glas.	Mers.	Ips.	Glas.	Mers.	Ips.
Parks and public gardens	64	65	..	73	74	..	60	60	..
Access to countryside	54	67	67	72	74	75	46	65	61
Museums, theatres	42	50	24	59	61	32	35	45	19
Pubs, clubs, nightlife	40	45	41	39	31	44	41	52	40
Spectator sports	36	33	17	32	19	18	38	39	17
Fine old buildings (a)	33	53	51	45	61	63	27	50	44
Participation in sport	26	26	20	36	24	29	23	27	14
Lots of local activities to get involved in (b)	23	29	19

Source: PSI
(a) The question was about 'attractive towns and villages' for Ipswich region.
(b) Not asked in Glasgow and Merseyside.

(c) *Some 70 per cent believed that the arts were personally important*
The next question concerned the *personal* importance placed by the respondent on the availability of arts facilities. The results were again remarkably consistent. Some 69 per cent in Ipswich and 71 per cent in Glasgow considered that arts provision was 'very' or 'quite' important to them personally. An important social difference emerged. C2DEs indicated that, despite holding to an equal belief with ABC1s that the arts were important for residents in general, the arts were less important to themselves personally (61-65 per cent) than to ABC1s (82-85 per cent). The question was not put in this form in Merseyside but it should be remembered that 51 per cent of Merseysiders regarded the arts as important for enjoying living and working there.

(d) *Levels of expressed interest in the arts were higher than attendance*
It was no surprise that people regarded the arts as less important to themselves personally. The note of realism in the result is rather reassuring. The data on actual attendance are also relevant since they might be regarded as more accurate indicators of 'interest' than the figures above recording responses to somewhat hazy propositions. Again, it was no surprise to discover that the levels of attendance were lower than levels of expressed interest. All these data are combined in Table 8.10 to complete a picture which shows: an ascent from one third of the population actually making use of arts facilities (at least twice a year); through the 62-65 per cent attending once a year; via the 69-71 per cent holding that the arts were personally important to them; to those 90 per cent or more believing that the arts were important for the people of their region. Thus, actual attendance at events and attractions is not necessarily a sound guide to the value placed by the public on the existence of arts facilities. People also valued the opportunity for themselves and others to attend, though they did not always exercise it. The broad benefit was strongly and equally appreciated irrespective of social grade, personal interest in the arts and actual personal usage of arts facilities. There was no support for the view that the arts were of value to only a small segment of the population.

127

Table 8.10 Valuation and use of the arts by adult resident population of Glasgow, Merseyside and Ipswich regions

	Glasgow	Merseyside	Ipswich	ABC1s	C2DE
Percentage of adult population considering the arts important:					
For the residents of the region	95	91	93	95 (a)	92 (a)
For themselves personally	71	51 (b)	69	83 (c)	63 (c)
Percentage attending an event or attraction (d)					
At least once	62	..	65	81 (c)	54 (c)
At least twice	41	32	37	60 (c)	29 (c)

Source: PSI.
(a) Average of Glasgow, Merseyside and Ipswich.
(b) Percentage considering arts important for enjoying living and working in Merseyside.
(c) Average of Glasgow and Ipswich.
(d) In 12 months previous to the interview.

(e) *An example of perceived benefits*
Some indication of the form these benefits took can be gained from the results of the questions designed to probe this matter further in Glasgow. Respondents were shown a series of statements which expressed various opinions about the arts in Glasgow and they were asked whether they agreed or disagreed. The approbatory statements all recorded a very high level of agreement, with upwards of three-quarters of respondents agreeing with them (see Table 8.11). Responses to a negative statement (framed to permit the positive expression of contrary opinion) further confirmed the high valuation of the arts. Only 18 per cent agreed that 'people in Glasgow often over-rate the importance of museums, theatres, concerts and cultural activities'. The responses in general showed little variation in terms of social class, place of residence, amateur activity or use of arts facilities.

Table 8.11 Attitudes to the provision of the arts in Glasgow

	Agree	Disagree	Don't know
Percentage of adult population agreeing or disagreeing with the following propositions about the arts:			
They are important for the personal development of Glasgow's children and young people	93	5	2
They improve the general public's image of the city	92	5	3
They make Glasgow a more pleasant place to live and work in	89	9	2
They make a lot of money for the city through the visitors they bring	75	13	12
People in Glasgow often over-rate the importance of museums, theatres, concerts and other cultural activities	18	76	6

Source: PSI.

(f) Broad support for maintaining public expenditure

Finally, some questions were designed to establish respondents' willingness to pay for the putative benefits of the arts out of their taxes. Questions about willingness to pay are inevitably hypothetical and rather divorced from reality. They become even less meaningful when related to aspects of arts provision (specific institutions or possible new developments) remote from respondents' knowledge or direct experience. On the other hand, demands for community benefits by their very nature cannot be observed in the market place and so there is little alternative to some form of direct questioning. Other approaches such as laboratory experiments create different but equally difficult problems. It was felt important to introduce an element of reality into the question, by giving accurate information about the level of public subsidy for the arts. The following question was put to respondents: 'The amount of public money used for all the arts and cultural attractions in the (relevant) region amounts to about (relevant sum) per year for every resident. Do you think this amount should be increased, remain the same, be decreased or be stopped altogether?'. Replies to this question, summarised in Table 8.12, indicated strongest support for maintaining the current level of public subsidy, average of 51 per cent, with a range from 49 per cent in Glasgow to 53 per cent in Merseyside. The consistency of the result must be set alongside the wide divergence in the size of sums cited as actually being spent, ranging from £4 per head in Ipswich to almost £10 in Glasgow. By the same token, those wishing to see the sums increased averaged 35 per cent, within the narrow compass of 34–37 per cent. ABC1s were more likely to favour an increase from the current level of spending, but the difference was small.

Table 8.12 Attitudes to public expenditure on the arts

	All	ABC1	C2DE
Percentage of adult population stating it should: (a)			
Be increased	35	40	34
Remain the same	51	48	52
Be decreased	4	2	4
Be stopped altogether	2	0	3
Don't know	9	10	8

Source: PSI.
(a) Average of opinions in Glasgow, Merseyside and Ipswich

In Glasgow and Ipswich those replying that public expenditure should be increased were asked whether they were willing for this to be financed 'by an increase in your personal taxation'. Some 70 per cent in Glasgow and 61 per cent in Ipswich replied positively. In Merseyside, those wishing to see an increase were asked to name a figure for an acceptable level of public spending per head on the arts. The actual level was £4.45, in relation to which one-third of respondents named a desirable sum between £5 and £7 and one quarter set it as high as £7-10. It should be pointed out that the figures chosen as an ideal in Merseyside fell rather below the sums actually being spent in Glasgow. There would be some benefit in creating better public understanding of what is provided elsewhere in Britain, and how it is funded. The survey did not specifically ask questions on people's willingness to make donations or pay admission charges where none currently operate. The warm public response in favour of the arts revealed in the study may indicate a greater inclination to support increased private contributions than is generally recognised.

THE ECONOMIC IMPORTANCE OF THE ARTS IN BRITAIN

CONCLUSION

Practical interest in the arts was not confined to a small minority of the population. The majority of adults attended some kind of arts event or attraction and a solid core of the population was also engaged in amateur artistic activities.

Some years ago (before the studies by Throsby and Withers in Australia and by West and Morrison in Canada) the positive valuation of community benefits from the arts was largely a matter of theoretical speculation or hunch. This investigation confirms the results of the other studies that the vast majority of the people did perceive the existence of some general benefits in the arts.

The kinds of benefits included an improved image for the city or region, a feeling of pride in the amenities of the locality, a concern for the welfare of future generations, and (in the case of Glasgow) the general economic benefit provided through the arts for the region.

The positive valuation of the benefits of the arts, and the willingness for this to be funded from taxation, was not restricted to a narrow section of the population, despite the variations in the interest in, and use of, available arts facilities. The levels of attendance at arts events and attractions are not necessarily a sound guide to the popular valuation placed on the availability of arts facilities. Over 90 per cent stated it was important that the arts should be available for the residents of the region. Individuals believed that arts organisations should be kept in being because they, their family and friends, might wish to make use of them one day.

Over one-third of the population (35 per cent) wanted to see an increase in public expenditure on the arts, but a larger group (51 per cent) wished to see expenditure remain the same. Few (6 per cent) wanted it to decrease or be stopped. Views on the subject of an increase were remarkably similar into the three regions despite great differences in the actual levels of public expenditure on the arts in the three areas. This evidence suggests that the level of public assistance for the arts may have been regarded as 'about right', though better public understanding of the benefits and levels of what is available elsewhere could change this and lead to greater expectations.

9. ARTS PROVISION AND THE BUSINESS COMMUNITY

The previous section looked at some of the less tangible influences of the arts on the Glasgow, Merseyside and Ipswich regions from the standpoint of their resident populations. A parallel line of inquiry concerned the business community. Was the cultural infrastructure an influence on the intentions of businesses to invest in the regions and on decisions of executives about where to live and work? The opinions of the business community were probed by a series of interviews with senior executives, supplemented by a survey of middle managers in a small but representative sample of companies in each of the regions. In a different vein, considerations influencing the location in Suffolk of creative enterprises in the arts and crafts were examined, especially for the role of amenity factors in the operation of small businesses.

The interviews with leaders of the business community in Glasgow, Merseyside and Ipswich were carried out in 63 companies and organisations. Most of those interviewed were managing directors or partners and the companies were of varying sizes and industrial interests. The executives were asked in a structured interview lasting up to an hour about their own and their family involvement with the arts, as well as about their perception of the extent to which arts amenities played a role in attracting businesses to the region and assisted in the recruitment of senior executives. They were also asked about their company record in business sponsorship and patronage of the arts and whether this brought any specific business benefits. Insights and impressions gathered during the course of these interviews are discussed, after some general remarks about the relationship between business and the arts under the following headings:

— influence of cultural infrastructure on the location of industry;
— role of amenity factors in the recruitment of senior executives and other staff;
— practical benefits for businesses from arts sponsorship.

The results of the survey of middle managers are examined in the context of the views of senior executives on factors affecting recruitment. While differing traditions and contrasting economic fortunes in the three regions make it necessary to stress the variety of impressions and insights gained, the results of the research point to the clear conclusion that a strong cultural infrastructure is a business asset for a region.

Arts and business

(a) GLASGOW

The industrial interests of the senior executives interviewed in Glasgow included textiles, electrical products, computers, commodity trading, distilling and brewing, shipping, oil, publishing, management consultancy, personnel recruitment, advertising, financial services and life insurance. The personnel directors of three large companies were also interviewed, together with the Glasgow managers of a large public sector company. The views of the Glasgow Chamber of Commerce, together with Locate in Scotland, part of the Scottish Development Agency (SDA), and the Economic Development Division of Strathclyde Regional Council were also obtained.

(i) Strong links to the arts sector

Almost all the senior executives interviewed had enjoyed personal contact with the arts of one sort or another. Most were greatly committed to the arts, either by way of personal donation, frequent attendance or by being on the boards of arts organisations. Nine of the individuals had between them served on the boards of 15 different arts organisations. As this seemed to be an extremely high proportion (and hence an unrepresentative group of people might have been chosen for interview), attempts were made to contact leading businessmen with no such involvement — but they proved hard to find. The two people who at first said they had no interest in the arts had nevertheless visited the Burrell Collection several times and had attended amateur theatre perfor-

mances. The others all had wide interests in the arts: opera, ballet, concerts, jazz, theatre and visual arts. Several of the companies bought and/or commissioned paintings — often Scottish — and one company had art displays in its foyer. All made use of arts facilities for entertaining business clients and employees; this ranged from informal visits to the Burrell Collection to big sponsored nights out at the opera, followed by a meal at the Theatre Royal or at a nearby restaurant. The Burrell Collection also provided facilities for business entertainment in the evenings.

Thus, the link between business and the arts in Glasgow was found to be unusually strong. Nor was this a recent phenomenon, as those interviewed were quick to point out; industrialists in Glasgow had for a long time displayed an interest in, and a financial commitment to, the arts, particularly the visual arts (Burrell being the best known example), but also the performing arts.

Business sponsorship and the considerable personal support from individual businessmen had played an important role in establishing major national companies such as Scottish Opera and Scottish Ballet. In recent years the 'Glasgow's Miles Better' campaign and the creation of Glasgow Action had strengthened the link between business and the arts and developed the perception of the arts as being of prime importance to the image of Glasgow and its quality of life. Glasgow Action is a group of leading business people and politicians which, with the backing of private interests, the district and regional authorities and the SDA, seeks to implement a plan for Glasgow to develop a strong business- and consumer-service industry base, which will stimulate the economic regeneration of the city as a whole. The more traditional focus on the arts as the manifestation of civic and national pride predates and reinforces these more recent initiatives.

(ii) *Improving the image of Glasgow*
As for the 'Glasgow's Miles Better' campaign, the business community, after some initial scepticism, believed that this was one of the best things done for the City in recent years. The campaign was conceived, in conjunction with the Lord Provost, by the business community as a 'corporate statement' for Glasgow, intended to change perceptions and raise awareness of the city. There were no specific aims, in respect say of tourism investment, save that of making a more favourable environment in which business, the Glasgow District Council (GDC), SDA and other agencies might operate. The campaign was initially directed towards the residents of Glasgow itself, where the effect in changing attitudes and sharply improving morale was most marked. There is evidence that media coverage in the rest of Britain has changed towards more positive reporting of Glasgow. The image of the city, as measured by a market research study of ABC1s carried out before and after the first three months of the national campaign, has also shown some improvement. The research found that a heightened perception of Glasgow's cultural reputation was a central point in its enhanced image, although factors other than the campaign, such as independent publicity for the Burrell Collection, may have helped.

The business community acknowledged that the arts had played a major role in improving the image of Glasgow. Awareness of the extent of the provision of cultural facilities was very high. Everyone interviewed felt that the forthcoming Garden Festival and the designation of Glasgow as European City of Culture (1990) would be good for business, though opinion differed as to the long-run effects of these events. A couple of sceptics felt that the short-run benefits could not be sustained, though all agreed that tourism would increase. Nevertheless, most thought that once people had been to Glasgow and found for themselves that the reality did not correspond to its generally negative image, a positive long-run response would be generated. The arts were an important part of this process and benefits from the arts mentioned in the interviews included:

— the effect of the arts in counteracting any negative image of the city;

— the information role of the arts in teaching people about Glasgow; people were attracted to the city by arts events and acquired a positive view of the quality of life in the city. Most

businessmen thought that this would convert outsiders to the benefits of working in Glasgow and some believed that this could even lead to businesses relocating in Glasgow;

— 'arts tourists' were people with developed tastes and standards and they would raise the quality of restaurants and hotels by demanding better food and service. High quality provision in these services was important to the business community.

It was frequently mentioned in the course of the interviews that Glasgow, unlike its rival Edinburgh, where the Festival is a sort of annual 'flash in the pan', had a deeper commitment to the arts and, being a more commercially-minded city, was in a better position to maximise the long-run business benefits emanating from European City of Culture (1990).

(b) IPSWICH AND ITS REGION

Companies covered in the survey of the Ipswich region were representative both of older established industries and of more recent arrivals. They were involved in engineering, food products, brewing, banking, insurance (both broking and selling policies to the public), newspaper publishing, advertising and telecommunications. The numbers employed ranged from 50 to 3,000. All the companies recruited staff locally as well as nationally. Several of the firms had moved large numbers of personnel into the Ipswich area in relocation operations. The views of the Ipswich and Suffolk Chamber of Commerce and Shipping, together with those of the Employment Development Office of the Ipswich District Council, the Planning Department of Suffolk County Council and of Babergh District Council, were also sought.

(i) Traditional approach

At first sight the arts seemed to play a lesser role in the thinking of the business community of the Ipswich region than in the larger metropolitan region of Glasgow. Whilst all the people interviewed had some personal experience of the arts (the theatre and the built heritage were often mentioned), few had extensive contact. Only two interviewees were members of the boards of arts organisations. The majority simply went to something 'several times a year'. It was stated by one executive that 'consciousness of the arts has not permeated everyday life'; another individual summed it up by saying that 'the arts are not a talking point in Ipswich in the way they are in London and its suburbs'.

There also seemed to be less by way of entertaining business clients and visiting executives in the Ipswich region, mainly because they tended to be in the area only for the day. The most common form of entertainment was taking people out to a restaurant, usually in one of the picturesque towns or villages around Ipswich. Even those companies which sponsored the arts did not all use the arts organisations for entertaining clients, though they gave tickets to their own staff. An exception was a branch of a national bank whose head office had sponsored a tour by a national arts organisation which included performances in Ipswich; the branch manager had taken a party of local businessmen and clients, besides giving tickets to staff.

(ii) New ambitions

But some senior executives pointed to factors which were changing this rather muted view of what the arts had to offer the business community. One factor was the new structure of employment and enterprise developing in the region. Another was the growing ambition of some local business leaders to put the Ipswich area on the map as a prestige business address.

The recent expansion of the Ipswich regional economy, based in part on the decanting of offices and research establishments from elsewhere in the South East, had increased the ratio of services to manufacturing industry in the regional economy, with professional and non-manufacturing companies moving into the region. This meant that more executive level personnel resided in the area. Changes in the constitution of the working population had implications for the arts, not least in placing fresh demands on available facilities. It was the executives of such expanding or re-

locating companies who were most conscious of the quality of arts provision in Ipswich and it was they who often criticised the nightlife as rather low key. A significant number had moved into the area from London and brought with them the standards and expectations of arts provision they were accustomed to in the London area.

On the other hand, many of the companies expanding into the Ipswich area were extensions of nationwide enterprises with limited demands and few powers of decision, the so-called 'branch mentality'. Entertaining clients and senior executive was usually done in London by head office, with visitors typically coming to Ipswich just for the day. At a personal level, executives of such companies were frequently in London themselves for business purposes and so relied less on local arts facilities. These considerations did not apply so much to indigenous firms, which also formed a growing part of the new pattern of service-based enterprises. This was reflected in the active and expanding role of smaller local firms in business sponsorship of the arts, which is discussed below. The overall view of the business community was that the changes in industrial structure were raising expectations locally for the quality of life, and with that came demands for better arts facilities. It implied an active role for the arts in expanding to meet the increasingly sophisticated recreational needs of a prospering region.

Other executives with strong ambitions for the region conceived of the arts in a pro-active role which would help to quicken economic development. Unlike some declining metropolitan areas, Ipswich had no negative image to counteract. An economic role for the arts was as a standard bearer for business expansion. This was a matter of image or, more strictly, identity. As one senior manager expressed it, 'the arts are a symbol of the vitality of an area' and another 'the arts create the right atmosphere in which business can operate'. These comments show a belief in the positive role the arts can play in furnishing an identity for the area at a time of economic transition and how they can contribute to the development of the Ipswich region as a prestige business address.

(c) MERSEYSIDE

The interviews in Merseyside were carried out with owners or senior partners of a number of small firms and with a range of senior executives in larger firms. The business activities included industrial chemicals, oil refining, wholesale and retail distribution, telecommunications, property services and development, financial services, fashion design, publishing and television production. The views of the Merseyside County Council, the Merseyside Chamber of Commerce and the Merseyside Development Corporation were also sought.

(i) Strategic value of the arts

The interviews were carried out at a difficult time in the declining history of Merseyside and they left an overriding impression that cultural amenities were regarded by senior executives as a vital asset in sustaining confidence in the region. Concern (even alarm) about Merseyside's serious decline and transparent economic and social problems was widespread. Many businessmen, especially in the larger companies, stressed that in these circumstances the arts were one of the slender threads holding together the region's viability and they warned that any decline in the level of arts provision — the future of the Royal Liverpool Philharmonic Orchestra (RLPO) seemed threatened at the time — could break Liverpool's fragile hold on its status as a sophisticated city upon which much of its economic future might depend.

The strategic value placed on the arts by senior executives was expressed in a number of ways. Many interviewees emphasised the positive contribution of the arts to preserving the self-confidence of the region. As one executive put it, 'the arts define the soul of Merseyside and its sense of place'. Cultural amenities were a means of counteracting unfavourable images of Merseyside. They were also seen as an essential element in the 'quality of life equation' which persuaded individuals to invest time, effort and resources for the future benefit of the region.

(ii) *Relation between business community and arts sector*
The value of an 'amenity base' for Merseyside was widely accepted amongst senior executiv
representatives of the business community. But this often appeared as an abstract notion whic.
not always translate into an active personal interest in the arts. Many executives were very invo.
in the arts, and the benefits to family were often mentioned, including the value for children of
learning about music, drama and dance from professional performers resident in the region. But,
unlike Glasgow, where executives showed a widespread commitment to the arts, combined with
frequent attendance, and an active intellectual interest in artistic matters, the arts had not yet fully
suffused the business culture of Merseyside.

There was also some room for improvement in understanding between the arts sector and parts of
the business community. A successful well-established form of support was the industrial subscrip-
tion scheme, whereby companies purchased ticket vouchers at a discount for use by their employ-
ees. This had been started by the RLPO and was taken up by the Liverpool Playhouse. The John
Moores Foundation (funded from a successful Liverpool business) made a major and distinct
financial contribution to the arts in the region. Sponsorship was developing and its importance was
understood as helping to 'build bridges', but it fell short of the scale of contributions made in
Glasgow. And there was some scepticism about the benefits of business sponsorship of the arts,
especially on the part of small companies and their spokesmen. They typically argued that there
was no point in supporting the arts because their clients and the general population were
'philistines'. Some of the business people interviewed were critical of the attempts by art
organisations to encourage sponsorship. One blanket judgement was that 'the arts have never made
a dynamic approach to commercial organisations in this city'. Reference should be made to the
Council for Business and the Arts in Merseyside, a new organisation established on the initiative of
a group of businessmen, to educate and inform on the benefits of arts sponsorship.

(iii) *Need for an amenity strategy*
Another contrast between Glasgow and Merseyside related to what one Merseyside executive called
the lack of a 'practical blueprint for the future of Merseyside which will enable people to be
positive, optimistic and to have a vision'. The development of Albert Dock was often cited as the
harbinger of a new amenity strategy for Merseyside and, like the Burrell Collection in Glasgow, it
was regarded as a symbol of a new future. As the largest collection of Grade 1 listed buildings in
Britain, the Albert Dock scheme put the exploitation of Merseyside's heritage at the centre of
redevelopment strategy. Two museums were integral to the scheme, the new Maritime Museum,
already established, and an outstation of the Tate Gallery, to be opened in 1988/89. The 'screen
industries' were another ingredient of the Albert Dock development which housed a new Granada
TV News Centre in the old Dock Traffic Centre.

Thus, the heritage, new arts facilities and cultural industries formed the building blocks of the
development, in a marriage of public sector arts provision with private commercial, tourist, office
and flat developments. The total likely investment in the Albert Dock was put at £100 million in
1986, of which half would come from public, half from and private sources. The public sector
making 90 per cent of the total investment so far was very much the senior partner still in 1986.

But, unlike Glasgow with its Glasgow Action plan, Merseyside had yet to develop an economic
blueprint applicable to the city centre as a whole, beyond its waterfront strategy. The elements
were present and ready to be woven into a credible vision of a service-based economy of the future
and an 'imaginative and complete rethink of the packaging of Merseyside' was inchoate in the
minds of many senior executives, with service industries, high technology and tourism interacting in
the economic regeneration of the region. An amenity base and cultural projects were widely seen as

central to the process and the various elements, together with their interrelationships, can perhaps be best laid out diagrammatically as follows:

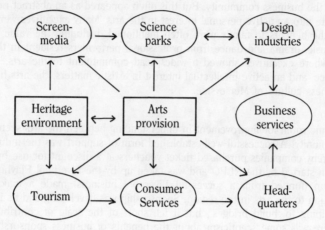

Location of industry

(a) *Glasgow*

It was an impression shared by businessmen and public officials alike that for firms contemplating opening new plant or offices in Glasgow the cultural factor had a positive value. Nobody could say for certain why firms chose Glasgow. Stated reasons were not always the real reasons and 'quality of life' was impossible to disentangle from other factors. But those responsible for selling the region as a business location believed that without a strong cultural infrastructure their task would be more difficult. For example, the arts reputation of Glasgow had been important in attracting a number of initial enquiries about the region as a possible business location. This was especially true of US companies, from whom the bulk of enquiries came; they tended to regard cultural assets as a 'real bonus'. On the other hand, some US companies preferred new-town locations where the political and social structures were more malleable. In promoting the region overseas, Locate in Scotland featured cultural amenities strongly as a source of favourable impressions, especially when hosting visits by journalists, politicians and businessmen. Similarly, when dealing with actual enquiries from 'locator firms', the quality of the reception by public officials was important and in this the stress on environmental and cultural factors was significant.

This is not to deny that companies, especially those in manufacturing, looked first at the hard business facts (ease of access to major markets and other business centres, transport costs, quality of suppliers, availability of labour and suitable factory space or office accommodation), and that overseas firms sought to locate where they could maximise the advantage of access to European markets, and best secure a sound hedge against currency fluctuations. But, in seeking to establish branches, subsidiaries or additional plant, companies were also aware of the advantages of a 'good address', and a location well-resourced with cultural amenities was taken as an indication of a dynamic, self-confident host community. Cultural facilities were a factor for senior personnel, including those making the decision about new locations, who were often not necessarily contemplating a move themselves. The operational advantage was that evident amenity advantages would make a new location more acceptable to the staff being posted there, regarded as a 'comfort factor' by those making the move and by others sending them there.

(b) *Ipswich*

No financial inducements were available for attracting businesses to the Ipswich region and so hard business facts were the only consideration. Many companies were there simply to gain access to a local market; this was especially true of branch offices of national companies. Three of the

companies interviewed were there for traditional locational reasons, i.e. access to suppliers of raw materials. Other advantages of doing business in Ipswich were good communications, both land-based (i.e. road and rail) and nearness to port facilities and to the Continent. Easy access to the City of London, since Ipswich trains went into Liverpool Street Station, was often mentioned. Again, this was important to branches of national companies, whose head offices tended to be in London. Another factor was the availability of suitable office and factory space in which to expand.

But it was also clear that traditional locational factors, such as cheap labour, were not as important as previously. The views of businessmen were changing. The new approach put more emphasis on maximising the amenities for employers as well as for employees. There was a body of opinion in the Ipswich region that if more were provided, especially 'more to do in the evening', more industry would move into the region. It was also clear that the 'comfort factor' discussed above in relation to Glasgow had been a consideration in Ipswich and its region.

(c) *Merseyside*
Merseyside was not a good place, nor was it a good time, to test any hypotheses about cultural amenities as an influence on the mobility of firms into a region. It was recognised that efforts were worth making to use the cultural attractions of Merseyside as a promotional tool for the region. It was also explained that personal tastes, like an interest in sailing or in the arts, came into account at the highest level of management when firms were choosing places for a move. But so few firms recently had set up head offices or local branches in Merseyside that the available evidence was insufficient to form any judgement on the matter.

(d) *Relocation*
The considerations affecting the relocation of existing operations, administrations or enterprises were rather different from the factors influencing the location of new starts, branches and expansion. Both Glasgow and Ipswich have relevant experiences on this aspect. Studies have shown that companies do not like to move unless something forces them out of an area. Locational inertia is strong, but it was the belief in both Ipswich and Glasgow that when locator firms were searching for possible sites, the quality of life and the general attractions of a region were weighed up, alongside cost, convenience and financial incentives. In such circumstances the arts as part of the quality of life became an influence on the choice of location.

A critical problem is persuading key workers to move, and it might be thought that good amenities would be a major benefit. But, according to some of the senior executives interviewed in the Ipswich area, difficulties had been experienced in moving staff from a previous location to the new region. Problems mentioned, apart from the usual ones of people being unwilling to uproot families, particularly those with children established in secondary schools, were the high price of housing and dislike of a more rural area after living in a metropolitan one. For the most part, the problem was dealt with by promotion and financial inducement, but cases were mentioned in which staff preferred to take redundancy payments.

In Glasgow, which had received several relocated operations, the example of the Ministry of Defence was examined in which some 350 people were moved from London, the home counties and Wiltshire to Glasgow in 1986. Basic resistance to the move from the staff was not overcome by stressing the attractions of Glasgow's lifestyle. Other kinds of inducement, mainly promotion and an appeal to Scottish expatriates who welcomed the opportunity to return, were more effective. The success of 'reconnaissance trips', in which leisure opportunities and the arts were featured alongside schooling and housing, lay in easing the transition for those already prepared to move, rather than in persuading any sceptics to change their minds.

The effect on those who moved was generally positive. Some had begun enjoying the 'benefits of inner-city life' and there was a 'greater awareness among senior colleagues of going to the theatre and the opera than ever in the South'. Very few wanted to go back to the South. Most spoke positively about Glasgow. But the favourable reaction of those who moved had not yet made it any

easier to find volunteers to go to Glasgow. In both Ipswich and Glasgow, whilst the outcome of relocation was generally satisfactory, the process was difficult, and the quality of life factor was not particularly influential with the less senior grades, who formed the bulk of the staff concerned.

Attracting senior executives and other staff

(a) *Glasgow*
Assessing the role of the arts in attracting senior executives to Glasgow was made more difficult by the fact that the city exerts a considerable pull over its own sons and daughters. Senior executives were recruited, by a significant number of companies, exclusively from within the company or from returning Glaswegians. In other companies, which hired people from outside, it was said to be the job itself that was the important factor in bringing people into the region. Where the arts played a role was in the retention of personnel and in offering a pleasing lifestyle to those already committed to the city for one reason or another.

These views were confirmed by the professionals in personnel management and recruitment. The amenity factor was never decisive and was much more important as a hold factor than as an attraction. Good amenities anchored people to the life of their community. The quality of life could be an important factor in stemming the flow of outward migration. This was an especially important consideration in relation to retaining personnel in the 'brain-box industries', where the international market for top talent was strong. Pay and prospects for a particular job were the main factors affecting geographic mobility for most people. In marginal cases, the amenity factor could swing the issue and the improvement in Glasgow's image, in which its cultural reputation played an important part, had broadened the field of possible candidates for top jobs. Uncertainties about the Scottish economy and the lack of prospects in a small country, together with a branch-office mentality for non-Scottish-owned industry, were still discouragements. The perfect combination was a job with pay and prospects and excellent amenities.

(b) *Ipswich*
Most companies had experienced no difficulty in attracting staff once the company was established in the region. Many of the managers interviewed did not think that arts provision (or the quality of life generally) was important in attracting staff. However, it is significant that those who took the opposite view in regarding arts provision as important were executives in companies employing highly educated personnel. One of these was a senior executive in a large telecommunications company with 1,500 graduate employees. When the company had moved into the area, bringing a large number of staff with it, a brochure was provided to personnel, which outlined provision of schools and art facilities in the Ipswich area, because it was felt that this would be important to their staff. The company continued to provide this information when recruiting new staff, which it did on a nationwide basis, usually straight from university.

Staff who moved, even unwillingly, to Ipswich came to enjoy life there, and many employers said that these people would not now want to move out. Improved arts provision had played a role in this; as one employer said, 'We could not keep staff here without the arts'. Thus, the amenity factor was never decisive in drawing people into the region; the job itself was the key factor. The arts were much more important as a hold factor than as an attraction. The quality of life could be an important influence in stemming the flow of outward migration by enterprising and talented youngsters. This was important in relation to retaining personnel in industries where the international market for top talent was strong. It also had a bearing on policies to stimulate home-grown industry and indigenous enterprise.

(c) *Merseyside*
Merseyside gave some confirmation to the view that quality of life factors could be important in attracting top graduate talent to work in a region. All the executives in a position to recruit new blood to Merseyside confirmed that it was a difficult matter at best to recruit high calibre managers

and technologists for commerce and industry in the face of the negative image of the region in recent years. In this sense, arts provision had a strategic role to play in presenting a favourable image of life in the region. It was also one of a small range of crucial factors which helped retain managers and technologists in the region.

Views of middle managers

It was partly to test the hypothesis that managers need strong cultural backup that a small survey was carried out at 12 representative companies in the three study regions. Short, self–completion questionnaires were distributed by the companies to members of their staff aged 25-45, working in management or advanced technical posts. The survey was restricted to this narrow group because it was presumed to be the most mobile part of the executive class. Its relative youth made its views relevant for some years to come. The sample was small — 238 questionnaires were completed overall — and the responses are thus of limited value, beyond the rough indication they give of general attitudes of middle managers in the three regions.

(a) *Heavy users of arts facilities*

The average age of respondents was 35. Males constituted 86 per cent of the sample. Sixty-two per cent were graduates and 28 per cent had post-graduate qualifications. The Merseyside managers in the sample were the most highly educated; some 38 per cent of the Merseyside sample had post-graduate qualifications. Seventy-seven per cent of respondents were married and 52 per cent had children living at home. The sample was relatively mobile; 61 per cent had lived and worked in another region of the UK or abroad for at least a year since entering full-time employment. Ipswich managers were much more mobile than the rest, 79 per cent having worked elsewhere. Middle managers, overall, had levels of interest in amateur artistic activities similar to those of the resident population. But they were much heavier users of arts facilities; 64 per cent had visited museums, galleries or historic houses from twice to five times during the previous twelve months and 62 per cent had also visited theatres, concerts or other live entertainment with the same frequency. Merseyside managers were exceptionally active, with 74 per cent attending twice to five times during the previous twelve months.

(b) *A basic factor in deciding where to live and work?*

The middle managers were asked a range of questions which explored the value placed on cultural facilities in relation to other amenity factors. The first question presented a range of amenities which might be considered important in the choice of a region in which to live and work. The results are summarised in Table 9.1. Although 74 per cent of the sample considered museums, theatres, concerts and other cultural facilities important, they were rated below other factors such as environment and housing, while good transport facilities figured surprisingly high on the list. Merseyside managers placed greater importance on the cultural factor (over 80 per cent), with Ipswich managers the least concerned about the arts (only 65 per cent).

On the other hand, when managers were asked what leisure facilities were important to them in contributing to their enjoyment of living and working in the region, the results (summarised in Table 9.2) show that cultural facilities were an equal second, behind 'access to pleasant countryside'. In Glasgow, the arts were a clear second; and they were third in Merseyside, after the two 'green' amenities. In Ipswich, they came fourth, with only spectator sports and participation in sporting activities below. The Ipswich score at 60 per cent was significantly lower than the 79 per cent in Glasgow and 68 per cent in Merseyside. But the level of personal interest in the arts indicated by Ipswich managers was not less than elsewhere. The result seems to reflect the limited array of arts facilities locally available in the Ipswich region. When asked which of the amenities they valued most, managers generally put the two green amenities top in all three regions. Cultural amenities were the second most important (i.e. the most popular of the second choices) in Merseyside and Glasgow. In Ipswich, sporting activities were the most important factor for a significant minority (22 per cent) and museums, theatres etc. scored high as a second most important factor (24 per cent).

Table 9.1 Middle managers' opinions of factors affecting the selection of a region in which to live and work

Percentages

	Respondents in			All
	Glasgow	Merseyside	Ipswich	respondents
Percentage regarding as important:				
Pleasant environment and architecture	100	..	97	98
Good road, rail and air links	88	..	80	84
Outdoor recreation and sporting facilities	84	>80	78	81
A wide choice of housing	82	>80	87	80
Good choice of schools for children	77	>80	72	76
Museums, theatres, concerts and other cultural facilities	77	>80	65	74

Source: PSI.

Table 9.2 Middle managers' reasons for enjoying and working in three regions

Percentages

	Respondents in			All
	Glasgow	Merseyside	Ipswich	respondents
Percentage regarding as important:				
Access to pleasant countryside	93	91	94	93
Museums, theatres, concerts and other cultural facilities	79	68	60	69
Parks and public gardens	74	73	40 (a)	62
Fine old buildings	60	51	96 (b)	69
Participation in sporting activities	51	56	56	54
Pubs, clubs and nightlife	32	37	80	50
Spectator sports	26	39	10	22

Source: PSI.
(a) Question on Ipswich referred to 'lots of local things to get involved in'; average relates to Glasgow and Merseyside.
(b) Question on Ipswich referred to attractive towns and villages.

(c) *Support for public spending*
Strong support for the arts was again revealed in responses to a question on public subsidy. Middle managers were asked, as were the resident populations, whether public expenditure on the arts should be increased, remain the same, be decreased or stopped altogether. Fifty-two per cent of the middle managers thought it should be increased, compared with 35 per cent of the resident populations. Thirty-seven per cent thought it should remain the same, compared with 51 per cent of the resident sample. Those who favoured an increase were asked if they would be willing to to pay for this through personal taxation, and 71 per cent in Glasgow said they would and 78 per cent in Ipswich. The question was not asked in this form in Merseyside.

(d) *Prospect of moving*

Finally, it was possible to corroborate the above results by comparing the responses of managers to the prospect of living and working in different parts of the country with their impressions of the variety and interest of cultural facilities in these regions. Table 9.3 sets out the results, which show that, although the theatres and museums of both Merseyside and Glasgow produced positive reactions, only one manager in ten from elsewhere would be 'happy to live and work there'. The positive impression of cultural facilities in Glasgow and Merseyside failed to outweigh other negative impressions. On the other hand, 44 per cent of Glasgow managers were happy to contemplate living and working in Suffolk, despite the generally low scores for its facilities (including museums and theatres). Suffolk scored very high for its 'attractive towns and villages' (91 per cent) and 'pleasant countryside' (88 per cent). By the same token, those managers who were happy to move to Glasgow and Merseyside showed no greater appreciation of the quality of available museums and theatres than those who were unwilling to move. This confirms the view that although the cultural infrastructure was an important influence on middle managers, especially in choosing to remain in a region, it was not a basic factor of overriding importance in deciding where to live and work.

Table 9.3 Views of Glasgow and Ipswich managers on places to live and work

Percentages

	'Good museums, theatres'	'Happy to live and work there'
Opinions on (a)		
Suffolk by:		
Glasgow managers	14	44
Merseyside by:		
Glasgow managers	37	11
Suffolk managers	56	9
Glasgow by:		
Suffolk managers	54	12

Source: PSI.

(a) Percentage of managers agreeing: the place has 'good museums; theatres', would be 'happy to live and work there'.

(e) *Conclusion on middle managers survey*

Middle managers and people in advanced technical posts were selected as a touchstone of whether amenity factors were relevant to employment strategies. The results showed that in choosing a region in which to live and work cultural facilities were relevant for as many as 74 per cent of managers, more so in Glasgow (77 per cent) and Merseyside (80 per cent) than in the Ipswich region (65 per cent). Other factors such as communications, housing and pleasant environment were considered rather more important. Cultural facilities were rated higher as a contributor to the good life. The arts were the second most important reason after access to pleasant countryside for 'enjoying living and working in the particular region'. This confirmed the views of those senior executives who believed that the arts were a positive influence on employment, more as a hold factor than as a pull factor.

Business sponsorship

One test of the value of the arts to the business community is the scaie of business support provided through sponsorship and donations. The survey of arts organisations estimated sponsorship at £540,000 in Glasgow, £183,000 in Merseyside and £72,000 in Ipswich. The total sum given through sponsorship was larger in Glasgow and the average size of sponsorship was greater. The figures are set out in Table 9.4

Table 9.4 Business sponsorship of the arts in Glasgow, Merseyside and Ipswich

Numbers and £

	Number of sponsorships	Total sponsorship (£)	Sponsorship from local firms (£)	Average sponsorship (£)
Glasgow	158	540,000	144,000	3,165
Merseyside	65	183,000	113,183	2,815
Ipswich	61	72,000	35,000	1,180

Source: PSI.

Glasgow was more successful at drawing sponsorship from outside the region (£396,000 out of £540,000), owing to the presence in the city of Scottish national companies in the high prestige art forms, such as opera and ballet.

Judging by the total number of sponsorships, it is evident that only a minority of companies in each of the regions was involved in the activity. Half of the executives interviewed in Glasgow, mainly in middle and large-scale companies had sponsored the arts. Some of the companies had given large amounts (£50,000), while others gave small amounts, down to a single corporate membership of the National Trust. The main characteristic of business sponsorship in the Ipswich region was the combination of a relatively large number of sponsorships with a small average value. The largest single sponsorship in 1985/86 was £8,500, though subsequently the Wolsey Theatre made a breakthrough with a major sponsorship from an overseas bank moving into the Ipswich area. The small average size of sponsorships in Ipswich was partly a result of the branch phenomenon. Many of the companies had only a small local budget for sponsorship, major decisions being made at head office. In some cases, local managers could recommend sponsorship of local events to the head office, but they had no other say. Other local companies saw no major direct benefit arising from sponsorship in the Ipswich region, especially when their products were not aimed at the local market. Most of the companies interviewed fell into this category. The latter was also a consideration in Glasgow, and in Merseyside.

Other companies, especially in Glasgow, took a wider view of the business benefits to be gained from arts sponsorship. The boost given to the status of the region by strengthening its cultural infrastructure was thought to be sufficiently important to merit financial support from the business community. In describing their motives for sponsoring as 'social responsibility to the area', companies were also aware that their support for the arts helped turn the region into a better business address, both for living and working. In this context, it is worth noting that executives generally did not think that funding the arts was the exclusive responsibility of the local authorities and of other public bodies.

Direct business benefits arising to a company from sponsorship were easier to appreciate: these included 'being a good employer' by offering employees tickets for sponsored events etc., or using the occasion to entertain business associates. In the case of a few major companies, the motive was the commercial aim of promoting a product or brand name in a particular local market. This was unusual. The relationship of most of the larger firms with the local economy was as a production centre (and employer), rather than as a market place, and they were accordingly more interested in the general benefits of sponsorship such as image enhancement. It was the smaller firms with essentially local markets, which had grasped the value of promoting their products and services through business sponsorship of the arts. Sponsorship was thought to be good value for money.

The sums of sponsorship money contributed by smaller companies were small, but the possibilities for expansion would seem to be considerable. As for the larger companies, there was much ground to be covered in reforming the 'branch mentality'.

Amenity factors in longer-term

In the longer term the amenity factor is likely to become an even more important influence on the location of businesses and their managers. Studies of the relocation of industry have shown that there is often little need for modern businesses to seek the comparative locational advantages normally associated with traditional industries. Modern methods of business communication have obviated the need for location in specific areas; to some, even the City of London nowadays would seem to be an anachronism. The growth of information technology and the 'decentralised office' reduces the need for large headquarters based in traditional locations, and so people and companies can choose to be where life is most congenial, away from congested centres. But a contrary tendency also seems to be in operation, which concentrates markets and specialisms into fewer places. The social environment of some types of business requires close proximity to political and financial centres of influence and to the sources of creative energy. In both scenarios, the role of the amenity factor would seem bound to increase, in the former case by enabling more individuals and companies to choose their favoured environment and in the latter by requiring greater efforts to make a shrinking number of city growth points more desirable places in which to live.

On an international level, a new spirit of competition is growing between the great cities, New York, Paris and London, to attract footloose headquarters and individuals seeking to live and work close to world centres of influence and creative energy. The French government is investing in Paris to make it the main cultural centre, lavishly adorned with new museums, an opera house and other 'grand projects' (many designed by international architects selected from the best in the world), and the host to the world's greatest artists and performing ensembles. In response to the French cultural card, London is replying with improvements to communications (London City Airport) and expanding available office accommodation. As the favourite destination for the travelling businessman, on grounds of good business facilities, entertainment and accommodation, London may have a head start (see *Business Traveller*, 1986) in the race to become world capital in the twenty-first century.

A further consideration is likely to increase the importance of the amenity factor. Limits may be set to the levels of financial inducements which can be offered within the EEC in aid of regional economic development. The role of non-pecuniary inducements (including improvements in amenities and cultural provision) will grow as a means of counteracting the lure of southern climates and locations closer to the centre of Europe. Indeed the competition among medium-sized towns in the South-East of England is already fierce and amenity has become a hard business fact to be considered alongside other locational factors.

Locational considerations for arts and crafts enterprises

In a different vein, the appeal of Suffolk as a business address for arts and crafts enterprises was given some consideration in the survey of artists and crafts people. This is relevant for what it reveals about the influences bearing on a particular type of small business. The respondents were asked to mark a list of 'factors you consider to be particular advantages for your creative work in being in this region of the country', and then to mark the disadvantages. The main advantage cited was the indefinable 'way of life' of the area. Local residents played some part in this, as many respondents found them friendly. But they were not seen as ready customers for craft products. The main disadvantage cited was distance from markets and suppliers, combined with the general requirement to travel. There was a difference between the responses of artists and craftspeople to the degree of creative inspiration derived from the area. This was an advantage for 75 per cent of

143

the artists but for far fewer of the crafts-people (41 per cent). The beauty of the region had proved a particular attraction for artists wishing to relocate, but less so for migrant craftspeople. Another necessity was a responsive and critical environment in which to work. A major city might supply this, as well as a bigger immediate market, better than a rural area. Both artists and craftspeople expressed dissatisfaction at the neglect of their work by critics, which they put down to being based in Suffolk, too far away from London. The other listed advantages and disadvantages were cited less often. On balance more thought that the local opportunities for alternative earnings were good than not, a major consideration with self-employed artists.

Table 9.5 Artists and craftspeople: advantages of Ipswich region as location for enterprise

Percentages

	Artists			Craftspeople		
	Total	Defin-itely	In part	Total	Defin-itely	In part
Percentage citing the following:						
'Way of life' in general	88	69	19	82	55	27
Friendly local residents	38	25	13	59	18	41
Support from others in your line of work (eg associations)	25	25	–	55	18	36
Local opportunities for sales	44	25	19	50	14	36
Creative inspiration from the area	75	63	13	41	14	27
Opportunity for other work (for self, spouse, or other family earners)	31	12	19	36	23	14
Helpful support agencies (eg CoSIRA, local authorities)	6	6	–	32	14	18
Nearness to suppliers of materials	12	6	6	23	–	23

Source: PSI.

Not surprisingly, overall the artists and craftspeople cited more advantages than disadvantages of being in the Ipswich area, but not by a large margin. On this basis, no great movement of arts and crafts enterprises either into or out of the region was predicted. Former advantages of the Ipswich area, such as the low cost of accommodation and studio space, may have lessened. The internal development of the sector would seem to be the most likely route for progress in the region.

CONCLUSION

The broad conclusion of the interviews with senior executives and leaders of the business community was that an increasing value was placed by them on cultural amenities as an encouragement to the regional economy and as a means of improving the image of and sustaining confidence in the region. The value of the arts as a business asset was most generally understood in Glasgow and most keenly felt in Merseyside. Executives in Ipswich, ambitious to turn the region into a prestige business address, saw a major role for the arts. This was an operational matter as much as a question of image. Cultural amenities were never an overriding consideration in the thinking of mover firms, but they could be an important supplementary factor, reinforcing a predisposition to locate in a particular place.

In seeking to establish branches, subsidiaries or additional plant, companies were increasingly aware of the advantages of a 'good address', and a location well-resourced with cultural amenities was taken as an indication of a dynamic, self-confident host community. Cultural facilities were a great 'comfort factor' for senior personnel, partly because they made a location more acceptable to the staff being posted there.

Good cultural amenities were also a strong factor assisting the recruitment and particularly the retention of senior and scarce managerial personnel. Senior executives thought that the quality of life was a particular influence on top post-graduate talent. The survey of staff aged 25-45 in management or advanced technical posts partially confirmed this view. In choosing a region in which to live and work cultural facilities were relevant for 74 per cent of managers but other considerations, schools, communications, housing, were rather more important. Managers were heavy consumers of the arts, which were regarded as a major factor (second only to pleasant countryside) in contributing to enjoying living and working in a particular region.

The business community put a value on the arts infrastructure in its willingness to contribute financially to its maintenance and development. More income might be pursued by the arts from that source of finance. Only a minority of businesses were involved, though the general and specific benefits of arts sponsorship were increasingly appreciated by business leaders.

Traditional locational factors were losing their importance; the new approach put a stress on the best conditions of life and work for employees and employers. This was an international development in which investment in amenity factors by public authorities and private business was part of the new spirit of competition among European (and world) cities for industrial and residential growth.

PART V: ECONOMIC POTENTIAL OF THE ARTS

10. ECONOMIC POTENTIAL OF THE ARTS

Findings of the report

The final section of this report concerns the potential for increasing the contribution of the arts to the national economy and to the quality of British life. The process must start from a recognition of the economic value of the arts, and the arts sector has already emerged in this report as a major contributor to productive employment, prosperity and the well-being of Britain. The findings of the report on this point can be summarised as follows:

— **The arts form a significant economic sector in their own right, with an annual turnover of £10 billion.**

The turnover amounted to 2.5 per cent of all spending on goods and services by UK residents and foreign buyers, and was comparable to the market for cars, motor cycles and other vehicles. Within the sector, the theatre was worth £422 million, concerts £194 million and museums and galleries £230 million. They were outweighed by the contribution of broadcasting and films and the manufacture of cultural products such as books and records (see Section 3, pp. 34ff).

— **The arts give direct employment to some 496,000 people, or 2.1 per cent of the total employed population.**

Some 228,000 were engaged in supplying artistic ideas and experiences to the public by live or mechanical (broadcasting, film) means; 99,000 made cultural products; 96,000 supplied the essential catering, travel, retailing and accommodation which underpin visits to arts events and attractions; and some 63,000 people with literary and artistic occupations worked in industries other than the arts (see Section 3, p. 53ff).

— **The arts are an expanding sector of the economy.**

Expenditure, employment and activity in museums and galleries, theatres and concerts have been increasing in the 1980s, employment by 23 per cent since 1981. The output of cultural products and of mechanical performances has also expanded (see Section 2, pp. 16ff, Section 3, p. 56 and Section 10, pp. 151ff).

— **The arts are a high value-added sector of the economy.**

The value-added, or productive contribution, of the arts sector was worth £4 billion. It was particularly high for arts events and attractions, where the value-added was equivalent to 55 per cent of turnover (see Section 3, p. 35).

— **The arts are a major export earner for Britain.**

The sector was much orientated to overseas sales, which contributed 34 per cent of turnover, compared with the 27 per cent of British manufacturing sales which are exported. The overseas earnings of the arts totalled £4 billion, representing 3 per cent of total export earnings. Some £3.2 billion were invisible earnings, which placed the arts sector fourth among the top invisible export earners (see Section 3, pp. 46ff).

— The arts provide spin-off into other industries

The fine arts are a source of ideas, stimulus, expertise and training for many of the applied arts, such as fashion, architecture, design, printing and photography. They make an input into commerce (window dressing, theatrical sales presentations, advertising), catering (hotel pianists), religion and other industries. There is a deep synergy between the creative process in the arts and other forms of creative thinking (see Section 3, pp. 50 or 51).

— The arts generate growth in ancillary industries.

People going to the theatre or visiting museums spend money on food, shopping, travel and accommodation. Attendances numbered 122 million in 1984/85, 73 million to museums and galleries and 49 million to theatres and concerts (not counting the 70 million cinema admissions and 59 million visits to historic houses). Spending on these visits totalled £4 billion, which gave rise to 190,000 direct and indirect jobs. Some £2.7 billion of this spending can be specifically ascribed to the arts and would not have taken place without the events and attractions concerned (see Section 4, p. 75).

— The arts stimulate tourism.

Tourism with an arts ingredient (basic or incidental) was worth £3.1 billion or 25 per cent of total tourist earnings. The arts were particularly important to overseas tourism; they attracted some 41 per cent of total earnings, including business tourism and visiting friends and relatives. The arts-specific element brought in £1.5 billion, or 27 per cent of the total (see Section 5, pp. 82–83).

— The arts are a potent means of sustaining employment.

The effects of arts sector spending are felt throughout the economy. Indirect employment arises from the spending of the arts organisations and their customers in the rest of the economy. The size of this effect depends on the links between the arts sector and the rest of the economy, the scale of spending at the various stages within the economy and the need for imports. From a regional point of view, each job in the arts organisations of Merseyside gave rise to a further 2.8 jobs in the region because of arts spending in the local economy. The equivalent figures in Ipswich and Glasgow were 1.8 and 2.7 jobs respectively (see Section 6 p. 104).

— The arts are a cost-effective means of job creation.

The arts were a cheaper way to create extra jobs than other forms of public sector revenue spending, including some special employment measures. The net public sector borrowing requirement cost per person removed from the unemployed count by public revenue spending on the arts in the three study regions ranged from £1,066 to £1,361. This can be compared with the cost of £2,200 for each place filled in the Community Programme and £15,300 for jobs arising from public revenue expenditure overall (see Section 7, pp. 108 and 114).

THE ECONOMIC IMPORTANCE OF THE ARTS IN BRITAIN

— **The arts are a catalyst of urban renewal.**

Arts facilities (theatres, museums, studios etc.) are a prime magnet drawing people to particular localities, including city centres at appropriate seasons and times of day: they also act as social nodes around which the future prospects of communities cohere (see Section 4, pp. 76-78).

— **The subsidised sectors of the arts provide lines of financial and artistic support to the wider commercially based entertainment sector.**

This included trained personnel, tested products and new ideas. Not all such benefits could be 'charged' to the commercial sector. The new co-financing arrangements between subsidised theatres and commercial management exemplified the growing partnership between public and private sectors, which has the effect of making the public expenditure go further (see Section 7, p. 114).

The previous findings concern the tangible economic value of the arts; other findings relate to less tangible aspects of their economic importance.

— **The arts improve the image of a region and make it a better place in which to live and work**

The public placed a positive value on this and on other perceived community benefits arising from the arts, which add to the vitality and attractiveness of a region. Over 90 per cent of the resident population in the three regions studied thought that the arts should be available, irrespective of whether they personally made use of local facilities. The arts are a source of local pride, which establishes specific regional and civic identity and inspires new-found confidence (see Section 8, pp. 128-129).

— **A strong cultural infrastructure is a business asset for a region.**

The arts boosted the confidence of the business community in a region; they added to the vitality of city centres, contributing to the longer term appreciation of property values and the quality of inner-city life. The arts can be used to express the rising status of a region as a prestige business address. This was a matter of image and also an operational consideration (see Section 9, pp. 131ff).

Locator firms take account of cultural amenities in deciding where to settle. Good arts facilities assist in the recruitment and especially the retention of senior personnel (see Section 9, p. 136-139).

Investment in amenity factors is part of the new spirit of competition among the European cities for industrial and residential growth (see Section 9, pp. 143).

THE TASK

Increasing the economic contribution of the arts to national life is a task for many partners. These include central government, local authorities and the arts organisations themselves, as well as public bodies in the arts and in tourism, and the business community. Understanding the economic value of the arts, their role in relation to tourism, regional development, the viability of urban areas (including the inner-city), not to mention their contribution to rural development, is central to grasping the opportunity.

Recognition of this point will be necessary in the appropriate areas of government and the report may be of interest to the Departments of Employment and of Trade and Industry, as well as the

Office of Arts and Libraries. Relevant responsibilities are shared among several ministries which will need drawing together in this task. Central government has an opportunity to create a more favourable climate, underpinned by measures to provide co-ordination and the application of resources appropriate to realising the growing importance of the sector.

By the same token, at the local level, development corporations, similar organisations and local authorities are key organisations and they will provide co-ordination within and among themselves, and match their resources to those of other relevant bodies, including the regional arts associations, area museum councils and tourism bodies. The partnership will extend to the private sector and to the local business community. Some agencies, especially those at the regional and local level, will wish to devise strategies for realising the economic potential of the arts; many will wish to relate this aspect of the arts to existing strategies in tourism or to more general economic strategies.

CHALLENGE OF GROWTH

(a) The sector is expanding
The process in made easier by the fact that the arts sector is already expanding. After a lull in the early 1980s, audiences for the arts have expanded so that most areas of the arts are trading at higher levels in the mid 1980s than prevailed ten years previously. Summary figures are set out in Table 10.1, which show rising attendances in all areas except dance and opera. There is a confident expectation that the wider leisure market in which the arts sector is partly situated will expand, according to a recent estimate by 26 per cent up to 1992 (see Leisure Consultants).

Table 10.1 Attendance at selected museum and galleries, theatres and concerts

Millions and percentages

| | Attendance (millions) | | Annual average |
	1981	1985	percentage change
National museums and galleries	21.5	22.9	+1.6
London's West End	8.5	10.8	+6.8
Grant-aided producing theatres	5.1	5.8	+3.4
Opera companies (a)	1.1	1.0	−1.2
Dance companies (b)	0.9	0.9	−0.7
Symphony concerts in London (c)	0.9	1.1	+5.6

Source: *Facts 2*; Office of Arts and Libraries; Society of West End Theatre; Arts Council of Great Britain.
(a) Main-scale.
(b) Main- and middle-scales.
(c) Figures relate to 1979/80 and 1983/84.

(b) Demand for higher quality
The real prices paid for admission have also been rising. After some price resistance in the early 1980s, attendances have expanded. One explanation of the phenomenon is that the market for the arts has been maturing through a growing demand for greater quality and for more personal choice in what is available. The presentation and the quality of the arts product in all its facets, from ease of travel and parking to the comfort of the venue, needs careful monitoring.

(c) Good prospects for media and entertainment
The output of the cultural industries has also expanded, with independent television and videogram sales in the forefront (see Table 10.2). The film, video and broadcasting sectors are entering a

critical period of rapid change. Many of the opportunities which may be emerging are based on a belief in expanding prospects for the media and entertainment sector as a whole. The UK market for entertainment is growing, more through a demand for greater variety, higher quality and personal choice than through any increase in the time spent by consumers on entertainment (see Leisure Consultants). On the other hand, some growth in broadcasting is likely from longer broadcasting hours and new channels of distribution, such as cable and satellite. New technologies (cassette, disc, cable, satellite) are also reshaping the industry, affecting the format and to some extent the content of the product, for example, computer-based animations. But there are major uncertainties about the consumer acceptance of new products and services, and the speed of the development. The decline of cinema (and of film registration) will be difficult to reverse, but there are new developments (including new cinema buildings) and signs of an increase in cinema admissions (see NEDO unpublished paper on entertainment sector).

Table 10.2 Output of cultural industries

£ million and percentages

	1982	1983	1984	1985	1986	Average annual percentage change
Independent television	648	760	874	939	..	+15
British Broadcasting Corporation	635	721	774	+11
Record industry (a)	272	289	329	375	425	+7
Book publishing	2,102	2,285	..	+9
Musical instruments (b)	52	51	55	57	..	+3
Videograms (c)	..	90	82	81	122	+12

Source: Business Monitor; Peacock Report; Videogram Dealers Association; BPI.
(a) Trade deliveries.
(b) Manufacture.
(c) Sale.

(d) Artistic and commercial challenge for independent producers

A boost for independent film and video producers can be expected from the growing use of their programmes by the statutory broadcasting organisations in line with the recommendations of the Peacock Report. The independents will need to gain and retain more access to the UK networks of both BBC and ITV. The growth of independent production will be matched by some shrinkage in the large broadcasting organisations. The challenge for the independents is whether a strengthened third force can achieve overall growth by bringing creative freshness, diversified products, greater commercial flair and cultural enterprise to exploiting wider markets. There are potential dangers arising from the boost to independent production by the broadcasting companies. Once the responsibility for regional production is relaxed or reduced on the part of the statutory companies, production may tend to concentrate more in London. By the same token, in the rapidly evolving international scene, major independent media conglomerates could grow to overshadow even the existing TV programme companies. Britain and its regions will need to strengthen their response in relation to these challenging prospects. On the other hand, this represents a major opportunity for London and for promoting other British centres for the screen industries, including Glasgow and Cardiff.

(e) 23 per cent extra jobs since 1981

The dynamism of the arts sector can also be seen in the employment figures which show some 23 per cent extra jobs emerging in the arts between 1981 and 1987 (see Table 3.19). Furthermore, the quality of the new jobs in the arts is good. Elsewhere in the economy the major increases have been in part-time female employment. The extra jobs in the arts were shared equally between men

and women and less than one third of the jobs for women were part-time. The scope for further increase in employment in mechanical performance will depend on new opportunities, but it may grow more slowly than output because of the considerable room for increasing productivity.

(f) Box office the main driving force

The years since the early 1980s have demonstrated a strong capacity for growth, but rising central government funding has not provided the main impetus for this, nor has it come through market forces alone. Overseas tourism has played its part in relation, say, to London's West End. Elsewhere, local authorities have made a major contribution by increasing their expenditure in the arts. The expansion has been mainly driven by the box office, with private funding playing an increasing financial, and important symbolic, role. There is some evidence of rising productivity in arts organisations (see *Facts 2* and West). And the growth has been fed by application of the new technologies. Mention was made above of the reshaping of the entertainment industry; this has implications for cultural activities in the home. Museums and galleries are applying the new technology in the management of their collections and in providing information and inter-active programmes for visitors.

(g) Rising incomes and education

An important background factor remains, rising incomes, with ticket prices paid actually increasing faster than incomes. There is abundant evidence that increase in the arts is closely related to education, especially further and higher education (see *Facts 2*). The market for the arts can be projected to rise in the light of expected increases in further education, but also in response to an emerging age of inevitably expanding leisure.

THE OPPORTUNITIES

In considering strategies for realising the economic potential of the arts, it is worth setting out some of the opportunities it presents under eight headings:

(a) Arts and tourism

(i) *Complementary relationships*

The arts and tourism enjoy a complementary relationship. Tourism supplies extra audiences for the arts, and the arts create attractions which draw tourists. Arts tourism constitutes a new market segment in tourism with distinct demand and trip characteristics. The potential for development seems considerable, since the demand is relatively new, up-market, expanding and fed by high levels of satisfaction and willingness to repeat the experience.

(ii) *Tourism saturation?*

Tourism saturation may be real fear, though the structural changes in tourism (towards short breaks, more sophisticated tastes, and activity holidays) will reinforce the expansion of arts tourism. Arts tourism can iron out seasonal variations in other forms of tourism.

(iii) *Need for reassessment of the arts in national tourism policy*

It will be necessary to develop arts tourism strategies making use, among other things, of the body of experience which is accumulating, for example, in London. Towards this end, some reconsideration of the arts in national tourism policy may be needed to reassess their place and to identify good practice and new developments in relevant areas.

(iv) *Regional dimension*

There is a particular challenge in defining and exploiting the possibilities in the great cities and rural locations outside London. The potential rewards are considerable in terms of job creation and the wider dispersal of visitors across the country. It will be particularly relevant, for example, to find the means of easing pressure on the popular museums and galleries in London and expanding

tourism to related facilities (major and minor) elsewhere in the country. Tourism has a big demand for unqualified manual labour but plenty of workers are now needed with skills, and an expansion of the arts as a primary attraction will call forth further requirements for skilled labour.

(v) *Co-ordination and local artistic roots*

It is also important that arts initiatives in the tourism context should be related to the work of existing arts organisations and grow out of the needs and ambitions of the arts community and its public. Effective co-ordination between the relevant parties (local authorities, the travel trade, tourism's administrative organs and the arts bodies) will be essential, as will be the existence of an effective means of implementing appropriate marketing and promotional initiatives.

(vi) *Broader tourism objectives*

Broader tourism objectives will have a role in relation to arts tourism initiatives. These include improvements in transport and communications, encouraging investment in accommodation and appropriate servicing of tourists with specialist promotional and explanatory literature, among other things. Support from the arts sector will be relevant in efforts to encourage investment for tourism and to remove constraints on the tourist business.

(b) **Regional variations and imbalances**

It is not surprising that the size and structure of the arts sector were different in each of the three regions which form the basis of this report. Glasgow's arts sector was the biggest of the three on all counts; its cultural industries (with major broadcasting companies, publishing houses and an independent film and video production sector) were especially important (see Table 10.3). The Ipswich region was smaller than the other two and the arts sector had a lesser place within it, but the cultural industries (especially crafts and the arts trade) were relatively more important than in Merseyside. The large number of job slots for own-account artists, community arts and other venues was the main distinguishing feature of Merseyside.

Table 10.3 Structure of the arts sector in three study regions

£ million and numbers

	Turnover (£ million)			Job numbers		
	Glasgow	Merseyside	Ipswich	Glasgow	Merseyside	Ipswich
Museums and galleries, theatres and concerts	25	14	4	1,821	1,326	492
Own-account artists, community arts (a)	5	3	1	762	806	159

Source: PSI.
(a) Including other venues.

Apart from these regional differences in the structure and scale of the arts sector, there were considerable regional imbalances in the distribution of employment (see Table 10.4) and activity (see *Facts 2*) in the arts. Over one third (38 per cent) of total employment in the arts industries was concentrated in Greater London, which attracted more than half (51 per cent) of the jobs in 'radio and television services and theatres etc.'. Museum and library jobs were more evenly distributed across the country and London contained only 23 per cent of the total. The figures on growth in employment between 1981 and 1984, admittedly a short period, set out in Table 10.5, show that London's share of the jobs fell slightly because of more rapid expansion elsewhere, especially in the rest of the South East, the South West, Wales and in Yorkshire and Humberside, the latter with a 47 per cent rise. The numbers of jobs in the North and North West fell.

Table 10.4 Employment in the arts: London and elsewhere, 1984

Percentages

	London	Elsewhere
Percentage of employees (a)		
Film production, exhibition and distribution	33	67
Radio and television services, theatres, etc.	51	49
Authors, music composers and other own-account artists	35	65
Libraries, museums and galleries	23	77
All employees	38	62

Sources: Department of Employment.
(a) Excluding self-employed and unemployed.

Table 10.5 Employment in the arts: by region

Thousands and percentages

	1981	1984	Gain/loss	Percentage change
Greater London	59.8	62.5	+2.7	+4.5
South East	21.2	23.9	+2.7	+12.7
Midlands and East Anglia	18.6	19.2	+0.6	+3.2
South West	9.2	11.5	+2.3	+25.0
Yorkshire and Humberside	9.2	13.5	+4.3	+46.2
North West	12.3	11.9	−0.4	−3.2
North	5.6	5.0	−0.6	−10.7
Wales	5.4	6.4	+1.0	+18.5
Scotland	11.6	11.9	+0.3	+2.6
All employees	153.1	165.8	+12.7	+8.3

Source: Department of Employment.

The House of Commons Select Committee on Education, Science and Arts stated in 1982 that 'we wish to ensure that people have a more equal opportunity to participate in the arts than at present so that the arts will flourish as widely as possible'. The aim should be extended to include a more balanced share in the economic benefits arising from the arts. There is the related need, referred to above in the context of the arts and tourism, to achieve a wider dispersal of visitors across the country.

(c) Arts initiatives in rural areas

(i) Main characteristics
The Ipswich region was chosen as a rural case study because it was reasonably remote from the influence of a metropolis. In that it was also experiencing a population surge and a wave of prosperity, it may not be typical of the rest of rural Britain. In the light of the usual assumptions about the isolated and passive nature of the rural existence, some of the main findings about the Ipswich region might prove to be rather surprising.

— The *reach of the arts* in the Ipswich region was generally no less than in other regions; it was even somewhat higher for the theatre. These 'metropolitan' tastes were not satisfied by the

existing levels and character of arts provision in the region. Residents and especially senior businessmen were somewhat critical of the available choice, but they were prepared to travel to the rest of the Eastern Region and to London for their arts' entertainment.

— The live arts in the Ipswich region were *mainly provided through receiving venues*, usually small organisations offering mixed programming. This was quite different from the pattern of provision in Glasgow and Merseyside (see Table 10.6). Seven out of 13 organisations in the performing arts in the Ipswich region were receiving venues.

— *Little creative activity in the performed arts originated in the region*; only four of the 13 organisations in the Ipswich region originated their own productions. In contrast, Glasgow was a great originating centre with 16 theatre companies and orchestras originating their own productions out of a total of 28 organisations active in the performed arts. Merseyside had one receiving theatre, and five companies and ensembles originating their own performances, together with five arts centres. (see Table 10.6).

— *Small venues* in the Ipswich area *attracted a much wider social mix* than most metropolitan venues. Some 46 per cent of attendances at the small venues (e.g. Quay Theatre Sudbury and village and town halls where Eastern Angles drama company toured) were C2DEs, compared with 33 per cent of the theatres and concerts in the region as a whole. The nearest equivalent figures in the other study regions were the receiving theatres in Glasgow (33 per cent C2DEs) and the Empire Theatre, Liverpool (30 per cent C2DEs).

— *Arts and crafts enterprises* and the art and antique trade formed a greater proportion of the arts sector than in the other regions.

(ii) *Initiatives*

In formulating a range of initiatives to help realise the economic potential of the arts in the Ipswich region, the regional report took account of the above strengths and weaknesses. The suggestions included:

— building up the arts and crafts;

— expanding arts-related tourism, especially cultural packages, short breaks and cultural mini-cruises;

— providing a large receiving theatre to serve the wider region;

— developing a new museum to act as a flagship for museum and heritage tourism;

— expanding the creative base of the live arts in the region (with a dance company and a chamber orchestra);

— establishing regular Suffolk Seasons of concerts, drama and dance in selected small towns and large villages of the region.

(d) **Urban redevelopment and renewal**

(i) *Linkages and the effects of arts facilities*
The arts can be an important tool for economic development, as well as a potent means of environmental improvement. This operates both through the 'customer effect', in which the arts act as a prime magnet drawing people with their spending to

particular localities, and as a source of extra jobs. The linkage between arts facilities (new or existing) and the region can be summarised under five headings. Arts projects:

— build confidence in their immediate vicinity as a business environment, amongst politicians, the public and financial decision makers;

— enhance the prestige of the region and make a mark in business and cultural circles outside the region;

— create extra jobs for people living in the locality, region and elsewhere;

— service the needs of the working population in the vicinity;

— draw significant numbers of people and their purchasing to the vicinity at appropriate seasons and times of day.

Table 10.6 Performed arts organisations and arts centres in three study regions

Number

	Glasgow	Merseyside	Ipswich
Producing theatres	2	3 (a)	1
Receiving theatres and other venues	5 (b)	1	7
Arts centres/festivals	6	5	1
Companies, orchestras, ensembles	14	2	2
Film theatres	1	1	2
Total	28	12	13

Source: PSI.
(a) Includes Liverpool Philharmonic Hall, permanent home of the Royal Liverpool Philharmonic Orchestra.
(b) Includes Theatre Royal, owned and operated by Scottish Opera.

Table 10.7 Attendances at theatres and concerts: by social class

Percentages

	ABC1s	C2DEs
Ipswich region		
All theatres and concerts	67	33
Small venues	54	46
Glasgow region		
All theatres and concerts	80	20
Receiving theatres	67	33
Merseyside		
All theatres and concerts	73	26
Empire Theatre	70	30

Source: PSI.

157

THE ECONOMIC IMPORTANCE OF THE ARTS IN BRITAIN

The geographic area in which the stimulus occurs depends on the linkages to the regional economy and the ambient circumstances around the facility, for example, the numbers of adjacent restaurants and shops. Arts facilities can be a catalyst for other developments and provide a reason to establish related facilities.

(ii) *Physical renewal*

The linkage between arts facilities and physical rehabilitation can be very immediate, concentrating on particular buildings or quarters. For example, artists were in at the beginning of the rise of Glasgow's Merchant City, with studios established in derelict buildings. But when rents begin to rise the future of such studios tends to be jeopardised. It is important to conserve the distinct contribution of the arts in such circumstances. At a general level, a study is needed to examine the opportunities for arts organisations provided by property finance and development in relation to the specific housing requirements of arts organisations, (studios and rehearsal and performing space), including the role of planning gain, and to show how appropriate finance and advice might be made available.

(iii) *Social role*

In an inner-city context, arts organisations of various different types can provide the social nodes around which future prospects can cohere. The Glasgow Citizens' Theatre played this role in the Gorbals, where the theatre and its audience kept the flame of inner-city life burning when the quarter was laid waste. The area around the theatre is now being successfully resettled.

(e) **Extra jobs**

(i) *Initiative lies with companies*
Extra jobs in the arts arise from expansion in the independent sector as well as from growth in the subsidised sector. With regard to the former, it is obvious that the initiative must lie with the industries themselves. Attention should be given to their financial needs and the particular risks involved in this activity.

(iv) *Encouraging better industrial organisation*
But public agencies can assist in a number of ways. Their basic tasks must be to maintain a favourable climate and a competitive environment for the sector. Where the sector consists of small firms, there can be benefit in drawing it together into a single voice for promotional and other purposes. This was proposed in relation to the screen industries in Scotland, uniting both the programme companies and the independent film and video production companies in a Scottish Association of Screen Industries. A similar approach was thought appropriate for the craft and design sector at a regional or city level. The design sector has not always had the public recognition it deserves. It was also proposed in Glasgow that consideration should be given to designating a Designer Quarter in the Merchant City, with workshops, studios, shops and a fashion resource centre, together with a new Costume Museum, to act as a focus. This would serve as a showcase and as a tourist attraction, bringing the market to the maker. Public agencies can also be helpful in resolving structural problems, as was suggested for the fashion trade in Glasgow, where the Scottish Development Agency might play an important role.

(iii) *High risks of research and development*
The high risk nature of the creative process poses particular difficulties. One rationale of an arts subsidy system is the experimental nature of the creative arts. In recognition of this point, public funds are made available for film production. In relation to the creative industries generally, some special consideration should be given to their financial needs and the particular risks involved in this activity. It would be appropriate in co-operation with the banks to consider extending the arrangements for soft loans in the sector.

(iv) *Improve marketing*
It should be reiterated that the many small firms in the crafts and design sector and other arts-related industries are a seedbed of future growth. Business advice is highly developed and available through many sources. More help with specific property requirements (on the part of developers and local authorities) and assistance with marketing would also reap dividends especially given the impact such businesses can have in the environment of selected localities.

(vi) *Extra jobs in the arts are an exceptionally good buy*
It was explained above that, in terms of the cost of extra jobs, the arts are a better buy than most other forms of public revenue spending. Extra jobs in the arts were found to be cheaper even than slots on the Community Programme. Though generating jobs through the arts may be desirable and economical, a number of issues remain. These include the problem of measuring output in the arts, the question of whether special employment measures (SEMs) support 'real jobs', the possible inflationary effects of expansion in public expenditure and, in particular, where the extra audiences needed to increase the 'marketed output' of the arts would come from. The conclusion on inflation is that, because the arts are such a good buy, the main argument is for a switch of resources within public spending towards the arts, rather than for an increase in the Public Sector Borrowing Requirement. In any case, excess labour supply in the arts is chronic and need not be a source of inflationary wage settlement. Extra 'spending' can be targeted towards regions with many long-term unemployed, in line with the need for dispersal referred to in the discussion of tourism policy and the need to rectify regional imbalances in arts provision. As for extra audiences, the evidence is that the level of displacement in the arts (switching audiences from one sector to another) is low. New facilities create new audiences and stimulate attendances in established attractions.

(vi) *MSC resources would be better devoted to training*
The arts have special advantages in providing the varied forms of experience relevant to the social aims of SEMs, especially the Community Programme (CP). The value to the arts of CP projects is less clear-cut. Museum and archival programmes have been particularly successful in helping long-term unemployed people into jobs. Other programmes have found a valuable niche for applying the arts to social and medical welfare. From the narrow point of view of the arts it would be better if SEM resources were devoted to assisting with training and helping bodies in a growth sector to expand output and employment. Proposals along these lines might be developed in consultation with the MSC by the regional arts associations, the Arts Councils, the Museums and Galleries Commission and the Office of Arts and Libraries.

(v) *Integrated sector*
A final question concerns training in the arts. This was not part of the remit of the report. But attention should be drawn to the point that the need for fresh talent lies at the heart of the dynamism of the arts sector. It was explained above that this feeds into the arts sector and the cultural industries by many complicated routes. The interaction between the different parts of the arts system needs emphasising, the subsidised with the commercial and the live with the mechanical. Whilst all parts do not necessarily need or deserve public financial support, long-term dangers can arise for the system as a whole if particular parts are allowed to become under-nourished. The issue has a regional dimension. For example, Glasgow is often seen as a good launching pad for a wider world, but the drain of talent away from the city towards larger markets is a continuing problem.

(f) **Overseas earnings**

(i) *Film and video*
As fourth among the top invisible export earners, the arts sector is already heavily oriented towards overseas sales. The world market for film and video is large and growing. Whilst the USA is dominant, the UK has several advantages of culture and language, and a high reputation in some areas. Production is international as performers and producers move from country to country.

Considerable growth seems possible as the new communications systems increase the prospects for international exchange. Further opportunities will emerge with the de-regulation of European broadcasting and the integration of the European market.

(ii) *Cultural tourism*

The proposed re-assessment of the place of the arts in national tourism policy will have particular relevance for the overseas market where the study has revealed that the UK already has considerable achievements resulting from the positive view held abroad of the UK's cultural assets.

(iii) *Art trade*

A threat surrounds the contribution of the arts market to overseas earnings from the EEC draft Seventh VAT Directive, calling for the replacement of the UK's special scheme of VAT on margins with a more orthodox form of tax including the imposition of VAT on imports. The danger, according to some, is that it would promote the net export of works of art from Britain, whilst driving overseas (and away from the EEC) a large part of the market place in which present transactions occur. It would be better, because of the peculiar circumstances of the international trade in art, to establish uniform treatment between the UK and the rest of the EEC by extending the special UK scheme to the other member states.

(iv) *British Council*

Encouraging commercial demand for British creative and performing arts is already implicit in the work of the British Council. This relates to, but is not necessarily identical with, the prime objective of the Council, which is to foster bilateral cultural relations by disseminating models of British creativity and excellence in the arts. It is difficult to make an assessment of the impact of Council spending and policy on the demand for British work overseas because many of the Council's activities, including the consequences of seeding new initiatives, can only be expected to have an effect over the medium or long term. Some aspects of the Council's programme relate to parts of the world not covered by agents and commercial touring, including areas where arts provision is unlikely to develop. The Council could well be encouraged to make regular assessments of its own achievements in relation to stimulating commercial demand for the arts. A limited analysis was possible in the context of this study. It showed that expenditure by the Council of £1.3 million on opera, dance, drama and music (supported and managed tours) produced an estimated direct return in the form of overseas earnings for Britain from these tours of £5.3 million. The 'gearing' (ratio of public expenditure to overall turnover) in this instance appeared to be very favourable and better than might be expected from public spending on similar companies for their operations in Britain. It is more than likely that the results would be equally impressive with regard to publishing and the book trade where the Council's promotional achievements are acknowledged. Overseas promotional activity, including creating more opportunities for producing theatres to obtain engagements overseas, has been a growing part of the Council's thinking. If the Council were to adopt a more overt promotional role overseas in relation to the arts sector overall, this would be widely welcomed. It would, however, require fuller and more systematic relations with the arts sector in Britain and it would also have implications, as the Council acknowledges, for the training of its staff.

(g) **Amenity factors**

(i) *Realising the value of the arts as a business asset: comprehensive approach*

It is worth setting out the range of responses in the three regional studies on the economic value of the arts as an amenity factor. Their value as a business asset was appreciated most in Glasgow. The link between business and the arts, based on a long tradition, was unusually strong in Glasgow. The arts had already helped offset the decline in manufacturing employment and contributed to the effort to regenerate the region. For example, the arts had fed into a number of initiatives set out in McKinsey's report on the *Potential of the Glasgow City Centre*:

— developing exportable business services (corporate video and graphic design provides such services);

— attracting headquarters to Glasgow (cultural amenities are a factor for locater firms);

— improving the city centre (the arts are basic to the animation and appeal of central Glasgow);

— improving Glasgow's image (the Burrell Collection and the creative revival of Glasgow have already had their effect);

— building Glasgow's tourist industry (cultural tourism is the cutting edge for expansion in this industry).

This is an appropriate area for public and private partnership in which the business community can take the lead.

(ii) *New identity*

Ipswich had no negative image to counteract. Some senior executives regarded arts facilities as a symbol of the vitality of the area and as an expression of its new identity as a prestige business address. To reiterate the words of one senior businessman: 'The arts create the right atmosphere in which business can operate'.

(iii) *A vision for the future*

For Merseyside the arts were one of the slender threads holding together the region's viability. They were also a factor in recruiting new blood to the region, acting in favour of the regional economy when other incentives had ceased to work. The arts were also part of a widely-shared vision of Merseyside's future, symbolised by the Albert Dock development, in which service in-dustries, high technology and tourism might interact with the arts and heritage in the economic regeneration of the region.

(iv) *International competition in amenity factors*

Those responsible for cities and regions should not fail to realise that traditional locational factors were losing some of their importance. The new approach stressed maximising for employees and employers the quality of life and work. This was part of an international development in which investment in the amenity factor by public authorities and private business evinced a new spirit of competition among British, European and world cities (New York v. Paris v. Tokyo v. London) for industrial and residential growth.

(h) **Additions to arts programmes**

(i) *Guidelines for assessing additions to cultural programmes*
In the effort to realise the economic potential of the arts, many cities and regions may wish to make additions to their cultural programmes. This will involve many pleasurable choices and some expensive investments. In the case of Glasgow, guidelines were suggested to bear in mind when judging proposals. They related to a wider strategy for realising the economic potential of the arts in the region. They were:

— Will they attract extra attendance (and increase the marketed output) for the arts in Glasgow?

— Will they enhance the prestige of the city and make a mark in international cultural and business circles?

— Will they attract international critical attention?

— Will they stimulate cultural tourism in both the short and the medium term?

— Are they consistent with the artistic ambitions and needs of Glasgow's existing arts organisations and their audiences?

(ii) *Museums have a higher economic impact: theatre market is more dedicated*

It was also shown on the basis of the impact analysis in the three regional studies that museums and galleries had a higher rate of impact (between 1.26 and 1.47 jobs created per £100,000 of museum turnover) than theatres and concerts (at 1.23 to 1.42 jobs per £100,000 turnover). Furthermore, spending by museum and gallery goers generally had a higher rate of impact than that of theatre and concert goers. This was reflected in the higher public revenue expenditure gross cost of sustaining jobs in theatres and concerts (£2,268–£4,614), compared with museums and galleries (£1,256–£2,248). On the other hand, the differences were not large and the two sectors offered complementary not rival attractions. The demand for the arts was not unified. People who attended one type of arts event were more likely than the general population to attend others. But the evidence suggests that, to a significant degree, museum and gallery goers represented a separate market-sector from theatre and concert goers. In any case, theatre and concert goers were more dedicated and determined attenders than museum and gallery goers, who seemed more willing to accept an alternative focus for their entertainment, and this counterbalanced the museum's higher rate of impact referred to above. A broad-based approach, encompassing all appropriate sectors of the arts, is therefore recommended.

(iii) *Efficient use of existing resources*

Where audiences and activities can be increased by more efficient use of resources, fuller-capacity working (less dark nights), widening the choice and adding extra programmes through existing organisations, this should be preferred. The cost of creating new facilities and new organisations is considerable. The evidence suggests that the capital cost of creating extra jobs through the arts by means of new facilities varied greatly from some £15,000 per job in the Maritime Museum and Tate Gallery Liverpool (1984/85 prices) to perhaps £100,000 per extra job in Glasgow's new concert hall.

(iv) *Role of new facilities*

On the other hand, the creation of new facilities may be essential in some circumstances. This is the case in Glasgow, where the new hall will transform the musical possibilities for the city, enable visits to be made by international orchestras and artists, as well as enhancing the quality of concert giving and generating an estimated extra attendance of 140,000. The level of displacement caused by new facilities in the arts has been shown to be low. New museums, such as the Burrell Collection, have been especially successful at generating extra attendance.

STRATEGIES FOR GROWTH

(a) Need for local strategies

The list of opportunities highlighted above is addressed to arts organisations and their partners in government, local authorities and the private sector. In devising strategies to realise the economic potential of the arts, the choice of initiatives will vary from place to place. These strategies will be influenced by, and in many places seek to reinforce, policies in parallel areas, be it urban regeneration, attracting headquarters, job creation, or promoting a region. In some instances, the arts themselves will become the main planks of such policies. The best initiatives will arise from, and relate, to local and regional ambitions. Objectives should be defined in ways which permit evaluation of their success. The Ipswich and Glasgow studies both contain costed initiatives which spell out their expected pay-off in terms of jobs. In Glasgow, for example, it was shown how some 5000 jobs might be achieved with an additional annual revenue expenditure of £1–£1.5 million, tapering off in due course as the trading income of participating arts organisations increased.

(b) Marketing related to the energy and enterprise of arts organisations

Much, indeed, will depend on the energy and enterprise of arts organisations and the relevant

public agencies, especially those on the ground such as regional arts associations. It was explained above that the utilisation of spare capacity in the arts sector is an important aspect of its job creating potential. Increasing 'marketed output' (that is the number or value of seats sold in the theatre or admissions to museums) is a key idea. Where there is waste, say, in the form of empty seats in the theatre, marketed output can be increased without much need for expanded provision. Successful marketing will be essential for achieving the full pay-off from the expanding arts sector. A marketing initiative was suggested for the Glasgow region.

(c) Private finance will be forthcoming

The prospects for realising the economic potential of the arts will be much affected by the financial context in which strategies are developed. It is clear that the private sector will become increasingly important operators. Private investment in theatres and theatre production is expanding, with more sophisticated forms of public and private partnerships evolving. There are positive returns to the arts and developers alike from providing for the arts in property schemes. Private individuals and organisations are taking a greater share of the burden of subsidy for the arts. With the recent growth of business sponsorship and the increase in box office receipts and other trading revenue to arts organisations, it is evident that the organisations and individuals which derive private benefits from the arts are contributing more to their support. There is no sign that the limits of this development have yet been reached.

(d) Public finance will remain important

On the principle that those who benefit ought to pay, the study examined the views of the general public and the business community on the benefits arising from the arts. The background to this part of the investigation was the hypothesis that the arts may give rise to general benefits for the community at large which are not reflected in the market place, in addition to the private benefits which people purchase for their immediate enjoyment. The presumption was that general benefits might require collective support because people could not be individually charged directly for these satisfactions. The results showed that practical interest in the arts was not confined to a small minority of the population and that the vast majority perceived the existence of some general benefits in the arts, such as an enhanced feeling of pride in the locality or in appreciation of their value for future generations. The positive valuation of the benefits from the arts applied to the population as a whole, irrespective of different levels of interest in, and use of, available facilities. They further indicated strong support for current levels of public spending in the sector.

(e) Central government's role

The relevant strategies will not be realised through market forces alone. But the extra resources required from central government will be small. A contribution from the centre towards a strategy for economic expansion of the arts would focus on:

— Pump-priming appropriate initiatives (including new projects and special programmes) with incentive funds, soft loans or grant-aid, as appropriate;

— Advertising good practice and successful initiatives in this area;

— Enabling the regions to benefit fully from the economic opportunity afforded by the arts whilst maintaining a national balance;

— Achieving an appropriate input by the arts into tourism development;

— Encouraging investment in the physical fabric of the arts;

— Recognising the contribution of the cultural industries and providing them with a fair and competitive trading environment.

— Ensuring that training of creative and performing artists and of the managements of arts organisations is adequate and effective;

— Encouraging, experimentation and innovation in the arts.

(f) Investing in experimentation and innovation

The latter is both the most difficult and the most vital task. Without the stimulus of continual renewal, cultural life becomes moribund. Yet no course of government action can guarantee that work of lasting quality will be produced. Experimentation and innovation bring the risk of failure. The same can be said of industrial research and development. The risks may be particularly great in artistic creation. This is one of the reasons why national governments are willing to accept responsibility for encouraging creative artistic talent.

(g) Returns to Britain

The returns to Britain in seeking to realise the economic potential of the arts would relate to the following targets:

— Expanding overseas earnings from the arts;

— Encouraging service industries in Britain (and saving imports);

— Generating extra jobs in tourism, the arts and other allied areas;

— Creating more jobs for a more highly skilled work force;

— Helping solve the problems of inner cities;

— Bringing international prestige to Britain;

— Adding to the competitiveness of Britain as a location for residential and industrial growth.

(h) National prestige and value to the public

As a result of growth in arts spending and increased business activity, tax revenue will expand. There will also be savings in social security payments from bringing people into work. It would be a mistake if arts initiatives were allowed to become exclusively fixed on job creation and other extraneous targets. Such artificiality would be self destructive. Developments in the arts need to relate to, though not necessarily be restricted by, the aims and expectations of existing arts organisations and their audiences. It is an important conclusion of this report that the arts sector is capable of great expansion which will benefit the economy. It is an even more significant fact that this will increase the artistic experience of the British people for present and future generations.

Empirical evidence was presented in Section 8 that the arts are a matter of pride in Glasgow. Local morale and the image of the city have been transformed by drawing public attention to the arts as assets which give distinction and creative vitality to the city. Other regions are beginning to learn from this example. The argument also has a national dimension. The arts are a matter of national prestige and of public morale. They are a central part of the positive image which Britain presents to the world and in this they are a major influence on relations with people abroad. On the occasion of the opening of the Burrell Collection in 1983, Her Majesty the Queen said that 'Glasgow leads from the front in matters artistic'. It is a hope springing from this report that the remark might come to apply with equal force to Britain as a whole.

Appendix 1

SURVEY METHODOLOGY

This overview report on the economic importance of the arts in Britain brings together the results of the three regional case studies carried out in Merseyside, Glasgow and the Ipswich region. Some 19 special surveys formed the basis of these studies and they are listed below:

	Mers	Glas	Ipswich
Census of arts organisations	+	+	+
Survey of sub-sector of the cultural industries		+(a)	+(b)
Arts customer survey	+	+	+
Survey of businesses attracting arts customer spending	(c)	+	+
General population survey	+	+	+
Survey of middle managers	+	+	+
Interviews with senior executives	+	+	+

(a) Film and video
(b) Arts and crafts
(c) A survey was carried out by DRV Research as part of the Merseyside Tourism Study

Virtually identical survey programmes were carried out in each of the three study regions. For detailed descriptions of the survey methodologies reference should be made to the technical appendices in each of the regional reports.

As part of the preparation of the overview report three further arts customer surveys were carried out, mainly in London: a major survey of overseas tourists at arts events and attractions; a special survey of visitors at temporary loan exhibitions; and a small sample survey of non-overseas customers at London arts events and attractions. This appendix provides a description of these surveys.

1. OVERSEAS TOURISTS

A. *Introduction*
The overall aim of the survey was to provide estimates of the earnings from overseas tourism attributable to the arts. The survey was designed to establish the market profile of overseas tourists attending arts events and attractions in London, including information about the influence of arts events and attractions in the decision to come to Britain. In addition, the survey obtained data about spending patterns related to the trip to Britain and about attendance at arts events and attractions during the trip.

B. *Strategy*
Devising a technique for ascertaining the number of overseas tourists who included arts events and attractions in their trip was a major challenge. Since a cordon survey of the UK was not a practical possibility and a satisfactory sample of all overseas tourists was otherwise impossible to obtain, it was decided to tackle the problem directly and obtain a sample of overseas tourists who actually visited arts events and attractions. Information about frequency of attendance by individuals, and about the overseas proportion of attendance at arts events and attractions provided by the survey, could be combined with the available figures on total attendance to yield the desired results.

vn from information available to the British Market Research Bureau (BMRB) from
.earch carried out for the English Tourist Board that in August and September 1984 62
per cent of all overseas bednights in England were in the London area. It seemed likely that
overseas visitors staying in London would make up more than 62 per cent of all overseas arts
visitors and so it seemed justifiable to carry out the bulk of the research within the London area.

D. *Timing*

The sampling frame was required to produce a picture of arts attendance by overseas tourists which
was representative of all visits to arts events and attractions in London during the course of a year.
Sampling throughout the year was not possible within the time and budget available for the
research, and so it was necessary to take two samples of the annual picture by carrying out field
work in two phases, one in the summer to derive information during the high season of tourism
and an additional survey phase in late autumn during the lower tourism season. Although this did
not provide for a completely accurate grossing up of annual figures, it was felt that the two phases
would take reasonable account of the main seasonal variations.

E. *Interviewing*

It was decided that personal interviewing should be used. Other options were considered, but the
need to control the samples suggested that only personal interviewing would be rigorous enough. It
was felt that a self-completion method would not achieve a satisfactory response rate and that there
would be no guarantee that the person to whom the questionnaire was given was in fact the person
who completed it. Further, it was felt that personal spending data were best gathered by a trained
interviewer who had a measure of control over the situation. The idea of using self-completion
questionnaires available in a variety of languages was rejected. Experience suggested that the
majority of overseas arts visitors were not hindered by considerations of language in answering a
series of questions in basic non-technical English; that the exclusion of non-English speaking
respondents would not materially affect the results; and that such questionnaires were rarely
completed at the point of the interview, producing only a minority response.

Interviewing was carried out by members of BMRB's fully trained field force working under
extensive supervision. Field work was conducted from 11 August to 8 September for the summer
phase and from 27 October to 30 November 1985 for the autumn phase. Interviewers were
personally briefed by a BMRB executive, and were given precise instructions about the scheduling
of their interview days. The date, starting time and finishing time of the interviewer's day was
specified for each location, and was usually 11.00am to 5.00pm or 12.00noon to 6.00pm. Each
interviewer was given a map of the location which described where to stand and whom to count.

F. *Sample design*

The use of an interview method was well suited to research at museums and galleries where
respondents could be contacted on leaving and generally would have the time to be interviewed
there and then. But it was obviously impossible to carry out long interview in theatres and concert
hall foyers. The telephone technique developed in the regional case studies was not applicable here
because difficulties would be encountered in trying to contact overseas tourists at daytime tele-
phone numbers. It was decided to rely mainly on the sample of museum and gallery goers and to
extend the questioning of this group to include details of *all* visits to arts events and attractions,
theatres and concerts as well as museums and galleries. In addition, detailed expenditure informa-
tion was obtained about the most recently completed visit during the trip to a theatre, concert,
ballet or opera or the cinema. One limitation of this approach was that overseas tourists who had
visited the theatre or a concert but not been to a museum or gallery would not be included in the
samples. As a check on the validity of the theatre and concert data obtained from museum and
gallery goers, especially the information on frequency of attendance during the trip, a boost survey
was carried out of opera, ballet and concert goers contacted at random in the West End (see
below).

THE ECONOMIC IMPORTANCE OF THE ARTS IN BRITAIN

The large number of museums and galleries in London meant that it was impractical to carry out interviews at all of them. A list of the major museums and galleries was prepared to include all of those with an annual attendance of 200,000 plus (M. Nissel, *Facts about the Arts*, 1983). These were then weighted by the proportion of overseas visitors claiming to visit the various sites according to *A Survey Among Overseas Visitors to London Summer 1984*, BTA, 1984. The field days were split equally between the summer and the winter phases and were then assigned to the various museums and galleries in proportion to their weighted attendance figures; the assignment had a probability proportional to the index of overseas visitors. The sample design covered all days of the week in which venues were open and a range of opening hours. Table A1 sets out the locations, the number of field days and the interviews obtained.

Table A1 Overseas tourist survey; field days and interviews obtained

	Field days	Interviews obtained
National Gallery	10	118
Tower of London	10	181
British Museum	14	223
National History Museum	4	56
Tate Gallery	6	63
Victoria and Albert Museum	6	70
National Maritime Museum	2	18
Science Museum	2	17
Geological Museum	2	15
Total	54	761

The completed interviews with overseas tourists numbered 412 in the summer and 341 in the autumn, 761 in total.

It seemed likely that there might be differences in the types of people visiting museums and galleries at different times of the day and week. Accordingly, for the first five minutes of each hour the interviewers were requested to count the number of adults leaving the location to establish variations in the flow of arts customers. These counts were used subsequently as a basis for weighting the museum data. The next 50 minutes of each hour was spent interviewing, using a short contact questionnaire to establish whether people were overseas tourists. This gave a basis for establishing the proportions of overseas tourists in the total attendance. Where eligible, respondents went on to complete the extended questionnaire as appropriate. The remaining five minutes of each hour were a rest period.

G. *Questionnaires*

The questionnaires were developed by PSI in discussion with BMRB. They were piloted in London before being put to use. The main questionnaire gathered information on the number of times respondents had visited each type of arts event or attraction already on the trip in Britain and the number of visits they intended to make before leaving Britain, together with the length of stay. Information on spending was collected both for the trip overall and in relation to the last completed visit to any of the following: museum or art gallery, historic house, theatre, classical concert, ballet or opera. There were also questions which attempted to measure the degree to which the respondent's trip to Britain had been influenced by the availability of arts and cultural facilities. A copy of the questionnaire, together with a count sheet and contact sheet, can be found in Appendix 2.

H. *Weighting and analysis*

The results of the survey were weighted in line with the hourly flow of visitors leaving each venue as derived from the counts. This had the effect of standardising the data for hour of day, day of week and season of the year. Most of the analysis was carried out on an 'attendance' base, which described the market profile and views of people in terms of visits to museums and events rather than the individuals undertaking the attendance. No allowance was made for the different frequencies of attendance. The weighted data yielded information on the overseas proportion in the attendance at London museums and galleries. The number of overseas tourists including visits to arts events and attractions was estimated by combining the survey information on the average frequency of visits to events and attractions (including the patterns of cross visits to more than one type of event or attraction) with the proportion of attendance attributable to overseas tourists.

I. *Boost survey*

The purpose of the boost survey was to increase the sample information on tourists who attended opera, ballet and concerts, including non-museum goers. Interviewers were not assigned to particular locations and were simply instructed to try to contact as many eligible people as they could. The questionnaire used was exactly the same as for the main survey, but covered only the most recent trip to a concert or to an opera or ballet. In the summer during two field days 15 respondents were contacted and in the autumn phase during eight field days some 31 interviews were achieved.

J. *Stratford survey*

This aspect of the research was intended to provide information on the market profile and patterns of arts attendance by overseas tourists to the theatre in Stratford-on-Avon during part of the summer and mid-autumn period. The sample method was designed to be flexible because of the limitations discussed above about carrying out interviews in connection with actual theatre performances. Interviews were to be carried out with overseas tourists who had either been to or intended to go to the theatre during their visit to Stratford, either to the Royal Shakespeare Memorial Theatre or to the Other Place. Interviewers were given a timetable of locations to try during each field day, including hotel foyers, popular pubs, busy areas in the centre of Stratford, theatre foyers, but were directed to spend more time in areas where they found a large number of eligible people. Some 10 field days spread over different performance days in the period 29 August to 14 September and 24 October to 9 November produced 97 completed interviews.

2. TEMPORARY LOAN EXHIBITIONS IN LONDON

This survey covered British and overseas visitors to temporary loan exhibitions at the Royal Academy of Arts, the Barbican Art Gallery, Hayward Gallery and Tate Gallery . London residents (and workers) included in the contact phase of the survey but were not subject to the questionnaire. The aims and the procedures adopted were similar to those of the main London overseas tourist survey and the arts customer surveys carried out in the three study regions, but in this case the questioning was concentrated on the particular attraction, the exhibition itself. The venues were chosen as the four organisations with the largest attendance amongst those presenting temporary loan exhibitions in London. Some 32 field days were assigned equally to the four venues in the period 31 October to 8 December 1986. Some 429 successful interviews were obtained. Given the small sample, it was appropriate to analyse the results in a simple form with a post-weighting in proportion to the total attendance for temporary loan exhibitions at the four institutions during 1984, the year for which the most recent figures were available. As it happened, the four exhibitions were concerned with aspects of 20th century art (three of them non-British subjects), and so a question arises about the typicality of the sample in relation to the total market for temporary loan exhibitions. The sample may have contained rather more young people and more overseas visitors than usual.

3. CUSTOMERS AT LONDON ARTS EVENTS AND ATTRACTIONS (small sample)

The overall resources available for the project did not permit a full study to be undertaken of the market for the arts in London, apart from the survey of overseas tourists. It was decided that it would be appropriate to undertake a small sample survey along the same lines as the customer surveys carried out in the three study regions. The results would be tentatively used in the overview report as a rough guide to the levels of spending by London residents, day visitors and British tourists. The survey adopted similar methods and procedures to those used in the three regional studies. Interviews at the museums and galleries were conducted as respondents left the building. For theatres and concerts the method adopted was a foyer contact with a subsequent telephone interview. The questionnaires were modelled on those used in Merseyside, with minor modifications to fit the London situation. London was defined as the 13 inner London boroughs from Hammersmith and Fulham in the west to Harringey in the north, Newham in the east and Lewisham and Wandsworth in the south. The City of London was also included. Interviews were carried out in August and September 1986. The 40 field days were split between museums and galleries and theatres and concerts. They were assigned to museums and galleries in proportion to annual attendance to a representative range of concert halls (eight days at the Royal Albert Hall and the Barbican Hall) and theatres (12 days at the Barbican Theatre, Coliseum, Royal Opera House, National Theatre, Adelphi Theatre and Palace Theatre). Some 255 interviews were completed, 138 at museums and galleries (including 33 British tourists) and 117 at theatres and concerts (including 7 British tourists). The telephone contact method worked less well in London than in the three regional studies, achieving a much lower response rate. The interviews achieved are set out in Table A2. The results were analysed in a simple form because the sample was very small.

Table A2 London arts events and attractions: interviews achieved in small sample survey

	Museums and galleries	Theatres and concerts	Total
Day visitors	56	52	108
British tourists	33	7	40
Residents	49	58	107
Total	138	117	255

Appendix 2

QUESTIONNAIRES AND SURVEY INSTRUMENTS

British Market Research Bureau, 53 The Mall, London W5 3TE

<u>OCTOBER/NOVEMBER 1985</u> <u>ARTS TOURISM (AUTUMN)</u> J.N. 9 5 4 0 5

1/2/3/4/5

Respondents Full Name (Mr/Mrs/Miss)

QUESTIONNAIRE NO.

6/7/8/9/10

CARD NO. (1)

11

Venue _____ VENUE CODE

12 13

Interviewer _____ INTERVIEWER CODE

14 15 16 17

Supervisor _____

Interview time : From _____ To _____

HOUR INTERVIEW STARTED

18 19

Date of interview _____19_____

DATE: DAY

20 21

MONTH October 22. 0

November 1

OFFICE USE ONLY

23

SEX		AGE
Man	24. 1	What was your age last birthday?
Woman	2	16 - 24 25. 1
		25 - 34 2
		35 - 44 3
		45 - 54 4
		55 - 64 5
		65 or over 6

170

THE ECONOMIC IMPORTANCE OF THE ARTS IN BRITAIN

Q.1. In which country do you normally live?

Australia	26.	1
Belgium		2
Canada		3
Denmark		4
Eire		5
France		6
Germany (West)		7
Greece		8
Holland		9
Italy		0
Japan		X
Sweden		V
New Zealand	27.	1
Norway		2
Spain		3
Switzerland		4
USA		5
Other (CODE AND STATE)		6

Q.2.

Refused 7

28.

Q.2. How many people are there altogether in your party here today?

GIVE NUMBERS OF ADULTS AND CHILDREN

ADULTS

29-30

Don't know 31. 1

CHILDREN

32-33

Don't know 34. 1

Q.3.

SHOW CARD A

Q.3. Can you tell me from this card how interesting and enjoyable you found your visit to ... (STATE VENUE) today?

Extremely enjoyable	35. 1	
Very enjoyable	2	
Fairly enjoyable	3	Q.4.
Not very enjoyable	4	
Not at all enjoyable	5	
Don't know	6	

Q.4. And when you get back home, if you meet someone who is coming to Britain, will you recommend them to visit ... (VENUE)?

Yes	36. 1	
No	2	Q.5.
Don't know	3	

Q.5. How did you travel to get here?

Taxi/Hired car	37. 1	
Bus	2	Q.6.
Tube	3	
Train	4	
Private car	5	
Walk	6	Q.7.
Don't know	7	

IF "Taxi/Bus/Tube/Train"

Q.6. How much did your personal fare to this place cost?

WRITE IN BOXES TO THE NEAREST POUND; IF NOT GIVEN IN POUNDS STERLING WRITE IN SPACE PROVIDED, SPECIFYING CURRENCY

£ ☐☐ 38-39 Q.7.

Used Travelcard	40. 1	
Don't know	2	

ASK ALL

Q.7. Before you went into this place did you have any food or drink or other refreshments, or do any shopping near here?

Yes	41. 1	Q.8.
No	2	Q.10.
Don't know	3	

172

THE ECONOMIC IMPORTANCE OF THE ARTS IN BRITAIN

IF ANYTHING BOUGHT

Q.8. How much did you spend on things to eat and drink before you went into this place

WRITE IN BOXES TO THE NEAREST POUND; IF NOT GIVEN IN POUNDS STERLING WRITE IN SPACE PROVIDED, SPECIFYING CURRENCY

£ ☐☐☐ 42-44 Q.9.

Don't know 45. 1

Q.9. How much did you spend on shopping before you went into here?

WRITE IN BOXES TO THE NEAREST POUND; IF NOT GIVEN IN POUNDS STERLING WRITE IN SPACE PROVIDED, SPECIFYING CURRENCY

£ ☐☐☐ 46-48 Q.10.

Don't know 49. 1

ASK ALL

Q.10. How many nights have you spent in London so far?

☐☐ 50-51 Q.11.

Don't know 52. 1

Q.11. How many more nights will you spend in London?

☐☐ 53-54 Q.12.

Don't know 55. 1

Q.12. How many nights have you spent elsewhere in Britain so far?

☐☐ 56-57 Q.13.

Don't know 58. 1

Q.13. How many more nights will you spend elsewhere in Britain?

☐☐ 59-60 Q.14.

Don't know 61. 1

173

Q.14. And how many nights in all will you spend in countries other than Britain on this whole trip?

[][] 62-63 Q.15.

Don't know 64. 1

65.

↓

80.

NEW CARD NUMBER 11. ②

SHOW CARD B

Q.15. Here is a list of cultural and arts attractions. Can you tell me which of these you personally have gone into so far on this trip?

CODE IN FIRST COLUMN OF GRID BELOW

ASK Q.16. FOR EACH TYPE OF PLACE VISITED AT Q.15.

Q.16. How many ... have you gone into on this trip so far in the London area? And how many in the rest of the country, outside the London area?

	Q.15.		Q.16. HOW OFTEN BEEN TO	
	VISITED	NOT VISITED	IN LONDON	ELSEWHERE
Museum	12. 1,	13. 1,	14.-15 [][]	16-17 [][]
Art Gallery	2,	2,	18-19 [][]	20-21 [][]
Historic House	3,	3,	22-23 [][]	24-25 [][]
Theatre	4,	4,	26-27 [][]	28-29 [][]
Concert of classical music	5,	5,	30-31 [][]	32-33 [][]
Ballet/Opera	6,	6,	34-35 [][]	36-37 [][]
Cinema	7,	7,	38-39 [][]	40-41 [][]

Q.17.

THE ECONOMIC IMPORTANCE OF THE ARTS IN BRITAIN

IF MUSEUM, GALLERY OR HISTORIC HOUSE VISITED AT Q.15. ASK Q.17.

OTHERS SKIP TO Q.31.

SHOW CARD C

Q.17. Before coming to this particular place, where we are now, which of these did you go into most recently during your stay in Britain?

Museum 42	1	Q.18.	:
Art Gallery	2		:
Historic House or Palace	3		:
None before this one	4	Q.31.	:
Don't know	5		:

IF ANY PREVIOUS VISIT

Q.18. What was the name of that place?

CODE IF IN LONDON OR OUTSIDE

In London 43.	1	Q.19.	:
Outside of London	2		:
Don't know	3		:

Q.19. How many days ago did you visit ... (VENUE MENTIONED AT Q.18.)

☐☐ 44-45 Q.20.

Don't know 46. 1

Q.20. Now I'd like to ask you a few questions about your visit to ... (VENUE).

How did you travel to get there?

Taxi/Hired car 47.	1	Q.21.	:
Bus	2		:
Tube	3		:
Train	4		:
Private car	5	Q.22.	:
Walk	6		:
Don't know	7		:

IF "Taxi/Bus/Tube/Train"

Q.21. How much did your personal fare to this place cost?

WRITE IN BOXES TO THE NEAREST POUND; IF NOT GIVEN IN POUNDS STERLING WRITE IN SPACE PROVIDED, SPECIFYING CURRENCY

£ ☐☐ 48-49 Q.22.

Used Travelcard 50. 1 :

Don't know 2 :

ASK ALL WHO WENT TO A MUSEUM/GALLERY/HOUSE
Q.22. How much did your ticket to ... (VENUE) cost?

WRITE IN BOXES TO THE NEAREST POUND; IF NOT GIVEN IN POUNDS STERLING WRITE IN
SPACE PROVIDED, SPECIFYING CURRENCY

£ ☐☐ 51-52 Q.23.

Free 53. 1

Don't know 2

Q.23. And did you personally buy anything while you were in there, such as programmes,
guidebooks, refreshments, souvenirs, cards, or anything else?

Yes 54. 1 Q.24.

No 2 Q.25.

Don't know 3

IF ANYTHING BOUGHT

Q.24. How much did you yourself spend on these things altogether?

WRITE IN BOXES TO THE NEAREST POUND; IF NOT GIVEN IN POUNDS STERLING WRITE IN
SPACE PROVIDED, SPECIFYING CURRENCY

£ ☐☐☐ 55-57 Q.25.

Don't know 58. 1

Q.25. Before you went into ... did you have any food or drink, or do any shopping near
the ... (VENUE)

Yes 59. 1 Q.26.

No 2 Q.28.

Don't know 3

IF ANYTHING BOUGHT

Q.26. How much did things you ate and drank before you went into ... cost?

WRITE IN BOXES TO THE NEAREST POUND; IF NOT GIVEN IN POUNDS STERLING WRITE IN
SPACE PROVIDED, SPECIFYING CURRENCY

£ ☐☐☐ 60-62 Q.27.

Don't know 63. 1

THE ECONOMIC IMPORTANCE OF THE ARTS IN BRITAIN

Q.27. How much did you yourself spend on shopping before you went into ...?

WRITE IN BOXES TO THE NEAREST POUND; IF NOT GIVEN IN POUNDS STERLING WRITE IN
SPACE PROVIDED, SPECIFYING CURRENCY

£ ☐☐☐ 64-66 Q.28.

Don't know 67. 1

Q.28. After you came out of ... did you have any food or drink, or do any shopping
near the ... (VENUE)

Yes 68. 1 Q.29.
No 2 Q.31.
Don't know 3

IF ANYTHING BOUGHT

Q.29. How much did the things you ate and drank after you came out of ...cost

WRITE IN BOXES TO THE NEAREST POUND; IF NOT GIVEN IN POUNDS STERLING WRITE IN
SPACE PROVIDED, SPECIFYING CURRENCY

£ ☐☐☐ 69-71 Q.30.

Don't know 72. 1

Q.30. How much did you yourself spend on shopping after you came out of ...?

WRITE IN BOXES TO THE NEAREST POUND; IF NOT GIVEN IN POUNDS STERLING WRITE IN
SPACE PROVIDED, SPECIFYING CURRENCY

£ ☐☐☐ 73-75 Q.31.

Don't know 76. 1

177

IF CONCERT MENTIONED AT Q.15. ASK Q.31. OTHERS SKIP TO Q.46.

Q.31. I would like you to think now about the last time you went to a concert of classical music. What was the name of the place where you went to the concert?

CODE IF IN LONDON OR OUTSIDE

In London 77. 1

Outside of London 2 Q.32.

Don't know 3

Q.32. How many days ago did you visit ... (VENUE MENTIONED AT Q.31.)

☐☐ 78-79 Q.33.

Don't know 80. 1

NEW CARD NUMBER 11. ③

Q.33. Now I'd like to ask you a few questions about your visit to the concert. How did you travel to get there?

Taxi/Hired car 12. 1

Bus 2 Q.34.

Tube 3

Train 4

Private car 5

Walk 6 Q.35.

Don't know 7

IF "Taxi/Bus/Tube/Train"

Q.34. How much did your personal fare to this place cost?

WRITE IN BOXES TO THE NEAREST POUND; IF NOT GIVEN IN POUNDS STERLING WRITE IN SPACE PROVIDED, SPECIFYING CURRENCY

£ ☐☐ 13-14 Q.35.

Used Travelcard 15. 1

Don't know 2

ASK ALL WHO WENT TO A CONCERT

Q.35. How much did your ticket to the concert cost?

WRITE IN BOXES TO THE NEAREST POUND; IF NOT GIVEN IN POUNDS STERLING WRITE IN SPACE PROVIDED, SPECIFYING CURRENCY

£ ☐☐ 16-17 Q.36.

Free 18. 1

Don't know 2

178

THE ECONOMIC IMPORTANCE OF THE ARTS IN BRITAIN

Q.36. How did you obtain the concert ticket? (Where did you buy it from?)

BOX OFFICE: Personal visit	19.	1
Mail		2
Telephone		3
TICKET AGENCY		4
BOOTH IN LEICESTER SQUARE		5
PROVIDED WITH HOLIDAY PACKAGE DEAL		6
BOUGHT OVERSEAS		7
MAILING LIST		8
OTHER (CODE AND STATE)		9

Q.37.

Don't know 0

SHOW CARD D

Q.37. How easy was it to find out what was on, and to get a ticket for what you wanted to see?

Very easy	20.	1
Quite easy		2
Quite difficult		3
Very difficult		4
Don't know		5

Q.38.

Q.38. Did you personally buy anything while you were in the concert, such as programmes, guidebooks, refreshments, souvenirs, cards, or anything else?

Yes	21.	1	Q.39.
No		2	Q.40.
Don't know		3	

IF ANYTHING BOUGHT

Q.39. How much did you yourself spend on these things altogether?

WRITE IN BOXES TO THE NEAREST POUND; IF NOT GIVEN IN POUNDS STERLING WRITE IN SPACE PROVIDED, SPECIFYING CURRENCY

£ ☐☐☐ 22-24 Q.40.

Don't know 25. 1

Q.40. Before you went into the concert did you have any food or drink, or do any shopping near to the place where you saw it?

Yes	26.	1	Q.41.
No		2	Q.43.
Don't know		3	

179

IF ANYTHING BOUGHT

Q.41. How much did things you ate and drank before you went into the concert cost?

WRITE IN BOXES TO THE NEAREST POUND; IF NOT GIVEN IN POUNDS STERLING WRITE IN SPACE PROVIDED, SPECIFYING CURRENCY

£ ☐☐☐ 27-29 Q.42.

Don't know 30. 1

Q.42. How much did you yourself spend on shopping before you went into the concert?

WRITE IN BOXES TO THE NEAREST POUND; IF NOT GIVEN IN POUNDS STERLING WRITE IN SPACE PROVIDED, SPECIFYING CURRENCY

£ ☐☐☐ 31-33 Q.43.

Don't know 34. 1

Q.43. After you came out of the concert did you have any food or drink, or do any shopping nearby?

Yes 35. 1 Q.44.

No 2 Q.46.

Don't know 3

IF ANYTHING BOUGHT

Q.44. How much did the things you ate and drank after you came out of the concert cost

WRITE IN BOXES TO THE NEAREST POUND; IF NOT GIVEN IN POUNDS STERLING WRITE IN SPACE PROVIDED, SPECIFYING CURRENCY

£ ☐☐☐ 36-38 Q.45.

Don't know 39. 1

Q.45. How much did you yourself spend on shopping after you came out of the concert?

WRITE IN BOXES TO THE NEAREST POUND; IF NOT GIVEN IN POUNDS STERLING WRITE IN SPACE PROVIDED, SPECIFYING CURRENCY

£ ☐☐☐ 40-42 Q.46.

Don't know 43. 1

THE ECONOMIC IMPORTANCE OF THE ARTS IN BRITAIN

IF THEATRE MENTIONED AT Q.15. ASK Q.46. OTHERS SKIP TO Q.61.

Q.46. I would like you to think now about the last time you went to the theatre. What was the name of the theatre you went to?

CODE IF IN LONDON OR OUTSIDE

In London	44. 1	Q.47.
Outside of London	2	
Don't know	3	

Q.47. How many days ago did you visit ... (VENUE MENTIONED AT Q.46.)

☐☐ 45-46 Q.48.

Don't know 47. 1

Q.48. Now I'd like to ask you a few questions about your visit to the theatre. How did you travel to get there?

Taxi/Hired car	48. 1	
Bus	2	Q.49.
Tube	3	
Train	4	
Private car	5	Q.50.
Walk	6	
Don't know	7	

IF "Taxi/Bus/Tube/Train"

Q.49. How much did your personal fare cost?

WRITE IN BOXES TO THE NEAREST POUND; IF NOT GIVEN IN POUNDS STERLING WRITE IN SPACE PROVIDED, SPECIFYING CURRENCY

£ ☐☐ 49-50 Q.50.

Used Travelcard 51. 1

Don't know 2

ASK ALL WHO WENT TO THE THEATRE

Q.50. How much did your ticket to the theatre cost?

WRITE IN BOXES TO THE NEAREST POUND; IF NOT GIVEN IN POUNDS STERLING WRITE IN SPACE PROVIDED, SPECIFYING CURRENCY

£ ☐☐ 52-53 Q.51.

Free 54. 1

Don't know 2

181

Q.51. How did you obtain the theatre ticket? (Where did you buy it from?)

BOX OFFICE: Personal visit	55.	1
Mail		2
Telephone		3
TICKET AGENCY		4
BOOTH IN LEICESTER SQUARE		5
PROVIDED WITH HOLIDAY PACKAGE DEAL		6
BOUGHT OVERSEAS		7
MAILING LIST		8
OTHER (CODE AND STATE)		9

Q.52.

Don't know 0

SHOW CARD D

Q.52. How easy was it to find out what was on, and to get a ticket for what you wanted
to see?

Very easy	56.	1
Quite easy		2
Quite difficult		3
Very difficult		4
Don't know		5

Q.53.

Q.53. Did you personally buy anything while you were in the theatre, such as
programmes, guidebooks, refreshments, souvenirs, cards, or anything else?

Yes	57.	1	Q.54.
No		2	Q.55.
Don't know		3	

IF ANYTHING BOUGHT

Q.54. How much did you yourself spend on these things altogether?

WRITE IN BOXES TO THE NEAREST POUND; IF NOT GIVEN IN POUNDS STERLING WRITE IN
SPACE PROVIDED, SPECIFYING CURRENCY

£ ☐☐☐ 58-60 Q.55.

Don't know 61. 1

Q.55. Before you went into the theatre did you have any food or drink, or do any
shopping near to the place where you saw it?

Yes	62.	1	Q.56.
No		2	Q.58.
Don't know		3	

THE ECONOMIC IMPORTANCE OF THE ARTS IN BRITAIN

<u>IF ANYTHING BOUGHT</u>

Q.56. How much did things you ate and drank before you went into the theatre cost?

WRITE IN BOXES TO THE NEAREST POUND; IF NOT GIVEN IN POUNDS STERLING WRITE IN SPACE PROVIDED, SPECIFYING CURRENCY

£ ☐☐☐ 63-65 Q.57.

Don't know 66. 1

Q.57. How much did you yourself spend on shopping before you went into the theatre?

WRITE IN BOXES TO THE NEAREST POUND; IF NOT GIVEN IN POUNDS STERLING WRITE IN SPACE PROVIDED, SPECIFYING CURRENCY

£ ☐☐☐ 67-69 Q.58.

Don't know 70. 1

Q.58. After you came out of the theatre did you have any food or drink, or do any shopping nearby?

Yes	71. 1	Q.59.
No	2	Q.61.
Don't know	3	

<u>IF ANYTHING BOUGHT</u>

Q.59. How much did the things you ate and drank after you came out of the theatre cost

WRITE IN BOXES TO THE NEAREST POUND; IF NOT GIVEN IN POUNDS STERLING WRITE IN SPACE PROVIDED, SPECIFYING CURRENCY

£ ☐☐☐ 72-74 Q.60.

Don't know 75. 1

Q.60. How much did you yourself spend on shopping after you came out of the theatre?

WRITE IN BOXES TO THE NEAREST POUND; IF NOT GIVEN IN POUNDS STERLING WRITE IN SPACE PROVIDED, SPECIFYING CURRENCY

£ ☐☐☐ 76-78 Q.61.

Don't know 79. 1

183

IF BALLET/OPERA MENTIONED AT Q.15. ASK Q.61. OTHERS SKIP TO Q.76.

Q.61. I would like you to think now about the last time you went to a Ballet or Opera. What was the name of the place where you saw that Ballet or Opera?

CODE IF IN LONDON OR OUTSIDE

In London 80. 1	Q.62.	
Outside of London 2		
Don't know 3		

NEW CARD NUMBER 11. ④

Q.62. How many days ago did you visit ... (VENUE MENTIONED AT Q.61.)

[][] 12-13 Q.63.

Don't know 14. 1

Q.63. Now I'd like to ask you a few questions about your visit to the Ballet/Opera. How did you travel to get there?

Taxi/Hired car 15. 1		
Bus 2	Q.64.	
Tube 3		
Train 4		
Private car 5	Q.65.	
Walk 6		
Don't know 7		

IF "Taxi/Bus/Tube/Train"

Q.64. How much did your personal fare cost?

WRITE IN BOXES TO THE NEAREST POUND; IF NOT GIVEN IN POUNDS STERLING WRITE IN SPACE PROVIDED, SPECIFYING CURRENCY

£ [][] 16-17 Q.65.

Used Travelcard 18. 1

Don't know 2

ASK ALL WHO WENT TO A BALLET/OPERA

Q.65. How much did your ticket to the Ballet/Opera cost?

WRITE IN BOXES TO THE NEAREST POUND; IF NOT GIVEN IN POUNDS STERLING WRITE IN SPACE PROVIDED, SPECIFYING CURRENCY

£ [][] 19-20 Q.66.

Free 21. 1

Don't know 2

THE ECONOMIC IMPORTANCE OF THE ARTS IN BRITAIN

Q.66. How did you obtain the Ballet/Opera ticket? (Where did you buy it from?)

BOX OFFICE: Personal visit	22.	1
Mail		2
Telephone		3
TICKET AGENCY		4
BOOTH IN LEICESTER SQUARE		5
PROVIDED WITH HOLIDAY PACKAGE DEAL		6
BOUGHT OVERSEAS		7
MAILING LIST		8
OTHER (CODE AND STATE)		9

Q.67.

Don't know 0

SHOW CARD D

Q.67. How easy was it to find out what was on, and to get a ticket for what you wanted to see?

Very easy	23.	1
Quite easy		2
Quite difficult		3
Very difficult		4
Don't know		5

Q.68.

Q.68. Did you personally buy anything while you were in the ballet/opera such as programmes, guidebooks, refreshments, souvenirs, cards, or anything else?

Yes	24.	1	Q.69.
No		2	Q.70.
Don't know		3	

IF ANYTHING BOUGHT

Q.69. How much did you yourself spend on these things altogether?

WRITE IN BOXES TO THE NEAREST POUND; IF NOT GIVEN IN POUNDS STERLING WRITE IN SPACE PROVIDED, SPECIFYING CURRENCY

£ ☐☐☐ 25-27 Q.70.

Don't know 28. 1

Q.70. Before you went into the Ballet/Opera did you have any food or drink, or do any shopping near to the place where you saw it?

Yes	29.	1	Q.71.
No		2	Q.73.
Don't know		3	

IF ANYTHING BOUGHT

Q.71. How much did things you ate and drank before you went into the Ballet Opera cost?

WRITE IN BOXES TO THE NEAREST POUND; IF NOT GIVEN IN POUNDS STERLING WRITE IN SPACE PROVIDED, SPECIFYING CURRENCY

£ ☐☐☐ 30-32 Q.72.

Don't know 33. 1

Q.72. How much did you yourself spend on shopping before you went into the Ballet Opera?

WRITE IN BOXES TO THE NEAREST POUND; IF NOT GIVEN IN POUNDS STERLING WRITE IN SPACE PROVIDED, SPECIFYING CURRENCY

£ ☐☐☐ 34-36 Q.73.

Don't know 37. 1

Q.73. After you came out of the Ballet/Opera did you have any food or drink, or do any shopping nearby?

Yes 38. 1 Q.74.

No 2 Q.76. :

Don't know 3

IF ANYTHING BOUGHT

Q.74. How much did the things you ate and drank after you came out of the Ballet/Opera cost

WRITE IN BOXES TO THE NEAREST POUND; IF NOT GIVEN IN POUNDS STERLING WRITE IN SPACE PROVIDED, SPECIFYING CURRENCY

£ ☐☐☐ 39-41 Q.75.

Don't know 42. 1

Q.75. How much did you yourself spend on shopping after you came out of the Ballet/Opera?

WRITE IN BOXES TO THE NEAREST POUND; IF NOT GIVEN IN POUNDS STERLING WRITE IN SPACE PROVIDED, SPECIFYING CURRENCY

£ ☐☐☐ 43-45 Q.76.

Don't know 46. 1

THE ECONOMIC IMPORTANCE OF THE ARTS IN BRITAIN

ASK ALL

SHOW CARD B

Q.76. We have been talking so far about what you have done already during your trip to Britain. Could you now look at this card and tell me which of these sorts of places you will visit during the rest of your stay in Britain.

CODE IN GRID

IF "None" AT Q.76. SKIP TO Q.10.

ASK Q.77. FOR EACH TYPE OF PLACE CODED AT Q.76.

Q.77. How many ... do you think you will go to on this trip during the rest of your stay in the London area? And how many in the rest of the country, outside the London area?

	Q.76. WILL GO TO AT ALL	Q.77. HOW OFTEN WILL GO TO	
		IN LONDON	ELSEWHERE
Museum	47. 1,	48-49 ☐☐	50-51 ☐☐
Art Gallery	2,	52-53 ☐☐	54-55 ☐☐
Historic House	3,	56 ☐☐	58-59 ☐☐
Theatre	4,	60-61 ☐☐	62-63 ☐☐
Concert	5,	64-65 ☐☐	66-67 ☐☐
Ballet/Opera	6,	68-69 ☐☐	70-71 ☐☐
Cinema	7,	72-73 ☐☐	74-75 ☐☐
None of these	8,		

Q.78. I'm going to ask you some questions about what this trip has cost you. Thinking of your whole trip away from home. What was the total cost of your personal fare for the trip?

WRITE IN BOXES TO THE NEAREST POUND; IF NOT GIVEN IN POUNDS STERLING WRITE IN SPACE PROVIDED, SPECIFYING CURRENCY

£ ☐☐☐☐ 76-79 Q.80.

Don't know 80. 1

NEW CARD NUMBER 11. ⑤

187

Q.79. Does this fare include the cost of the place where you are staying in Britain (such as an hotel)?

Yes	12.	1	Q.81.	
No		2	Q.80.	:
Don't know		3		:

IF ACCOMODATION NOT INCLUDED

Q.80. How much do you think the cost of where you are staying in Britain will be?

WRITE IN BOXES TO THE NEAREST POUND; IF NOT GIVEN IN POUNDS STERLING WRITE IN SPACE PROVIDED, SPECIFYING CURRENCY

£ ☐☐☐ 13-16 Q.81.

Don't know 17. 1

Q.81. And approximately how much do you think you yourself will spend on everything else while you are in Britain?

WRITE IN BOXES TO THE NEAREST POUND; IF NOT GIVEN IN POUNDS STERLING WRITE IN SPACE PROVIDED, SPECIFYING CURRENCY

£ ☐☐☐ 18-21 Q.82.

Don't know 22. 1

THE ECONOMIC IMPORTANCE OF THE ARTS IN BRITAIN

<u>ASK ALL</u>

Q.82. Finally, I'd like to ask you about what it was that made you choose to come to Britain for this trip?

SHOW CARD E

This card lists the main reasons people give for coming to Britain. Please could you tell me which one was the most important reason for coming?
And which was the second most important reason?

	MOST IMPORTANT	2ND MOST IMPORTANT
Arts and cultural things like museums/Theatre	23. 1	24. 1
Business	2	2
Shopping	3	3
Sightseeing in London	4	4
Travelling to see different parts of Britain	5	5
Visiting friends/Relatives	6	6
None of these	7	7
Don't know	8	8

SHOW CARD F

Q.83. Thinking now about only one of these reasons, that is the arts and cultural things like museums, art galleries, theatres, concerts and so on, can you tell me from this card how important a reason these sorts of things were to you in choosing to come to Britain?

My sole reason for coming 25. 1
A very important reason 2
A fairly important reason 3 Q.84.
Only a small reason 4
No reason at all 5
Don't know 6

SHOW CARD G

Q.84. Supposing that you had known, at the time you planned your visit, that there would be a strike this month and none of the cultural activities that we have been talking about would be available to you in Britain at all. What would you have done?

Come to Britain anyway 26. 1
Go somewhere else 2
Delay trip until such places were open again 3 Q.85.
Not gone on the trip at all 4
Don't know 5

Q.85. Finally, could you tell me how many times have you been to London before this visit?

27-28 ✳

Don't know 29. 1

189

NATIONAL GALLERY

Trafalgar Square

BRITISH MUSEUM

Great Russel St.

THE ECONOMIC IMPORTANCE OF THE ARTS IN BRITAIN

<u>ARTS TOURISM (AUTUMN)</u>
<u>CONTACT SHEET</u>

JN. 9 5 4 0 5
1/2/3/4/5

$(6 \rightarrow 10)$

CARD NO. ⑦

11

VENUE NO. ☐ ☐
12 13

VENUE_____

INTERVIEWER CODE ☐ ☐ ☐ ☐
14 15 16 17

INTERVIEWER_____

SUPERVISOR_____

$(18 \rightarrow 19)$

DATE: DAY ☐ ☐
20 21

MONTH

OCTOBER 22.0

NOVEMBER 1

$(23 \rightarrow 30)$

Q.1 I'm from the British Market Research Bureau and we're doing a survey
of tourists to London. Do you live in Britain (or are you from
.overseas)?

CODE IN GRID. IF 'Yes' (BRITAIN) CLOSE INTERVIEW
IF 'No' (OVERSEAS) GO TO MAIN Q'AIRE

CONTACT NUMBER	HOUR							Britain	Overseas	IF OVERSEAS; RESULT OF CONTACTS		
										INTER-VIEW	REF-USED	Lang-uage Problem
1. 31.	11	12	1	2	3	4	5	6	7	8	9	0
2. 32.	11	12	1	2	3	4	5	6	7	8	9	0
3. 33.	11	12	1	2	3	4	5	6	7	8	9	0
4. 34.	11	12	1	2	3	4	5	6	7	8	9	0
5. 35.	11	12	1	2	3	4	5	6	7	8	9	0
6. 36.	11	12	1	2	3	4	5	6	7	8	9	0
7. 37.	11	12	1	2	3	4	5	6	7	8	9	0
8. 38.	11	12	1	2	3	4	5	6	7	8	9	0
9. 39.	11	12	1	2	3	4	5	6	7	8	9	0
10. 40.	11	12	1	2	3	4	5	6	7	8	9	0

191

CONTACT NUMBER	HOUR							Britain	Overseas	RESULT OF CONTACTS		
										INTER- VIEW	REF- USED	Lang- uage Problem
11. 41.	11	12	1	2	3	4	5	6	7	8	9	0
12. 42.	11	12	1	2	3	4	5	6	7	8	9	0
13. 43.	11	12	1	2	3	4	5	6	7	8	9	0
14. 44.	11	12	1	2	3	4	5	6	7	8	9	0
15. 45.	11	12	1	2	3	4	5	6	7	8	9	0
16. 46.	11	12	1	2	3	4	5	6	7	8	9	0
17. 47.	11	12	1	2	3	4	5	6	7	8	9	0
18. 48.	11	12	1	2	3	4	5	6	7	8	9	0
19. 49.	11	12	1	2	3	4	5	6	7	8	9	0
20. 50.	11	12	1	2	3	4	5	6	7	8	9	0
21. 51.	11	12	1	2	3	4	5	6	7	8	9	0
22. 52.	11	12	1	2	3	4	5	6	7	8	9	0
23. 53.	11	12	1	2	3	4	5	6	7	8	9	0
24. 54.	11	12	1	2	3	4	5	6	7	8	9	0
25. 55.	11	12	1	2	3	4	5	6	7	8	9	0
26. 56.	11	12	1	2	3	4	5	6	7	8	9	0
27. 57.	11	12	1	2	3	4	5	6	7	8	9	0
28. 58.	11	12	1	2	3	4	5	6	7	8	9	0
29. 59.	11	12	1	2	3	4	5	6	7	8	9	0
30. 60.	11	12	1	2	3	4	5	6	7	8	9	0
31. 61.	11	12	1	2	3	4	5	6	7	8	9	0
32. 62.	11	12	1	2	3	4	5	6	7	8	9	0
33. 63.	11	12	1	2	3	4	5	6	7	8	9	0
34. 64.	11	12	1	2	3	4	5	6	7	8	9	0
35. 65.	11	12	1	2	3	4	5	6	7	8	9	0
36. 66.	11	12	1	2	3	4	5	6	7	8	9	0
37. 67.	11	12	1	2	3	4	5	6	7	8	9	0
38. 68.	11	12	1	2	3	4	5	6	7	8	9	0
39. 69.	11	12	1	2	3	4	5	6	7	8	9	0

THE ECONOMIC IMPORTANCE OF THE ARTS IN BRITAIN

British Market Research Bureau, 53 The Mall, London W5 3TE

OCTOBER/NOVEMBER 1985 STRATFORD (AUTUMN) J.N. 9 5 4 0 5
 1/2/3/4/5

Name and Address
 Not Asked

QUESTIONNAIRE NO.

6/7/8/9/10

CARD NO. ①
 11

VENUE
STRATFORD ⑦ ①
 12 13

Interviewer _____

Supervisor _____

Interview time: From _____ To _____

Date of interview _____ 19____

INTERVIEWER
CODE
 14 15 16 17

HOUR INTERVIEW STARTED
 18 19

DATE: DAY MONTH
 20 21 October 22. 1
 November 2

OFFICE USE ONLY
 23

SEX	(24.)	AGE		(25.)
Man	1	What was your age last birthday?		
Woman	2		16 - 24	1
			25 - 34	2
			35 - 44	3
			45 - 54	4
			55 - 64	5
			65 or over	6

193

Q.1 In which country do you normally live?

		SKIP TO
	(26.)	
Australia	1	
Belgium	2	
Canada	3	
Denmark	4	
Eire	5	
France	6	
Germany (West)	7	
Greece	8	
Holland	9	
Italy	0	
Japan	X	
Sweden	V	
	(27.)	
New Zealand	1	
Norway	2	
Spain	3	
Switzerland	4	
USA	5	
Other (CODE AND STATE)	6	

Refused	7	
	(28.)	Q.2

Q.2 How many people are there altogether in your party
here today? GIVE NUMBERS OF ADULTS AND CHILDREN

ADULTS [|]

(29.) (30.)

(30.)

Don't know X

CHILDREN [|]

(31.) (32.)

(32.)

Don't know X Q.3

(33.)

194

THE ECONOMIC IMPORTANCE OF THE ARTS IN BRITAIN

Q.3 Have you personally already been to a performance at the
Royal Shakespeare theatre during your visit to Stratford? (34.)

Yes	1	Q.4
No	2	Q.7

IF 'Yes'

Q.4 How many times have you been to a performance at the
theatre during your visit?
 WRITE IN BOX

 (35) Q.5

Q.5 (Thinking of the last time) How much was your ticket?
WRITE IN BOXES TO NEAREST POUND STERLING
WRITE IN SPACE PROVIDED IF GIVEN IN OTHER CURRENCY,
STATING CURRENCY

AMOUNT _____

CURRENCY _____ (36) (37)

 (37.)

Don't know	X	
Package Tour/ Included in fare	V	Q.6

Q.6 And how much did you spend when you were at the theatre
on other things like programmes, souvenirs, refreshments,
drinks and so on?

 OTHER CURRENCIES STATE STERLING CODE
 IN BOXES

AMOUNT _____
 £
CURRENCY _____

 (38.) (39.) (40.)
 (40.)

Don't know	X	Q.7

ASK ALL

Q.7 Do you expect to go to any performances at the Royal
Shakespeare theatre at all during the rest of your time
in Stratford? (41.)

Yes	1	Q.8
No	2	
Don't know	X	Q.9

IF 'Yes'

Q.8 How many performances do you expect to go to?

 WRITE IN BOX

 (42)

 (42.)

Don't know	X	Q.9

195

SKIP
TO

ASK ALL

Q.9 Have you personally been to a performance at Stratford's
 other theatre 'The Other Place' at all during your visit
 to Stratford? (43.)

 Yes 1 Q.10
 - - - - - - - - - -
 No 2 Q.13

IF 'Yes'

Q.10 How many times have you been to a performance at 'The
 Other Place' during your visit?
 WRITE IN BOX

 (44.) Q.11

Q.11 (Thinking of the last time) How much was your ticket?

 STERLING CODE
 OTHER CURRENCIES STATE IN BOXES

 AMOUNT _____ £

 CURRENCY _____

 (45) (46)
 (46.)
 Don't know X
 Included in fare V Q.12

Q.12 And how much did you spend when you were at 'The Other
 Place' on other things like programmes, sourvenirs,
 refreshments, drinks and so on?
 STERLING CODE
 OTHER CURRENCIES STATE IN BOXES

 AMOUNT _____ £

 CURRENCY _____

 (47) (48.) (49.)
 (49.)
ASK ALL Don't know X Q.13

Q.13 Do you expect to go to any performances at 'The Other
 Place' at all during the rest of your time in Stratford? (50.)

 Yes 1 Q.14
 - - - - - - - - - -
 No 2
 Don't know X Q.15

IF 'Yes'

Q.14 How many performances do you expect to go to?

 WRITE IN BOX

 (51) (51.)

 Don't know X Q.15

196

THE ECONOMIC IMPORTANCE OF THE ARTS IN BRITAIN

SKIP
TO

ASK ALL

Q.15 Where are you actually staying: in Stratford itself, close
to Stratford, or not staying in this part of the country
at all?

(52.)

Stratford	1	
Close to Stratford	2	Q.16
Not this part of the country	3	Q.22

Q.16 How many nights will you stay in Stratford (close to
Stratford) in all?

(53) (54)

(54.)

Don't know X Q.17

Q.17 In what sort of accommodation are you staying - a hotel,
a guest house, or where?

(55.)

With friends/relatives	1	Q.19
Hotel	2	
Guest House	3	
Youth hostel	4	
Caravan	5	
Other (STATE AND CODE)	6	
		Q.18

Q.18 What will be the cost of your accommodation for your
whole stay in Stratford?

STERLING CODE
IN BOXES

OTHER CURRENCIES STATE

AMOUNT _____ £

CURRENCY _____

(56.) (57.) (58.)

(58.)

Don't know	X	
Package Tour/ Included in fare	V	Q.19

197

SKIP
TO

Q.19 Were you in Stratford yesterday? (59.)

 Yes 1 Q.20

 No 2 Q.22

 IF 'Yes'

Q.20 I'd like you to think about how much money you <u>personally</u>
 spent in Stratford yesterday.

 How much did you spend on food and drink in Stratford
 yesterday (excluding accommodation)?

 <u>OTHER CURRENCIES STATE</u> <u>STERLING CODE</u>
 IN BOXES
 AMOUNT _____ £ | | | |
 CURRENCY _____ (60.) (61.) (62.)
 (62.)

 Don't know X Q.21

Q.21 And how much did you spend on shopping and other things?

 <u>OTHER CURRENCIES STATE</u> <u>STERLING CODE</u>
 IN BOXES
 AMOUNT _____ £ | | | |
 CURRENCY _____ (63.) (64.) (65.)
 (65.)

 Don't know X Q.22

THE ECONOMIC IMPORTANCE OF THE ARTS IN BRITAIN

ASK ALL

Q.22 Did you travel directly to Stratford from overseas or did you go somewhere else in Britain first?

(66.)

Direct to Stratford	1	Q.28
Somewhere else first	2	Q.23

Q.23 How did you travel to Stratford - by train, plane, car, or how?

(67.)

Train	1	Q.24
Car	2	
Other (STATE AND CODE)	3	
		Q.25

IF 'Train'

Q.24 How much did your personal fare cost?

OTHER CURRENCIES STATE

AMOUNT _____

CURRENCY _____

STERLING CODE
IN BOXES

£ [|]

(68) (69)

(69.)

Don't know	X	
Included in Package	V	Q.25

Q.25 How many nights did you stay elsewhere in Britain before you came to Stratford?

[|]

(70) (71)

(71.)

Don't know	X	Q.26

(72)
↓
(80)

199

SKIP
TO

SHOW CARD A

Q.26 Which of these types of cultural and arts attractions did
you personally go into elsewhere in Britain before you
came to Stratford? CODE BELOW

ASK Q.27 FOR EACH VISITED AT Q.28

Q.27 How many did you visit before you came to Stratford?

NEW CARD (11.)
 ②

	Q.26		Q.27
	Visited	Not Visited	Number Visited
	(12.)	(13.)	
Museum	1	1	(14.) (15.)
Art Gallery	2	2	(16.) (17.)
Historic House	3	3	(18.) (19.)
Exhibition	4	4	(20.) (21.)
Theatre	5	5	(22.) (23.)
Concert	6	6	(24.) (25.)
Ballet	7	7	(26.) (27.)
Opera	8	8	(28.) (29.)
Cinema	9	9	(30.) (31.)

ASK ALL
 Q.28

Q.28 When you leave Stratford will you be staying somewhere else
in Britain or will you be leaving Britain altogether? (32.)

Stay somewhere else 1 Q.29
Leave Britain 2
Don't know 3 Q.32

Q.29 After you've left Stratford, how many more nights will
you be staying in Britain before you leave Britain?

(33) (34)
 (34.)
Don't know X Q.30

200

THE ECONOMIC IMPORTANCE OF THE ARTS IN BRITAIN

SKIP
TO

SHOW CARD A

Q.30 And which of these types of cultural and arts places do
you expect to visit elsewhere in Britain before you leave?
CODE BELOW

ASK Q.31 FOR EACH EXPECT TO VISIT AT Q.30

Q.31 How many do you expect to visit elsewhere in Britain
during the rest of your stay?

	Q.30		Q.31
	Expect Visited	Expect Not Visited	Number Expect to Visit
	(35.)	(36.)	
Museum	1	1	(37.) (38.)
Art Gallery	2	2	(39.) (40.)
Historic House	3	3	(41.) (42.)
Exhibition	4	4	(43.) (44.)
Theatre	5	5	(45.) (46.)
Concert	6	6	(47.) (48.)
Ballet	7	7	(49.) (50.)
Opera	8	8	(51.) (52.)
Cinema	9	9	(53.) (54.)

Q.32

ASK ALL

Q.32 I'm going to ask you some questions about what this whole
trip has cost you. Thinking of your whole trip away from
home. What was the total cost of your personal fare for
the trip?

OTHER CURRENCIES STATE

STERLING CODE
IN BOXES

AMOUNT _____ £ | | | | |

CURRENCY _____ (55.) (56.) (57.) (58.)

(58.)

Don't know X Q.33

SKIP
TO

Q.33 Did this fare include the cost of all the places where you
are staying in Britain?

(59.)

Yes	1	Q.35
No	2	Q.34
Don't know	3	Q.35

IF 'No'

Q.34 How much do you think the cost of all the places you are
staying in Britain on this trip will have cost you in all?

OTHER CURRENCIES STATE

AMOUNT _____ £

CURRENCY _____

STERLING CODE
IN BOXES

(60.) (61.) (62.) (63.)

(63.)

Don't know X Q.35

ASK ALL

Q.35 Approximately how much do you think you yourself will
spend on everything other than where you stay during your
whole trip to Britain?

OTHER CURRENCIES STATE

AMOUNT _____ £

CURRENCY _____

STERLING CODE
IN BOXES

(64.) (65.) (66.) (67.)

(67.)

Don't know X Q.36

Q.36 Will you be visiting any countries other than Britain
on your whole trip?

(68.)

Yes	1	Q.37
No	2	
Don't know	X	Q.38

IF 'Yes'

Q.37 How many nights in all will you spend in countries other
than Britain on this whole trip?

(69) (70)

Q.38

THE ECONOMIC IMPORTANCE OF THE ARTS IN BRITAIN

SHOW CARD B

Q.38 I'd like to ask you how important a reason the Royal
Shakespeare theatre was for your coming on this trip to
Stratford. Please choose an answer from this card. (71.)

My sole reason for coming	1	
A very important reason	2	
A fairly important reason	3	
Only a small reason	4	
No reason at all	5	
Don't know	6	Q.39

SHOW CARD C

Q.39 Supposing that at the time you planned your visit you
had discovered that the Royal Shakespeare Theatre would be
closed just for this year. What would you have done? (72.)

Come to Britain and also still visited Stratford	1	
Come to Britain but not visited Stratford	2	
Delayed visit to Britain till next year	3	
Gone to a different country	4	
Not gone on a trip at all	5	
Don't know	6	Q.40

SHOW CARD D

Q.40 Now, this card lists the main reasons people give for
coming to Britain. Please could you tell me which was
your most important reason? And your second most
important reason?

	Most Important (73.)	Second Most Important (74.)	
Royal Shakespeare Theatre at Stratford	1	1	
Arts and cultural things throughout Britain	2	2	
Business	3	3	
Shopping	4	4	
Sightseeing in London	5	5	
Travelling to different parts of Britain	6	6	
Visiting friends and relatives	7	7	
None of these	8	8	
Don't know	9	9	Q.41

SKIP
TO

Q.41 Have you been to the Royal Shakespeare Theatre at Stratford
before your visit this year?

(75.)

Yes 1 Q.42

No 2

IF 'Yes'

Q.42 In how many years have you been to the Royal Shakespeare
Theatre in Stratford?

(76.) (77.)

Don't know X

(77.)

(78)
↓
(80)

THE ECONOMIC IMPORTANCE OF THE ARTS IN BRITAIN

<u>ART TOURISM</u>(SUMMER)

JN.95405
1/2/3/4/5

<u>THEATRE AUDIENCE SHEET</u>

6 —10

Card No.

⊗

11

THEATRE
CODE

☐☐

12 13

Interviewer _____

Supervisor _____

Code No: ☐☐☐☐
14 15 16 17

DATE ☐☐ DAY
18-19 20 21

☐ MONTH
22

Hours worked_____pm to _____pm

Q. Were doing a survey to find out the proportion of the audience who are from overseas. Do you live in Britain or are you from overseas?

<u>LIVE IN BRITAIN</u>	<u>LIVE OVERSEAS</u>
1 2 3 4 5 6 7 8 9 10	1 2 3 4 5 6 7 8 9 10
11 12 13 14 15 16 17 18 19 20	11 12 13 14 15 16 17 18 19 20
21 22 23 24 25 26 27 28 29 30	21 22 23 24 25 26 27 28 29 30
31 32 33 34 35 36 37 38 39 40	31 32 33 34 35 36 37 38 39 40
41 42 43 44 45 46 47 48 49 50	41 42 43 44 45 46 47 48 49 50
51 52 53 54 55 56 57 58 59 60	51 52 53 54 55 56 57 58 59 60
61 62 63 64 65 66 67 68 69 70	61 62 63 64 65 66 67 68 69 70
71 72 73 74 75 76 77 78 79 80	71 72 73 74 75 76 77 78 79 80
81 82 83 84 85 86 87 88 89 90	81 82 83 84 85 86 87 88 89 90
91 92 93 94 95 96 97 98 99 100	91 92 93 94 95 96 97 98 99 100

Totals: Live in Britain ☐☐☐ 23-25

Live Overseas ☐☐☐ 26-28

Total ☐☐☐ 29-31

32 →80

ARTS TOURISM (AUTUMN) JN. 9 5 4 0 5
 COUNTS SHEET 1 1/2/3/4/5

$(6 \rightarrow 10)$

CARD NO. ⓪

 11

 ☐ ☐
VENUE CODE
 12 13

INTERVIEWER CODE ☐ ☐ ☐ ☐
 14 15 16 17

VENUE_____

 $(18 \rightarrow 19)$

INTERVIEWER_____

 DATE: - DAY ☐ ☐
SUPERVISOR_____ 20 21

 - MONTH

 OCTOBER 22.0

 NOVEMBER 1

 $(23 \rightarrow 30)$

	HOUR WORKED							NUMBER COUNTED IN 5 MINUTES			
31	11	12	1	2	3	4	5	32-34	☐	☐	☐
35	11	12	1	2	3	4	5	36-38	☐	☐	☐
39	11	12	1	2	3	4	5	40-42	☐	☐	☐
43	11	12	1	2	3	4	5	44-46	☐	☐	☐
47	11	12	1	2	3	4	5	48-50	☐	☐	☐
51	11	12	1	2	3	4	5	52-54	☐	☐	☐
55	11	12	1	2	3	4	5	56-58	☐	☐	☐

APPENDIX 3

NOTE ON SOURCES OF DATA ABOUT THE COMPOSITION OF ARTS ATTENDANCE

It is worth summarising the sources of the various figures on overseas attendance included in Tables 5.1 and 5.2 of the main report.

A. *London museums and galleries*
The overseas proportion in museum and gallery attendance in London was obtained from the weighted data of the London overseas tourist survey. The samples were not large enough to give reliable results for the individual facilities, but it would appear that the Tower of London attracted the largest overseas proportion at 60 per cent of total attendance, with the British Museum attracting 44 per cent. These figures can be compared with the overall overseas proportion for London museums and galleries of 31 per cent. The split between British tourists, day visitors and residents was based on data in the OPCS survey of the Science Museum and the Victoria and Albert Museum, summarised in *Facts 2*.

B. *London theatres and concerts*
A survey was undertaken to establish the proportion of overseas tourists in the audience of theatres in central London. Interviewers were used to monitor the arrival of audiences for three-quarters of an hour before the performance began. The placing of interviewers in theatre foyers was chosen in conjunction with the theatre managements to ensure a representative flow of respondents whilst minimising the inconvenience to the general public. The interviewer simply ascertained whether the respondent was a UK resident or from overseas. A representative sample of the London theatres audience was obtained by dividing the theatres into three groups according to their product (the two national theatres; theatres presenting musicals; and the rest playing comedy or serious drama). Some 20 field days were assigned to the three groups in proportion to the seating capacities of the theatres; within the groups, the field days were assigned again in proportion to seating capacity. The interview programme, which took account of the different days of the week, was carried out in two phases, from 12 August to 7 September and from 28 October to 23 November 1985. The autumn phase was designed exactly to repeat the summer pattern.

Some 2,660 interviews were completed. As for the analysis, the summer and autumn phases were averaged and the results post–weighted by the actual total attendance in each of the three groups. The Society of West End Theatre supplied data on attendance at musicals; the national theatres and opera and dance houses were covered with information taken from *Facts 2*. The overseas percentage of opera and dance theatres was taken from the Royal Opera House survey (summarised in *Facts 2*). The resulting estimate for the overseas proportion in the London theatre audience was 42.5 per cent. This can be compared with an estimate of 37 per cent for the period May 1985 to April 1986 supplied by SWET from the box office research carried out by City University. PSI's figures may be somewhat high because of a possible tendency for overseas tourists to arrive earlier for a performance than residents; equal sampling during the 45 minutes before a performance could have led to an over-representation of overseas tourists. On the other hand, the overseas proportion in the West End audience was estimated at 42 per cent for 1985 in the London Tourist Board and Convention Bureau's *Tourism Strategy for London*. Nevertheless, it was decided to average the SWET and the PSI figures to produce a final estimate of the overseas proportion of 39.5 per cent. The split between British tourists, residents and day visitors was taken from the SWET study prepared by City University (see Gardiner). An estimate of the overseas proportion in the London concert audience of 8 per cent was prepared from existing audience surveys summarised in *Facts 2*, several of which had been carried out in previous years. This was combined with the theatre estimate in an average weighted by actual attendance figures to produce an overall figure for the overseas proportion in theatre and concert audiences in London of 35 per cent.

THE ECONOMIC IMPORTANCE OF THE ARTS IN BRITAIN

C. *Elsewhere*

The figures on the composition of arts attendance elsewhere in Britain are based on the results of the three regional case studies, with various minor adjustments, for example, to the museum and gallery figures, where the overseas proportion has been revised upwards to take account of the English Tourist Board estimates (see *Heritage Monitor*, 1985), which were more representative of a wider range of institutions than those covered in the three regional case studies.

APPENDIX 4

A NOTE ON METHODS FOR ESTIMATING OVERSEAS EARNINGS IN THE ARTS

INTRODUCTION

The purpose of this part of the research was to provide estimates of the overseas earnings of the arts. The results and their implications are discussed in Section 3 of the main report. This note sets out the details of the results, summarises the main sources of information and explains the methods of estimation.

This note concerns only the direct earnings arising to the arts from the sale of artistic goods and services overseas. The indirect effect on overseas tourist earnings of arts events and attractions based in Britain is considered in Section 4 of the report, where estimates of the value of overseas tourist earnings attributable to the arts, together with the methods used for assessing the influence of the arts on decisions to make the trip to Britain, are discussed.

The available official statistics were better on visible trade than on invisible earnings. In general, the gaps in information about visible trade were filled by reference to industry sources. As for invisible earnings, official statistics include good data on film and broadcasting companies. Otherwise, the necessary statistics were assembled by direct enquiries from arts organisations and their representative bodies or by inference from available information. The approach varied sector by sector.

The statistics have been assembled following as closely as possible the approach used in the preparation by the Central Statistical Office of the official estimates of the United Kingdom balance of payments, published annually as the Pink Book or *United Kingdom Balance of Payments*. These record transactions between residents of the UK and residents overseas in a way that is suitable for analysing the economic relations between the UK economy and the rest of the world. The term 'resident' covers both individuals living permanently in the UK and corporate bodies located here, but not their overseas branches and subsidiaries. Remittances to the UK from non-resident branches and subsidiaries, but not their total receipts, are treated as UK earnings. Whilst the Pink Book covers both credits and debits, the remit of this study covered only the credits. In some cases (e.g. the overseas earnings of symphony orchestras) it was appropriate to record earnings net of relevant overseas expenses (e.g. travel and accommodation costs) by the institutions concerned.

The figures referred to the financial year 1984/85, or to the nearest equivalent 12 month period. This was selected as the most recent year for which information was available.

The scope of the figures relates to the definition of the arts sector employed in the study overall. These are classified in five main groups:

— theatrical performance, films and TV material;
— musical performance, recorded and broadcast material;
— publishing and the book trade;
— art trade, visual arts and crafts;
— miscellaneous transactions.

Where appropriate, the distinction has been drawn between earnings from services (in the form of fees and royalties) and from the sale of cultural goods. The details of the sectors are described in the following five sections.

1. THEATRICAL PERFORMANCE, FILMS AND TV MATERIAL

1.1 Receipts from live performance by theatre companies (£4.5 million)

(a) *Drama companies* (£2.3 million)

The overseas earnings of drama companies were taken to be equivalent to the performance fees received by the companies (usually relating to actors' payments, production and management costs) and the subsistence payments to the travelling party. In effect, the figure represents the earnings to the company and its personnel resulting from its *artistic* operation overseas. International fares and expenditure on accommodation were excluded from the calculations. These were often the responsibility of overseas promoters and generated few direct or indirect earnings for the UK. Even when fares and hotels were paid for by the British drama company with finance supplied from overseas any earnings for Britain by British carriers or UK owned hotel chains would have been virtually impossible to unravel. The earnings relate to an estimated 1,500 performances and these are set out below according to the different categories of companies.

	Earnings (£ thousand)	Number of tours	Number of performances
National companies	649 (a)	1	..
British-Council supported tours	534	21	439
Other small-scale companies (b)	175	90	577
Commercial companies (b)	896	16	400

(a) Excluding British Council support.
(b) Excluding British Council supported tours.

Of the national companies, the National Theatre gave no overseas performances in 1984/85, though in the following two seasons £575,000 was earned from touring abroad. The figure included here was supplied by the Royal Shakespeare Company. Some 26 companies were involved in tours supported and managed by the British Council. Details of performances (439 in 1984/85), tour days and company sizes were obtained from British Council records; financial information from a sample of tour budgets provided the basis for estimating earnings. The same financial information was used to estimate the earnings of the small touring companies. Information on the number of overseas performances by these companies was supplied by the Arts Council (two clients in the small-touring category gave performances overseas), the Independent Theatre Council (the annual survey of members shows 21 companies working abroad not included in any of the previous categories) and the Netherlands Theatre Institute (its record of visiting companies contained 21 British groups and 6 one-man shows). The latter figure was used as a basis for estimating small-scale touring in the rest of Western Europe, bearing in mind that the opportunities for touring in the Netherlands were exceptionally good. The estimated earnings from commercial touring companies took into account the list of companies using Actors' Equity overseas touring contracts (by no means comprehensive) and information supplied by overseas actors' unions on the number of actor weeks worked by (and the relevant fees for) British artists in unit companies: US Equity, 192 actor weeks; Canadian Equity, 583 weeks; Equity of Australia, 9 unit company tours. It should be noted than none of the Arts-Council funded producing theatres undertook foreign engagements in 1984/85; it would seem that this was not an untypical year.

(b) *Dance companies* (£0.8 million)

The major British dance companies provided information in a survey of the number of overseas appearances. The data were crossed-checked with the British Council which, together with the

Independent Theatre Council, supplied further information on smaller companies. Details of companies and overseas appearances are listed below:

	Performances
Royal Ballet and Sadler's Wells Royal Ballet	74
Medium-scale companies (Rambert and London Contemporary Dance)	30
Other British-Council-supported tours	72
Other companies (8)	159

The Royal Ballet performed in Southern and Eastern Europe; Sadler's Wells Royal Ballet had an ambitious tour to New Zealand and the Far East; Ballet Rambert toured to Portugal, Turkey and Cyprus. Of the other main-scale companies, Scottish Ballet and London Festival Ballet gave overseas performances in 1985/86, but not in 1984/85. A number of smaller companies and commercial operations toured abroad relatively often. London City Ballet, for example, gave 43 performances on three tours in Scandinavia. Figures on earnings by the Royal Ballet and Sadler's Wells Royal Ballet were supplied by the companies; the remaining figures are estimates derived from a sample of budgets held by the British Council.

(c) *Opera companies* (£1.4 million)

The mounting of overseas performances by opera companies is an expensive operation and rarely succeeds without resort to special grants and donations from the British Council and from private sources, including sponsorship. There is little market opportunity overseas for small-scale opera tours. Figures on performances and earnings were supplied by the companies. The performance numbers were as follows:

	Performances
English National Opera	26 (USA)
Opera North	3 (East Germany)
Royal Opera	11 (USA)
Welsh Opera	3 (West Germany)

The figures on earnings may include some allowance for fares and are not strictly comparable with the equivalent figures on drama, dance and symphony orchestra tours. English National Opera estimated overseas expenditure on payments to artists and on travel to see important productions abroad at £138,000 in 1985/86.

1.2 Exploitation of rights and other earnings by theatre companies (£1.1 million)

Figures on earnings from the overseas exploitation of rights were taken from the annual reports of the national drama companies. English National Opera provided information on earnings from co-production with foreign companies, the hire and sale of sets and costumes, and donations from individuals overseas, totalling £301,000 in 1985/86. No separate figures were available for overseas earnings from the Royal Opera House National Video corporation productions; these are accounted under film and TV earnings.

1.3 Appearance fees for individuals and ensembles (£8.6 million)

(a) *Stage appearances by individual actors* (£0.5 million)

The earnings of individual actors from stage appearances abroad were estimated from figures supplied by the actors unions in the USA and Canada. The engagement of overseas artists in these countries is strictly controlled and the unions monitor this closely. Work permits were granted in the USA for the equivalent of 408 actor work weeks and in Canada for 72 weeks. Further allowance was made for the fact that a number of UK actors found engagements in Australia, Sweden and South Africa and several English language theatre companies operate abroad, including a well established theatre in Vienna.

(b) *Variety artists* (£4.5 million)

Variety artists negotiate their own contracts with overseas managements. Equity of Australia recorded that 53 UK acts (79 individuals) were engaged in 1984/85, with their length of stay limited to a maximum of two months, and their earnings estimated at 3,000 Australian dollars a spot. The total overseas earnings of variety artists might be roughly estimated at £4.5 million.

(c) *Choruses and dancers* (£2.7 million)

Actors' Equity estimate that some 1,000 dancers were employed overseas on Equity contracts, with 200 being abroad at any one time. The average sterling equivalent fee for a dancer was £120 per week plus £90 subsistence. According to Equity, engagements were increasing in the Far East, especially in Japan in hotel and cabaret venues, whilst opportunities were declining in the Middle East.

(d) *Circus performers* (£0.5 million)

Some information was provided by Chipperfield's Circus and by Actors' Equity. Circus tours tend to be long and involve many non-resident artists. Only the principal ancillary workers and a few core performers tend to be UK residents; on the Chipperfield's eight-week seasons in Hong Kong for Christmas 1983 and 1984, they amounted to half the team. Chipperfield's have been touring in Taiwan since June 1985.

(e) *Guest appearances* (£0.4 million)

The value of overseas guest appearances by ballet dancers, choreographers, opera and drama directors, designers and lighting directors can only be estimated very roughly. Many UK directors work in the world's theatres, especially European, North American and Australian houses. This estimate relates to their fee income.

1.4 Royalties from the performance of British work (£19.7 million)

The figures weres based on information taken from *Variety*, the principal North American stage newspaper. This publishes weekly figures on box office receipts for Broadway shows and major touring productions. These were analysed for their British contributions. The Society of West End Theatre obtained from its New York counterpart information on the British participation (authors, producers, directors, designers or other) in productions listed in *Variety*. During 1984/85 some 15 Broadway shows alone had at least one type of British artistic input and the British flavour on Broadway has continued to expand. Royalty percentages were calculated on the following standard basis:

	Percentage
Authors	10.0
Producers (a)	2.5 (a)
Directors (b)	2.0 (b)
Designers	1.5–2.0
Others	0.5–1.0

(a) Rises to 3 per cent post recoupment.
(b) Rises to 4 per cent post recoupment.

Pre- and post-recoupment was judged according to *Variety's* own classifications; 'success', 'failure', 'non-profit'. The royalty earnings of 'successes' were estimated on a post-recoupment basis. Similar techniques were used for calculating British royalties from shows on the road, numbering 19 in the 1984/85 season. Five shows, including one of the four North American productions of *Cats*, were on the road for the major part of the year. Average durations (derived from *Variety* by dividing total playing weeks by the number of shows) were used for estimating the royalties of the other shows. The royalty earnings from North American productions were estimated at £12.8 million, of which £6.8 million was earned on Broadway, with the rest 'on the road'. The Really Useful Group plc provided information on their earnings from *Cats* which validated the method used in the estimating procedure. The company's North American remittances totalled £8 million in 1985/86 with £4.9 million from the rest of the world. This ratio was used for converting total British North American earnings into an estimate of world earnings from stage performances of British work. It is assumed that this also covers earnings from stock hire of plays and foreign language rights, for which no separate information was available.

1.5 Film and television companies (£370 million)

The source for this information was the estimates obtained from the Department of Trade and Industry's annual enquiry into overseas transactions by film and television companies, relating to the production and exhibition of cinematographic film and television material. This is published in *British Business* and is summarised in *Business Monitor* MA4. The survey covered 316 film companies and 18 television programme companies. The information encompasses royalties from the showing of film and TV programmes, including the sale of 'formats', and the earnings of UK production houses. Excluded are figures on interest, profit and dividends from overseas branches, which are recorded elsewhere in the Pink Book, but not separately itemised. The DTI survey includes overseas expenditure as well as receipts. The net earnings for film companies were £136 million (£260 million gross) and for television companies £28 million (£110 million gross). Gross receipts rose by 116 per cent from 1980 to 1985, net receipts by 102 per cent. Some 66 per cent of film receipts, an expanding share, were from North America, compared with 59 per cent of television earnings. These figures also include the residual payments for UK actors and other artists arising from the screening of material abroad. Actors' Equity estimated residual payments to actors made by the BBC at £2 million and £7 million by ITV. For the most part, these figures relate to invisible earnings, but, according to the DTI, they included about half the £31 million physical exports of exposed cinematographic film as recorded by the Customs and Excise.

1.6 Fees and royalties paid direct to film and TV writers, actors and other artists (£15 million)

Some writers, actors and others involved in film, video and television productions are engaged directly by overseas production companies. Most of the work for actors was limited to major artists; the rest was probably of little significance, judging by the Australian figure where seven UK actors were engaged in 1984/85, five in television (three for commercials) and two in films. Opinions in the industry on the earnings by script writers and directors from overseas film and television work varied greatly. The chosen estimate lies towards the lower end of the range.

1.7 Ancillary goods and services (£24 million)

The figure includes theatre consultants (theatre design and rigging, including box office systems), artists, agencies, the provision of crews for overseas theatres and trade shows and the hire/sale of equipment (lighting, sound, rigging, cameras). Figures for the earnings of theatre consultants were estimated on the basis of enquiries among the leading companies. Their engagement often leads to orders for British theatre equipment. An informed industry source provided figures for the overseas earnings from the hire of equipment. In addition, the official trade statistics include some relevant details; 'theatrical scenery, back-cloths' (£3.2 million); 'roundabouts, swings, home ground amusements, travelling circus and theatre' (£7.8 million).

2. MUSICAL PERFORMANCES, COMPOSITION, PUBLISHING, RECORDED AND BROADCAST MATERIAL

2.1 Appearances by orchestras, ensembles and soloists (£10.3 million)

(a) *Symphony orchestras* (£1.8 million)

The symphony orchestras supplied figures on numbers of overseas engagements. They are set out below:

	1982/83	1983/84	1984/85
London orchestras	86	102	131
Contract orchestras	28	10	33
BBC orchestras	24	16	46
Total	138	128	207

They show a marked growth, especially by the London orchestras; which enjoyed an active concert life abroad and, as fee-based organisations, found overseas engagements a useful extra. Earnings were inferred by reference to financial details supplied by two of the orchestras. The basis of the estimation for the four London orchestras was the same as that described in 1.1 (a) above. The earnings of the contract orchestras were either taken from annual reports or supplied direct by the orchestras. They consisted of fee income, which usually represented the marginal cost of undertaking the engagement, and so the figures are not strictly comparable with the London figures. In estimating the earnings of the BBC orchestras it was assumed that these were comparable with the London orchestras, although it is realised that as salaried bodies, they also had similarities with the contract orchestras. The figures on symphony orchestras relate to income from engagements. Income from other sources was either negligible or is included elsewhere (e.g. income from recordings).

(b) *Chamber orchestras* (£1.1 million)

The figure was based on information about the number of overseas performances, supplied by 13 out of 16 surveyed chamber orchestras, there was an element of grossing-up and full allowance was made for the different size of groups. Information on fees and subsistence payments was obtained from a number of sources, including the British Council and the Musicians' Union. Overseas performances of chamber orchestras numbered 254 in 1984/85.

(c) *Individual musicians, solo artists, small ensembles and groups* (£5.2 million)

Figures were obtained on the overseas earnings of a selection of UK artists represented by two of the major British concert agents. Industry sources suggested that these amounted to one third of the overseas earnings of solo musicians represented by members of the British Association of Concert Agents (BACA). It was assumed that BACA artists accounted for 90 per cent of total overseas earnings by UK artists. The estimate includes a small sum for overseas earnings by agents from the representation of non-UK resident artists. One agent indicated that singers accounted for 46 per cent of earnings, conductors 31 per cent and instrumentalists and ensembles 23 per cent. Some 66 per cent of earnings were from the continent of Europe, with 30 per cent from North America and 4 per cent from the rest of the world.

(d) *Pop, jazz, folk and light music artists* (£2.2 million)

The estimate is derived from figures supplied by the Musicians' Union (MU) on British musicians working overseas under its reciprocal agreements with overseas unions to facilitate the exchange of musicians. These numbered 10,433 musician days in 1984, of which 9,568 were in the USA. The

agreement with the American Federation of Musicians was very strong and the information there was likely to give an accurate and full picture of the situation. Earnings were estimated at $65 per hour, the regional musician's rate in the USA, with an average performing session lasting two hours. Appropriate subsistence payments were added. An allowance was made for touring in the EEC which is not subject to the MU agreement. The quality of this estimate is low. Recording companies regard overseas tours principally as promotional exercises and the main earnings for musicians arise from record sales. The overseas concert earnings of star musicians defied estimation.

2.2 Performing rights to composers, writers, publishers (£22.3 million)

A figure of £22.3 million was supplied by the Performing Right Society (PRS), which represents the vast majority of composers, songwriters and music publishers in the UK. The 1984 figure represented a 13 per cent increase on 1983. Some 49 per cent of rights were received from North America, with 40 per cent from Western Europe. The PRS does not collect royalties for dramatico-musical works, which are subject to negotiable agreements for rights in performance or broadcast.

2.3 Recorded Material (£473 million)

(a) *Sales of records and pre-recorded tapes* (£77.1 million)
The figures on trade values and volume were obtained from the trade statistics published in *Business Monitor* MQ 12 and they show a rising trend, despite the fact that, according to British Phonographic Industry, 26 UK pressing plants have closed since 1979.

£ million

	1980	1981	1982	1983	1984
Audio	37	39	44	55	56
Video	6	12	17	15	21
Total	45	51	61	70	77

The value of exports rose by 71 per cent from 1980 to 1984, with video sales arising from 14 per cent to 33 per cent of the total. The volume of overseas sales rose by 11 per cent from 37 million units in 1980 to 41 million in 1984. The majority of imports (86 per cent) came from within the EEC.

(b) *Royalties to individuals and recording companies* (£396 million)
The official figure for royalties earned on 'printed matter, sound recordings and performing rights', taken from the *Business Monitor* MA 3, was £100.2 million in 1984. This was based on a DTI survey of UK record and publishing companies and of the relevant collecting societies. The Central Statistical Office supplied a figure of royalties on printed matter of £56.6 million and the Performing Right Society earnings from affiliated societies are known to be £22.3 million. The residual of £21.3 million would appear to represent a possible estimate for the royalties on sound recordings. But figures from the industry put royalty earnings at a vastly higher level than this and major doubts exist about the coverage and meaning of the DTI survey. The main industry source for figures is the British Phonographic Industry (BPI), an industry association formed by manufacturers, producers and sellers of gramophone records, pre-recorded tapes and compact discs in the UK. It has pointed out that 'the complex structure of the international recorded music industry makes it difficult to assess precisely the value of earnings which accrue to individuals or corporations of specific nationalities. Many successful artists who are British nationals may no longer be British residents and transnational companies may not necessarily remit royalty or fee income to the parent company headquarters.' The BPI approach is to estimate the notional earnings to

British companies and artists by assessing the extent to which UK performers, companies, publishers and composers are involved in world sales. Figures on world retail sales are provided by the International Federation of Phonogramme Industries (IFPI) and the BPI identifies the UK elements in the top 20 single and album charts. The latter figure was roughly 25 per cent. In preparing the estimate the method was refined somewhat. The British artistic penetration was analysed separately for the seven major world markets, Australia, Canada, Italy, Japan, Netherlands, USA and West Germany. Deductions were made for local sales tax rates, with figures supplied by IFPI. Conservative figures for standard royalty rates were used to estimate national earnings. For record companies, it was assumed that two-thirds of records with UK artists carried UK labels, with a royalty for the company of 10 per cent. The royalty for composers and publishers was taken as 6.25 per cent and for artists as 13.4 per cent. A final deduction of one-fifth was made to the composer and artist figures to allow for earnings by non-resident British artists. The resulting estimates for royalty earnings are: for companies £111 million, composers and publishers £57 million and artists £228 million. As for the DTI survey, it would appear that royalty earnings may be registered under other headings in the balance of payments and that UK artists may be receiving royalties direct from overseas, not through UK recording companies, in which case they would not appear in the DTI survey.

2.4 Music composition and publishing (£17 million)

(a) *Commissions for composers*
Industry sources suggested that commissioning fees for composers received directly from overseas were very small. The overseas element of composers' earnings from performing rights, mechanical rights and the sale/hire of printed music are included elsewhere.

(b) *Printed music* (£17 million)
The figure was supplied by the Music Publishers Association (MPA) and is based on a survey of its members. Many small publishers are not members of MPA and so the figure is an underestimate. Official figures on 'music printed and in manuscript' are much lower than the MPA estimate. They probably fail to record sizeable quantities of music dispatched in the parcel post.

2.5 Musical instruments (£32 million)

The figures are official statistics taken from the *Business Monitor* PQ 4920. Exports rose from £30 million in 1980 to £32 million in 1984 and £36 million in 1985. Imports have been rising faster. The value of piano sales declined, whilst those of brass and electro magnetico and electro static instruments increased.

3. PUBLISHING AND THE BOOK TRADE

3.1 Receipts from foreign rights (£56.6 million)

The figure was obtained from the *Business Monitor* MA 4. Earnings mainly derived from the sale of foreign rights by UK publishers to their overseas equivalents. A survey of companies with known overseas transactions is the source of the statistics.

3.2 Sale of books (£642 million)

The official trade statistics on the export of books (including booklets and children's picture books) collected by the Customs and Excise put the total at £294 million in 1983. The figure does not include books and other published material dispatched by parcel post. Sample surveys of items dispatched in the parcel post suggest that the actual value of books leaving the UK could be 'up to twice as much again' as the figure recorded by the Customs and Excise. The quarterly *Business Monitor* PQ 4753 on the publishing trade included information on book exports, but this relates only to firms with 25 or more employees. Following a procedure (explained in the *Business Monitor*) for grossing up to include the firms with fewer than 25 employees, an estimate was

obtained for book exports in 1983 of £548 million. This can be compared with the Customs and Excise figure for the same year (chosen because royalty earnings were excluded from the data that year) of £294 million. The figure used here is based on the *Business Monitor*.

4. ART TRADE, VISUAL ARTS AND CRAFTS

4.1 Sale of art, antiquities and craft items (£747 million)

(a) *Organised art trade* (£484 million)

The figure was obtained by means of a survey of the organised art trade, represented by the membership of the Society of London Art Dealers (SLAD), the British Antique Dealers Association, the Antiquarian Book Sellers Association and the London and Provincial Antique Dealers Association (LAPADA). The survey took the form of a self-completion postal questionnaire; the sample frame consisted of the full membership of SLAD and a one in three sample of the other organisations, with quotas for the London and provincial membership; the response rate was 42 per cent in London and 22 per cent elsewhere. The figure of £484 million relates to receipts from the sale of objects to overseas residents; it excludes the auction houses.

(b) *Other trade (including re-exports from the auction houses)* (£220 million)

The above survey was extended to include the three main London auction houses. On the basis of an analysis of the buyers' premium, an estimate was prepared for the value of auction purchases by overseas residents. The figure excludes purchases at auction by agents on behalf of overseas clients. Re-exports are included in the total, in line with the Pink Book approach. A figure for the non-organised trade was derived by reference to the official figures on fine art exports. These cover paintings, drawings, engravings, sculptures and antiques exceeding an age of 100 years. It was possible to infer a rough value for the sales to UK residents of antiques less than 100 years old from the gross VAT figures compiled in the survey of the organised trade. VAT is charged on the sale price of antiques under 100 years old, but only on the dealers' margin for other items in the fine art trade. The balance of the overseas figure was assumed to be in the same ratio as the sales to UK residents. The 'other trade' was assessed as a residual of the official figure (£571 million) plus the estimate of the trade in antiques under 100 years old (£133 million) less the organised trade (£484 million) and auction house sales (£107 million).

(c) *Contemporary art and craft items* (£43 million for craft only)

The survey of the Society of London Art Dealers (SLAD) provided a figure of £4.2 million for receipts from overseas sales by dealers specialising in the 'art of the last ten years'. The SLAD membership included some major dealers but only a small fraction of the London contemporary art galleries. The low response rate in this category also means that the estimate can not be regarded as robust. The Gulbenkian Foundation report, *The Economic Situation of the Visual Artist*, estimated that payment by London commercial galleries to artists for overseas sales were £3.8 million in 1979/80, with a further £0.1 million by galleries outside London. This implies that the overseas market for contemporary art in 1984/85 might have been in the region of £10 to £15 million. This figure is included in 4.1 (b) above. Crafts are not separately identified in the official trade statistics. The Crafts Division of the Scottish Development Agency, using the wide definition of crafts employed in Scotland to include much batch manufacture of items such as knitwear, provided a rough estimate of £25 million for the direct and indirect overseas sales of Scottish craft items. Some 30 to 35 per cent of sales at the Highland Trade Fair went to overseas buyers. The Crafts Council is increasingly active in overseas promotion of the crafts, including the New York Craft Fair, which, together with Scottish crafts at the Los Angeles Fair, produced orders of over £95,000. It might be roughly estimated that overseas sales amounted to 35 per cent of total output or £43 million.

4.2 Auction houses, valuations, shipping (£39 million)

(a) *Auction houses* (£19 million)

The figure was derived from the survey of the three main London auction houses and covers

buyers' premiums, vendors' commission and other receipts from overseas. None of the houses surveyed reported any remittances from overseas branches to the UK parent companies.

(b) *Valuations, restoration and other dealer services* (£8 million)
The survey of the art trade was the source of this figure. London's pivotal role in the world art trade made these services a not insignificant source of income.

(c) *Fine art shippers and forwarders* (£4 million)
This figure derives from the survey of the shipper and forwarder members of LAPADA. It is consistent with the figure of £2.7 million for 1980/81 in G. Norman, *Overseas Earnings of the UK Art Market*. The estimate is probably on the low side.

(d) *Remittances to trade from overseas branches* (£7 million)
The figure was obtained from the survey of the organised art trade, and relates to dealers.

4.3 Other receipts, exhibitions, commissions executed overseas and other overseas earnings by artists (£1 million)

The figure here is merely notional. The earnings from temporary loan exhibitions relate mainly to management fees, payments to designers and other contributors, and catalogue royalties.

4.4 Artists colours and paint brushes (£12 million)

The figure was taken from the official trade statistics.

5. MISCELLANEOUS TRANSACTIONS

5.1 Direct ticket sales overseas (£7 million)

The UK's two main ticket agents, Keith Prowse and Edwards and Edwards, have established a number of overseas offices and work through overseas travel agents by means of computer links. Trade estimates put the level of direct ticket sales for arts events at about £7 million. London pop concerts are a significant draw, as is London's West End. A 1986 survey of the Aldeburgh Festival showed that 1 per cent of ticket sales had been made through Edwards and Edwards' overseas agents.

5.2 Overseas students on further and higher education courses in the visual and performed arts (£17.1 million)

Figures on student numbers were taken from Department of Education statistics for the Royal College of Art, Royal Academy of Music and other principal colleges, including the central institutions in Scotland and the music, drama and design courses in polytechnics and further and higher education establishments. The British Council provided figures on overseas students attending private colleges (mainly for drama) in London. A small upward adjustment was made to compensate for omissions from the above figures. Statistics on expenditure other than tuition fees (£10.5 million) were derived from information supplied by the Association of Commonwealth Universities. In calculating fee income (£6.6 million) it was assumed that one-third of students were from EEC countries and paid the home fees. This EEC proportion was based on information supplied by the British Council and from published DES statistics.

5.3 Examinations in the performed arts (£3 million)

The figure was roughly estimated on the basis of the number of overseas entries for examinations operated by the Associated Board of the Royal Schools of Music. These totalled 155,867 in 1984.

5.4 Cultural spending in Britain by overseas embassies (£1.2 million)

Some twelve embassies or cultural agencies of overseas governments in London supplied estimates of direct spending on fine arts activities in Britain. These included countries with major spending programmes such as Canada (£192,000), West Germany £320,000) and France (£200,000). Sweden spent £132,000 with a further £57,000 on administration. The figure for Austria was £85,000, Norway £140,000 and Switzerland £20,000, though this excluded spending by cantons and communes. Some £33,000 was spent by Brazil and £9,000 by Finland.

BIBLIOGRAPHY

Arts Centres UK R. Hutchison and S. Forrester, *Arts Centres in the United Kingdom*, Policy Studies Institute, 1987.

Battelle 'Le poids economique de la culture et l'effect multiplicateur des nouvelles technologies', Interim Report of the Commission of the European Communities, Battelle, 1987.

BBC *Public for the Visual Arts in Britain*, BBC, 1980.

Bipe 'Les enjeux économiques de la culture en France', Study for the Commission of the European Communities, Bureau d'Informations et de Prévisions Economiques, Paris, 1987.

Blaug M. Blaug (ed.), *The Economics of the Arts*, Martin Robertson, 1976

Bruce A. Bruce and P. Filmer, *Working in Crafts*, Crafts Council, 1983.

Davies and Metcalf G. Davies and D. Metcalf, *Generating Jobs: The Cost Effectiveness of Tax Cuts, Public Expenditure and Special Employment Measures in Cutting Unemployment*, Simon & Coates, 1985.

Facts 1 M. Nissel, *Facts about the Arts*, Policy Studies Institute, 1983.

Facts 2 J. Myerscough, *Facts about the Arts 2*, Policy Studies Institute, 1986.

Gardiner C. Gardiner, 'The West End Theatre Audience 1985/6', A Report of the City University Audience Surveys for the Society of West End Theatre, Society of West End Theatre, 1986.

Graves F. Graves, 'Meta-analysis of the role of economics in evaluating public investment in the arts', Unpublished paper delivered at Fourth International Conference on Cultural Economics and Planning, Avignon, 1986.

Helm D. Helm, ' The real costs of supporting the Arts Council of Great Britain', Unpublished Paper, Arts Council of Great Britain, 1986.

Heritage Monitor *English Heritage Monitor*, BTA/ETB Research Services, annual.

Leisure Consultants *Leisure Forecasts 1988-1992*, Leisure Consultants, 1987.

McAlhone B. McAlhone, *British Design Consultancy: Anatomy of a Billion Pound Business*, Design Council, 1987.

Medlik S. Medlik, *Paying Guests. A Report on the Challenge and Opportunity of Travel and Tourism*, Confederation of British Industry, 1985.

Museums UK D.R. Prince and B. Higgins–McLoughlin, *Museums UK: The Findings of the Museum Data-base Project*, The Museums Association, 1987.

Myerscough J. Myerscough (ed.), *Funding the Arts in Europe*, Policy Studies Institute, 1984.

Nissel M. Nissel, 'Financing the arts in Great Britain', in J. Myerscough (ed.), *Funding the Arts in Europe*, Policy Studies Institute, 1984.

Peacock Report	*Report of the Committee on Financing the BBC*, Cmnd. 9824, HMSO, 1986.
Peacock	A. Peacock, E. Shoesmith and G. Millner, *Inflation and the Performed Arts*, Arts Council of Great Britain, 1984.
Phillips	J. Phillips, *The Economic Importance of Copyright*, The Common Law Institute of Intellectual Property, 1985.
Pick	J. Pick, *The Theatre Industry*, Comedia, 1985.
Pink Book	*United Kingdom Balance of Payments: The CSO Pink Book*, Central Statistical Office, HMSO, annual.
Pleasure	*Pleasure, Leisure and Jobs. The Business of Tourism*, Cabinet Office (Enterprise Unit), HMSO, 1988.
Pommerehne	W.W. Pommerehne and B.S. Frey, 'Public promotion of art and culture: why and how?', Unpublished paper presented at Conference on Europe in Transformation: The Cultural Challenge, Florence, 1987.
Radich	A.J. Radich (ed.), *Economic Impact of the Arts: a Sourcebook*, National Conference of State Legislators, Washington D.C., 1987.
Select Committee	House of Commons Select Committee Education, Science and Arts, *Public and Private Funding of the Arts*, Eighth Report, Session 1981-82, 3 volumes, HC 49-I/II/III, HMSO, 1983.
Throsby and Withers	D. Throsby and G. Withers, *What Price Culture?*, Australia Council, 1984.
West	E.G. West, *Subsidising the Performing Arts*, Ontario Economic Council, 1985.

Recent studies of the economic impact of the arts.

Radich above contains a full critical account of the numerous impact studies carried out in the USA. A pioneering British study was undertaken by D.R. Vaughan 'The economic impact of the Edinburgh Festival, 1976' for TRRU in 1977. More recently R. Perry, with T. Noble and S. Harris, carried out an unpublished study 'The economic contribution of the arts and crafts to Cornwall', Cornwall College of Further and Higher Education, Redruth, 1985. Two important Australian studies deserve mention: *Building Private Sector Support for the Arts. A Review of the Economics of the Arts in Australia with Recommendations Relating to Private Sector Support*, Myer Foundation, Melbourne, 1977; P. Brokensha and A. Tonks, *Culture and Community: Economics and Expectations of the Arts in South Australia*, Social Science Press, New South Wales 1986. Simple and effective studies have been carried out on the Avignon Festival (by BIPE, 1984), on the Salzburg Festival (B. S. Frey, 'The Salzburg Festival — from the economic point of view', *Journal of Cultural Economics*, 10 (Dec)) and on the cultural organisations in the city of Zurich *(Die wirtschaftliche Bedeutung der Züricher Kulturinstitute*, Julius Bär-Stiftung, Zürich, 1984).